PHILIP II *of* SPAIN *and the* ARCHITECTURE *of* EMPIRE

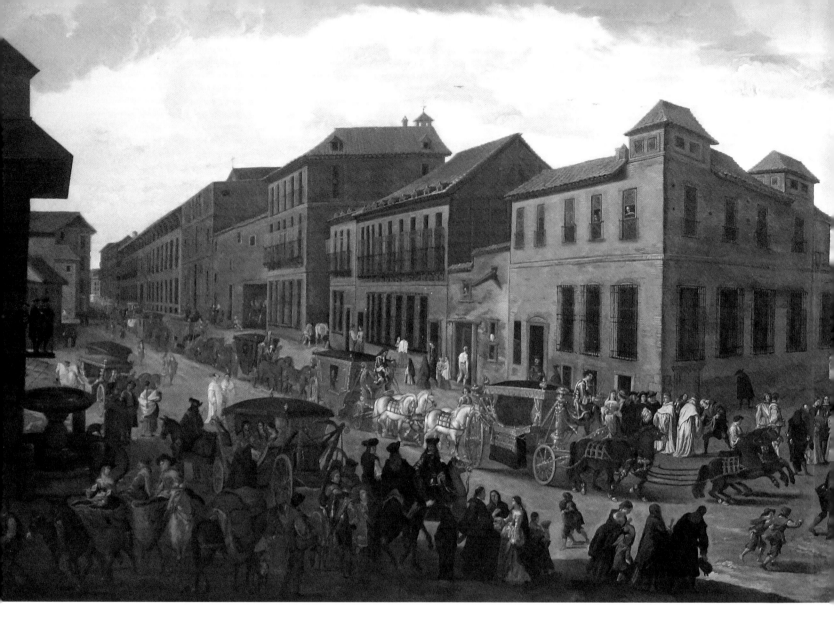

The Pennsylvania State University Press, University Park, Pennsylvania

LAURA FERNÁNDEZ-GONZÁLEZ

PHILIP II *of* SPAIN *and* *the* ARCHITECTURE *of* EMPIRE

Library of Congress Cataloging-in-Publication Data

Names: Fernández-González, Laura, author.
Title: Philip II of Spain and the architecture of empire / Laura
 Fernandez-Gonzalez.
Description: University Park, Pennsylvania : The Pennsylvania State
 University Press, [2021] | Includes bibliographical references and
 index.
Summary: "Explores the architectural and artistic projects of Philip II of
 Spain, placing them in the wider context of the peninsular, European,
 and transoceanic Iberian dominions"—Provided by publisher.
Identifiers: LCCN 2020051802 | ISBN 9780271087245 (cloth)
Subjects: LCSH: Philip II, King of Spain, 1527–1598. | Architecture—
 Spain—History—16th century. | Architecture and state—Spain—
 History—16th century. | Architecture and society—Spain—History—
 16th century. | Spain—Kings and rulers—Dwellings—History—16th
 century. | Spain—History—Philip II, 1556–1598.
Classification: LCC NA1305 .F465 2021 | DDC 720.94609/031—dc23
LC record available at https://lccn.loc.gov/2020051802

Title page: Jan van Kessel the Younger (1654–1708) (attributed),
*View of the Carrera de San Jerónimo and the Paseo del Prado with a Procession
of Carriages*, ca. 1680. Photo: Hugo M. Crespo.

A much abridged earlier version of chapter 2 appeared in "The
Architecture of the Treasure-Archive in the Early Modern World: The
Archive at the Simanca Fortress, 1540–1569," in *Felix Austria: Lazos
familiares, cultura política y mecenazgo artístico entre las cortes de los
Habsburgos*, edited by B. J. García García (Madrid, 2016), 61–101.

A much abridged earlier version of chapter 3 appeared in "Negotiating
Terms: King Philip I of Portugal and the Ceremonial Entry into Lisbon in
1581," in *Festival Culture in the World of the Spanish Habsburgs*, edited by
F. Checa Cremades and L. Fernández-González (Aldershot, 2015), 87–113.

To my parents and my brother.

CONTENTS

ILLUSTRATIONS

ACKNOWLEDGMENTS

Many friends and colleagues have greatly contributed to the completion of this book. I am very grateful for the support of colleagues and friends at the School of History and Heritage at the University of Lincoln and the Schools of Architecture and Landscape Architecture and the History of Art at the University of Edinburgh. I would like to thank Teo Ruiz for suggesting that my manuscript could be a future Penn State University Press book. The extremely helpful feedback from the reviewers has been fundamental to strengthening the manuscript. The encouragement and support of Ellie Goodman and her terrific team at Penn State University Press, especially Maddie Caso, Laura Reed-Morrisson, Jennifer Norton, Garet Markvoort, and Brian Beer, have been extraordinary, thank you. Colleagues and friends who have read the manuscript in different iterations have had a tremendous impact on the final version. Nancy Campbell has read several versions of the manuscript as it progressed over the years; her feedback not only sharpened my prose but also influenced my thinking, thank you indeed. Ralph Kiggell's fine eye for detail helped me to further polish the manuscript. Susan V. Verdi generously read and thoroughly commented on an earlier version of chapter 1. The late Rosemarie Mulcahy's feedback on an earlier version of my work and her ideas on how to frame my argument have been instrumental. I am extremely grateful to Alex Bremner for his comments and support over the years. While this book is very different from the project he advised years ago, his insightful feedback and his own work continue to inspire me. I thank Fernando Checa Cremades, Alejandra B. Osorio, and Charo González for many stimulating conversations that helped me shape my argument. The generous support and friendship of José Luis Rodríguez de Diego, Isabel Aguirre, and Julia Rodríguez de Diego have undoubtedly made chapter 2 much better than it would have been otherwise. Fernando Bouza's, Bernardo J. García García's, and José Luis Rodríguez de Diego's revisions on earlier versions of chapter 2 have been instrumental in enhancing it. I learned much from the comments of Hugo Crespo, Marjorie Trusted, John H. Elliot, and Annemarie Jordan on earlier versions of chapter 3, and Fernando Bouza, again, was essential to the development of this chapter. I spent a wonderful day with Geoffrey Parker and Bethany Arran looking at drawings of battles in Jerez and discussing their parallels with the fresco of La Higueruela included in chapter 4. A lively discussion at the PALATIUM conference in Vienna helped me frame ideas with regard to the fresco cycle at the Hall of Battles at El Escorial, and discussions that followed with Catherine Wilkinson-Zerner, Krista de Jonge, and many others gave me important insights. Many colleagues and friends have discussed ideas, replied helpfully and

patiently to my queries, and offered support over the years, including, in no particular order, Harald Braun, Carmen Fracchia, Jesús Escobar, Michael Schreffler, Benito Navarrete, Fernando Marías Franco, Richard L. Kagan, Víctor Mínguez, Maria Inés Aliverti, Lucia Nuti, Miguel Ángel Zalama, Pedro Cardim, Ângela Barreto Xavier, Lisa Voigt, Iris Kantor, Federico Palomo, Miguel Soromenho, Sílvia Ferreira, Pedro Flor, Inmaculada Rodríguez Moya, Carmen García-Frías Checa, Juan Luis González García, Almudena Pérez de Tudela, José Luis del Valle Merino, Jaime Bernal, Jeremy Roe, Felipe Pereda, Juan Chiva, Céline Ventura Teixeira, Luisa Elena Alcalá, Jill Burke, Tom Cummins, Jim Lawson, Rafael López Guzmán, Miguel Ángel Tabales, Rafael Fort, José Manuel Barbeito, Suzanne Ewing, Claudia Hopkins, Yue Zhuang, Catriona Murray, Giovanna Guidicini, Krista Cowman, Antonella Liuzzo Scorpo, Jamie Wood, Graham Barrett, Michele Vescovi, Ignacio J. López Hernández, Susana Fonte, Kristina Potočnik, Andrea Hyslop, Kika González, and Hugo Vázquez, among many others. Thank you indeed to my dear brother, Javier Fergo (a talented photojournalist), for his help with the illustration program and for allowing me to use one of his photographs. Thank you also for the photographs offered by Ignacio J. López Hernández, Hugo Crespo, and Martijn Zegel, and to all the institutions that allowed me to use the images. I am grateful to Harry Kirkham and Cameron Stebbing for their help with some of the drawings. I also thank Nick Sharp and Andrea Hyslop for their help with my initial sketches and drawings; all these earlier drawings featured in an exhibition I curated at the Matthew Gallery in Edinburgh in 2010 and were important for the development of the final drawings that appear in this book. There are many other colleagues and friends, too many to mention, whose knowledge, advice, and wisdom are reflected in these pages: I am grateful to all of you.

I am also thankful for the support of institutions and funding bodies, which enabled me to research, write, and travel. I am grateful to the College of Arts research grants at the University of Lincoln for its generosity and support. The Calouste Gulbenkian Foundation's program for foreign researchers generously funded research in Lisbon in 2011 and 2014. The Institute for Advanced Studies in the Humanities at the University of Edinburgh offered generous support and a peaceful space in which to work. Research for this book was also made possible by grants from the British Spanish Society (2010) and a Career Development Fellowship awarded by the University of Edinburgh and, prior to this, a full doctoral studentship that covered fees, research, and maintenance, also generously funded by the University of Edinburgh. Curatorial commissions have also supported this book project directly or indirectly; for example, the Spanish Consulate in Edinburgh co-funded a 3D visualization project. Many thanks to Federico Palomera Güez, Spanish Consul in Edinburgh at the time, who made this possible. This project also received generous funds from the Schools of Architecture and Landscape Architecture and the History of Art at the University of Edinburgh and the Society for Renaissance Studies, UK. This work attracted a curatorial commission to digitally re-create the architecture of early modern Lisbon, a work that has been shown at a major exhibition on the Rua Nova dos Mercadores at the Museu Nacional de Arte Antiga in Portugal. I am also grateful to the staff of all the libraries and archives cited in this book. A generous grant awarded by the Society of Architectural Historians of Great Britain (SAHGB) has supported the publication of this book.

This book would not have been possible without the encouragement and loving support of my family and my lovely friends. This book is dedicated to them.

Introduction

PHILIP II OF SPAIN, ARCHITECTURE, AND VISUAL CIRCULATIONS

Imagine a grand palatial chamber in the Alcázar (royal palace) in Madrid, the room designed in the form of an enlarged rectangle of monumental dimensions, the architecture of which aimed to impress the viewer. This gallery's spatial configuration effectively suited the progress of pageants in ceremonial procession, which in turn accentuated the majesty of the king's palace.[1] To commemorate the ceremony of the Order of the Golden Fleece that took place in the palace in 1593, the walls of the gallery were lined with some of the finest tapestries in the royal collection. Some of these tapestries were from the Conquest of Tunis series, a set woven by Willem de Pannemaker (1512–1581) from the cartoons by Jan Cornelisz Vermeyen (ca. 1504–1559). The ceremonial committee progressed through this grand palatial chamber and accessed an adjacent room, located in the northwest area of the palace. Described by the chronicles as a *saleta* (small chamber), this space boasted tapestries on its walls from the Fame series (now known as the Honors series) woven by Pieter van Aelst (ca. 1495–ca. 1560).[2]

This *saleta* was also "covered with beautiful carpets" and included "a very rich chair," a throne under a canopy embroidered with gold, silver, diamonds, rubies, emeralds, pearls, and other precious stones. The throne and canopy had been brought from Antwerp at great expense. From this chamber the procession continued to the next room, where members of the Order, the noblemen receiving the chain of the Order of the Golden Fleece, and officials waited for the king to be ready. The committee subsequently joined the king in his quarters. King Philip II of Spain (r. 1556–98) sat in his ceremonial seat, which was flanked by two benches covered with carpets from the Indies; on the right-hand bench sat Prince Philip, heir to the Spanish throne, who was fifteen years old at the time.[3]

A chronicle of the event recounted some of the lavish decoration fashioned for the ceremony in the Alcázar: magnificent Flemish tapestries, a royal throne made in Antwerp with a profusion of precious metals and stones, and carpets that impressed the observer, some of which came from

the Indies. The presence of the empire—trans-oceanic and European—could be sensed through some of these objects. The brief description of the decoration of the chambers for the ceremony exemplifies some of the objects that were found in Philip's palaces. While the presence or absence of objects from the West Indies at the court in Madrid has been famously debated, and the present piece by no means intends to fully engage with such discussion, one can conclude that the composition of the spaces described in the Alcázar combined materials and objects crafted in different parts of the world.[4]

Chambers decorated with diverse objects from around the globe were indeed found in Iberian Habsburg palaces. The designs, materials, and construction techniques used for some of the buildings erected in sixteenth-century Iberia synthesized broader trends. Sixteenth-century Spain is generally linked to Habsburg European political prowess and imperial expansion in the Americas. The European and colonial empire that Philip II inherited in 1556 would be dramatically expanded in 1580, when the monarch became king of Portugal and thus ruler of the vast Lusitanian transoceanic empire. Trans-European artistic and design influences were present in Iberia; however, visual trends were greatly influenced by the building and artistic traditions of Al-Andalus. The latter is illustrated in Jakob Cuelbis's description of the Alcázar in Madrid in 1599, where the German traveler recounted the array of maps and city views found in the Salón Dorado (Gilded Hall), which included a selection of city vistas that Anton van den Wyngaerde had depicted for Philip II. This chamber also included maps of Rome and Seville, an image of Malacca, and a view of Mexico City.[5] The representation of Mexico City was moved some decades later to the Alcázar's then less prominent Galería del Cierzo (Northern Gallery), where the chambers of the old Trastámara palace were located. The architectural development of the Alcázar

during the reigns of Charles V and Philip II presented a synthesis of coexisting visual trends.[6] During Charles V's reign, some chambers of the Trastámara palace were conserved together with their *artesonados* and *armaduras*, demonstrating the magnificent Andalusian woodwork tradition that was widely employed in the Iberian Peninsula in the sixteenth century.[7] The *artesonados* and *armaduras* in these rooms were restored and embellished during Charles V's reign and retained during Philip's rule. During Philip II's reign, new spaces, especially the Golden Tower, gained more prominence in the palatial complex—incorporating designs and decorations according to the king's taste and reflecting pan-European design trends—yet these other chambers were still used in the daily life of the court.[8] A devastating fire destroyed the Alcázar in 1734, and while it is impossible to know whether the building and some of its oldest chambers would have survived the passage of time, its loss has also affected the way in which the arts of Philip's time, particularly architecture, are understood.

Prince Philip, the son of Charles V (1500–1558) and Isabella of Portugal (1503–1539), was born in Valladolid in 1527. Educated in the courtly circle of Isabella until her death in 1539, Philip's tutors included Juan Martínez Siliceo (1486–1557) and the humanist Juan Calvete de Estrella (1520?–1593). Philip became Duke of Milan in 1540 and regent of Spain in 1543. Philip's education in letters, sciences, martial arts, and statesmanship resembled that of other contemporary princes of the period. Philip's language abilities never compared to his father's and, while he traveled often, Philip felt most at home in Castile. In 1541, at the age of fifteen, Prince Philip already had a small collection of books on geometry, mathematics, and architecture.[9] In the mid-1550s, the prince had two important encounters with architectural theory. Francisco de Villalpando (ca. 1510–1561) published his translation of the third and fourth books of Sebastiano

Serlio's treatise into Castilian in 1552. Villalpando proposed architecture as a vehicle to impose royal authority and argued that it could be exploited for the glorification of the king.[10]

Philip owned an anonymous treatise on architecture, dated around 1550; the manuscript, entitled *De arquitectura*, was dedicated to the prince and stems from Leon Battista Alberti's *De re aedificatoria* (1485).[11] The author praised Vitruvius's work, emphasized the role of architecture as a medium to project esteem, and made a distinction between the duties of a mason and those of an architect.[12] Thus rulers, as architects of the state, should assert their presence through architecture and urbanism. The author advocated for the creation of a royal architectural style, unornamented, that emulated ancient Roman public buildings. The anonymous author evoked the Albertian reinterpretation of Ciceronian oration to emphasize that ornamentation should be reserved for religious buildings; public buildings should be less decorative.[13] *De arquitectura* condensed the characteristics of the style developed under Philip II's patronage in subsequent years, contending that an ordered city with fine architecture would improve the realm and echo the good governmental praxis of the ruler. Thus *De arquitectura* buttressed the moral constellations of architecture and urban planning.

The prince was summoned by his father to travel in central Europe (1548–51) in order to familiarize himself with the northern parts of his realm and future allies. He traveled through Italy, Germany, and the Low Countries. Charles V intended to abdicate the Holy Roman emperorship in his son's favor; however, the imperial throne remained in the Austrian branch of the Habsburgs. In addition to receiving the Dukedom of Milan, Philip became king of Naples and Sicily in 1554. Philip's first European sojourn is the period in which he cultivated his artistic preferences. He famously met Titian, his favorite painter, and in this sojourn the Venetian artist also portrayed Philip. The prince's

encounters with artists and architecture, particularly in Italy and the Low Countries, had a tremendous impact on his artistic taste. Upon his return to Castile, Philip implemented an intensive program of reforms in his properties. These projects included the palace in Aranjuez and its gardens as well as major architectural reforms in the royal palaces in Madrid, El Pardo, and Valsain.[14] Apart from El Escorial, these palaces have either disappeared or changed significantly over time. Philip's involvement went beyond the reading of reports and receipt of plans for his approval; he amended proposals extensively and drafted plans for the architects. The prince's correspondence with the Junta de Obras y Bosques, the committee in charge of these architectural developments and the management of royal forests, was fluid, and the flow of correspondence with his architects increased over time.[15]

On the second journey, between 1554 and 1559, Philip traveled to England to wed Mary Tudor and became Lord of the Seventeen Provinces in the Netherlands in 1555. Philip then traveled to France to support his father in the French campaign that culminated in the Peace of Cateau-Cambrésis (1559). The peace gave the Spanish Habsburgs virtual control over the Italian peninsula, a hegemony that lasted practically undisturbed until the end of Philip's reign. Charles abdicated in 1556, and from then until his death in 1598, Philip was king of Spain and also ruled over the expanding dominions in America.

In 1559, Philip appointed Juan Bautista de Toledo (ca. 1515–1567) architect of the realm and master mason, and in 1561 he designated Madrid as the temporary seat of the royal court. Master masons at the court, such as Alonso de Covarrubias (1488–1570) and Luis de Vega (d. 1562), would continue their labor for Philip. However, Bautista de Toledo was the designer of the master plan for the Monastery of San Lorenzo of El Escorial and contributed to the creation of the austere classicism

that characterized the style of royal buildings. After Bautista de Toledo's death in 1567, the architect and scientist Juan de Herrera (1530–1597) became one of the most important designers at court.[16] Gaspar de Vega (ca. 1523–1575) and Francisco de Mora (1553–1610) also made vital contributions to the evolution of architectural design at court. During the reigns of Philip's heirs, architects such as Juan de Valencia and Juan Gómez de Mora (1586–1648), among others, further consolidated the Habsburg style in architecture.[17]

The style in architecture created by Philip II and his architects has been called the Herrerian style, after Juan de Herrera.[18] This new style was a combination of Castilian design, Italian trends, and Flemish solutions to building roofing and towers, which in turn echoed the theories of the ancients.[19] The style, epitomized by El Escorial, continued to thrive after Philip II's death and came to symbolize the lineage of the Spanish Habsburgs. Carl Justi (1832–1912) coined the term *desornamentado* with a pejorative bias, which echoes the wider influence of the Black Legend.[20] George Kubler (1912–1996) found stylistic parallels between the Spanish Habsburg style and the plain style in Portugal, which had greater longevity.[21] For the former, Jesús Escobar has appropriately posited the use of *Austríaco* style, a term that bolsters the notion of a style developed by, and for the representation of, the Spanish branch of the Habsburg dynasty in the early modern period. Thus this term seems the most suitable designation for the architectural style of the Spanish Habsburgs. The critical role that Philip II had in its creation and his interventionist approach to architectural design and practice are fundamental for an understanding of his reign and the prestige of the built environment therein.

In 1580, Philip became king of Portugal, a realm he ruled until his death that included the vast dominions of the Lusitanian empire. The Spanish branch of the Habsburgs became Europe's most powerful composite monarchy, with an empire that stretched from Europe to the Americas and Southeast Asia. Philip's dominions enjoyed only six months of peace during his reign: he engaged in military campaigns with other European realms and with the Turks in the Mediterranean, and he faced a significant uprising within Castile known as the Rebellion of the Alpujarras (1568–71). Military campaigns, attacks on the convoys from the Americas and on imperial ports in both Europe and the wider world, and bankruptcies successively emerged during Philip's reign. In 1588, the Spanish monarch planned a full-blown invasion of England. Despite the Armada disaster, the Spanish monarchy under Philip's rule continued to exert dominion in Europe and abroad, while Philip's fame and reputation as a religious fanatic circulated across Europe. Philip's political decisions and his arduous defense of the Catholic faith have overshadowed the perceived image of the monarch. However, Philip was also passionate about architecture, art, books, nature, and gardens.[22]

The historiography of Philip II's contribution to architecture has been dominated by an analysis of the magnum opus created by his royal architects under his patronage, the Monastery of San Lorenzo of El Escorial (fig. 1). The magnificent view of the seventh design included in Pierre Perret's book shows the architecture of the monastery in all its splendor. The series of etchings is based on drawings by the royal architect Juan de Herrera.[23] The view offers an overview of the main façade and displays the ordered layout of the building, the sequence of cloisters, and the basilica. An extraordinary building in terms of design, construction materials, and decorative program, El Escorial was constructed in twenty-one years between 1563 and 1584, an incredible feat. The monastery sought to commemorate the victory of the Battle of St. Quentin (1557) and above all to serve as a pantheon for the kings of Spain. Dedicated to Saint Lawrence, El Escorial was originally a monastery of the Order of Saint Jerome, following Habsburg

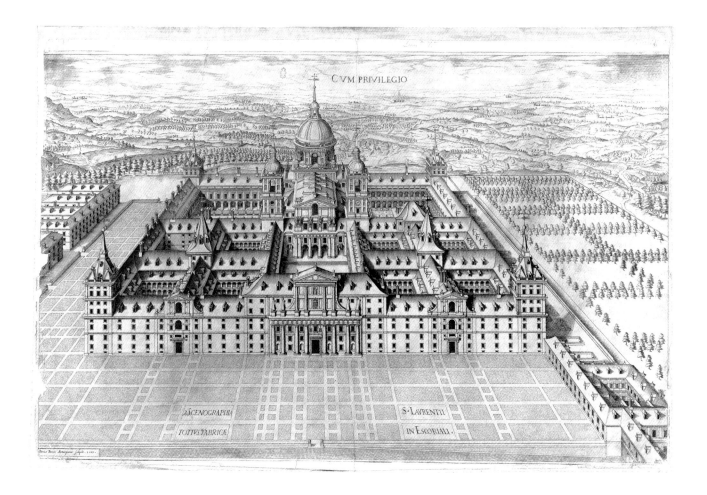

tradition. For the work on the monastery, Philip sought the best architects and artists he could attract to his court. El Escorial was not only a monastery and a mausoleum but also a palace and a seminary, which houses a magnificent library and a vast collection of relics. The erection of this building, which in the collective imagination identified Philip as the defender of the Catholic faith, gives us a partial view of his rule. It also informs our understanding of the arts, including architecture, during his reign.[24] Scholarship in the past few decades has reclaimed a more balanced image of Philip II as both a monarch and a patron of the arts; of particular interest for the present book are works on architecture and visual culture.[25] Philip was one of the major patrons of the arts in the

FIGURE 1 | Pierre Perret, seventh design of the General Vista of El Escorial, 1587. From *Diseños de toda la fabrica de San Lorenzo el Real del Escurial, con las declaraciones de las letras, numeros y caracteres de cada uno* (Madrid, 1587). Courtesy of the Biblioteca Nacional de España.

period: he amassed a large collection of Titians (among other prominent painters), commissioned tapestries, and funded grand architectural and artistic projects.

The literature has focused on placing the artistic taste of the Habsburg Spanish Court at the forefront of well-regarded southern and northern Renaissance art and architecture. Philip had clear preferences for Italian and Flemish art; however,

neither El Escorial nor his collections fully convey the rich array of architectural and cultural trends that characterized the artistic landscape of the Iberian Peninsula in this period. Since El Escorial is one of the few surviving sixteenth-century royal residences, it is not possible to comprehend the full spectrum of architectural production in the period, or the spaces that royalty and Philip's subjects inhabited in cities across his realms. While attempting to condense all architectural, visual, and cultural circulations in one book is an impossible task, it is nevertheless necessary to contextualize the circulation of visual trends in Philip's world more widely. Philip and his entourage intended to "modernize" the arts in the peninsula and their former imperial dominions to reflect major European visual trends. His artistic and architectural preferences, and his many interventions in architectural projects, did not, however, obliterate other traditions from the Iberian world during the sixteenth century. But is it really possible to write a book on architectural, visual, imperial, and cultural circulations during Philip II's reign and not make El Escorial central to the discussion?

The realities of the royal premises and the wider cultural context in the Iberian Peninsula and beyond during Philip's reign cannot be understood solely by examining El Escorial. In this vein, it seems most logical, even necessary, to investigate the wider context, local and transregional, that conditioned the design, construction, and decoration of buildings during Philip's reign. While this book engages with El Escorial, one of its major concerns is also to examine other models that allow us to understand the rich array of trends that informed the buildings and contexts that Philip, his court, and his subjects inhabited. Thus chapters in the present book examine the manner in which architectural design, technologies, and images circulated in the Iberian world, Philip's role in the creation of buildings and images (or, alternatively, in fostering imperial mechanisms that promoted them), and the local and wider contexts that conditioned the

production, flow, and circulation of pan-Iberian visual culture. The book crosses the traditional distinction between high art and the so-called vernacular traditions. I analyze architectural and visual circulations within the cultural, social, and material contexts. This approach has been productive in uncovering some of the mechanisms that fostered intercontinental circulations. To this end, this book examines some of the lesser-known architectural and artistic projects of Philip II of Spain and places them in the wider context of the peninsular, European, and transoceanic Iberian imperial dominions. The case studies explored in this book are wide-ranging and have never been examined comparatively before (city and house design, archival architecture, and festivals and the circulation of kingly imagery, among others). I have also employed architectural drawings and digital re-creations, which have added new dimensions to our understanding of ephemeral and domestic architecture.[26] Thus this book makes an important new contribution to the scholarly conversation on Philip II's reign through its transoceanic comparative approach.

The historiography devoted to Philip II is overwhelming. William H. Prescott's unfinished opus is considered a pioneering example of biographical work. Geoffrey Parker has considered the scholarly contributions that emerged at the beginning of the twentieth century by Carl Bratli (1909), Rafael Altamira y Crevea (1926), and Ludwig Pfandl (1938). Louis Prosper Gachard undertook systematic archival research in the mid-nineteenth century, and Gregorio Marañón and Fernand Braudel took an approach to historical research that opened a new path for historians. The number of publications grew exponentially on the commemoration of the death of the monarch and his father in 1998. Biographical works on Philip II have increased considerably since a new wave of scholars began to reassess Philip's personal and political career. Parker alone has published several biographies, among them some of the most recent

and important contributions to our understanding of Philip II.[27]

There are other significant biographical contributions authored, for example, by Friedrich Edelmayer and Henry Kamen. Mía Rodríguez Salgado has analyzed the transition between the reigns of Charles V and Philip II. José Luis Gonzalo Sánchez-Molero has published a fundamental study of the monarch's childhood. José Antonio Escudero analyzed the manner in which Philip II worked in his office. Fernando J. Bouza Álvarez also wrote an important biography of Philip in his role as king of Portugal. Richard L. Kagan has explored the uses of history in the Spanish medieval and early modern world as a fundamental basis for propaganda.[28]

Surveys and monographs on the arts, architecture, urbanism, and culture during Philip II's reign are also numerous. Philip II's influence on the modernization of the arts has been reassessed in a major monograph by Fernando Checa Cremades (1992). Rosemarie Mulcahy has important publications on the decoration of the basilica in El Escorial and she published the last monograph to date focused on the monarch's patronage of the arts (1994 and 2004, respectively). There are many surveys on architecture and art, including the pioneering work of Llaguno y Amírola and Ceán Bermúdez on architects and architecture in Spain (1829). George Kubler completed a monograph on the construction of El Escorial (1982). Fernando Marías Franco has substantially contributed to our knowledge of early modern Spanish architecture. José Javier Rivera Blanco explored the work of the royal architect Juan Bautista de Toledo.[29] Catherine Wilkinson-Zerner's monograph on Juan de Herrera has also been a major contribution to the field.[30] Fernando Bouza's publications on the images and propaganda produced during the Iberian Union are essential reading.[31] Scholarly works on the arts under the Spanish branch of the Habsburgs, and especially on Philip II, are numerous and growing. However, for the case studies on which I focus,

the literature is still slim, and it does not apply the same methods for comparative analysis (or architectural drawing) that I have employed in my work. This book is composed of the present introduction, four substantial chapters, an epilogue, and a glossary. Chapter 1, titled "'A World, an Empire, Under Construction': Domestic Architecture and Spanish Imperial Authority," charts the regulatory mechanisms that Philip's court and local authorities aimed to implement in Madrid to regulate residential architecture. Madrid was designated the "temporary" seat of the court in 1561 and became the de facto center of imperial administration. Philip vigorously expanded and redeveloped the royal palace and the streets in its vicinity. With the court in Madrid, the city's population increased substantially, and legislation aimed at fulfilling hosting duties and improving residential architecture emerged in the form of the *reales cédulas* of 1565 and 1584 and a *real provisión* in 1567. Publications on the Alcázar of Madrid constitute an important resource for the study of the city's urbanization under Philip II.[32] Jesús Escobar's crucial contribution concerning the Plaza Mayor in Madrid has shed new light on our understanding of baroque urbanism in Habsburg Madrid.[33] Alfredo Alvar Ezquerra examined the nascent capital during Philip II's reign at length, and Claudia Sieber opened a new path for our knowledge of the social history of the capital city.[34] Nevertheless, none of these works explores the ways in which Madrid was "imagined" in the early years of Philip II's rule through the lens of domestic architecture. The role that the regulation of domestic architecture played in the making of imperial Madrid, and its relationship with wider pan-Iberian architectural and imperial circulations, requires further scrutiny.

Chapter 1 examines the impact of the royal *aposento* (seat) of court on domestic (nonpalatial) architecture in Madrid and its wider context. It focuses in particular on the relationship between the legislation for the development of houses enacted in Madrid in the period between 1565 and 1584 and

similar regulations in cities in the Iberian world.[35] Newly identified original drawings of houses designed to comply with legislation in Madrid and Valladolid shed new light on the streetscapes of the capital city that were imagined at the time. These drawings demonstrate that the design envisioned for houses in Madrid can be contextualized within wider contemporary theoretical thinking in architecture.

Chapter 1 also comparatively explores similar regulatory practices in a number of cities and towns across the Iberian world. The mechanisms for the control of the built environment and architectural practice in these locales are useful means for examining the circulation of designs, technologies, and materials, and their necessary adaptation to particular local conditions. The last section of this chapter scrutinizes the manner in which the influx of information concerning the development of American cities was received and managed at the Spanish court and compares it with the role the court played in the development of Madrid.[36] This part of the chapter contributes to the conversation about architectural knowledge and exchange in the Spanish empire. By focusing on the different offices held by court members in Castile and the Americas, I posit new lines for research on the impact that itinerant officials within imperial administration had on the built environment.

With the loss of the Alcázar in the Madrid fire of 1734, no palaces in which Philip II resided survive, other than El Escorial and other royal retreats that have been substantially modified over time. While Philip only spent some nights in a temporary chamber prepared for him on his visit to the royal archive at the Simancas fortress in 1592, and while the castle cannot be considered one of his residences, its architecture, I argue, echoes coexisting Iberian trends that were also present in the royal palace in Madrid and is reflective of wider practices. The second chapter of this book is titled "Ruling an Empire Through Paper: Architecture

and the Simancas Archive." Philip II's empire was ruled through the written word, with an increasingly specialized and sophisticated bureaucracy. This bureaucratic character, I argue, was reflected in the architectural reform of the Simancas fortress to adapt it for archival needs. The archives of any kind of "institution" reflect (or at least should reflect) the structure of the organization, and, accordingly, the Simancas archive echoes the practices of governance in the sixteenth century. There is no study to date on the architectural creation and evolution of early modern archives in Europe or in the territories overseas. In the case of Simancas, the most important publications are the notable contributions to its archival history by former director José Luis Rodríguez de Diego.[37] The present study addresses this shortcoming, not only by examining the architecture of the royal archive in Simancas but also by comparing it with other contemporary archives. This is the first comprehensive study of the building in relation to concurrent European and Iberian design trends. The architectural reform of the fortress shows the crucial role that the archives played during Philip II's rule. I examine the first two archival chambers adapted in the castle, the so-called *cubos* of Charles V and Philip II, built between 1540 and 1568, in relation to a vernacular tradition that spread across Europe. Newly uncovered correspondence between the monarch and the archivist at Simancas shows royal intervention in the decorative program of the chambers and the integration of coexisting Iberian styles in its design.

The second part of chapter 2 examines the grand expansion of the Simancas archive in the 1570s and 1580s. I study in detail Philip II's visit to the royal archive in 1592 and the architectural reverberations of his visit. I suggest that the architectural evolution of this building not only echoes the development of Philip's empire but also shows the evolution of architectural taste at court. Reforms in the Castle of Simancas also reflect the synthesis of

pan-Iberian and vernacular design in courtly buildings. In short, the Simancas fortress provides a useful window into how designers integrated existing structures and new designs in other significant royal buildings, such as the Alcázar in Madrid.

Architecture, empire, and their circulations during Philip's reign are explored in the first two chapters. Both the design and the role of residential architecture in Madrid and locales across the Iberian world and the Simancas archive not only reflect imperial administration but also show the amalgamation of Iberian architectural trends. Both case studies have proved to be useful models for examining visual and design exchanges and circulations. The third chapter, "The Global Empire and Its Circulations: Philip II and the Iberian Union," explores the refashioning of Philip II's image upon his accession to the Lusitanian throne in 1580 and the lasting circulation of the images created to celebrate his victory. The strategy Philip and his court envisioned leading up to his succession to the Portuguese throne included the renovation of the ruler's imperial image. This imperial imagery would integrate his political supremacy with his responsibility as a defender of the Catholic faith. In these years, the imperial rhetoric at Philip's court reached its peak. The literature has extensively discussed the campaign that concluded in the period known in historiography as the Iberian Union (1580–1640). Fernando J. Bouza's monumental contribution to our understanding of the cultural aspects of royal propaganda is essential reading, as are his publications on festival culture in Habsburg Portugal. Miguel Soromenho and Ana Paula Torres Megiani have studied significant aspects of this festival.[38] Both Philip's grand ceremonial entry into Lisbon in 1581 and the union's impact on the representation of the monarch deserve closer examination.

On 29 June 1581, King Philip I of Portugal (Philip II of Spain) was received in the city of Lisbon in one of the most magnificent ceremonies ever staged in Portugal. The royal procession, combined with religious interludes and popular celebrations, resumed a dialogue between ruler and ruled. Fifteen triumphal arches and other ephemeral structures were erected, while plays and songs celebrated the union of the largest global empire ever known. The principal theme of the entry was the glory of Philip as universal global monarch and ruler of two of the largest early modern European kingdoms: Portugal and Castile. Chapter 3 charts the imagery of the political union of the Crowns in the grand ceremonial entry that was prepared to receive Philip in Lisbon in 1581. I examine the narratives and the images described in contemporary accounts of the festival and the integration of local, courtly, and pan-Iberian artistic trends in the ephemera erected in Lisbon. I employ not only methods for comparative analysis but also architectural drawing and three-dimensional modeling to fully understand the architecture of the ephemeral structures described in the written sources. I also analyze the role of Philip II as a leading performer in the pageant and his dialogue with religious and lay elites, as these offer insights on the ways the ruler and the ruled negotiated their place at this particular political juncture. Thus this case study charts the ruler's imperial representation in this period also as a relevant means of exploring the long-lasting circulation of images of the monarch in Iberia and other far-flung lands of Philip's empire in Europe, Asia, and America. As I demonstrate, the imperial imagery created in this period reverberated across the Iberian empires. The imperial visual and cultural circulations that the Iberian Union prompted have not been examined in any particular detail before.

Imperial circulations, visual and cultural, in Iberia and the wider empire are also the focus of chapter 4, the final chapter of the book, titled "On History and Fame: Philip II's Kingly Image and the Spanish Monarchy." This chapter explores both written and visual chronicles of warfare and

funeral accounts that emerged upon Philip's death to examine the circulation of the ruler's kingly image. It offers a new reading of the fresco cycle in the Hall of Battles at El Escorial as a work of history. Existing literature has contextualized the sixteenth-century battle scenes in the Hall of Battles with books, tapestries, and paintings in the royal collections.[39] My contribution expands this discussion by comparing methods of pictorial copy, replication, and history recording employed at the hall with other examples elsewhere in Castile. I focus in particular on the *La Higueruela* scene that famously depicts John II of Castile's victorious battle over the Kingdom of Granada in 1431. This fresco has received less attention in scholarship than the other scenes in the hall, for there was no other known copy of a fifteenth-century battle image to which it could be usefully compared.[40] In the concluding chapter, I compare *La Higueruela* to a little-known drawing of the siege and Battle of Jimena that occurred in 1431 as part of the same campaign; this drawing, like the fresco at El Escorial, is a copy of an original. This comparison has enabled me to establish a parallel between the hall and practices beyond the Spanish court, in line with the comparative approaches employed in preceding chapters. The comparison between the fresco and the drawing, I contend, shows that the scenes in the fresco cycle project a historical narrative that celebrates the history of the realm and the royal dynasty, and also illustrates that the trends in visual chronicles of history transcended court circles. More significantly, an analysis of how the themes depicted in the frescoes at the hall are reflected in Philip's funerals not only vindicates the suitability of reading the hall as a work of history but also demonstrates that the channels that fostered architectural, visual, and cultural circulations were well established by the end of Philip's reign. Upon Philip II's death, the "image" of the king was portrayed in sermons, funerals, and ephemeral architecture erected to mourn his loss. In the funerals, fragments of the

life of the universal monarch were presented as a "summarized" biography. Elegies and other publications of this type underscored aspects of his personality and devotion. Thus the second part of chapter 4 compares the representation of the ruler, immediately after his death, by cross-examining accounts from funerals staged and sermons preached in cities in the peninsula, Europe, and America. Why were the events and themes narrated in the hall present, sometimes in explicit detail, in funeral accounts that mourned Philip II's death? This chapter explores the projection of Philip's kingly image in the funerals celebrated to mourn his death and the role of repetition in enabling imperial circulations.

The case studies examined in this book collectively demonstrate that while Philip intervened decisively in architectural and artistic projects, the large majority of these projects resulted in works that showcased and reflected his world. Philip II's visual world encompassed and synthesized trends beyond his particular preferences. While El Escorial and the unfinished Herrerian project of the grand Cathedral of Valladolid are outstanding architectural models of the time in terms of their quality, detail, and reflection of Philip's rule, they do not on their own convey the richness of architectural and visual production that artists and masons and officials produced in the Iberian world. In sum, this book examines the manner in which design trends and images traveled across the Iberian world, the role played by Philip II in creating or influencing them, and the circulation of pan-Iberian visual culture.

Chapter 1

"A World, an Empire, Under Construction"

DOMESTIC ARCHITECTURE AND SPANISH IMPERIAL AUTHORITY

The designation of Madrid as the temporary seat of Philip II's court in 1561 brought significant changes to the architecture of the new de facto capital city. The monarch vigorously developed the Alcázar and the surrounding area. The population growth that followed the court's arrival in Madrid can be charted in the dramatic increase of building activity in the town. The quality of the design and construction of domestic architecture, however, did not comply with the imperial streetscapes the king and his court had envisioned for sixteenth-century Madrid. Three pieces of legislation, aimed at fulfilling the court's hosting needs and improving the design of houses, emerged in Madrid during the reign of Philip II. The *reales cédulas* of 1565 and 1584 and a *real provisión* in 1567 were only partially successful, as only a fraction of the residential developments in Madrid adhered to them. Nevertheless, these pieces of legislation offer a window onto the streetscapes that the king and the court imagined for Madrid, for they detail the houses' scale, design, construction technologies, and materials. Unlike palatial and religious buildings, domestic architecture has not been examined as a vehicle for promoting imperial architecture in Madrid or as a model for exploring the circulation of design trends in the Iberian world during the reign of Philip II.

This chapter examines the impact that the royal *aposento* (seat) of court had on domestic (non-palatial) architecture in Madrid. However, it does not aim to chart the city as it was built but rather the city as it was imagined. Newly identified drawings of house elevations and floor plans designed to comply with the new legislation in Madrid and Valladolid shed new light on the capital city that was envisioned at the time. The images of houses and their allied administrative process demonstrate the direct involvement of the king and his court and prove that the Austríaco design applied to domestic architecture emerged during Philip's reign. With these drawings it is also possible to establish wider comparisons within contemporary theoretical thinking and practice in architecture. Thus the present chapter also compares legislation for the development of houses enacted in

sixteenth-century Madrid and similar regulations issued in cities in the Iberian world. This chapter thus makes a substantial contribution to the conversation about Habsburg Madrid and architectural exchange in the Spanish empire. By focusing on the offices held by court members in Castile and the Americas, I suggest new lines for research on the impact of itinerant officials on the built environment. This comparative study of domestic architecture allows for an assessment of the circulation of design trends in the Iberian world through the lens of legislation, construction materials, technologies, and architectural and social circulations. These intellectual and design circulations were enriched by local and indigenous contributions in the creation of architectural forms, yet they all partake of a common architectural lexicon. In short, I explore domestic architecture through a series of synthetic analyses in locales in the Iberian Peninsula and America. In doing so, I argue that the Spanish empire, on both sides of the ocean, was an empire under construction. Thus

FIGURE 2 | Anton van den Wyngaerde, *View of Madrid*, 1562. ANL/Vienna Cod.min.41, fol. 35r. Courtesy of the Austrian National Library.

architectural practice and design developed in parallel terms on both sides of the Atlantic.

Madrid and the Aposento Real, 1561

[Philip was] disposed to found a great city [that he could] augment over time and through art by means of magnificent buildings, recreations, gardens, and orchards. It was proper that so great a Monarchy should have a city that could perform the duty of the heart, that its principality and seat be in the middle of the body to administer equally its virtues in peace and war to all its States.

Luis Cabrera de Córdoba, *Filipe Segundo, rey de España*

The Spanish writer and historian Luis Cabrera de Córdoba (1559–1623) summarizes in the passage cited above the perceived suitability of the selection of Madrid as the royal seat of Philip's court.[1] Cabrera de Córdoba evokes ancient Roman notions of centrality and authority. According to Giovanni Botero (1544?–1617), a capital city was where the "head of the realm" resided, and it was where the parliament or senate, the state council, and other important institutions were sited.[2] The 1561 designation of Madrid as the *aposento real*, or royal residence, of Philip II's court marked the beginning of an extraordinary transformation of this small town in central Castile. Anton van den Wyngaerde

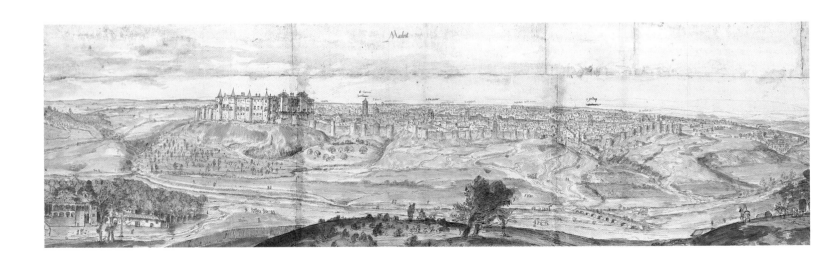

(1525–1571) depicted a view of Madrid in 1562, the time during which Philip's court settled in the town (fig. 2).

Wyngaerde depicted Madrid in this vista as a town determined by topographical conditions, emphasizing the Guadarrama (now Manzanares) River, the orchards, and the vegetation. Although Madrid was the administrative center of Philip II's court, the monarch never officially designated it the capital of Castile, and it was certainly underdeveloped in comparison with Toledo, Valladolid, or Seville.[3] In the years preceding the court's relocation to Madrid, Philip had not only resided there for extended periods but had also begun to energetically redevelop the Alcázar and improve the streets in the surrounding area. Madrid was, before its designation as the *aposento real*, already at the center of Castilian court administration.[4] In 1544, Philip ordered the valuation of some houses for expropriation and demolition in order to create a passage for a new street in the dense urban fabric of the town. With this thoroughfare, he aspired to connect the Alcázar with the Church of San Juan for the purpose of *ornato y policía* (the embellishment and order) of the town.[5] Philip's perceived interest in remodeling the architecture of Madrid early in his reign is illustrated by a 1559 letter to him from Luis Hurtado de Mendoza (1489–1566), second Marquis of Mondéjar and third Count of Tendilla, at the time also president of the Council of the Indies: "All those cited constructions are undertaken with care and diligence to conclude them with the brevity your Majesty demands . . . and then everyone says this town of Madrid is the favored one of your Majesty with particular favor in ennobling it with sumptuous and royal buildings, and not allowing anyone else to leave a mark or set foot in [your Majesty's] territory."[6]

Despite Hurtado de Mendoza's enthusiasm concerning Philip's interest in Madrid, there is no evidence of the court's sustained financial support for the betterment of the town, which largely relied on the local authorities. The king, however,

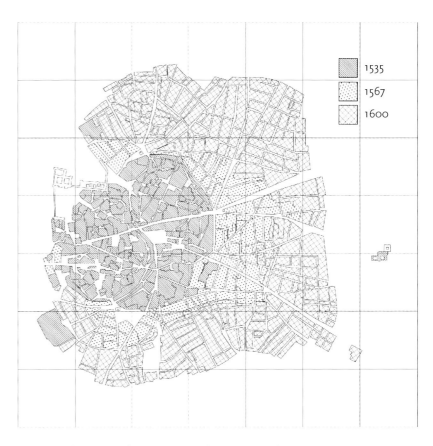

FIGURE 3 | Growth of Madrid, 1535–1600. Diagram by C. Stebbing, inspired by V. Pinto Crespo and S. Madrazo Madrazo, eds., *Madrid: Atlas histórico de la ciudad, siglos IX–XIX* (Madrid, 1995), 34.

redeveloped and expanded his residences and supported the building activity of religious orders in Madrid. The number of inhabitants in Madrid before the arrival of Philip's court has been estimated at between twelve and sixteen thousand, but by end of the century it had reached ninety to ninety-five thousand, which considerably expanded the urban area of the city, as figure 3 illustrates.[7] As a result of Madrid's lack of resources and inability to accommodate a burgeoning population, residential architecture of poor quality proliferated. Local authorities made gargantuan efforts to improve the architecture and urbanism of the city. During the sixteenth century in particular, these efforts would not produce the desired results.[8]

Philip's role in the development of Madrid from the 1560s to the 1580s has been scrutinized by several scholars.[9] The anonymous "Report on the Works in Madrid" (ca. 1565) has been at the center of this discussion. This report summarizes a series of developments that were required to improve the town; some of the works were already under way, but most never materialized. The report has been attributed to the royal architect Juan Bautista de Toledo and also to the *corregidor* (royal representative in cities) Francisco de Sotomayor.[10] The report sketched an ambitious blueprint for a capital, one advanced, for the period, in terms of hygiene, urban order, and embellishment. Local authorities also enacted regulations (1566 and 1567) to control growth, improve sanitation, and foster tree plantation.[11] Public works in Madrid were contemporary with the royal developments in the Alcázar and the Casa de Campo. Philip II officially created the Junta de Policía de Madrid (Committee of Public Works in Madrid) in 1591 to control the city's built environment, though there is evidence that such a committee had been functioning since the early 1580s.[12] The establishment of the junta and the accompanying bylaw, issued in the same year, has made 1591 the pivotal year for examining the development of the city.[13]

The set of urban regulations pertaining to domestic architecture issued before 1591 deserves further scrutiny. The pieces of legislation issued in 1565, 1567, and 1584 are crucial to comprehending domestic architecture in Madrid and imperial urbanism. The *real provisión* enacted in 1567 also outlined the boundaries of the city. The specifications for residential architecture in the *provisión* were for the most part minor modifications of a previous *real cédula del real aposento* enacted in 1565. Both mandates detailed the scale and materials required for the erection of new houses in the city.[14] The *cédula* and *provisión* of 1565 and 1567, respectively, were a result of the *regalía de aposento* and were coordinated by a Junta de Aposentadores (committee of *aposento*). The *regalía de aposento* required

homeowners to cede half of their dwelling in order to accommodate royal officials while the monarch resided in the city.[15] In 1584, Philip decreed another *real cédula* pertaining to the exemption of the *aposento* duties for those residences built under the *cédula*'s parameters in the proximity of the Alcázar.[16]

Despite the efforts of local authorities, there is no evidence of integrated urban reform in the city during Philip II's reign.[17] While there were demonstrable attempts to improve the architecture and urban design of Madrid, collectively considered, these developments do not compare to the urban boom the Spanish Americas experienced in this period, or the major interventions that Rome and Palermo saw in the seventeenth century. As a result, assessments of the planning of Castile's capital city have reflected the negative reports issued at the end of the century. The inefficacy of Philip's decisions relating to Madrid's residential architecture and the inability of the local authorities to implement development control are undeniable.[18] Nonetheless, to draw the conclusion that there was no thought given to urbanism at Philip II's court in this period may be a step too far. The *real provisión* of 1573 for the Americas, considered a masterpiece of urban legislation, emerged in Madrid's court during the 1560s. This *provisión* concerned the creation of new urban settlements and the organization of towns, including the layout of cities.[19] A comparative analysis of the sixteenth-century building regulations of Madrid and other regulations enacted in the Iberian Peninsula and America contextualizes the theoretical and practical thinking concerning architecture and urbanism at the Spanish court.

Imagining Imperial Townscapes: Residential Architectural Design in Madrid, *1565–1584*

The term *casa a la malicia*, or *de malicia* (malfeasance house), refers to the poorly constructed dwellings that emerged in Madrid to evade the

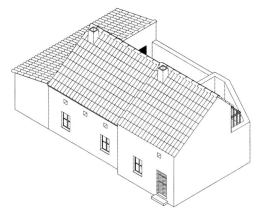

Street Axonometric

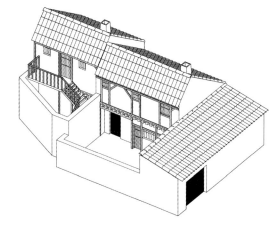

Rear Axonometric

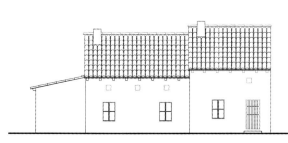

Street Elevation

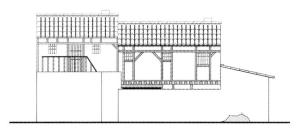

Rear Elevation

regalía de aposento levies. The *aposento* duties stipulated that a residence of more than one story was obliged to host ministers and other government personnel. In the *Tesoro de la lengua castellana o Española*, published in 1611, Sebastián de Covarrubias y Orozco (1539–1613) defined *casa a la malicia* as a house that "is built in a manner which cannot be divided, so two residents could live therein."[20] The accommodation burdens were costly and often undesired. The design of *casas a la malicia* deliberately aimed to flout the *aposento* duties by distributing the windows of the building unevenly and creating the false impression that the dwelling had only one story. The street façade of a *casa a la malicia* appeared to have only one story; however, viewed from the back patio, the "hidden" upper story was visible (fig. 4).

To mitigate the spread of poor domestic architecture in Madrid, Philip II enacted a *real cédula*

FIGURE 4 | Diagrams of a *casa a la malicia*. Diagrams by C. Stebbing, inspired by the exhibit at the Museo de la Villa in Madrid.

in 1565 granting exemption from the *regalía de aposento* for up to fifteen years to any resident who wanted to build or reform his home. The *cédula* sought to foster the improvement of residential architecture in the city. The court and local council had advised the king that the incentive would result in the erection of more orderly edifices in the town. In order to qualify for the exemption, the new or reformed dwellings had to meet a number of minimum requirements.[21] Each building had to have at least three rooms on the ground floor plus an entrance hall (*zaguán*). The façade had to be well built, with a podium constructed of lime-based mortar and stone measuring fifty-five centimeters in both height and width (two *pies* of a Castilian

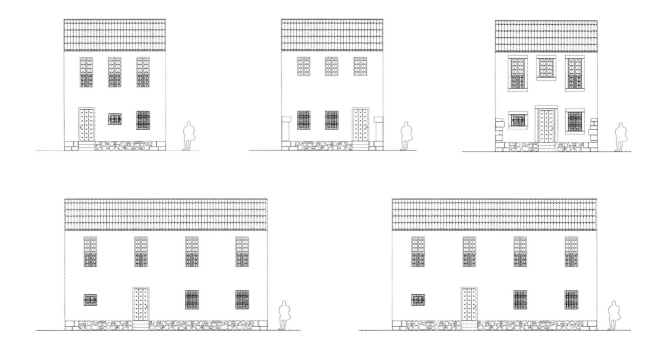

FIGURE 5 | Diagrams (hypothetical) of house façade elevations showing the minimum requirements outlined in the *real cédula del aposento* of 1565 in Madrid. Drawing by author and Harry Kirkham.

vara). Façades had to be a minimum of twelve and a half meters long (forty-five *pies* of a Castilian *vara*). If the façade of the existing house or new development lacked sufficient area facing the main street to comply, then the sum of the front and rear façades had to total this measurement. These requirements were envisioned as a set of ideal parameters that would inevitably be adapted to the conditions of each site. The total height of the façade, including the podium, ground floor, and first story, was to be a minimum of six meters (twenty-two *pies* of a Castilian *vara*). The diagrams in figure 5 show some hypothetical re-creations of the elevations of house façades under the requirements outlined in the *real cédula* of 1565 in Madrid. The elevations do not contain information on the

materials used to construct the façade (except for the podium and building corners) or the colors of the houses. The location and size of windows, balconies, and door are only indicative, as the legislation did not provide details; their estimated location in the façade and frames are inspired by other surviving sixteenth-century buildings in Madrid.[22] Façade lengths were to be accommodated to the dimensions of each individual plot. Thus the diagrams in the figure represent some possible façade lengths under the specifications of the *real cédula*. In 1571, the *cédula* of 1565, which initially was intended to be active for fifteen years, was extended for three additional years; it would then be successively protracted.[23]

Two years later, the *real provisión* of 1567 attempted to eradicate poor construction in the town by delimiting city boundaries and establishing minimum specifications for domestic architecture. Local authorities and officials at court deliberated on the scope of the *provisión*, which established that

beyond the city boundaries as defined therein, all constructions under way and all existing buildings were henceforth unlawful. Any new development had to be approved by the authorities, and permits had to be sought for those already in progress. The *corregidor* and an official from the city council were to supervise the building permits and report them in full to an official from the Council of Castile, who would ultimately be responsible for granting all concessions.[24] The *provisión* resolved to stop the adverse ramifications of the *regalía de aposento* by creating statutes that would govern the construction of domestic architecture. Houses were to be built with a solid foundation for the structural wall of the façade—that is, a podium, similar in height and width to that mandated by the *cédula* of 1565. The façade was also to apply the technologies and characteristics required by the *cédula*. The diagrams in figure 6 show some elevations of house façades as outlined in the *real provisión* of 1567 in Madrid. The legislation required that each *pieça* (room) had to be at least 3.64 meters in length on the façade. The desired façade lengths under the aegis of the *provisión* and inclusive of a hall would have been around 9.30 meters or more in length; thus their size and scale was very similar to that mandated for houses in the *real cédula* of 1565.

Some of the building permits granted under the *provisión* of 1567 described existing plots of small dimensions that made adherence to the design

ideals outlined in the law implausible.[25] Regulated incentives enacted between 1565 and 1567 project a vision of the city that had been imagined, not the one that was built. In this ideal urban image, the residential architecture, and even buildings designed for homeowners with lower incomes, had ample façade lengths. The *provisión* of 1567 added two pivotal prerogatives: all building activity in the city would be subject to control, and architectural expansion beyond the delimited perimeter was made illegal. In this period, an official and four *alarifes* from the city council would undertake house inspections.[26] The exemptions would still be supervised by the Council of Castile, which directly involved the royal court in the regulation of domestic architecture. The demarcation of a city limit was intended to control the growth of the city. Nevertheless, construction continued outside the city boundaries.

The encroachment of the *cédula* (1565) and *provisión* (1567) did not substantially improve domestic architecture in Madrid in the following two decades. The quality of the residential architecture in the city was a cause of concern at court. In 1582,

FIGURE 6 | Diagrams (hypothetical) of house façade elevations showing the minimum requirements outlined in the *real provisión* of 1567 in Madrid. Drawing by author and Harry Kirkham.

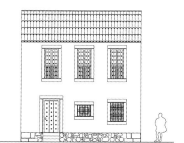 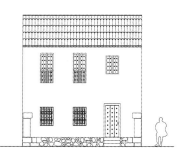 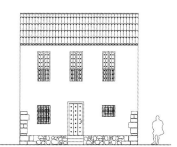

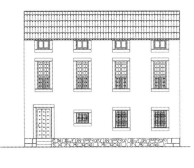
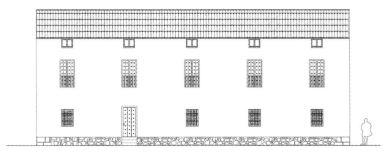
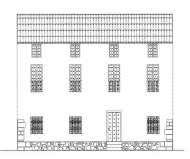
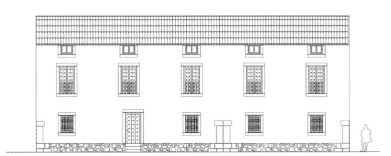

FIGURE 7 | Diagrams (hypothetical) of house façade elevations showing the minimum requirements outlined in the *real cédula del aposento* of 1584 in Madrid. Drawing by author and Harry Kirkham.

Juan de Herrera, troubled about the built environment in Madrid, wrote to the secretary, Mateo Vázquez de Leca (1542–1591), "It is important to ennoble this town . . . , because it is certainly strange, that despite the many buildings erected and the money spent on construction, how little this [effort] is seen [in the city], . . . this is . . . because it has not been built with order . . . it would be convenient . . . [if] your majesty considers that the bad housing is either to be redeveloped or that [someone] expropriate them."[27] Herrera lamented the impoverished domestic architecture of the city, which had not fully adhered to the incentives issued in previous years.

In 1584, King Philip II undertook a modification to the *real cédula* of 1565. The proposed residential architecture had grand dimensions and was restricted to the area in the vicinity of the Alcázar.[28] Homeowners who sought exemption from the *aposento* hosting duties had to build or redevelop their properties with four rooms and an entrance hall on the ground floor, and at least five rooms plus a corridor on the upper story. The podium of the façade had the same scale as in previous legislation, but the length of the façade required in order to obtain the exemption was extraordinary: a minimum of approximately twenty-one meters (seventy-five *pies* of a Castilian *vara*). The height of the building was also augmented at almost seven meters (twenty-five *pies* of a Castilian *vara*). The dimensions revealed in this piece of legislation were impressive, with the increase in height allowing the addition of either a small attic or a basement (fig. 7). The prototypical house described in the *real cédula* of 1584 also had a *corral* (a backyard or patio) for animals or an orchard, which was necessarily located to the rear of the house.

Philip II read many of the petitions and amended or ratified decisions made by the Cámara de Castilla and the committee of *aposentadores*.[29] Philip's amendments to the exemptions demonstrate his direct involvement in the regulation of domestic architecture in Madrid. The royal *aposentador* was Diego de Espinosa, nephew of Philip II's famous minister of the same name, who had held the presidency of the Council of Castile and became bishop of Sigüenza.[30] The king rejected many petitions, especially those that sought to build outside the city perimeter delineated in 1567. The monarch's vision for the quality and role of domestic architecture in the city was made explicit in a favorable response he gave in 1574 to prolong the legislation. Philip wished for residential architecture to be of the highest quality and believed that the legislation would foster the construction of good houses, mitigating the unfavorable image of Madrid conveyed by wastelands and empty plots. Philip referred to the need to improve the building fabric within the city walls on several occasions, and often requested further information from Espinosa when the report on the exemption did not satisfy him.[31] The text of the *cédula* of 1584 insisted that the buildings erected under the aegis of earlier regulations had not fulfilled the court's accommodation needs; thus the new legislation sought to enlarge the dimensions of residential architecture. Juan de Herrera claimed that he had been working in the city since 1561, and Philip II also charged him and, later in his reign, the royal architect Francisco de Mora (1553–1610) with writing reports on particular building applications.[32] In short, Philip and his court remained involved in the building activity in Madrid.

Applications for exemptions for hosting the court in domestic buildings also shine some light on the preferred materials for the construction of dwellings in Madrid. In 1578, Juliana de Guadalupe solicited exemption for a house she owned in Calle de las Carretas, the façade of which had been designed with red bricks and a stone doorframe.[33] In 1583, Alonso Esteban requested permission to improve his house on the Calle Mayor. An inspection showed that the house had *soportales* (arcades) and, owing to its proximity to the plaza, he was advised to build the walls and the door with stone jambs instead of bricks.[34] The *cédulas* and *provisión* issued in 1565, 1567, and 1584 determined requirements for the materials, construction technologies, and dimensions of the houses, namely, *tapial* (rammed earth), wood, stone, and bricks. These materials and techniques reflected existing building trends in Castile; however, technologies and construction materials of higher status were present and encouraged. One of the most significant omissions in this fledgling body of urban legislation concerning residential architectural design was the distribution of windows. When the c*édula* of 1565 was enacted, drawings were provided for the use of landowners, *alarifes*, and architects involved in the process of seeking exemption from the *aposento* duties.[35] These drawings have not yet been identified; however, the Simancas archive holds surviving drawings of houses that were also produced for the exemption of *aposento* duties. These drawings and accompanying reports have not been studied before.

The earliest drawing is a floor plan of a house in Madrid owned by Bautista Spinola, the development of which was approved in 1589.[36] Spinola's house, located on the Plaza de Santa Catalina de los Donados, was processed under the aegis of the *real cédula* of 1584. Dr. Antonio Pinto from the Council of Castile wrote a memorandum to the royal *aposentadores* requesting the repair of the rooms he had been allocated in Spinola's house. The *alarife* Antonio Sánchez inspected the house and the rooms in question. According to Sánchez, the façade of the house was more than twenty meters long and was generally well built; however, the *alarife* identified a number of vital repairs the residence required. To that end, Sánchez wrote a

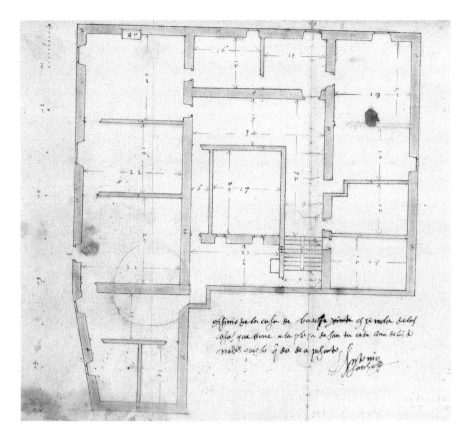

FIGURE 8 | Antonio Sánchez, floor plan of the house owned by Bautista Spinola in Santa Catalina de los Donados near the Alcázar in Madrid, 1589. España, Ministerio de Cultura y Deporte, Archivo de Simancas, Mapas, Planos y Dibujos, 16, 182.

detailed report and drew a floor plan of the house (fig. 8). At the same time, Spinola wrote to the *visitador de aposento* (inspector), Pablo de Laguna (?–1606), with a proposal to restore the chambers and soliciting an exemption from hosting duties in perpetuity. If the exemption in perpetuity was not deemed suitable, Spinola appealed for two alternatives: either that an exemption be granted during his lifetime or that Pinto be substituted with someone else of Laguna's choice from the Council of Castile, Indies, or Orders. Spinola also pleaded that the repairs required in the house should be estimated promptly in order for him to proceed with his application.[37] Laguna was a member of both the Council of Castile and the Council of the Royal Treasury (Real Hacienda), and he was at the time also a *visitador* (inspector) of the *regalía de aposento* and had an excellent reputation at court.[38] Luis Gaytán de Ayala, *corregidor* of Madrid, also

appraised Spinola's exemption and, like Laguna, played a prominent role in the development of sixteenth-century Madrid.[39]

In 1589, Laguna and Gaytán de Ayala formed part of a special commission entrusted with the inspection (*visitas*) of houses and the process of exemption permits.[40] The exemptions were considered royal privileges (*gracias* or *privilegios*) granted by the Crown. While the principal objective of these regulations was to improve the quality of the residential architecture in Madrid, the building permit followed a procedure in which the Crown would approve and tax these exemptions. Those granted exemptions normally paid an annual levy; privileges of exemptions could be temporary, they could last the lifetime of the applicant and/or that of the applicant's heirs, or they could be awarded in perpetuity. Exemption in perpetuity was typically granted only upon receipt of a substantial

monetary payment, its size estimated by the office of the *aposentadores* or by a special commission, as in the case of the exemptions granted by Laguna and Gaytán de Ayala in 1589 and subsequent years.[41] The pair was given extensive powers and during their tenure they accelerated the issuing of licenses. Philip's vision in building this team sought to achieve two objectives: the efficient implementation of the desired residential architectural design and the generation of income from taxes to supplement the royal treasury after the significant expenditure invested in the Armada.[42] Thus Bautista Spinola's process is a good example through which to analyze crucial aspects of the development of Madrid at this particular juncture. First, the administrative process followed by Spinola's petition illuminates the interactions of local and court officials working with the building exemptions. Second, Sánchez's floor plan is the first drawing to be identified that emerged from this body of legislation in the sixteenth century, and it in turn allows a closer examination of the residential architecture that was desired for Madrid.

Laguna and Gaytán de Ayala approved Spinola's application in 1589. The floor plan of the house shows a residence of monumental dimensions, far surpassing those advocated by the *cédula* of 1584. The plan reflects the spatial arrangement agreed upon for the upper story of a grand residence. There are clearly defined structural walls, which—except for a handful of interior divisions—separate the eleven rooms drawn in the floor plan. The house has a generous staircase and corridor, and also boasts a central patio that would afford light into the residence. The distribution of the building around a patio echoes palatial structures; indeed, many houses in Madrid during this period had *corrales* at the back.[43] The patio, which in the case of Spinola's house is of modest dimensions for the size of the building, is fundamental in the spatial configuration of Philip II's royal palaces. The design of a house around a central patio reflects both Castilian palatine traditions and the transregional influence of Italian treatises on architecture. Interior courtyards had become increasingly prominent in Castilian palatial architecture since at least the fourteenth century.[44] Domestic (nonpalatial) architecture in Andalusia was also configured around an interior patio. In addition, the Serlian treatise (and in particular the floor plan of the fifteenth-century Neapolitan Villa Poggio Reale) greatly influenced Castilian and more broadly European palatial architecture in the sixteenth century. Geometrically perfect squared patios can be found in most Austríaco-style buildings—for example, El Escorial, which exhibits several cloisters. The Ducal Palace of Lerma, designed by the royal architect Francisco de Mora in the seventeenth century, deploys a void cube in the form of an exceptionally well designed patio. While legislation issued in Madrid in 1584 had included *corrales*, as they were frequently found in the configuration of houses in town, this did not prevent homeowners from including courtly architectural designs in their dwellings. Spinola's building presented a façade length of more than twenty-three meters, corresponding to the monumental architectural design the Crown sought for this area of the city closest to the Alcázar. The reforms that Bautista Spinola undertook in his residence on the Plaza de Santa Catalina de los Donados to secure an exemption of *aposento* duties is a successful example of the application of the *real cédula* of 1584. The reforms to the house not only enhanced the building but also improved the status of residential architecture in the city. The report demonstrates that Spinola was well acquainted with the *aposento* system and the officials who worked in an array of royal councils. This example shows the impact of the court in Madrid on the social lives of residents, particularly those in the area near the palace.

Philip's heir, King Philip III of Spain (r. 1598–1621), moved the court temporarily to Valladolid during the period 1601–6. The *regalía de aposento*

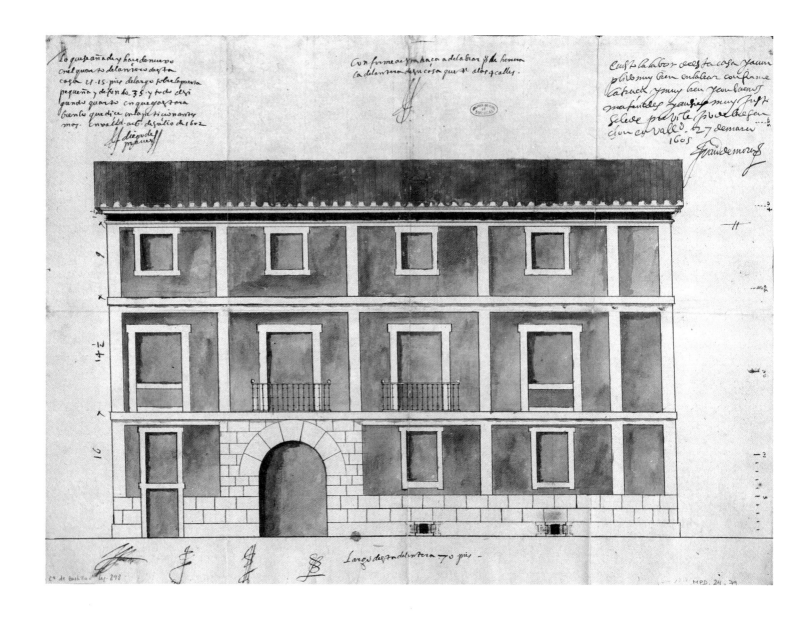

FIGURE 9 (*above*) | House façade designed by Francisco de Mora, 1602. España, Ministerio de Cultura y Deporte, Archivo de Simancas, Mapas, Planos y Dibujos, 24, 79.

FIGURE 10 (*opposite*) | Façade of the Palace of Lerma, designed by Francisco de Mora. Photo: Wikimedia Commons (Carlos Delgado).

and its allied incentives for residents willing to redevelop or construct new houses in Madrid issued between 1565 and 1584 applied now also to Valladolid.[45] One of the architects to Philip II, Francisco de Mora, who continued his service for Philip III, processed an application for a house of similar characteristics in Valladolid in 1602. Mora had been styled master mason of Madrid in 1591, and he undertook similar responsibilities in both cities.[46] A gouache drawing representing the façade in black and red ink accompanied a memorandum from Pedro Herrera y Lintorne, appealing for an exemption from *aposento* duties (fig. 9).[47] He had submitted his application to the Junta de Policía, Ornato y Obras (Commission of Works) in Valladolid, requesting a permit to build on a plot of land beside a house he owned. Herrera y Lintorne also wished to join the new development to the existing one: the latter was to be enlarged to present a proportional grand façade to the street for the embellishment of the city. Mora surveyed the house and noted the measurements of the plot and the existing building. The house, Mora explained, had a fine front and a squared patio inside. The

architects Mora and Diego de Praves (1556–1620), the latter active especially in Valladolid, supported the permit so that the façade could be built according to the drawing. The request was granted in Valladolid on 27 May 1604.[48]

The measurements of Herrera y Lintorne's house were very close to those of the order of 1584 for Madrid. The building was more than ten meters high, thus three meters higher than what was recommended in the 1584 *cédula* for Madrid. The façade length was slightly shorter than that encouraged in Madrid: this example in Valladolid measured seventy *pies*, or roughly 19.25 meters, compared to the minimum of 20.85 meters required in Madrid. The elevation presents a residence of three floors comprising a ground floor and two stories plus a basement. The main door of the house is depicted in the drawing as a grand stone arch. The height of the building is unevenly distributed in the stories, reflecting the significance and usage of each floor. The ground floor is the highest, followed by the first and then the second story. The house has nine windows and two balconies, distributed in an orderly fashion.

FIGURE 11 | Casa de Oficios, El Escorial, designed by Juan de Herrera. Photo: author.

The drawing of the façade presents a modification: initially, it had an attic in which small windows can now only vaguely be discerned, as they were subsequently covered with red ink. The austere classical proportions applied to the design and visible in the distribution of the windows in the elevation of this house are modeled on the Austríaco style applied to domestic architecture. The elevation of Herrera y Lintorne's house, devoid of the emblematic corner towers, is very similar to the façade of the Ducal Palace of Lerma in the distribution of windows and the proportional system projected on the façade (fig. 10). These buildings are indebted to earlier designs created during Philip II's reign, such as the first and the second Casa de Oficios at El Escorial designed by Juan de Herrera and executed by Francisco de Mora from 1587 (fig. 11). The Casa was required to house visitors and other personnel of the royal court after the space in the monastery became insufficient.[49] The façades facing the monastery of the first and second Casas at El Escorial display a robust design that mirrors the main building. The Casa was built with granite and slate roofs and presents a façade design that was subsequently synthesized in the Ducal Palace of Lerma and the drawing of Herrera y Lintorne's house in Valladolid. The contrasting dimensions, materials, and color of the two buildings in Lerma and El Escorial and the drawing of Herrera y Lintorne's house notwithstanding, the elevation of the façades also presents significant similarities. In both royal buildings and in the drawing of the house, the windows are vertically aligned in every story, while the horizontal façade design is emphasized. A marked horizontality in façade design is also promoted in the legislation issued in Madrid in 1565, 1567, and 1584, achieved through the relationship between façade length, and building height under the parameters of the law. Thus Herrera y Lintorne's house, a successful application of the legislation on domestic architecture, echoes

the design of royal buildings. Herrera y Lintorne's house elevation was depicted four years after Philip II's death. The façade, however, presents architectural solutions that architects had applied to royal residences during Philip's reign.

Residential architecture among the upper echelons of society often presented dimensions that surpassed the conditions expressed in the legislation, especially that issued in 1565 and 1567. Under the *cédula* of 1565, for example, Gaspar de Escobar Pereira built a residence of palatial dimensions in Madrid, the façade of which was more than thirty meters long.[50] There are other surviving drawings of early seventeenth-century house elevations in request for exemption from the *aposento* hosting duties that were approved during Philip II's reign. However, in these cases, the façades were built entirely of bricks. The new type of Flemish red brick introduced in the royal edifices in the sixteenth century had become fashionable, and it was used in buildings around the court in both Madrid and Valladolid.[51] Gregorio Tapia's house in Valladolid, for example, was made of brick, and during the absence of Francisco de Mora, an *alarife* from Madrid named Agustín de Pedrosa drew the new façade in 1608 (fig. 12).[52] The façade length of Tapia's house reached sixty *pies* of Castilian *vara*, or 16.68 meters. As in Herrera y Lintorne's house, the façade design is distributed in three stories, and the proportions echo other royal buildings. The dimensions of this residence are smaller and the entrance to the house is not centered in the plan but instead is adapted to the particularities of the plot. As in the case of the Spinola and Herrera y Lintorne houses, the report on Tapia's residence does not discuss construction materials in any detail, except for the use of brick. The drawing of the house appears, however, to depict a podium likely to have been constructed with lime-based mortar and stone, the corner of which was reinforced with well-cut square stones. This kind of structural solution for external façades is found in other

sixteenth-century buildings in Madrid and elsewhere in Castile; it adheres to the recommended construction technologies issued in the 1565 and 1567 legislation on the domestic architecture of Madrid. Tapia's house in Valladolid shows the integration of courtly trends (the use of Flemish brick and the design of the façade) and ingrained traditions such as the configuration of the podium.

Also in 1608, Agustín de Pedrosa approved a façade design for an exemption of *aposento* duties for a house belonging to Rodrigo de Herrera y Ribera in Calle Nuestra Señora de Loreto in Madrid (fig. 13).[53] The extant houses the owner wanted to redevelop were classified as *casas a la malicia*, and the *aposentadores* and architect thought the proposal greatly improved the building and the urban environment. The plot was located well beyond the city boundaries established in the *real provisión* of 1567. During Philip's reign it would have been rare to gain permission to build there, even with the support of the committee. However, the land within the city boundaries had proved insufficient to house the incoming residents by the time Philip III acceded to the throne. Herrera y Ribera's house is well designed and built with red bricks. The marked horizontality of the house's design reflects the conditions of the plot and the choice of a two- rather than three-story building, a departure from the other houses examined here. The façade spanned 121 Castilian feet, or thirty-three meters, over two streets. The distribution of windows and balconies on the second floor mimics the design the *alarife* Pedrosa made for Tapia's house in Valladolid. The ancillary space between the top of the balconies and the roof is far more generous in Herrera y Ribera's house, and similar ample space is found on the ground floor. This house, though it was located outside the city boundaries defined in 1567, reflects the success of the sixteenth-century legislation for domestic architecture. The homeowner implemented a new design in his property that radically changed the quality of the building,

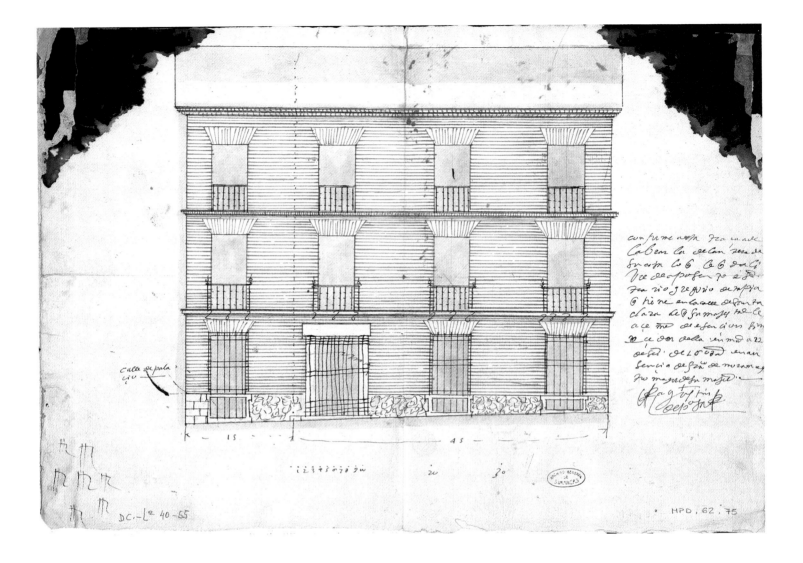

FIGURE 12 | Agustín de Pedrosa, façade elevation drawing of the house of Gregorio Tapia, Calle Santa Clara, Valladolid, 1608. España, Ministerio de Cultura y Deporte, Archivo de Simancas, Mapas, Planos y Dibujos, 62, 75.

for the *casas a la malicia* had been substituted with a well-designed two-story house built with excellent construction materials. The aim of the body of legislation issued in Madrid in the sixteenth century was to gradually improve the city's streetscapes. If more residents and homeowners in Madrid had

been attracted by the incentives promoted in the *reales cédulas* of 1565 and 1584, or had adhered to the *provisión* of 1567, the residential architecture envisioned for Madrid would have emerged more clearly by the end of Philip's reign.

The elevations of these houses in Madrid and Valladolid are the closest surviving examples of the drawings that homeowners, architects, and *alarifes* would have been shown in the course of their application for exemption from hosting duties during Philip II's reign (figs. 9, 12, and 13). Their façades are very similar to some of the new drawings

made for this study (see figs. 5–7) and aided in the identification of the surviving original drawings of the houses. Without these estimative drawings, it would have been challenging to imagine the ideal house court architects envisioned for Madrid, or indeed to identify the original images.

In 1609, Francisco de Mora designed a house for Gaspar de Villegas in the Plazuela del Ángel in Madrid for his application for an exemption from the *aposento* (fig. 14). Mora's design was adapted to the small plot available and as such illustrates the spatial solutions enshrined in the legislation issued in Madrid in 1565 and 1567. The distribution of the balconies and windows follows an orderly design: it presents a generous podium on the ground floor and the façade showcases the red brick seen in other coeval residential buildings. The façade is composed of a ground floor, two upper stories, and an attic. The second story showcases the integration of local design trends; a similar design can be found, for example, in the Casa Cisneros. Furthermore, this drawing includes

FIGURE 13 | Agustín de Pedrosa, façade elevation drawing of the house of Rodrigo de Herrera y Ribera, Calle Nuestra Señora de Loreto, Madrid, 1608. España, Ministerio de Cultura y Deporte, Archivo de Simancas, Mapas, Planos y Dibujos, 67, 97.

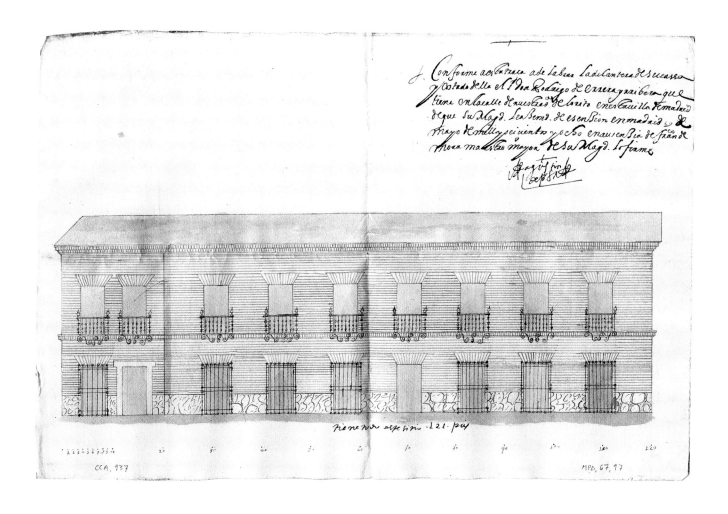

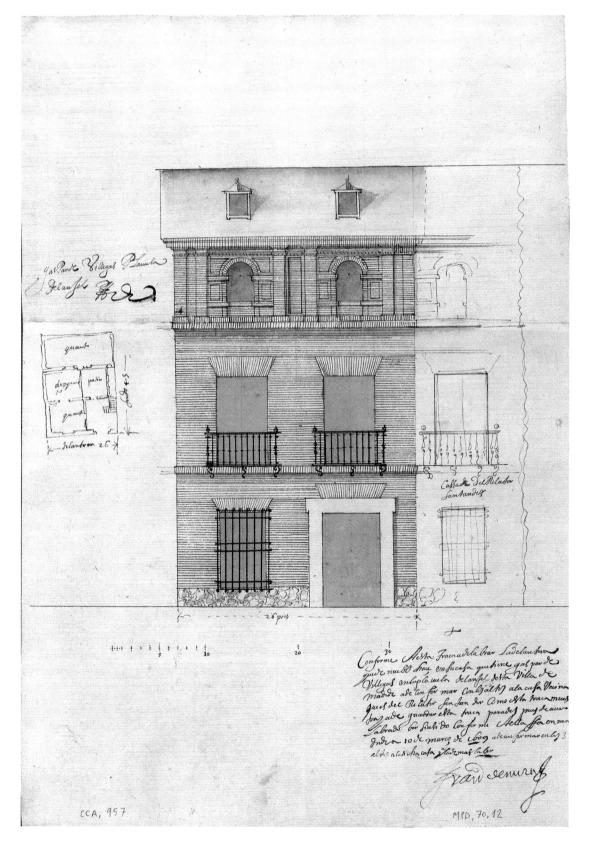

FIGURE 14 | Francisco de Mora, façade elevation drawing and a floor plan sketch of the house of Gaspar de Villegas, Plazuela del Ángel, Madrid, 1609. España, Ministerio de Cultura y Deporte, Archivo de Simancas, Mapas, Planos y Dibujos, 70, 12.

a very small sketch of the floor plan of the house. It is illuminating that within such a small space Mora decided to include an interior patio and not a corral, as was traditionally found in Madrid. The design of this house is fascinating for its synthesis of transregional and local design trends applied to domestic architecture. Images of houses designed by other architects in the seventeenth century have survived, such as the façade elevation of Miguel Rodríguez's house in Calle del Bastero in Madrid, designed by José de Villarreal (ca. 1610–1662) in 1661.[54] The design of this house replicates models that emerged in Madrid and Valladolid in the sixteenth century. While the body of legislation issued during Philip II's reign did not achieve immediate results, the house design proposed therein formed the basis of the residential architecture developed thereafter in the Habsburg capital. In this regard, the domestic architecture envisioned at Philip's court reflected the novel designs introduced in royal buildings. The façades and interior spaces sought in the *reales cédulas* (1565 and 1584) and *real provisión* (1567) present a utopian urban fabric of great status and adaptability that reflected Habsburg authority. Thus residential architecture in Madrid was designed to be an orderly mirror of courtly buildings. The scale and proportions of residential architecture were intended to create an urban hierarchy. In this ideal Albertian townscape, domestic architecture occupied an orderly secondary plane—in both scale and magnificence—and urban vistas directed the view toward royal and religious buildings. In Albertian thought, cities with finely designed buildings were thought to cultivate social improvement. Alberti's treatise was translated into Castilian in 1582 in the context of the Academy of Mathematics created at the court in Madrid, and the king had studied Alberti's theories in his youth, as noted above.[55] Some of these ideals were also reflected in the ordinances of 1573 for the foundation of cities in transoceanic imperial domains.

Madrid and the World: Regulations, Materials, Technologies, and the House

The historian, writer, and Dominican friar Bartolomé de Las Casas (1484–1566) wrote an account of the foundation, development, and abandonment of La Isabela and other fortresses in Hispaniola between 1493 and 1499. Las Casas described the construction of the Santo Tomás fortress in Cibao as a structure built with *tapial* (rammed earth) walls and wood. The majority of the fortresses erected in Hispaniola in those years had been built with similar technologies.[56] Las Casas's description of the buildings in La Isabela echoed the construction materials and technologies found in Iberia; *tapial*, for example, was widely employed for structural walls in the peninsula. *Tapia* walls are obviously not only found in the Iberian Peninsula; structural walls built with a wide variety of *tapia* mixtures have been found in regions of the Mediterranean since antiquity.[57] The Columbus house, for example, was constructed over a podium made of rubble stone and mortar of around sixty centimeters in width. The walls were built with rammed earth coated with lime mortar and plaster.[58] The technologies of construction in the early Spanish settlements in the Caribbean were similar to those stipulated by the legislation issued in Madrid in the mid- to late sixteenth century. The dimensions and composition of the podium in the Columbus house are very similar to those advocated for this structural element in the legislation in Madrid.

Francisco de Mora's drawing for Pedro Herrera y Lintorne's house in Valladolid affords a good model for comparative purposes. The walls of the house in Valladolid, one can reasonably hypothesize, were probably constructed with a technology (perhaps *aparejo toledano* or something similar) that was traditionally coated with lime plaster and paint to produce finely polished façades like the one seen in the drawing (fig. 9). The *aparejo toledano* was extensively used in central Castile;

however, in Herrera y Lintorne's case, given that the rows of bricks (*verdugadas*) that delimit the masonry are not visible in the drawing, it is likely that a similar mixed technique was chosen for the structural wall of the façade. The uniform surfacing of the walls through the application of lime plaster and painting, paired with the structural sturdiness of *tapia* or *aparejo toledano* walls, was well regarded.[59] The application of *aparejo toledano* is also found in the Casa de Cisneros (fig. 15), built in 1537 in Madrid, and in the Descalzas Reales convent. The construction materials and technologies were not new, as the fifteenth-century Casa de Lujanes in the Plaza de la Villa in Madrid shows. Although the Casa de Cisneros was extensively restored, some original aspects (particularly visible in Calle Sacramento) echo the regulations issued by the Habsburgs in the sixteenth century, such as a generous podium framed by stone corner pillars. The construction technologies of the walls of the Casa de las Siete Chimeneas in Madrid (fig. 16), built in 1570 (rebuilt in 1583–85), display similarities to other examples developed in the seventeenth century, such as Juan Gómez de Mora's project for the Puerta de Fuencarral.[60] Despite the use of similar technologies, the design of the façade in the Columbus house in La Isabela would have reflected its defensive nature as well as existing design trends in the Iberian Peninsula at the end of the fifteenth century. Herrera y Lintorne's house in Valladolid, however, exhibited a façade at the forefront of coeval transregional design in the Spanish Habsburg court in the early 1600s. Lasting construction technologies such as *tapia* walls and *aparejo toledano* demonstrate trans-Mediterranean traditions in architectural practice that had been employed and developed in Iberia and America decades before they were recorded in the sixteenth-century legislation in Madrid.

The design and processes followed for the reconstruction of the city center of Valladolid after the fire of 1561 set a precedent for the urban legislation in Madrid. Much of the plaza's building process was also contemporary to the construction activity seen in Madrid. In Valladolid, the ruler and the city were more successful in implementing orderly proportions in residential architecture, street alignment, and urban space than in Madrid. The design of the Plaza Mayor of Valladolid and other plazas, such as Zocodover in Toledo and Medina del Campo, were influential in Iberia and beyond.[61] As in Madrid, both the court and the local council at Valladolid were invested in the design for the

FIGURE 15 (*below*) | Casa de Cisneros in Madrid, Calle Sacramento. Photo: author.

FIGURE 16 (*opposite*) | Casa de las Siete Chimeneas, Madrid. Photo: author.

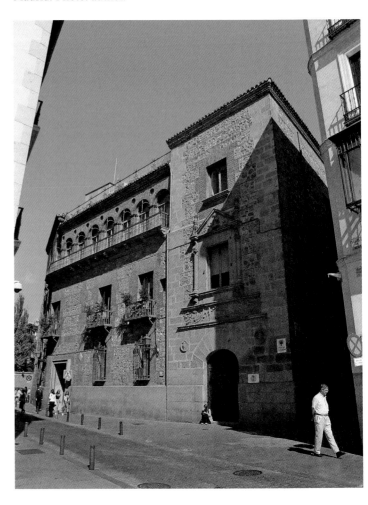

reconstruction of the city; however, the design finally adopted for the reconstruction was the one favored by the king. The royal architect Francisco de Salamanca (ca. 1514–1573) had been entrusted with the reconstruction of the city center and, after his death, his son, Juan de Salamanca, succeeded him in these duties. The *real provisión* issued by Philip II in 1563 amalgamated all previous orders, and the monarch saw the reconstruction of Valladolid completed in his visit to the city in 1592.[62]

The residential architecture erected in Valladolid presented the same characteristics of the design envisioned to embody Habsburg authority in Madrid (fig. 17). Roofs in Valladolid were covered with tiles and also slate, which was fashionable in Madrid, as Philip had implemented it in his palaces. In 1559, the king wrote an order with instructions for the Palace of Valsain: "that the roofs [should be] made in the fashion of these realms [i.e., the Low Countries] covered with slate [because] as you have seen they are magnificent."[63] Flemish builders were brought *ex profeso* to install slate roofs on royal buildings, and they were also brought to Valladolid. The royal architect rigorously regulated design and building techniques in domestic architecture. Different measurements and scales, for example, were given for the bricks employed in the façades of buildings and for those

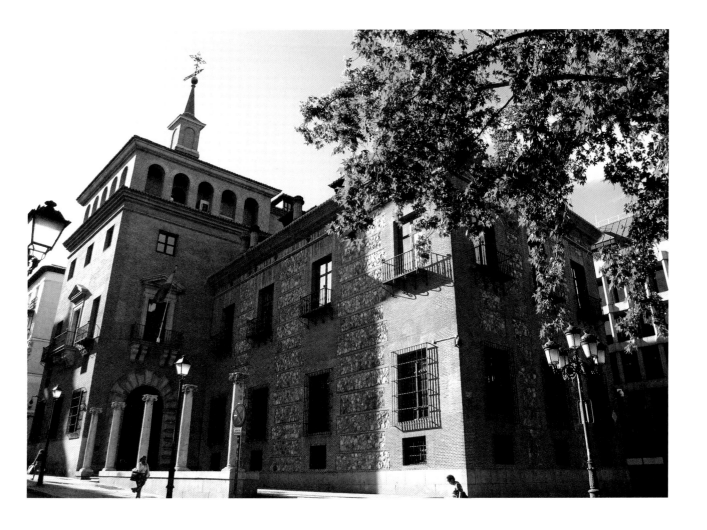

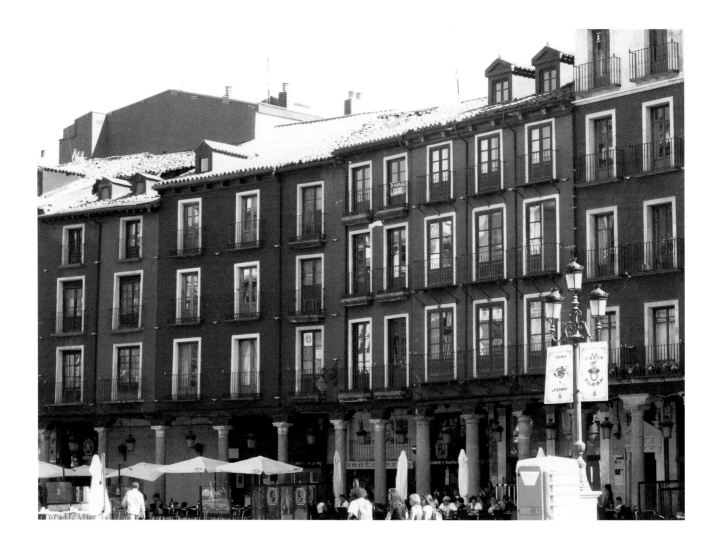

FIGURE 17 | Buildings in Plaza Mayor, Valladolid. Photo: author.

used in structural walls. The architecture presented mixed construction technologies, such as *tapia* walls, in particular the inclusion of *emplentas* (sections of *tapial* "premade" in one block) or a section of *aparejo toledano*, combined with bricks, stones, and wood, which were also seen in Madrid. Preventive planning against fire stipulated that for every ten houses, a solid dividing wall was to be built with brick, stone, or *tapial*, the last being employed more frequently owing to its lower cost and resilience.[64]

The architectural quality of the construction in Valladolid was also regulated through the 1583 ordinances of the building trade. These ordinances meticulously detail the skills required of masons, *alarifes*, and carpenters, among others, who worked in the building trade. Masons not only had to know how to design and build the classical orders in architecture but also had to be able to design a variety of arches and vaults, measure and calculate street alignment, know the construction technologies and the correct mixture and distribution of materials for the building of *tapia* walls, and know how to design and build a door or balcony and design a perfectly quadrangular room, among other

skills. Similar ordinances for the building trade and guilds existed in Burgos, Medina del Campo, Segovia, Palencia, and other Castilian cities.[65]

In the Iberian world, many cities regulated architectural activity through legislation implemented by local authorities or coordinated by the building trade guilds. Details regarding building tools, techniques, and materials are included in a plethora of royal regulations directed at the urban settlements in the Americas. In 1501, the Catholic Monarchs wrote to the *corregidor* in Jerez de la Frontera in Andalusia, requesting that he select experienced masons with sufficient construction tools to embark for the Americas to aid in the building of new cities.[66] Five years later, a royal order stipulated that the Sevillian *alarifes* working in Santo Domingo should construct with stone and *tapial* to ensure the sturdiness of the city's architecture. A report from the Council of the Indies in 1533 described a now-lost bastion that was erected in Santa Marta in the New Kingdom of Granada. Not surprisingly, the construction materials and technologies employed to build the bastion were stone, *tapial*, mortar, bricks, and wood. In 1536, Charles V enacted a *real provisión* with a mandate to improve the living conditions of the native population in the Viceroyalty of Peru.[67] The intention of the *provisión* was for the Spaniards to found a permanent settlement by means of architectural improvement. The Spanish overseas empire was founded on a network of cities and towns, for which the quality of the built environment and the orderly layout of cities was the fundamental basis. The Council of the Indies insisted that domestic architecture should be permanent and well built (with stone, mortar, wood, and *tapial*). The materials and construction technologies that the Council sought gradually to implement in American cities was none other than the same traditions employed in Castile. The Spanish transatlantic empire was organized with an urban emphasis, in which a network of cities and towns allowed the Spaniards to

establish a desired social order based on a sophisticated administration that mimicked peninsular models. *Tapial* was a well-regarded, effective, and inexpensive solution for structural walls: the anonymous treatise *De arquitectura* (ca. 1550), which had been given to Philip II in his youth, praised its qualities as a structural solution.[68] There is no evidence of this kind of structural wall in the Americas that predates the arrival of the Spaniards. The built environment, including domestic architecture, also underwent significant developments in cities in the Iberian Peninsula.

Sevillian residential architecture is a good model with which to analyze the influence of Renaissance ideals of order and proportion. The Venetian diplomat and poet Andrea Navagero (1483–1529) visited Seville for the wedding celebrations of Charles V and Isabella of Portugal in 1526 and wrote about the city. Navagero thought that Seville's architecture closely resembled the beauty found in Italian cities. Sevillian streets were wide and beautiful, and the city boasted some of the most beautiful palaces and gardens in the realm. Navagero admired the cathedral but was unimpressed with the quality of the houses and thought the city merited better residential architecture. In 1547 Pedro de Mexía (1497–1551) noted how construction materials inundated the streets of Seville. The building activity in the city increased dramatically in the sixteenth century; while the seat of court had transformed architecture in Madrid, the wealth of the convoys from the Indies would also impact the built environment of Seville. Between 1561 and 1588, it has been estimated that more than 2,454 new houses were erected in the city.[69]

In 1582, the historian Alonso Morgado described the gradual transformation of Sevillian domestic architecture, which aimed to embellish the city's streetscapes with new façades, the design of which was infused with Renaissance ideals. Residential architecture had traditionally been configured inward around the patio, a spatial configuration

of Andalusian origin that suited the city's climate. Domestic architecture in Seville was not constructed to such a height as in central Castile; the lower height and the interior spatial configuration allowed air circulation through the patio and corridors, a necessary adaptation to Seville's particular climatic conditions. The patios were paved and richly decorated with tiled walls and marble pillars. In addition, they were well looked after, and many had fresh fountains with potable water from the Caños de Carmona, an ancient Roman aqueduct. The improvements in domestic architecture

FIGURE 18 | Façade of Casa Alfaro, Seville. Demolished in the 1970s. Photo: Antonio Palau. Courtesy of the Fototeca, University of Seville.

FIGURE 19 | Patio of Casa Alfaro, Seville. Demolished in the 1970s. Photo: Antonio Palau. Courtesy of the Fototeca, University of Seville.

worked in tandem with the embellishment of some of the spaces of social encounter in the city, such as the Alameda de Hércules. In addition, the city council began to improve pavements and sewage. The streetscapes of Seville were thus gradually beautified through the regulation of the city's façades.[70] Despite Morgado's appreciation of the houses being built in Seville, the city was plagued by significant health and safety problems. As with most major urban centers in the period, there were also areas with poor housing, where shacks with thatched roofs predominated, particularly toward the outer areas of the city. Merchants nevertheless thrived thanks to the dynamic commerce of the Sevillian port, and they were responsible for the erection of the vast majority of new residences in the city. The economic boost and building activity not only transformed residential architecture but also substantially expanded some neighborhoods. In Triana alone, for example, around nine hundred

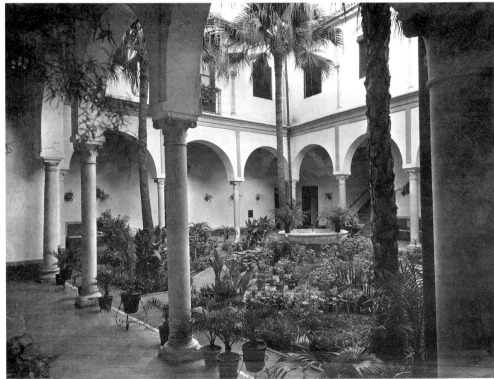

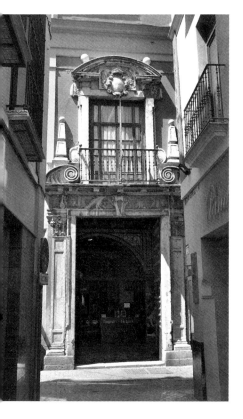

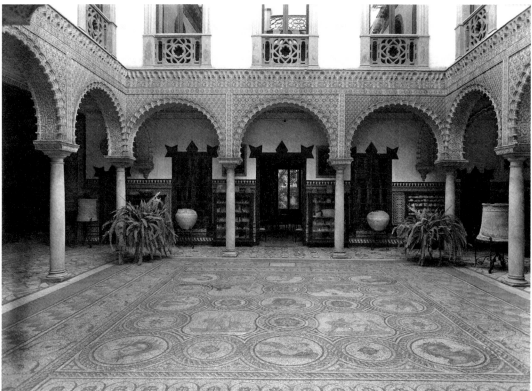

new houses were built in the second half of the sixteenth century.[71] The Casa Alfaro is representative of a typical residence owned by an enriched merchant in Seville, but this house only survives in images. The grand residence of the Condesa de Lebrija still survives and is a fine example of the type of dwelling that enriched aristocrats would have erected in Seville. These two residences show the gradual integration of classically infused design and motifs in the domestic architecture of the city (figs. 18–22).[72] The façade of the residence of the Condesa de Lebrija boasts aligned balconies and windows on both stories, which projects versions of the proportional systems in façade design found in Valladolid and Madrid. Both houses presented only the ground and first floor; as Morgado noted, houses were adapted to Sevillian climatic conditions and were not as high as in central Castile. The façade of the Casa Alfaro in figure 18 also

FIGURE 20 | Façade of the Condesa de Lebrija's Palace, Calle Cuna, Seville. The façade was designed and built in the sixteenth century. Photo: Ignacio J. López Hernández.

FIGURE 21 | Patio of the Condesa de Lebrija's Palace, Calle Cuna, Seville, photo ca. 1956. Photo: Antonio Palau. Courtesy of the Fototeca, University of Seville.

shows the alignment of the house's doors and balconies. The Condesa de Lebrija's house, however, boasts a magnificent sixteenth-century façade, of which the portal features a classically inspired design found in Sevillian residential architecture of the period. The Casa Alfaro, which echoes contemporary residential architecture developed by merchants in the city, is more modest. Its interior square patio is delimited by a series of arches supported by marble columns, as described by

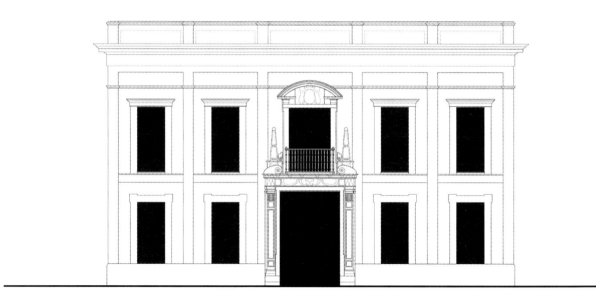

FIGURE 22 | Diagram of the façade of the Condesa de Lebrija's Palace, Calle Cuna, Seville. Drawing by C. Stebbing.

Morgado in his account of houses in Seville. The patio of the Condesa de Lebrija's house is also square, and a series of marble columns support the arches. These arches display the geometrical and vegetal decoration characteristic of the Mudejar style. This house thus presents coeval architectural styles, with a classical façade facing the street and Mudejar arches in the patio. Many other houses in the city, famously the Casa de Pilatos, aptly integrated coexisting architectural trends that merged ingrained Mudejar traditions and architectural motifs infused by Renaissance design ideals.

In sixteenth-century Seville, the city council had endeavored to promote the orderly design of domestic architecture, including windows and balconies and their ancillary spaces on the façades.[73] The local guilds had established regulations for the building trade, which had been famously compiled in the ordinances of Seville of 1527.[74] These ordinances specified the materials and construction technologies that should be employed in the

erection of buildings and were similar to the regulations implemented elsewhere in the Iberian Peninsula and Spanish American locales.[75] The rich architectural heritage and coeval trends present in sixteenth-century Seville infused the building trade in the city. The ordinances aimed to control the building trade, including the activity and education of masons, officials, and *alarifes*. Similar ordinances and regulatory mechanisms were also in place in Madrid, Valladolid, and many other Iberian cities and towns.[76] The ordinances in Seville also distinguished the types of buildings that masons and *alarifes* needed to be able to draw and construct: common houses, principal houses, and also royal houses (*casas comunes, principales,* and *reales*), as well as churches with three naves, among other buildings.[77]

As in Seville, legislation issued in Madrid followed a classification for residential architecture. The different kinds of houses can be charted in the dimensions promoted in the legislation of 1565–67, as compared to the monumental scale of the stipulations of 1584 for domestic architecture that affected the area near the Alcázar. The body of legislation that emerged in Madrid and Valladolid

in the second half of the sixteenth century replicates some ideas and traditions prevalent in Iberia before the arrival of the Habsburgs in Castile. The introduction of proportional scales, and some materials (e.g., slate) in residential architecture also shows the monarchy's firm intention to implement the characteristics of the Austríaco style in architecture beyond royal premises. In particular, the legislation and examples seen in Madrid and Valladolid responded to transregional intellectual and design trends that were deployed by local authorities and the court as suitable images for self-representation. In sixteenth-century Seville, residential architecture began to show the impact of these pan-European trends in the redesign of façades and also the introduction of new materials, such as the marble for the columns and pillars in patios. The ordinances of Seville predate the legislation in Madrid and Valladolid and precede or are contemporary with the orders issued for American cities.

The vast array of royal orders and regulations enacted from the start of the Spanish settlement in America were compiled in the ordinance of 1573 for the foundation of new cities in America, issued by Philip II.[78] Juan López de Velasco (ca. 1530–1598), the royal cosmographer and chronicler of the Indies, recorded that 191 cities and towns has already been founded in Spanish America in the 1570s. The number of cities and towns registered in the Americas increased over time; documents dated 1630 estimate 331 locales.[79] Many of these cities and towns were in development at the same time Madrid was under major urban and architectural expansion. The legislation issued in 1573 not only amalgamated earlier royal orders but also included the changes envisioned during Juan de Ovando's *visita* (inspection) of the Council of the Indies between 1567 and 1571 and his presidency of the same council.[80] The ordinance included an article (no. 33) that outlined succinctly the way houses should be erected in American cities. Once the layout of the city and the plots had been allocated

to settlers, the legislation urged that the houses should be "built with good foundations and walls, for which [. . .] *tapiales* or wood planks and the rest of tools [had to be made available] to construct [them] rapidly and at low cost."[81] Thus the use of *tapial*, a tradition widely employed in peninsular Castile, was sought as the principal and most effective way to construct domestic architecture in the Americas. The ordinance of 1573 (no. 135) also emphasized the formal coherence of the houses in the city: "[put] all possible endeavor into [designing] the buildings in one form, for the ornament of the settlement."[82] By adopting peninsular models, the Council of the Indies steered a homogeneous criterion for domestic architecture in the Iberian Peninsula and its transoceanic empire.

The implementation of *tapial* in construction technology, which is not documented to have predated the arrival of the Spaniards, did not prosper widely in the Americas. The use of *tapial* was chiefly found in the Royal Way (Camino Real), an area stretching from Mexico City to the port of Veracruz.[83] Indigenous technologies in mud, adobe, and stone continued to thrive instead and supported the erection of buildings as newly founded towns and cities proliferated. *Bajareque* (wattle and daub), for example, was widely employed in the construction of structural walls in New Spain due to its elasticity and suitability to the environmental conditions.[84] The *quincha* in Lima similarly thrived owing to its elasticity, as vaults built with stone and other technologies did not survive the city's seismic activity and were rebuilt with suspended *quincha* vaults.[85] The Casa de Pilatos in Lima, developed in stages between 1590 and 1644, was built with stone foundations and with a main portal in the façade; bricks and adobe were used for the walls and minor portals and the patio, whereas wood was employed in the beams for the roof and floors.[86] Despite the efforts to homogenize local and imperial legislation concerning the built environment, builders across the Spanish empire

continued to employ proven local technologies. In Madrid, for example, *aparejo toledano* and brick appear more frequently in surviving buildings than other construction technologies promoted in the sixteenth-century legislation.

The Spanish court in Madrid received information on the houses of towns and cities in the Americas. In 1577, the Council of the Indies sent an extensive questionnaire to cities and towns throughout the Americas, known as the *Relaciones Geográficas*. Question 10 in the *Relaciones* included specific queries about the settlement of the cities and towns, and requested images that showed the design of the streets, plazas, and buildings. Questions 28 to 32 requested detailed descriptions of mines, quarries, and—crucially—the form, design, and building technologies employed in the construction of residential architecture and fortifications.[87] Not all locales replied fully to the questions and, despite the efforts to gather knowledge, the information the Council received was at best fragmentary.[88] However, a closer examination of the responses to the 1577 questionnaire with regard to houses gives insight into the varying degrees of integration of imperial mandates. The use of local indigenous building technologies and materials was widespread, particularly in locales farther afield from major urban centers. The choice of building technologies and materials was often determined by climate conditions, social organization, and availability of the materials in the vicinity of the town.

The description of houses in a number of small towns and villages in New Spain enables comparisons with similar building technologies in Spain, although these traditions were far from the imperial ideals envisioned at the court. The description of the houses in the town of Amatlán, for example, reads, "The houses they [i.e., Amerindians] used to have before [the arrival of the Spaniards] were the same as now, they [are built with] stone and adobe and thatched roofs, this is a roof in the form

of a shack from Spain; and . . . the roof can last for fifteen years and more."[89] The specific use of the Spanish term *choza* (hut or shack) is illuminating, for it allows us to compare construction technologies and materials not only in relation to American locales, such as the houses in Tetiquipa (Río Hondo), which employed a similar roofing system, but also, more significantly, to *choza*s in towns in Castile. *Chozas* were also common in the uncontrolled expansion of major cities such as Seville and Madrid, and other major urban centers in Iberia describe the poor state of buildings in some suburban areas. More significantly, housing—including buildings with thatched roofs and the use of less permanent materials—was also found in small towns and villages across Iberia.[90] Thus varying degrees of application of urban legislation found in American locales were also seen in Iberia. A parallel can be established with regard to the urban development that important cities and urban centers witnessed in this period on both sides of the Atlantic.

While the majority of the records in the *Relaciones* show the survival of entrenched building materials and technologies, the houses erected in the area of Puebla de los Ángeles, which as part of the Royal Way to Mexico City was among the most populous areas in Mexico, are illustrative of the gradual integration of transregional design trends. The houses and urban design of Cholula show the application of Spanish imperial urbanism, and the extensive description in the *relación* reads:

> The houses are built . . . in the manner the Spaniards build: with stone, bricks and adobe, and with whitewashed flat roofs.[91] The façades are built with brown and black stones or with bricks made in situ. The quarry of the brown stone is half a league from this city . . . and the black stone is brought from Calpan, three leagues from here. The corners of the streets are all constructed with

well-cut stones. [The houses] have rooms and bedrooms, which are smaller than those that the Spaniards build, the rooms are well adorned, plastered with lime and a yellow sand that is lustrous, and with painted stories, or hangings and profusely painted *petates*.[92] And there is no house that does not have many images of saints. All pavements in the streets are made of bricks, . . . and in general, [Cholula] has the best houses in all New Spain . . . [and has] well-designed and ordered streets in the form of a chessboard.[93]

The *relación* of Cholula also describes some other building materials that were brought from Puebla; furthermore, the descriptions of the houses inhabited and built by Amerindians showcase the integration of imperial legislation and Spanish and indigenous materials, designs, technologies, and decorations.

The responses to the questionnaire in Tepeaca also emphasize the synthesis of trends: while the majority of material and building technologies employed in the erection of houses were pre-Hispanic, some houses began to introduce so-called Spanish elements, such as the use of flat roofs. Examples of the integration of the architectural language, materials, and technologies proliferate particularly in smaller towns and villages. Major urban centers began to display architecture that complied with the courtly vision reflected in Spanish legislation. Responses to the *relación* from the port city of Veracruz stated that the "form and construction of the houses in this city were in the same form that is built in Spain, walls made of stone, brick, and *tapial* and lime plastered. . . . The wood for the beams and planks are of cedar and pine." The houses were covered with tiles, and while many of the houses were built in the Spanish manner, there were also other regular houses on which the roofing was created of boards.[94] The variety of houses in Veracruz echoes the different degrees of adoption of trans-Iberian building technologies and design found in other cities in both the Americas and the Iberian Peninsula.

Towns and cities in the Viceroyalty of Peru would also widely deploy pre-Columbian building technologies and materials. The *relación* of San Francisco de Quito showcases the survival of indigenous building traditions and the gradual integration of some Spanish architectural elements. The stone available in a quarry near Quito was used to upgrade the main city church, which until then had been built with *tapial* and thatched roofs. The new building, comprising a nave and two aisles, was built with stone, bricks, adobe, and a wooden roof covered with tiles, and was very spacious. When the city was founded, plots were given to settlers, depending on their social and racial rank, who initially built small houses with *bajaraque*. The *relación* states that shortly thereafter, new houses for Spaniards were built with good podiums and that the city had around three hundred houses. Plenty of construction materials seem to have been available in the vicinity of the city, including stone, lime, bricks, tiles, adobe, and wood. The houses of the Amerindian population in the vicinity of the city were chiefly constructed with thatched roofs and *bajaraque*, although the larger houses had *tapia* walls and thatched roofs. The latter materials and technologies were also employed for the smaller churches of Saint Blas and Saint Sebastián in Quito.[95] The questionnaire from Quito illustrates the diversity of the trends, materials, and construction technologies present in large cities. The examples discussed demonstrate the extent to which imperial legislation was applied. The limited success of the royal legislation in cities in the Iberian Peninsula due to the swift architectural development further emphasizes that cities and locales across the Atlantic, particularly wealthy urban centers, were also experiencing rapid urban development and as such sought to gradually upgrade their architecture and regulate the building trade.

The ordinances of the builders' guild in Mexico City in 1599 may have been inspired by similar practices in Spain, and they were also a compilation of earlier documents: the carpenters' guild had had its own regulations since 1557.[96] Sixteenth-century chroniclers, such as Fray Gerónimo de Mendieta (1525–1604) and Fray Bernardino de Sahagún (1499–1590), wrote that architectural activity in New Spain was well organized through a hierarchical system of labor.[97] No early modern domestic architecture in Mexico City survives; however, the House of the First Printing Press in the Americas may have resembled residential architecture built on the perimeter of the city center. The city center, particularly its perimeter, was the focus of a "new *traza*" designed by the Spanish *alarife* Alonso García Bravo (1490–1561) in 1523–24. García Bravo made use of the existing regular planning of the former Aztec capital of Tenochtitlan. He also drew the city plans for Veracruz and Oaxaca.[98] In the same vein, the contribution of indigenous urban design to the layout of American cities and construction activity cannot be ignored, and it is not surprising that preexisting structures were reused in Mexico City. Barbara Mundy has shown that the elite indigenous social structures in the city survived and indeed thrived under colonial rule, including structures associated with the building trade.[99]

Spanish conquerors and settlers in other imperial domains in the Americas also integrated the extant urban designs and materials they encountered. Andean cities founded on preexisting Inca urban centers are a good example. In Cuzco, the solid stone foundations of buildings, streets, and the plaza were built atop Incan buildings. The plan of the city still shows the radiating network of streets designed by the Incas, while Spanish artists portrayed the city as an ideal square along the lines of similar visual representations employed for the display of newly founded settlements.[100] These depictions were not a faithful portrayal of the newly

founded cities but acted as a statement of colonial intent to control the images of imperial cities.[101] There are many examples of the use of *spolia*—for example, the reuse of Tiahuanaco stone in the nearby colonial settlement. The reuse of earlier materials was indeed recommended in the ordinances of 1573.[102] The indigenous influence and presence in the architectural and urban planning of colonial America can also be explored through colonial building practices and residential architecture.

The Casa del Deán, completed in 1580, survives in Puebla de los Ángeles. The house built for the dean of the Cathedral of Puebla, Tomás de la Plaza, is an excellent model of the elite domestic architecture of sixteenth-century Puebla (fig. 23).[103] The triumphal arch of the main façade echoes Serlian examples; indeed, Serlio's treatise had inspired the design for the Túmulo Imperial, built in Mexico City to commemorate the death of Charles V. The catafalque designed by the architect Claudio de Arciniega (ca. 1520–1593) employed Tuscan columns topped by an entablature. A similar solution can also be found in the lower body of the Casa del Deán's main façade. The design of the house has been attributed to the Spanish *alarife* Francisco Becerra (ca. 1545–1605), who worked on a number of major projects, including the Cathedral of Puebla, and also in such cities as Lima and Quito.[104] Artists and architects aimed to implement the classical language found in the treatises of Alberti, Serlio, and Vignola. The distribution of the windows, balconies, and doors is reminiscent of other examples seen in the Americas and in the Iberian Peninsula and shows that the Casa del Deán incorporates a variety of trends. The construction of this house, which otherwise adheres to Renaissance ideals of order and proportion not only in the architectural design but also in its magnificent mural paintings, precedes the houses from Madrid and Valladolid discussed above. The proportions applied to the elements in the façades of the houses examined in Madrid, Valladolid, Seville,

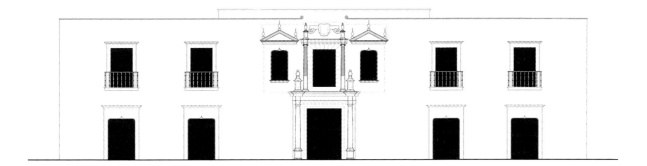

FIGURE 23 | Diagram of the façade of the Casa del Deán, completed in 1580. Puebla de los Ángeles. Drawing by C. Stebbing.

and Puebla de los Ángeles present some variations within a similar classical grammar. These classical similarities demonstrate that builders and masons in cities across the Iberian world were informed by a common architectural lexicon. This grammar or lexicon emanated from visual trends present on both sides of the Atlantic, which had been as-similated into the education of architects, masons, and *alarifes* through the regulation of the building trade. The integration of knowledge acquired through regulated practice and often borrowed from Renaissance treatises on architecture was manifested in a number of cities across the Iberian world. The common cultural grammar or archi-tectural lexicon found in buildings in the Iberian world in this period is not only a reflection of the influx of a classical vocabulary from architectural treatises but also, and more significantly, of a lexi-con fostered in the law, in the mechanisms for the regulation of the building trade, and in the training of masons, architects, and artists. The façade com-position demonstrated in the models examined in this chapter, however, presents distinct interpreta-tions of classicism applied to architectural design. The flexibility in the application of a classical language in architecture in different locales across the Iberian world was key to the successful inte-gration of local and transregional design trends. The Casa del Deán shows a tendency toward hori-zontality, with accentuated ancillary space between the balconies in the façade. While the elevations

of houses in Valladolid also present a horizontal tendency, the slender form of the balconies in the façade of the buildings in the Plaza Mayor, paired with the superior height applied in the one and a half stories present in the *soportales* on the ground floor, underlines the harmonic balance between the flat and the more emphatic vertical lines in the façade (figs. 17–22). An analogous composition of façades with harmonic balance between horizontal and vertical tensions is found in many Austríaco buildings in the courtly area of influence in the Iberian Peninsula. Austríaco residential architec-ture also mirrored other royal buildings, in which the horizontality in the configuration of the façade was accentuated to comply with the hierarchical visual scales of the surrounding urban environ-ment. This is illustrated in Herrera y Lintorne's residence and in the Casa de Oficios at El Escorial. The architectural language found in residential Austríaco buildings in the sixteenth and seven-teenth centuries projects a distinct identity that represents the Spanish Habsburgs. The buildings analyzed in New Spain, the Viceroyalty of Peru, Seville, Madrid, and Valladolid were largely con-structed within a similar time frame: they employ a shared visual lexicon and at the same time project distinct identities that reflect the traditions of each

particular locale or region. The variety and richness of identities that populated cities, especially major metropolitan centers in the Iberian world, were reflected in the visual arts and particularly in architectural design. Restoration work in the Casa del Deán has recovered mural paintings depicting themes from classical Roman antiquity. These paintings, executed by Amerindian artists, are a formidable example through which to explore the synthesis of indigenous and pan-European imagery and symbolism.

The Casa del Deán in Puebla is a good example of the integration of the indigenous population into building and artistic activity in America. Notions of identity and representation can be charted through similar case studies in the period. There is a plethora of records that evidence the role that native builders and artists played in the trade in Mexico City.[105] Susan Webster has solidly demonstrated that indigenous architects in Quito designed major monumental structures that showcase the application of designs found in Renaissance architectural tracts, particularly in the treatises of Sebastiano Serlio, Andrea Palladio, and Giacomo Barozzi Vignola.[106] The translated versions of treatises by Alberti, Serlio, Palladio, and Vignola, along with Diego de Sagredo's *Medidas del romano* (On Roman proportions), among others, reached the Americas in the sixteenth century. Indigenous architects, masons, and artists also played a key role in the dissemination of intellectual and design trends at both local and transregional levels.[107] Thus Webster has argued that the people and processes that made building activity possible are as significant as the buildings themselves and the materials, designs, and technologies used to build them.[108] The same can be said of Madrid: examining the procedures through which the building permits for the *aposento* exemptions were distributed has offered a glimpse into the townscape imagined for the nascent capital city. Our theoretical understanding of cultural and visual syncretism and of how

architectural design embodies the myriad identities of the early modern Iberian world cannot be static or impose artificial divisions on what is interpreted as "European" or "indigenous." The manner in which Quito's indigenous artists organized themselves and employed European architectural treatises mirrored architectural activity in other cities across the Atlantic. In designing and constructing these buildings, native builders were also expressing their identity by employing common sources of inspiration and regulatory practices, namely, the same architectural lexicon employed in Spain.

Artists and masons in the Iberian Peninsula also routinely conceived designs that catered to a patron's particular taste. Religious and lay buildings often evince similar design elements, as can be seen in such buildings as the Convent of Santa Clara in Seville.[109] The amalgamation of materials and technologies used in domestic architecture in Iberian cities and beyond demonstrates that the synthesis present in these buildings is pivotal to an analysis of the built environment. These houses, in turn, also embody the assimilation of local and pan-Iberian identities in the manner in which they integrate designs and technologies. The organization of the building trade in Valladolid during the fifteenth and sixteenth centuries shows that the majority of carpenters and *alarifes* were of Mudejar and Morisco descent.[110] It is not surprising that regulation of the building trade on both sides of the ocean reflected the integration of different traditions visible in their construction technologies, materials, and architectural design.

In Madrid, the permissions granted for the *aposento* represent only a fraction of the building activity that the city saw in the sixteenth century. Nevertheless, the aim of this chapter is not to study the city that was built but instead to chart the city that was imagined. The administrative procedures that were followed to enact the pieces of legislation in Madrid reveal how officials from the city council and the court worked in tandem to process

FIGURE 24 | City house for a merchant, in Sebastiano Serlio, "Sesto libro d'architettura: Delle habitationi fuori e dentrodelle città," fol. 48r. Bayerische Staatsbibliothek München, Codex Icon 189.

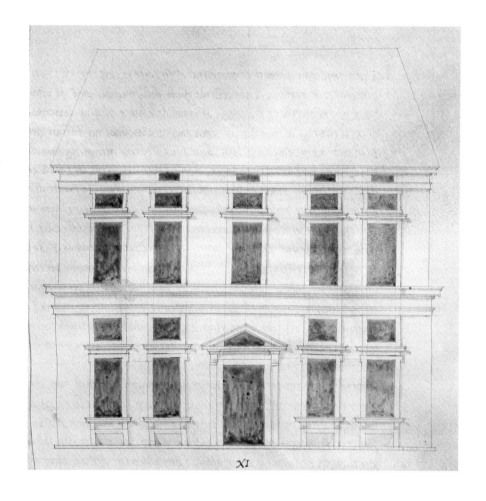

applications. The examples of exemptions studied also show Philip II's engagement in a number of applications. The legislation and regulations of building practice enacted in cities across the Iberian world reveal the materials and technologies that were considered useful for building an urban empire. These materials, whether adhering to imperial legislation or adapted to environmental conditions, demonstrate the crucial role that people, processes, materiality, and technology still play for an investigation of domestic nonpalatial architecture.

Both indigenous and Spanish architects made use of architectural treatises that spread wider transregional trends. Sebastiano Serlio's "Sesto libro d'architettura" was devoted to domestic architecture, but unlike other treatises, it was never printed and there is no evidence to demonstrate that it was employed or known in the trade, as were its analogous printed treatises. Among the many drawings included in Serlio's "Sesto libro," a proposal for the "ideal" house of a merchant in the city resembles some of the examples seen in the Iberian world (fig. 24).[111] Serlio integrated some of the French and Italian building traditions and design precedents in this manuscript; however, there is no mention of potential alternative façades or spatial arrangements for houses in the Iberian world. Nevertheless, one of the houses illustrated in the treatise is very similar to the house elevation

that Francisco de Mora designed in Valladolid in 1602 for Herrera y Lintorne (compare figs. 9 and 24).[112] Architectural treatises were instrumental in disseminating classical concepts, but they were not the only medium by which architectural design trends circulated: the mobility of people also contributed to the dissemination of architectural forms and ideals. Some of the examples documented in Seville and in the American cities preceded the translation of published treatises and indeed also the original manuscript for Serlio's book on domestic architecture. When Spanish and indigenous *alarifes* and architects traveled regionally or across the ocean, they brought with them their learned techniques and designs. As noted above, most cities in the Spanish empire had established building traditions, with or without official guilds, that regulated the building trade.

The urban ideal, as laid out in the ordinances of 1573 and reiterated in the pieces of legislation and regulatory practices considered above, was that residential architecture be homogenous across the cities of America and Iberia. The façades of surviving houses in Lima, Puebla, Seville, or Madrid can be usefully compared, for they largely present formal coherence. However, the materials and technologies employed in Valladolid and Madrid show some variation when compared to house façades elsewhere. The adaptation of residential architecture to its particular context (climatic conditions, accessibility of materials) attests to the rich variety of building traditions that informed architectural practice in the Iberian world. Traditional building techniques were also encompassed in the legislation issued by the court for Madrid and Valladolid. In the end, these legislative mandates integrated proven, effective, enduring building practices with formalized spatial design in façades and domestic interiors. The variations in the interior arrangement of the houses, along with their material composition, reflect the local contribution to the residential architecture of an urban empire. As

noted above, the gargantuan efforts made to regularize domestic architecture and the building trade suggest that the Spanish imperial world, on both sides of the Atlantic Ocean, was an empire under construction. Thus building practices and architectural design developed in parallel terms in both the Iberian Peninsula and the Americas.

Space, Architecture, Trees

Mexico City and Seville had a consolidated urbanism and architectural fabric; the Plaza Mayor of Mexico City was designed and built much earlier than the Plaza Mayor in Madrid.[113] Building activity in both Seville and Madrid shows a boom in the construction of residential architecture from the 1560s to the end of the century. As seen earlier, both cities were under development. In 1534, the local council in Mexico City enacted bylaws for the aesthetic uniformity of the built environment and became responsible for public hygiene and public utilities such as the water supply.[114] A year earlier, Lima had implemented legislation requesting that walls be erected for all properties in the city, promoted policies for tree planting and keeping the streets clean, and demarcated areas of the city for cleaning animals and clothes to preserve a potable water supply.[115] Similar legislation was enacted in Madrid with the arrival of the court, thirty years after Mexico City formulated a set of regulations for urban control. In 1565 Madrid, boundaries were established for the cleanliness of the city.[116] Civic health was a matter of concern in early modern cities, which had severe sanitation problems. Philip II encouraged city councils in matters of cleanliness and urbanism.[117] In Madrid, the cleaning boundaries were almost equal to the "commercial fence" that had been built under the king's auspices in 1566: both were very similar to the delimitation of Madrid under the *provisión* for the built environment of the city issued in 1567. A nondefensive wall had commercial purposes, but

it might also shield the city from plague and other infectious diseases.[118] The introduction of trees in Iberian cities was fostered in tandem with the regulation of domestic architecture.

Between 1564 and 1566, Madrid's town council devised a tree-planting strategy. Philip had also made important efforts to counter the deforestation of territory around Madrid after the settlement of the court there. In 1564, the town promoted the planting of trees around the boundaries of Madrid.[119] The next year, there is evidence of an incipient plantation on the esplanade outside the Alcázar; willows and black and white poplars were planted along the Guadarrama riverbank at the city's expense. Additionally, inhabitants interested in planting trees on their properties could acquire one for free from the city council. Philip II ratified this strategy by issuing a *real provisión* in 1566 stipulating that any landowner in Madrid with a property of at least one square mile was obligated to plant trees.[120] While these initiatives seem to have been instigated by the local authorities, the trees selected to landscape the streets of the city were those favored by the king.

On 20 June 1563 Philip wrote a memorandum to his secretary, Pedro de Hoyo, containing detailed instructions concerning the works and gardens at his palace in Aranjuez. The monarch was very specific as to the trees he desired and the location of the specimens. He specified that the plaza in front of his property should have black poplars and that the following year Calle Toledo should also be planted with black poplars in front of the line of white poplars. The idea behind the lines of two different species of trees was to take advantage of the slightly different blooming period of each.[121] Thus the choice of black and white poplars was not incidental; both are characterized by rapid growth with a leafy crown to provide shade for passersby. This report shows that the selection of trees in Madrid simulated the landscape of royal premises; black and white poplars and willows would

transform streets and spaces of social encounter in the town. The council, in conjunction with the monarch, established a twofold plan of action by providing trees for those interested in embellishing the city and by imposing a planting regime on the landowners with the largest holdings. The correlation between the design of royal buildings and the desired residential architecture sought for Madrid has been established; the preferred specimens of trees to embellish the capital city were also to mirror those employed at the court residences.

Local authorities reordered the orchards and agricultural lands in what was later known as the Paseo del Prado de San Jerónimo for the ceremonial entry of 1570 to receive Queen Anna of Austria (1549–1580), the fourth wife of King Philip II.[122] It has been widely discussed how Philip II tried to impose his wishes, at times forcefully but not always successfully, against the rights of the city council and private owners in Madrid. In the preparations for the entry of Anna of Austria, for example, the king sought to demolish a number of houses in the area of Sol and requested the erection of fountains and a lake in the Paseo de San Jerónimo.[123] In 1599, this *paseo* was described as a "very beautiful grove where the poplars form two long, wide avenues and where everyone parades on summer evenings to the sound of music which goes on until midnight."[124] Poplars appear to have been the preferred species for the urbanization of avenues, including the street network that formed part of the ceremonial route in royal festivals.[125] During such events, the city became the ritual tableau for the ruled and the ruler; these spaces ideally mirrored the court. After all, cities were transformed for royal entries, and capital cities and those where the prince resided were considered an extension of the court.

A painting titled *View of the Carrera de San Jerónimo and the Paseo del Prado with a Procession of Carriages* (ca. 1680), attributed to Jan van Kessel the Younger (1654–1708), depicts the Paseo as a

lush tree-lined space (fig. 25). The buildings act as a backdrop to the procession in the foreground of the painting.[126] The façades of the buildings present the characteristic design outlined in the legislation issued during the sixteenth century. To the right side of the canvas, the aesthetic nuance of tree-lined streets and roads embellishing the urban space is significant. Trees not only provided freshness and shade to the citizens but also helped in directing the urban vistas toward certain buildings, either royal, religious, or civic, emphasizing the visual hierarchies of the cityscape. Trees were a suitable medium by which to regularize the urban form. The creation of a homogeneous body of vegetation in the city also reinforced an ordered urban townscape. Covarrubias y Orozco defined *alamedas* as the spaces where poplars were planted.[127] *Alamedas* or *paseos* were not confined to Madrid, as they emerged in other prominent cities of the

FIGURE 25 | Jan van Kessel the Younger (1654–1708) (attributed), *View of the Carrera de San Jerónimo and the Paseo del Prado with a Procession of Carriages*, ca. 1680. Photo: Hugo M. Crespo.

Iberian world. The city council of Seville developed the Alameda de Hércules in 1574; Valladolid created the Alameda of Nuestra Señora del Prado in 1603; the Alameda of the Descalzos in Lima dates from 1610; and *alamedas* were also developed in Quito, Mexico City, and Habsburg Flemish cities.[128]

The sixteenth-century body of legislation issued in cities in the Habsburg world that regulated domestic architecture was intended to create a quasi-homogeneous design that could be modified to suit each particular urban center. Residential architecture had to adhere to the visual hierarchies of Spanish imperial cities: it was required to reflect a civilized society, which in turn was symbolic of Habsburg authority. The regulations promulgated in Madrid aimed to achieve minimum standards of urban order and housing quality through formal and material uniformity. Claudia Sieber has argued that the architecture of Madrid in this period was the result of decades of urban experimentation in the Spanish imperial dominions in combination with an adaptation of Italian architectural theory.[129] Indigenous master architects and builders in Quito, and the native mural artists who decorated

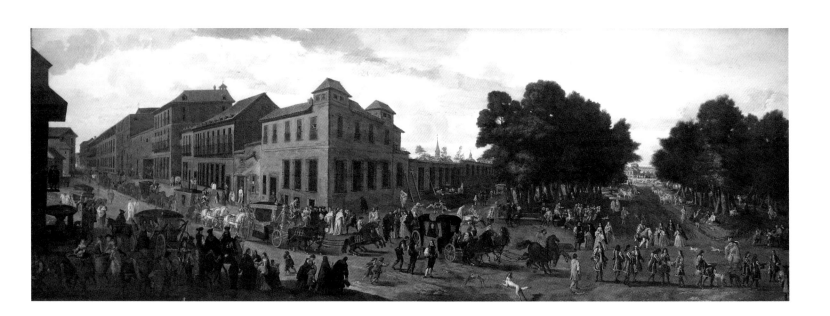

the Casa del Deán in Puebla de los Ángeles, are just some of the evidence that calls into question previous assumptions. The development of domestic architecture in locales across Iberia and America shows an array of trends and technologies as illuminated in the descriptions found in the *Relaciones Geográficas*. The analysis of the architectural development of major urban centers seems to offer some useful parallels in urban and architectural development. Within the architectural diversity present in the cities that has been examined in this chapter, there were also significant common aspects in the design, regulations, technologies, and materials found in houses in the Iberian Peninsula and America. Legislators, city and court officials, masons, and architects contributed to the creation of a common cultural grammar, in this case an architectural lexicon, that was reflected in the built environment. In this respect, it is also important to consider the manner in which information about the built environment from the Americas was mediated at the Spanish court.

A Common Architectural Lexicon: Pan-Iberian Circulations

This chapter has explored architecture in sixteenth-century Madrid and other cities and towns in the Iberian world by examining domestic buildings rather than grand palatial or religious structures. This analysis of legislation, architectural materials, practices, and specific houses has revealed a number of common threads. Many cities and locales on both sides of the Atlantic mediated the integration of vernacular building technologies and materials that were proven to excel in their particular locale. In addition, novel designs, and at times new materials, were imported and adapted to residential architecture throughout the Iberian world. Marble for columns in Sevillian patios in the Italian palazzo style began to appear in the sixteenth century. Flemish brick and slate roofs

featured prominently not only in royal buildings but also in the domestic architecture of Valladolid and Madrid. The use of *tapial* proved challenging across the Atlantic; however, transregional design merged effectively with Amerindian building technologies, which in turn would be developed further in viceregal America. The present study examines only key examples, for the rich variety that characterized the architectural production of the early modern Iberian world prevents the formulation of sweeping notions that might integrate the whole. Many other metropolises, such as Lisbon, Valencia, Siena, Rome, Naples, and Palermo in Europe, and Goa in India, among other places farther afield, enacted regulations or architectural practices in this period. Although space constraints prevent further comparative analysis, such an investigation may indeed provide insights into the wider mechanisms that allowed the circulation of ideas, practices, and designs. The Council of the Indies tried to gather intelligence from viceregal America, and the *Relaciones* questionnaire is one example of the mechanisms employed by the court to govern transatlantic dominions.[130]

Nevertheless, while the Council of the Indies received reports and information from America, this does not necessarily mean that knowledge from that distant land was properly understood. Juan de Ovando, in his *visita* (inspection) of the Council in 1569, concluded rather bluntly "that in the Council of the Indies, one neither has nor can have any intelligence (*noticia*) of American matters to which governance (*gobernación*) can and must relate." Ovando explained that the reports received from the Americas were in disarray. In addition, such reports were unlikely to reflect the complete spectrum of particular issues but in many cases projected an image that the author wished to present to court. In the end, the changes introduced in the Council of the Indies to generate universal knowledge and intelligence (*entera noticia*) from the Indies would not achieve a complete survey,

but instead cemented the loyalties of subjects at home and abroad.[131]

Architectural exchanges in the early modern Iberian world have intrigued scholars of the Iberian empires. The histories of the global expansion of the Spanish and Portuguese empires can no longer perpetuate divisions imposed by nineteenth-century visions of nationhood that separated the Iberian Peninsula from America or the wider colonial empire by considering them as two or more distinct entities.[132] The architectural projects of the Mexican prelate Antonio de Monroy e Hijar (1634–1715), who became the archbishop of Santiago de Compostela, exemplify the array of patrons and agents involved in architectural development across the Iberian world. There have been significant contributions to our understanding of how architectural knowledge circulated between the Spanish court and the Americas.[133] Knowledge exchange with regard to architecture and city development repays further analysis.

As discussed above, by the time the ordinances for American settlements were issued in 1573, around 191 cities and towns had been founded in the Americas. Thus it is untenable to argue that the king's entourage in the sixteenth century did not know about urban development and governance in those parts of the world. With regard to Madrid, the engagement of the ruler and court officials—including royal architects and local *alarifes*—in the codification and management of building activity during the period 1567–84 has been demonstrated. The administrative processes of *aposento* applications in Madrid and Valladolid corroborate the procedure laid out in the legislation. Officials, *licenciados*, and other members of the court who rose to high echelons in the councils were routinely appointed to different positions, often moving among the councils and juntas. Those who served in the Council of Castile, the Cámara de Castilla, and the Council of the Indies are of special interest for their potential role in the

development of the legislation in Madrid as well as for the access they would have had to the information that came from America, and more significantly, because some of these council members also traveled to the Americas.

The Junta de Obras y Bosques, which included the presidents of the Council of the Indies and the Real Hacienda (Royal Treasury), managed architectural activity at royal sites, including the royal residences the Habsburgs used regularly in central Castile.[134] Presidents and members of Philip II's councils were in charge of different positions, often moving between the two councils. For instance, Luis Hurtado de Mendoza, second Marquis of Mondéjar, was involved in major architectural developments for the Crown. He held the presidency of the Council of Castile and was also a member of the Cámara de Castilla between 1561 and 1563, and he had previously served as president of the Council of the Indies (1546–59).[135] Hurtado de Mendoza had also managed architectural developments for the royal premises in the city of Granada for Charles V. In 1559, he wrote to Philip the letter (cited above) that emphasized Philip's investment in the architectural embellishment of Madrid. The presidency of the Council of the Indies gave Hurtado access to documentation on the new transatlantic dominions, including that relating to the boom in newly founded American cities. Yet Hurtado and other court members may not have received complete information from the American dominions. Some information about the planned layout of cities and their governance did reach the Council, but detailed descriptions of particular buildings, especially residential architecture, would not have figured prominently in many of the reports they received; even the information gathered in the *Relaciones Geográficas* was at times succinct. On occasion, more detailed accounts and sometimes drawings reached the court, but they would not have provided a complete picture of domestic architecture in the period, as Renaissance

city views rarely portray images of residential buildings.[136] Even so, Hurtado de Mendoza and other councilors had either been in charge of or contributed to the management and regulation of architecture in cities across the empire. Thus it is reasonable to suggest that councilors, and in particular Hurtado de Mendoza, would be well acquainted with the practice, organization, and regulation of the architectural activity in both peninsular and imperial dominions. As demonstrated above, many cities in New Spain mimicked peninsular models for the regulation of the building trade. When the marquis moved from one council to the next, he also appointed some of the officials of the Council of the Indies to the Council of Castile, including, for example, Gracián de Briviesca de Muñatones.[137] Gracián was an official at court who had also been in charge of the Simancas archive for several years, even though his brother Diego had officially held the post; because Diego did not reside in Castile during his tenure, Gracián took charge.[138] Gracián shipped numerous boxes of documents from the Council of the Indies to the Simancas archive. There is evidence, however, that the Council of the Indies kept substantial documentation in its premises in the Alcázar in Madrid.[139] Thanks to Briviesca de Muñatones, among others, chests full of papers from the Council of the Indies gradually reached the Simancas archive in Valladolid. In 1572, Diego de Ayala, the archivist in Simancas, collected fifty-three chests containing this documentation from Madrid.[140]

Francisco Tello de Sandoval (d. 1580) and Juan Rodríguez de Figueroa (1490–1565) succeeded Hurtado de Mendoza in the presidency of the Council of the Indies (1565–67) and the Council (and Cámara) of Castile (1563–65), respectively.[141] In 1542, Rodríguez de Figueroa was *visitador* (inspector) of the Council of the Indies, which resulted in the promulgation of the New Laws of 1542. Tello de Sandoval was also an inspector of the Indies and visited New Spain in 1544 to deal with the implementation of the New Laws. *Visitadores* of the Indies were inspectors whose principal objective was to investigate whether the legislation issued at the court was properly enacted in America. *Visitadores* reported on compliance with the regulations and any other news that would be deemed of interest to the Crown. One of the aims of the New Laws were, in theory, to palliate the terrible treatment of the indigenous population. The spiritual and physical well-being of the indigenous population was deemed the responsibility of the sovereign, who had to ensure that Spanish settlers adhered to the legislation. In his instructions to the viceroy of New Spain of 1566, Philip II ordered enhancements to hospitals for the care of mixed-race orphans in Mexico City, and other instructions followed in subsequent years.[142]

In 1568, the Junta Magna in Madrid aimed to establish a plan of action for the Indies that would alleviate recent social unrest, improve the treatment of the Amerindian population, and devise an approach to propagating the Catholic faith in America. While the junta focused on imperial strategies of evangelism, the body of legislation examined earlier and Philip II's regular instructions to the American cities provide context for how urban affairs were often merged with spiritual pursuits. The junta concluded that there was a need to gather detailed information on the American dominions. The Junta Magna of 1568 met at Diego de Espinosa's residence in Madrid and convened several times over the course of the year.[143] The king was part of the junta, as was secretary Francisco de Eraso (1507–1570). Numerous officials and ministers of the court were also invited, including the presidents of the Council of Castile and the Council of the Indies. From the Cámara de Castilla came Dr. Francisco Hernández de Liébana, Dr. Velasco, and the *licenciado* Diego de Briviesca de Muñatones, who had returned from the Americas, and from the Council of the Indies came Dr. Juan Vázquez de Arce and Dr. Gómez Zapata. The

visitador Juan de Ovando and Fray Bernardo de Fresneda, bishop of Cuenca, were among those present. More important, D. Francisco de Toledo, who had been appointed viceroy of Peru, was also invited.[144] Upon his arrival in Lima, Francisco de Toledo, as newly designated viceroy, embarked on a multiyear progress to inspect the viceregal lands and to gather *noticia*. The second viceroy of New Spain, Luis de Velasco (1511–1564), recounted the weekly routine he followed for the governance of the viceroyalty. In one report, Velasco illustrated how he devoted every Wednesday afternoon to the discussion of city affairs, which suggests that the viceregal capital, Mexico City, was central to his government.[145]

Many of the reports from the Americas would have received a royal response; in most cases these arrived too late to be of much value, but they offer a glimpse of how the monarch and his court tried to govern urban and architectural affairs remotely. In 1568, only a few months before Philip II convened the Junta Magna, the monarch sent an extensive instruction to the viceroy of New Spain, Martín Enríquez de Almanza (ca. 1510–1583), which discussed a number of issues and focused for the most part on the conversion of the Amerindian population and its protection from abuse. Some of the orders in the instruction were very detailed and pertained to particular buildings or urban design more generally. Philip requested that the viceroy prevent the construction of monasteries in close proximity to one another and indicated the most appropriate means of raising funds to erect the monastery buildings. He also gave orders regarding the houses erected in Mexico City and other cities and towns in New Spain where Amerindian *doncellas* (maidens) were educated in the Catholic faith and Spanish customs. The viceroy had to ensure that houses were well constructed and that good materials and tools were provided to build them where necessary. Philip requested information on the places most suited to the establishment

of new cities. He suggested the construction of another 'city of the Spaniards' (*ciudad de los Españoles*) in the vicinity of Veracruz in order to move its population from the port, as he had been informed of major health concerns there. The king also reminded the viceroy that any transaction involving the sale of properties or 'cities of the Indians' (*ciudades de los Indios*) to Spaniards was unlawful.[146] Philip's instructions show the interest that he and his court took in all matters related to the Indies, including details concerning the built environment and the urban planning of cities in America.

Many other officials rotated between councils in the Spanish court, and while few of the councilors had visited the Indies, those who did were often appointed to positions that gave them access to information and even authority over urban and architectural matters.[147] In 1543, during the reign of Charles V, the *licenciado* Cristóbal Vaca de Castro (1492–1566), knight of the Order of Santiago, was designated *oidor* (judge) in the Audiencia of Valladolid. In 1540 he was sent to Peru, where he rose to be governor of Peru and president of Lima. These successive roles gave him direct knowledge and access to information with regard to the building trade. In 1543, for example, Vaca de Castro ordered the construction of good houses for the indigenous population working in the mines. He was succeeded in his role in Peru in 1544, and then became president of the Council of Castile (1557–61) at the Spanish court.[148]

The *licenciado* Lope García de Castro (1516–1576) was a minister in the Council of Castile during Philip II's reign. He also served as *corregidor* of Toledo, a position that allowed him to intervene in the urban development and regulation of architectural activity in the city. He was governor of Peru between 1564 and 1569, in which capacity he oversaw the work of local authorities in cities and towns in the region and also the founding of new settlements. In a letter addressed to the king in 1564, García de Castro discussed the state of

the cities of Santa Marta, Cartagena, and Nombre de Dios. Two years later, he wrote another letter to the king that discussed some details of the organization of the building trade in Spanish cities where indigenous masons worked on the erection of houses. In 1567, García de Castro requested funds from the Council of the Indies to purchase fifty black enslaved people to work under the supervision of master masons in erecting bridges in the region.[149] As discussed earlier, Luis Gaytán de Ayala and Pablo de Laguna, *corregidor* of Madrid and member of the Hacienda, respectively, had been closely involved from 1589 in the exemption of *aposento* duties granted by the Crown in Madrid. Both Gaytán de Ayala and Laguna became ministers in the Council of Castile, and Laguna would also become president of both the Real Hacienda and the Council of the Indies.[150] There are many other cases of officials and ministers of the empire who rotated through such positions. These examples demonstrate how officials involved in the day-to-day management of residential architecture in Madrid and other cities in the Iberian Peninsula also had access to, and sometimes visited and managed, architectural activity in viceregal America. Above all, the regulation of the building trade in cities throughout the empire, through the training and organization of the work of *alarifes*, architects, and masons, created a common architectural lexicon. Legislation, guild organization, and the training of architects, *alarifes*, and masons also integrated knowledge and trends acquired through treatises on architecture. Thus this lexicon was reflected in the pan-Iberian visual trends that architecture displayed in both Europe and America.

There are significant similarities in legislation and the regulation of architectural practice on both sides of the Atlantic. The Council of the Indies emerged as a sophisticated institution with the appointment of Juan de Ovando (1571–75).[151] During Ovando's tenure, new methods for data gathering were implemented in the Indies, and while these did not always achieve the desired results, they are still useful to our understanding of architectural governance. The ordinances on American urban settlements of 1573 were issued during Ovando's tenure. These ordinances were developed on the basis of the knowledge acquired by the Council of the Indies and the long-standing experience in urban design and management of architectural activity accrued by agents on both sides of the ocean.[152] Some of the orders and instructions that Spanish monarchs, in particular Philip II, sent to viceroys or city councils in Iberia were equally detailed and concerned with similar issues of building quality and city design.

In the light of these clear connections, I would argue that urban planning in Habsburg Iberia, and more precisely in Madrid, and the body of legislation and regulatory activity that occurred in sixteenth-century America were part of a common and continuous "field" of thought and activity. The evidence for this connection can be found in the personnel involved not only in the creation of the body of legislation regarding architecture and urban design, but also—and more significantly—in the implementation of mechanisms for urban control within cities and towns on both sides of the Atlantic. These mechanisms to regulate the building trade were mostly implemented by local actors, except in cities within the courtly network of influence in the peninsula. The mechanisms for the regulation of architecture and urbanism that aimed to implement a decorum in the design and building materials and technologies were not always successful, as in the case of Madrid, and as evidenced by the vast use of pre-Columbian traditions in locales in America. The slow and gradual change seen in major urban centers—as evidenced by the *Relaciones* of Veracruz and Quito, for example—echoes that of other locations in the peninsula, such as Seville, and emphasizes the role that the circulation of ideas, peoples, and trends had in the period.

In sum, the evidence shows how the austere classical design developed in royal residences permeated domestic architecture in Madrid and Valladolid before the seventeenth century. In other words, while the impact of sixteenth-century urban regulations on domestic architecture in the newly designated capital city in 1561 would take decades to become widely employed, they had been formulated earlier than previously believed. The desired design for domestic architecture in Madrid, which mirrored royal architecture, was devised during Philip II's reign and developed subsequently. A substantial part of the content of the regulations enacted in Madrid and Valladolid had already been employed in other cities across the Iberian world. The body of legislation, local bylaws, guild ordinances, and other regulatory activity prior to 1561 not only shows the strong urban emphasis of the imperial mission but also demonstrates that to understand the regulation of the built environment in the capital, it is necessary to study its wider context, and the legislation that preceded it.

Cities and towns across the Spanish empire during the sixteenth century were decidedly under construction. A closer examination of the regulatory practices and the surviving and planned residential buildings in cities across the Iberian world demonstrates that technologies and materials of construction are a useful means by which to examine the integration of local and transregional traditions. Local actors, including indigenous masons and builders, made possible the circulation of pan-Iberian design trends, since they were responsible for regulating the building trade and ultimately for the construction of houses. The incentives promoted by imperial legislation and its agents provided a framework; however, in Madrid, Valladolid, and cities and towns across the empire, homeowners, architects, masons, builders, and local authorities made cities function. They were the ultimate agents who created a local voice and particular identity for the city's architecture.

This chapter has examined residential architecture in order to reflect on the ways and forms in which house façades were designed and built—that is, through their contribution to the streetscapes of cities. By exploring domestic architecture, the existence of a common architectural lexicon employed by many and informed by the contribution of many has emerged. Masons from a variety of backgrounds (descendants of Morisco families in Valladolid, Amerindians, and new and old Christians), as well as homeowners and local and imperial authorities, employed similar sources to envision houses, whether found in architectural treatises or learned through training and tradition. This "army" of agents involved in and influencing the building trade created residential architecture and employed and fostered an architectural lexicon. Their contributions are as compelling as the individual narratives of "leading" architects and artists who traveled and whose works have been the focus of scholarly attention. Above all, the present chapter has shown the manner in which local and imperial agents engaged with the built environment and contributed to this lexicon. This chapter has demonstrated that the built environment has much to offer for our understanding of the circulation of ideas, identity, and cultural exchange. However, this study represents only a fraction of the built environment that defined this particular period and imperial system. Further study of dwellings and additional comparative work would be necessary to further develop our understanding of architecture and urbanism in the early modern Iberian world.

Ruling an Empire Through Paper
ARCHITECTURE AND THE SIMANCAS ARCHIVE

The historian Luis Cabrera de Córdoba (1559–1623) claimed that Philip II "moved the world by means of papers."[1] Cabrera de Córdoba's hyperbolic statement voices a widely held belief among Philip's contemporaries that he was seemingly able to govern his extensive and disparate realms through the written word. Writing was a vehicle through which to exercise power in the early modern world. Authority was enacted in correspondence, edicts, and legislation, later distributed to far-flung imperial territories. The increasingly complex machinery of the state and allied institutions generated an ever-growing mass of papers that had to be kept secure. The image of Philip as an omniscient ruler was created in part through his use of the written word. Described as "the largest brain in the world," Philip was seen as a king who knew everything and was able to gather intelligence through textual or visual records.[2] Thus the royal archive acted during this period as a symbol of the ruler's access to knowledge and the place where the records that legitimized his authority were kept.

The royal archive was created in the fortress in Simancas, a town near Valladolid (fig. 26). The original castle was an Islamic construction rebuilt by Admiral Alonso Enríquez in the fifteenth century. In 1540, Charles V ordered the creation of an archive to store royal deeds in one of the strongest bastions in the Simancas fortress. The necessity of expanding the archival spaces in the Simancas castle became more pressing once the court had settled in Madrid, as the collection began to incorporate a significant number of record chests. The castle underwent major reforms during Philip II's reign, and it is not surprising that Cabrera de Córdoba emphasized the crucial role that Philip played in the establishment of the Simancas archive: "Philip wanted to order and keep safe all the old deeds [which were] dispersed in Castile and at risk of getting lost, [so as] to put them to the service of the Crown and for the good of his subjects."[3] As the collections grew, the archival spaces in the old castle were adapted to receive more papers. In 1567, work began for the adaptation of another chamber in the tower. In 1570, Philip and his court envisioned a major expansion of the Simancas archive that would substantially transform the use of space in the medieval castle. The royal architects Juan de

FIGURE 26 | The Castle of Simancas. Photo: author.

Salamanca and Juan de Herrera drew architectural plans for the new galleries, and this expansion effectively introduced the courtly Austríaco style in architecture into the building. In 1588, Philip and his court implemented significant reforms in imperial administration. The "Instructions for the Governance of the Simancas Archive" were issued that year, and the royal architect Francisco de Mora drew up plans for the building of new archival chambers. Philip supervised the architectural development of the royal archive as closely as he oversaw the gathering and arrangement of archival papers therein. The final reforms to the Simancas archive during his reign were designed by Herrera and Mora, and work based on these designs continued after Philip's death in 1598. This chapter explores the major architectural projects that transformed the fortress into a royal archive in the sixteenth century, particularly during Philip II's reign. I examine surviving sixteenth-century plans, accounts, and letters that chart this transformation.

The archival collections of any kind of "institution" reflect (or at least should reflect) the structure of the organization and the changes in

the administration throughout its history. The collections originally housed in the Simancas archive reflected the practices of governance of the Spanish Habsburgs. In this chapter, I suggest that the architectural evolution of the Simancas archive echoes the machinery of the state implemented by the Spanish Habsburgs, especially during the reign of Philip II. I show how the spatial configuration and design of the building reflects the hierarchies and organization of Philip's empire. The archive is a testament to Philip II's reign and the legacy he wished to leave for posterity. One of the functions the king and his court attributed to the royal archive as the keeper of the memory of the kings recalls the pantheon at El Escorial and the collection of relics kept in the monastery.[4] In a similar vein, the theologian and historian Fray Francisco Diago (1562–1615) described the archive of the Crown of Aragon in 1603 as "the general burial of the princes and kings of Aragon, their successors, where their memories lie."[5] If El Escorial was the royal burial, the Simancas archive, as the present work shows, was also a tribute to Philip's dynasty and a projection of his authority.

While there have been recent important contributions to the history of archives in the early modern period,[6] the literature has thus far failed to examine the architecture and the spaces created to house these collections, including the Simancas archive.[7] Thus this part of the book examines the architecture, organization, and cultural context that governed the creation and construction of the Simancas archive between 1540 and circa 1600. This chapter not only examines the royal archive in Simancas but also compares it with other contemporary archives. It also examines a vernacular tradition in the construction of treasuries and archival chambers that spread across Europe. This vernacular tradition is compared to the two first archival chambers adapted in the castle, namely, the so-called *cubos* of Charles V and Philip II, built between 1540 and 1568. Newly uncovered

correspondence between the monarch and the archivist at Simancas shows royal intervention in the decorative program of these chambers. The second part of this chapter examines the grand expansion of the archive in the 1570s and 1580s. I examine the architectural project designed by Juan de Herrera and Francisco de Mora that resulted in the vigorous introduction of the Austríaco style in the building. I explore the parallels between the organization of ancient Roman archives and the Simancas archive and analyze the notion of the archive as the "memory of the realm." I study in detail Philip II's visit to the royal archive at the end of the century and its architectural reverberations. After inspecting the Simancas archive, for example, Philip ordered the construction of a royal corridor so that he and his successors could access the archive without the need to be seen. I suggest that the architectural evolution of this building not only echoes the development of Philip's empire but also shows the evolution of architectural taste at court. Reforms in this building also reflect the synthesis of pan-Iberian design in courtly buildings. The building boasts an amalgamation of spaces that display coeval architectural trends that offer insights into the way designers might have negotiated the integration of existing structures and new designs in other significant royal buildings, such as the Alcázar in Madrid.

The Simancas Archive, Europe, and the Wider World, *1540–1567*

Years before the construction of the first archival chambers at the Castle of Simancas, Charles V began to assemble documents of interest to the Crown.[8] In 1540, when the collection had become substantial, Charles V ordered the construction of archival spaces in the fortress. In the emperor's letter referring to the chambers, he employed the Spanish word *cubo*, from the Latin *cubiculum*, which indicates a building or chamber with a

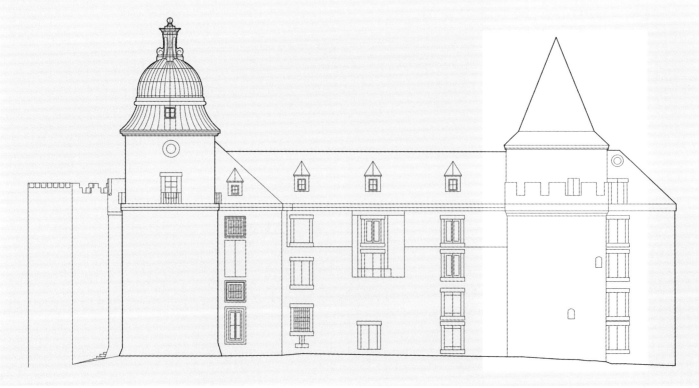

FIGURE 27 | Floor plan (attics) and axonometric view of the Simancas archive. The section highlighted in both images is the tower of Obras y Bosques. Drawing by author and Harry Kirkham.

FIGURE 28 | Southeast elevation of the Simancas archive. Detail of the Tower of Obras y Bosques highlighted. Drawing by author and Harry Kirkham.

central floor plan.[9] The chambers adapted for the royal archive were finally located in one of the towers in the Simancas fortress.[10] The papers most closely related to the king were located at the top of the tower, in the largest chamber, and, whereas the other spaces in the tower were substantially transformed during Philip II's reign, this high chamber, known as Charles V's *cubo* (cubicle or *cubiculum*), retains important original features from the 1540s. A close observation of the floor and elevation plan of the tower where the chamber was located is useful to learn the location of the first archival spaces within the fortress (figs. 27 and 28).

The archival collection kept in Charles's cubicle enshrined dynastic rights and details of royal properties as well as royal control over the church and lands (known as the *patronazgo real*). The collection also included manuscripts of genealogical or political importance, such as marriage contracts and treaties. During Charles V's reign, it was expected that documentation from royal councils not employed on a daily basis would be transferred to Simancas.[11] In the mid-1540s, there is evidence that documentation was routinely retrieved from Simancas, however, as petitions increased considerably during Philip II's reign.[12]

In the fifteenth-century rebuilding process at the Castle of Simancas, most of the original walls were replaced. The Simancas archive maintains some features of the fifteenth-century fortress; most of the exterior wall survives, with the exception of the gate.[13] The archival chamber known as Charles V's *cubo*, which was completed in 1540–43, has been transformed over time. A false ceiling introduced during the last conservation project on the building now covers a vault. However, this vault was drastically transformed in one of the historical reconstructions that the castle underwent in the past century. Other aspects of the chamber suggest that the now-lost original vault would most probably have been unembellished. Like the ceiling, the floor is not original, but the rest of the furnishings

in carved wood date from the sixteenth century. During the few years that Charles V resided in Castile, Valladolid was the de facto administrative capital. The secretary Francisco de Cobos (ca. 1477–1547), who was also governor of Valladolid, may have determined the designation of Simancas as the site for the royal archive. He also oversaw the construction of the first archival spaces in Simancas (1540–43), which further indicates his role in choosing the location for the archive.[14]

Charles V's *cubo* is slightly elevated above the tower's embattlement; built with a redbrick wall from the top of the bastion, it made the space slightly higher and kept it inaccessible.[15] The red brick is still visible from the outside and the external walls were never painted, reinforcing the functional character of this chamber (fig. 29). One window illuminates the cubicle. The interior walls of the *cubo* were covered with wooden shelves with

FIGURE 29 | Tower of Obras y Bosques, featuring Charles V's *cubo* at the top of the tower. Photo: author.

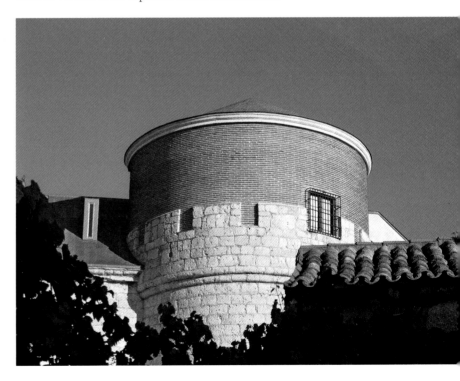

secured doors. These furnishings have two levels and a small corridor, with a balustrade for access to the second level added in 1567 (fig. 30).[16] The room has a secluded atmosphere; the dim light provided by the window and a vault would have created the impression of entering a small chapel. The cabinet-lined walls enhance the severity of the room, notwithstanding the elegance of the dark pine carvings. For centuries, this cloistered space guarded important imperial treasures, including records that guaranteed the continuity and rights of the dynasty to the Castilian realm and its overseas domains. The silence in the interior of the chamber and its sense of remoteness show that this space was never intended to receive visitors. Instead, it acted as an unpretentious strong room, access to which was restricted to a select number of people.

Access to this high chamber was intricate and difficult, along a stretch of corridor and several flights of stairs, which reinforced the impregnability of the *cubo*. A project to deposit the Crown's

FIGURE 30 | Charles V's chamber, interior. Photo: author.

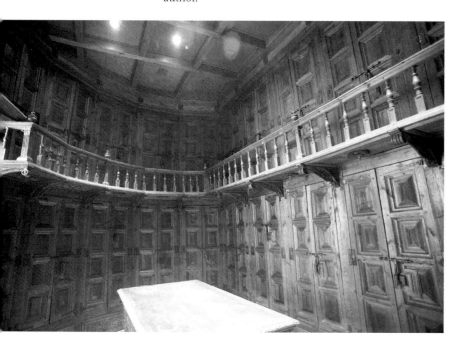

collection of books in the fortress during Charles's reign did not materialize. This collection may have been the books that were deposited, together with the treasury (including thirty thousand golden *escudos*), in the Alcázar of Segovia. Nevertheless, this book collection cannot be considered a library but rather a precious miscellany that would in this period have included jewelry, tapestries, and other valuable objects kept by royalty in their treasure chambers.[17]

The location and form of the chamber within the fortress are practical; the sparse attention to architectural detail, as seen in the unembellished exterior, indicates that the builders aimed for functionality: keeping its contents, the papers, safe. There is no evidence to suggest that Charles V visited the chamber. In contrast, Philip II visited the archive and thoroughly supervised most aspects of its organization, architectural development, and decoration. The creation of the archive in Simancas in 1540 was not unique, and neither was it the first archival repository in sixteenth-century Europe. On the contrary, religious congregations and other rulers and realms kept archival collections, such as the Archivum Arcis, in the Vatican. The Simancas archive has been compared to other peninsular models, like that of the Chancellery of Valladolid or the viceregal archive of Aragon in Barcelona. Comparisons can also be made with kingly archives, such as Torre do Tombo in Lisbon, among others. The archive was not located in the palace in Valladolid, as was the case for the viceregal archive in Aragon. The still peripatetic nature of Castilian courtly culture might have prevented this option, and the location of the archive in this period may not have been seen as permanent.[18] A further chamber was adapted and furnished to house papers on the floor below Charles V's archival cubiculum. This space is known as Philip II's *cubo*. The spatial configuration of these two chambers corresponds to the vernacular typology of the architecture of the treasure-archive that is found in

many castles and ecclesiastical buildings in Europe from the early Middle Ages to the early modern period. These archives with similar spatial configurations were often not complex administrative secretariats.

In the Kingdom of Aragon, for example, James II (1267–1327) created a royal archive in 1318. John II (1405–1454) and Henry IV (1425–1474) of Castile may have been inspired by the Aragonese example when they tried to pursue an archival project for the royal records; however, these attempts were not successful, and the archive of the Crown of Castile was only established with the imperial order of 1540.[19] The Aragonese archive acted as an administrative tool for the Crown from the rule of King Peter IV (r. 1336–87) onward. It allowed the Aragonese king and his court greater access to the documentation, and was an office put to the service of the court.[20] The location of archival repositories in princely palaces is logical, and on many occasions the treasure was kept in the same safe chambers. During Charles V's rule, the fortress at Simancas temporarily housed some treasures; for example, in 1530 the Marquis of Cenete deposited his rents, and later it also housed the ransom money obtained for the release of Francis I of France.[21] Elsewhere, the use of secure chambers to keep the treasury and archives was not new. In the tenth and eleventh centuries, a number of northern Italian religious institutions with settled communities had similar rooms. Adolf Brenneke observes that archives were often housed "in conjunction with the treasure of the church . . . in specially protected parts of the churches: in the tower, in vaulted chambers, or the sacristy."[22] The use of vaulted chambers in towers and sacristies—the most sacred spaces in religious buildings, and surely the most secure—became a vernacular tradition that extended across many European kingdoms.

The construction or adaptation of chambers to house archives and treasures, the architecture of the treasure-archive, developed in places where ecclesiastical or lay authority established a permanent center. Thus when authorities made arrangements to store treasures and archives, many of them simply adopted identical architectural solutions (for the most part, vaulted chambers in towers). Traces of this architectural tradition are difficult to find, since most of these chambers have not survived and were not widely known or discussed in the documentation. The context improves later, with the development of a number of grand state archives. The grand expansion of the Simancas archive was developed by Philip II, while in the seventeenth century renovation work was undertaken on the archives in the Tower of London and on the new archival chambers in the Vatican palace complex adjacent to St. Peter's Basilica. These reforms changed the furnishings or the architecture of the buildings that housed the collections, especially in the case of Simancas and Rome. Analysis of surviving structures and historical evidence can be used to establish an architectural pattern connecting practices in a number of European examples.

Maximilian I of Habsburg (1459–1519) sought to assemble all the archival collections in a unified imperial archive. Ultimately, these collections, or at least part of them, were gathered at Innsbruck's Kaiserliche Hofburg. The palace underwent major rebuilding during the eighteenth century.[23] In 1512, Maximilian set up a commission, which included the humanist Johannes Cuspinian (1473–1529), to study the possibility of assembling the imperial collection in a large purpose-built *Briefgewölbe* (a vaulted chamber for filing documents) in the castle in Vienna. The project remained unfulfilled until Ferdinand I (1503–1564) ordered the documents to be held in two locations: the Tyrolean documentation at the treasury in Innsbruck called the Schatzarchiv (the treasure-archive), and the Habsburg archives in the treasury room of the castle in Vienna. Maximilian I also had *Schatzkammer* (treasuries) in a castle in Wiener Neustadt

and elsewhere, and these structures served as archival repositories, too. Some of the archival collections on Austrian soil had been kept in the Convent of Neuburg from the twelfth century onward, and two centuries later they were reported to be in Lilienfeld Abbey.[24] These vaulted chambers where treasures were kept also housed important records: there were "extensive deposits" of records located in Vienna, Wiener Neustadt, Graz, and Innsbruck.[25]

A surviving image that reflects the appearance of one of these archive treasuries under Maximilian I's rule is the woodcut representing the emperor's treasury in a celebrated print of the triumphal arch (fig. 31). The text that accompanies this image describes the emperor's treasure of silver and gold

FIGURE 31 | Albrecht Dürer, *Treasure: Triumphal Arch of Maximilian I,* 1512–15. Woodcut. Photo © The Trustees of the British Museum.

FIGURE 32 | Original chest for archival records in Simancas, ca. 1567. Photo: author.

as the grandest ever known, accumulated for the greater glory of God. The treasure and curiosities were framed architecturally within a vaulted room with a very small window. The sober nature of the space resembles the room Charles V built for the first archive in Simancas, except for the decoration that embellishes the treasures; there was no such décor in the first Castilian archive. The involvement of architectural features in the term *Schatzkammer* links it to the notion of safe or secure chambers in towers with vaulted roofs. This is the architectural type closest to what we can imagine were the first archival chambers and royal treasury rooms. The ancient Greek term *thēsauros* and the Latin *thesaurus* mean "storehouse" and "treasure," which is also the secondary definition of the word in English. The chests and coffers depicted in the print correspond to examples found in Simancas and many other archives across the early modern world (figs. 31–32).

In the Low Countries, the Burgundian archival tradition was also associated with castles. The County of Flanders held its archive in Rupelmonde

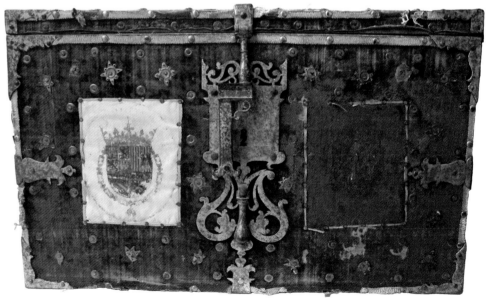

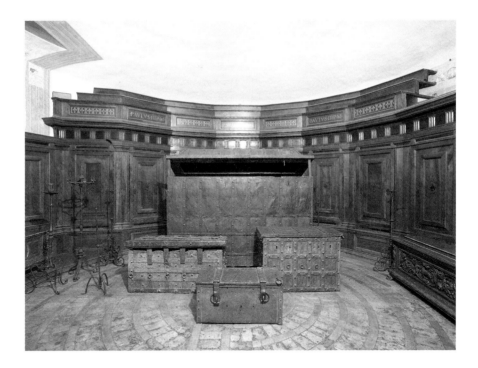

FIGURE 33 | Archivum Arcis (treasure room) at Castel Sant'Angelo. Courtesy of the Polo Museale del Lazio—Museo Nazionale di Castel Sant'Angelo, Rome.

Castle and the Duchy of Brabant in the ducal castle of Vilvoorde, near Brussels.[26] Certain ecclesiastical archives in Franconia (the northern part of Bavaria) were more developed in the first decades of the sixteenth century than their lay counterparts. As mentioned earlier, some religious authorities used their archival repositories to guard their deeds as well as their treasure, and they often kept these collections in castles and palaces. This was the case in the Bishopric of Würzburg, which was established in the Marienberg Fortress from the fifteenth century onward.[27] The sixteenth-century archivist, chronicler, and diplomat Lorenz Fries (1489–1550) wrote on the history of the collections kept in Marienberg and also arranged the archives. The archival chambers were located in one of the castle's towers; about five drawings from different archival cabinets still survive.[28]

The Vatican archive was housed in Castel Sant'Angelo, Rome, from at least the fifteenth century.[29] The treasury room in Castel Sant'Angelo

was located in one of the highest chambers of the ancient mausoleum, a monolithic structure with a spatial configuration similar to the towers used for archival purposes elsewhere. The pope's archive was also kept in this space (fig. 33). The chamber has a centralized floor plan and is located on the sixth level of the building, exactly at its epicenter. The castle was originally Hadrian's mausoleum and it is believed that this room held the Roman emperor's tomb. In 1545, Pope Paul III Farnese (1534–49) commissioned the fitting of walnut cabinets to house the documentary collections of the Archivum Arcis, thereby transforming the original circular space into a polygonal room.[30] The security of the chamber was formidable, with keys to the two doors kept only by the papal treasurer and the cardinal-deacon. While the documents were stored in wooden cabinets, the treasure stood in the center of the room inside a large iron chest fastened with six locks whose respective keys were assigned to different people. The treasure room was virtually

impregnable. The Archivum Arcis chamber is connected to the library, which was developed during the same period.[31]

The Sala Rotonda is exactly above the Archivum Arcis. Access to the chamber is by a narrow staircase located in the library. Traditionally believed to have been the first chapel in the castle devoted to the Archangel Saint Michael, the Sala Rotonda had numerous uses over time. By the late sixteenth century, it was incorporated into the expanded archive of Pope Clement VIII (1592–1605). Bartolomeo Cesi refurbished the room, lining the walls with carved wooden cabinets. Like the original treasure chamber below, the Sala Rotonda included a "safe" guarded by numerous locks and a door reinforced with iron. The collection of papers kept in this upper room was known as the Archivio Vecchio. Storage of the treasure and pope's archive in the safest tower of a castle was found in other European courts.

The Torre do Tombo archive in Lisbon was located in one of the towers of the Castle of Saint George. The archive was created between 1373 and 1375, almost coeval with its Aragonese counterpart and much earlier than the Castilian repository. King Ferdinand I of Portugal (1345–1383) was responsible for housing the collection of ancient royal manuscripts, together with his treasure, in one of the chambers in the Tower of Ulysses at Saint George's Castle in Lisbon. The castle became the royal palace in the fourteenth century, under the rule of King Denis (1261–1325), who adopted the former Islamic fortress as his residence. John I (1358–1433) changed the name of the castle to Saint George at the end of the century. The military function of the castle developed into a residential palatial structure. However, when King Manuel I built a new royal palace on the Tagus riverfront, the archive remained in the Torre do Tombo, one of the strongest bastions in the complex. The Tombo tower had two chambers, one on top of the other, and was known as the Torre do Thesouro

(treasure tower). In 1526, Thomé Lopes described loose papers kept there in iron-reinforced chests.[32] The spatial configuration of the first archive of the Tombo was similar to that of the Vatican archives in Castel Sant'Angelo and the Simancas tower archive, with two rooms located in the strongest tower. In Lisbon, the earthquake of 1755 destroyed these archival chambers, and the present rooms have been changed. However, the Museu de Lisboa holds two iron chests in which the local authorities kept their cash and papers; these are very similar to those used by the local authorities in Madrid in the Archivo de la Villa.[33]

Comparisons between these European archival chambers are multilayered and present a number of common features: for example, the mixed use of chambers for both treasury and archival collections and the implementation of designs derived from an architectural strong room or tower archive. The chests in which the papers were delivered to Simancas became part of the first fitments, which were adapted to this kind of archival "filing" system (fig. 34). The chests had secure locks and the opening of them, as with the opening of the archive, followed a ritual imposed not only in the Simancas archive but also in archives across the Iberian world.[34] The form of these chests, arks, or strongboxes was re-created on a greater scale in the design of the architecture of the treasure-archive. In other words, the design and spatial configuration of a strongbox and a strong room were governed by similar objectives, namely, the security of the objects and strength of the structure, which in turn ensured the impregnability of the chest or chamber. The Vatican and Lisbon repositories present significant parallels. Philip II visited the Lisbon archive while residing in the city, and years later he also visited Simancas.[35]

Other examples indicate the extent of this practice across Europe. In Dublin, the rulers kept their archive with their treasure in Bermingham Tower in the city castle beginning in the fifteenth century,

and although part of the collection was moved elsewhere in the seventeenth century, it remained there, for the most part, until the twentieth century. The Scottish royal archives were stored in the treasury chamber of Edinburgh Castle from 1282. The Scottish archives were transferred to London at the end of the thirteenth century and only partially recovered in the fourteenth century. Holyrood Abbey in Edinburgh housed the old registry for the chancellery archives from the fourteenth century. After a fire in 1544, they were transferred to Edinburgh Castle until the English conquest in 1650.[36] The English royal records were kept in different locations during the Middle Ages, including Westminster Abbey, Chancery Lane, and the Tower of London. From the end of the thirteenth century, the Tower of London became a substantial

FIGURE 34 | Francisco de Mora, design for the fittings in the Simancas archive. España, Ministerio de Cultura y Deporte, Archivo de Simancas, Mapas, Planos y Dibujos, 50, 39.

repository of documentation, held alternately in the White Tower and the Wakefield Tower. A chamber in the latter tower was adapted to archival needs in the early seventeenth century.[37] In Germany, the archival collection of the Duchy of Wolfenbüttel was also kept in the Schloss Wolfenbüttel from the fifteenth century, and similarly the documentary collection of Schauenburg was conserved in one of the castle's towers.[38] Some municipal archives seem to have followed the same patterns: for example, the chambers for the city archives of Cologne were located in the communal tower of

the municipal palace from the fifteenth century.[39] The scant information available concerning these largely forgotten chambers demonstrates how little attention this type of architecture has attracted in the past. In spite of the fragmentary information on these archival chambers, an architectural vernacular tradition is discernible in the European context. The connections of such archives to the first two chambers at Simancas are manifest in examples throughout Europe.

The principal necessity that this type of architecture had to address was the security of the contents. The association with the treasury underlines the critical role played by the legal documents in securing the rulers' dynasties and their rights to rule over their realms. In the fifteenth century, the Castilian treasury was housed in a tower in the Alcázar of Segovia.[40] Inventories are an extraordinary source of information about the quality and importance attributed to these treasures.[41] Religious institutions also inventoried books and manuscripts among their treasured objects, along with silver and gold and liturgical items. An example is the book collection documented in Zamora's cathedral in the thirteenth century.[42] In other, earlier examples in Iberia, the treasury was housed in a secure chamber in a tower, such as the treasure room at Santiago de Compostela. The treasury in Santiago's cathedral had been kept in the chapter room above the mausoleum of the archbishops since the mid-thirteenth century. In the fourteenth century, however, because of disputes between the local authorities and the cathedral, a new tower was built in the cloister to house a safe room for the treasury, the library, and a new chapter room.[43]

A similar architectural solution was devised when royal archives were separated permanently from the rest of the treasury. The location of archival collections in the strongest bastion available guaranteed their impregnability. This was essential, since the papers conserved in these chambers served to legitimize a ruler's prerogatives over his realms. The architectural tradition for the building of archival chambers inherited from treasury rooms had another important element of security: a stone-built vaulted chamber helped to guard against fire. In this respect, it seems logical that the most important chambers in the Simancas archive, even those finished at the close of the sixteenth century, were built under similar parameters.[44] Archives kept within fortresses can also be found elsewhere—for example, in the archive at the Portuguese port city of Goa. The *real provisión* issued by Philip II in 1595 and formally accepted by Philip III in 1602 ordered the creation of a Torre do Tombo in Goa under the authority of the historian and archivist Diogo do Couto (ca. 1542–1616). Nevertheless, Philip II, in a letter to Francisco de Gama in February 1597, explained that the viceroy had located the archives in the chambers in the fortress of Goa, which were completed in 1596, and that Couto had been in charge of the collections for some time.[45] The spatial configuration of the architecture of the treasure-archive was broadly governed by space, a vaulted chamber located in a tower of a castle or palace, or alternatively in the sacristy of a religious building. The tower customized in the Castel Sant'Angelo and the Tombo in Lisbon enshrined this practice.

On 15 April 1540, Charles V, with Antoine Perrenot de Granvelle (1517–1586), ordered the distribution of *cédulas* and *provisiones* to the cities, towns, and settlements on American soil. This order not only specified how the regulations from Castile were to be read and acknowledged in American cities but also mandated that they be kept in archives.[46] This regulation was delivered a little more than a month before the construction of Simancas was ordered on 26 May 1540. During this period, archival practice in the lands of the Habsburgs aimed to create a network of archives, an empire ruled by a "web of papers." The spread of information and knowledge and the enactment of authority in the early modern world were

conducted through the written word.[47] The Spanish empire was governed by the creation of cities and towns, and each of these urban centers had its own archival collection (as did ecclesiastical authorities, universities, and aristocratic families). These cities and towns networked at a local, regional, and in some cases international level, and most transactions and interactions were made through correspondence. Archives, therefore, multiplied in the Iberian world, too. Not all archival buildings followed the same architectural design. A month after Charles stayed in Innsbruck, he delivered a further order for the regulation of the law and archives in cities and towns in the American viceroyalties, decreeing that they had "to collect every [royal] *cédula* and Provision [ordered and sent] . . . and the rest of the convenient deeds, and papers, and once an inventory of them is made, to put them in an Archive, or chest . . . with three keys, of which one [key should be] in possession of the regular Major [*Alcalde Ordinario*] . . . another one in the possession of one *Regidor*: and the other one the scribe of the city or town council where they would be in good form, and one inventory will be [kept] outside the Archive, so it can easily be known what it contains."[48] Legislation stipulated that the law had to be obeyed and copies of the pieces of legislation kept in archives. Viceroys should also comply with the laws established in the past, as well as with present and any future laws and orders enacted by the emperor or by Prince Philip in his name. The archive thus became an instrument to secure order and to impose a new moral code within a model of government that echoed the peninsular experience.

Archival deposits were so integral to early modern culture that they are not referred to explicitly or in detail in the sources, because every ruler or aristocrat had his own archive. Their location and architecture were at once secret yet widely known: everyone knew that the king's archive existed, and usually also where it was kept. The secrecy came in the details of the collection's location within a building and the specifics of access to these spaces. Travelers and other chroniclers, for example, often referred to the king's archive in Simancas during the seventeenth century, but they did not know how the chambers were arranged. This is why surviving evidence of the architectural spaces of sixteenth-century archives tends to be scarce. It is clear, however, that archives played an important role in legitimizing the power of rulers, because the documents contained within them represented monarchs' legal rights and justified their claims. Often, early modern monarchs and the upper social strata used archival documents to support their arguments and impose their will on others. Diego de Ayala, the archivist of Simancas, wrote to Philip II in November 1567 concerning the copy of the inventories and the need to gather more documents for the collection in Simancas. He argued that the documents should "be in two parts like it is done in every archive in the world."[49] Ayala asserted here that knowledge of archival repositories was widespread, and he implied that the way archives were arranged was widely known, or at least that he was acquainted with it. The architecture and furnishings of such archives were not made to impress the spectator, because if the archive functioned properly, these spaces were made for the eyes of only a small number of select people.

Philip II's Cubiculum: *The Tower of the Archive at Simancas, 1559–1568*

As a young prince, Philip was actively involved in the affairs of government, and there is evidence that he contributed to the assembly of the royal documents for the Simancas repository initiated by his father. A letter from Philip to the heirs of Pedro Ximénez, secretary to the Catholic Monarchs, in 1545 illustrates the royal interest in retrieving deeds that the former peripatetic court had left in the hands of secretaries, religious institutions, and

other repositories. Prince Philip would send similar letters to a number of families and institutions deemed to have kept royal records. The core of the message in the letters reads: "The Emperor and King my Lord realized that there was not [enough] care and diligence in the conservation of the deeds concerning his patrimony and that of the royal crown. . . . He ordered the creation of an archive in the fortress of Simancas to gather all the archives together." Philip ordered that the records be given to the city's *corregidor*, who would send them "to the graduate Catalan who is in charge of said archive so [he] can deposit them in the presence of commander Joan Mosquera de Molina current lieutenant governor of said fortress of Simancas."[50] The text reveals the role of the king's secretaries, who guarded important documents, and of the *corregidores*, who represented the king's interests in the towns and cities of Castile by gathering the royal records. There is also a reference to the person in charge of the archive, Antonio Catalán. He had responsibility (witnessed only by the fortress's governor) for depositing the papers in the archive.

The procedure became a ritual, mimicked elsewhere in the Iberian world under Habsburg rule, in which the opening of the chamber of the archive, or chest, and the depositing of papers followed strict rules, with witnesses and a detailed course of action. This indicates a secure modus operandi imposed by the prince, who was acutely aware of the importance of the treasured records guarded in the chamber. This procedure was not new; on the designation of Antonio Catalán as the first person to take charge of the archive in 1545, Charles V ordered that both Catalán and the fortress governor should have copies of the keys to the archive, and that both had to witness any opening of, addition to, or loan of the archival documentation.[51] Sebastián de Covarrubias y Orozco's definition of an archivist is informative in this respect: "Archivists [are those] who have the keys to the archives."[52]

Antonio Catalán was in charge of the archive for only two years, although during this period the project of assembling papers continued. After Catalán's death, the graduate Diego de Briviesca de Muñatones was designated "guardian and keeper of the archive of the crown and royal *patronazgo*'s deeds." This designation was only honorary, as Briviesca's brother, Gracián de Briviesca de Muñatones, was the acting keeper of the archive in Simancas. The archive began to function and acquired more collections with the appointments of Sanci and Diego de Ayala in May 1561.[53] These archivists were appointed a month before Philip II settled the court's capital in Madrid. Sanci died the next year, and from approximately 1563 Ayala became the main archivist in Simancas. Diego de Ayala began his tenure by arranging the documentation, which he found extremely disorganized. He wrote the first systematic inventories and regularly reported on their development to the king. Philip encouraged the collection of more deeds and other materials useful to the monarchy.[54] During this early period, he also refurbished and adapted the chamber of Charles V, and oversaw the redesign of the second chamber, known as Philip II's *cubiculum*, or *cubo*. Ayala referred to these premises as the "upper" and "lower" archives.

Philip's *cubo* is centralized in conformity with the tower's circular floor plan, although the fittings make the central space octagonal (fig. 35). In the new design, a small space was carved out from the tower wall toward the window to enlarge the chamber and to accommodate the metal safes. This supplementary space in the tower also made it possible to introduce a window that enhanced the lighting in the chamber. The new room was rebuilt between 1565 and 1568. The second level of cabinets had new chests; there were three chests in pine and seven in chestnut, and all were lined in red, blue, and black velvet. The chests were embellished with colored arms and labeled to indicate the manuscripts they contained.[55] Some of the chests made

during this period can be identified among the few surviving at the Simancas archive (figs. 32–34).[56] The elaborate metalwork of the locks is similar to that used on the wooden cabinets of Philip II's chamber. Philip's coat of arms with the chain of the Order of the Golden Fleece on the left is a likely example of the labels and decorated coats of arms sent from the court in Madrid. A similar tag on the right side of the chest has disappeared, which would have been a label indicating the documents it contained.

Access to the compact space is through a wooden door with a strong lock, decorated with Philip II's arms, which are crowned and encircled by the chain of the Order of the Golden Fleece. The space is secluded and the subtle decorative program is profuse in comparison to the emperor's chamber above. The *cubiculum* is slightly smaller than Charles V's chamber, limited as it is by the original tower walls. Although the walls were carved out to enlarge the chamber, the space is still compact. The décor of the cabinets is austere. The metal bolts were gilded during this period, and their delicate design elegantly displays a political agenda by including the golden crowns. This marks a significant change compared to Charles V's chamber, in which the relationship between function and form has been completely transformed. In Philip's *cubiculum* the notion of royal representation is as central as the security of the chamber. Two small cabinets, which were set into the walls and sealed with metal doors to form small strong rooms, displayed more refined materials and decorations than the rest of the chamber. The ornamentation of the safe doors has been attributed to Pedro Berruguete's workshop.[57] However, there is evidence of the involvement of other artists in this project, all of them from Valladolid with the exception of Cristiano de Amberes, who painted the canvases with the coats of arms of Charles and Philip in Madrid. The artists involved in the decoration of the chamber included

Alonso del Barco, who made the metal doors that were later embellished by Gaspar de Valencia with grotesque ornamentation. Valencia also painted the coat of arms on the door. Alonso Esteban gilded the locks of the cabinets in gold and silver and Francisco de Palencia and Diego Ribín gilded their keys. Finally, Rodrigo de Daques and Juan de Albuquerque built the corridor giving access to the shelves on the second level.[58]

The room was adapted to the reduced space within the tower; a false vault tops the centralized octagonal plan (see fig. 36 and fig. 35, no. 7). This woodwork acts as a false ceiling supporting the balcony of the second level of cabinets. The wooden cabinets were tailor-made for the documents: for example, a ladder was fitted in one of the side cupboards to allow access to the second level (fig. 35, no. 10). The room was designed specifically for archival purposes, and included features such as air ventilation holes to protect the documents from humidity and the use of lime plaster on the perimeter walls to keep the papers dry (fig. 35, no. 6). The small strongboxes or cabinets are identical, located on opposite sides of the only window in the chamber, in a small space carved out from the original tower wall (fig. 35, no. 4). They are treated with the decorum of a religious altar in which the most sacred treasures were kept. On top of one of the cabinets, a framed oil painting on canvas by Cristiano de Amberes depicts Philip II's arms as they were in 1567. The canvas had been sent from the court in Madrid. The shield is crowned and encircled by the chain of the Order of the Golden Fleece, of which both Philip II and Charles V became grand masters. The legend reads PHILIPPI SECVNDI HISPA. REGIS (Philip II King of Spain). The other cabinet was once embellished with a canvas showing Charles V's coat of arms, but this was stolen during the Peninsular War (fig. 35, no. 5).[59] A small space beside the window was adapted for the reading and consultation of papers (fig. 35, nos. 2–3). The chamber combines

FIGURE 35 | Diagram of Philip II's *cubiculum*. Drawing by C. Stebbing.

1. Floor Plan. 6. Ventilation Holes.

2. Window. 7. Octagonal False Ceiling.

3. Bench. 8. Entrance Door.

4. Metal Strongbox. 9. Lower Cabinets.

5. Painting. 10. Upper Cabinets.

woodwork of excellent execution with apparently unfinished ornamentation on the walls, particularly framing the closets with metal doors.

The letters between Ayala and Philip with regard to the decoration of the entrance door to the archive are revealing. In the following letter Ayala explains the decorative program deployed in the chamber:

> The door [that is the] principal entrance to the archive is [located] at the end of the . . . corridor [on the second story] on the right hand side, adjacent to the patio of the fortress. . . . [Beside] this door to the archive, there was another door painted [and adorned] with *yesería* which simulates [an exact copy of the real one]. . . . The colors for the arms [are] the same as those in the small arms sent by your highness and the rest of the paintings are water-based black and white. On the right hand side of this [entrance is a representation of] the Faith for your Catholic majesty and on the left hand side [is a representation] of the Fame of your kingdoms.[60]

Philip's response to this description of the decorative program for the entrance to the archive was formerly difficult to read, as the paper on which he made his comments was damaged. However, recently restored, the royal reply is significant in understanding his vision for the Simancas archive: "It is my wish that the interior [decoration] is completed but not the exterior [decorative program],

FIGURE 36 | Woodwork, Philip II's *cubiculum*. Photo: author.

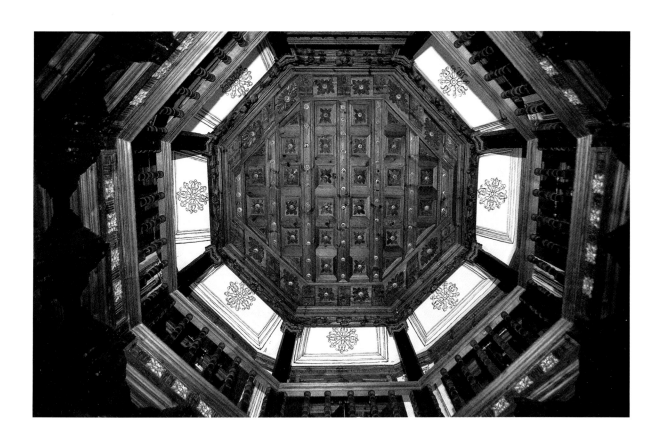

because the latter could be dismantled but with regard to the figures ensure these are not painted but only the [coat of] arms."[61]

When this description was written in 1567, the archive was housed in these chambers alone. During the expansion and renovation of the archive over the following decades—which included a new stairway leading to this room from the ground floor—what had been built of this portico was dismantled. The letter quoted above contains a lengthier description of the chamber. One of the features described confirms that this gate is now lost, and the measurements given do not match the current door that gives access to Philip II's *cubo*. For example, the frieze above this gate was four and one-third Castilian *vara* in length, or approximately four meters. There are certainly no remains of such a gate now.[62]

The letter referred to above describes more features within the chamber, including the coats of arms decorating the chests and the canvases of the arms. It also notes that part of the interior ornamentation of the chamber consisted of "black and white" (water-based) painted decoration on the small lime-plastered vaults. These painted decorations form part of those that seem "unfinished" and of a much lower quality than the woodwork. The letter also describes two figures that were designed to flank the "two doors," the real door and the feigned door painted beside it on plaster; these were both, as noted earlier, removed by royal order.

I have recently identified an unpublished sketch that corresponds to the description of the figures of Fame and Faith; it is kept in the same file that contains the letters regarding the works on Philip II's *cubo* (see fig. 37). The drawing has Latin text below and, on the reverse, an alternative version of the text (also in Latin) that celebrates the creation of the archive (fig. 38). The lack of dexterity shown in the drawing of the figures, paired with the content of the text, suggests that Ayala may have been its author. The first Latin text emphasized Ayala's

role in the archive: "Diego de Ayala erected, built and implemented the space for the . . . archives, . . . to keep the public deeds and . . . dedicated it to his majesty Philip II king of Spain," while the second version paints Philip as the protagonist: "Philip, Catholic King of Spain, restored and restituted the royal archive, which had been damaged by the depravity of time, and the prefect of the archive, Diego de Ayala, [had been] charged . . . with keeping the public and private documents of the kings." A note claims that Ambrosio de Morales (1513–1591) wrote this second version of the text. There is no further evidence to suggest that the inscriptions or the decorative program were ever produced, and no response from Morales has been found.[63] In the original plan, designed under the auspices of Diego de Ayala in collaboration with local artists, the ornamentation of the archive was elaborate. Philip II's reaction to this program is an invaluable insight into his artistic and architectural preferences for the archive. Likewise, the correspondence underlines the close royal involvement in these works. Philip's wish was to dismantle the "architectural delusion" of the duplicate simulated door. The king also wished for the painted figures of Faith and Fame flanking the faux door to be excluded. The ruler wanted only his arms, gilded with gold and silver, to decorate the gate. The self-fashioning of the archivist as a prefect from the *tabularium* evokes imperial Roman archives, which in some ways Simancas resembled.

The archive of architectural drawings for the Cubo de las Trazas, which was being built during the same period in the Alcázar in Madrid (fig. 39), with frescoes by Gaspar de Becerra (1520–1570) and architectural design by Juan Bautista de Toledo, is informative. This chamber was also built in a tower. In a letter to Becerra, Philip II expressed his concerns regarding the quality of the grotesque decorations that the artist's assistants were capable of achieving.[64] The ruler's artistic taste, shown in his concerns for the chamber in Madrid, further

FIGURE 37 | Sketch, decoration for the entrance of the archive. España, Ministerio de Cultura y Deporte, Archivo de Simancas, Archivo de Secretaría, file 5, fol. 13.

FIGURE 38 | Sketch, decoration for the entrance of the archive, reverse. España, Ministerio de Cultura y Deporte, Archivo de Simancas, Archivo de Secretaría, file 5, fol. 13.

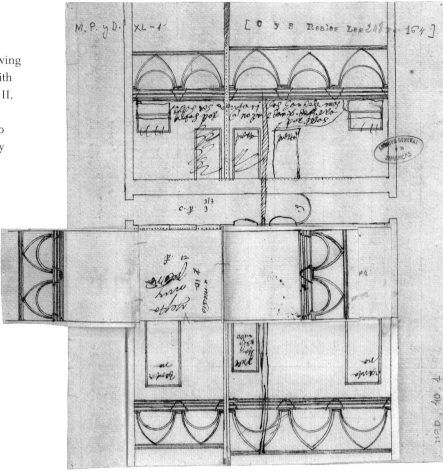

FIGURE 39 | Cubo de las Trazas, Alcázar, Madrid. Drawing by Juan Bautista de Toledo with corrections from King Philip II, 1562–63. España, Ministerio de Cultura y Deporte, Archivo de Simancas, Mapas, Planos y Dibujos, 40, 1.

emphasizes the way he might have viewed the decorative program in the Simancas *cubo*. Philip disregarded any artistic features reminiscent of other contemporary visual trends in sixteenth-century Castile. The use of *yesería* decoration, commonly found in the still present Mudejar and plateresque styles was, in the king's view, not adequate for the newly created spaces representing the monarchy in the 1560s. Furthermore, the king himself corrected the drawings from Bautista de Toledo's designs for this room in the Alcázar. Not surprisingly, the monarch also intervened in Simancas. The Alcázar and many of the Iberian Peninsula's royal palaces presented spaces that had been created during earlier historical periods. As seen earlier, Philip

conserved rooms with magnificent *artesonados* in the Alcázar in Madrid, while the Austríaco style in architecture was deployed confidently in the new spaces he created within the old palace.[65] The Alcázar in Madrid and the Simancas archive are good illustrations of the integration of preexisting buildings and a variety of styles in Philip's royal buildings. In fact, I would argue that the presence of coeval trends in the Iberian visual arts makes the Simancas archive, with its sober decoration, not intended to be seen by the many but reserved for the few, an excellent model for studying how royal residences integrated old and new structures. Other royal buildings, and more general architectural and artistic trends in Iberia at the time, often blended

styles that represented the nuanced identities present in Philip II's world.[66] This multiplicity of visual languages is found in the Simancas archive.

In Philip II's *cubiculum* in the Simancas archive, the doors of the two small metallic cabinets were painted with grotesques. The use of lime-based plasterwork was a traditional feature in the Iberian Peninsula. As discussed in chapter 1, the building trade in Valladolid in this period was dominated by families of Mudejar and Morisco origin. These families also worked after the fire of 1561 in the reconstruction of the city center, which vigorously introduced the Austríaco style in the city.[67] Valladolid's architectural practice contextualizes how building and design traditions were blended in the design for Philip's chamber in the Simancas archive. By this period, Philip II's particular preferences in architecture and art had already been expressed in a variety of forms, through the development of his residences and, in the case of the Simancas archive, also explicitly in his correspondence. Ayala personally oversaw this part of the project as it underwent changes proposed by the king.[68] While the extant ornamentation, fittings, and spatial arrangement of the interior of Philip's *cubiculum* present a heterogeneous décor, the chamber has a harmonic feeling. The false-coffered ceiling visually corrects the proportions of the space. Inside the *cubiculum*, the refined and understated decoration symbolized the archival documentation within, the sober exterior of which disguised the value of the objects stored there. Thus the basic functionality apparent in the form of Charles V's chamber was completely transformed in the design of the new archival chamber. Compared to the functional architecture and sturdy fittings of the earlier chamber, Philip's archival *cubo* shines like a precious, delicate box in which to safeguard treasures.

The wooden octagonal structure is magnificent. This type of work is rooted in the coffered ceilings for octagonal and circular chambers built in the region, which originated in *artesonado* techniques

(fig. 36). The decoration is refined and has gilded embellishments on the vegetal motifs carved in the intersections created for the crossing beams. Eight grooved wooden pillars support the ceiling. The interlocking beam structure boasts classical capitals and foliage decoration, resulting in an excellent integration of visual traditions and techniques. This visual assimilation embodies the artistic context that allowed the decorative program in the chamber to emerge. The wooden octagonal structure projects a sense of accurate proportions onto the space. In the context of Renaissance humanist thought, perfect geometry had divine connotations; a perfect cube in geometry had a corresponding sequence of nonnegative perfect cubes: zero, one, eight, and so on. There are eight sides in an octagon, while the volumetric form is an octahedron or *stella octangula* and its conjugate polyhedron is a cube. The octahedron's line of symmetry adds up to a total of seventy-two: $2 \times (3 \times 4 + 6 \times 2 + 4 \times 3)$.[69] The numbers reflected in the cube's sequence and then in the line of symmetry of the octahedron are discernible in the false ceiling of the cubicle, through the repetition of eight, six, twelve, and so on.

Euclid's *Elements* and the notion of the golden ratio in geometry were fundamental to architectural development in western Europe. *The Elements* was translated and copied several times over the centuries, and Philip owned a copy of this work. Euclid was reinterpreted by many other authors, such as Luca Pacioli (1445–1517), who interpreted the golden ratio as the divine proportion in his *De divina proportione*. Accomplishing a geometrically "perfect" space in this chamber was probably unintended, a reflection, instead, of the artists' implementation of techniques passed down by the local guilds. This is not to say that it did not carry significance to the trained eye. At a more pragmatic level, it was a suitable solution for the compact space, and it provided the required functionality for the archival collections. There is no documentary

evidence to support any link between the purpose of the chamber and knowledge of theories about the golden ratio and divine proportions among the team involved in its design and construction. The only such connections are found in the wider theoretical concerns of the period. In addition, the king did not visit the archive until much later, and neither did his architects. In the correspondence, no particular attention is given to the octagonal structure. Evidence thus far indicates that the program conformed to the initial design of the archivist Diego de Ayala, together with the initiative of the artists involved in the work, since the cabinets are tailored with extreme care to meet archival needs. Philip also made substantial changes to the decorative program. Alas, very little is known of the group of artists involved in the work for this chamber, except that they came from Valladolid.[70] The symbolism inherent in Philip II's *cubo*, whether its meaning was intentional or not, resulted nonetheless in a remarkable space. The chamber celebrated the significance of the treasures it kept, the rights of the monarch to his realms, and the ruler's prerogative over the space and the papers it contained. One has only to compare this *cubo* to Charles V's *cubo* to discern that it not only presents an evolved vision for the representational purposes of the royal archive but also exudes a semisacred atmospheric feeling.

The Grand Expansion of the Simancas Archive, *1571–1588*

In the decade that followed the completion of Philip II's *cubo*, the Simancas archive expanded considerably. Instead of readapting rooms from the old castle, however, newly designed spaces were built. The new rooms were attentive to the archival function of the building, and the Austríaco style was confidently implemented in their furnishing and architectural design.

Ayala traveled to the Madrid court once the work on Philip II's chamber had been completed in 1568. His intention was to assemble the collections generated by the various royal councils and other institutions.[71] Ayala returned from his residence at the court with a large number of archival boxes, and more arrived thereafter. The royal intention was to foster the efficacy of the archive. The archive would mainly keep the documentation that was not required on a daily basis and would thus better remain in Simancas for safekeeping. In this period, archives and offices at court routinely copied messages and reports of significance. In theory, royal councils were required to send original records to Simancas, and their offices would keep "authenticated copies"—that is, documents that had been copied and approved by officials who attested that the copy was identical to the original. The procedures and function of the archive in this period is illustrated in a letter from Philip to his secretary Eraso in 1571 regarding the Council of the Indies documentation: "they are to make every effort to find all the papers and charts which exist on this [matter], and to keep them safe in the council offices; indeed the originals should be put in the archives of Simancas, and authentic copies taken to the council."[72]

In 1571, Ayala complained about the state of the archive, and in particular about the lack of room to house the incoming papers: "In the *cubo* [of the archive of] this fortress . . . , more papers cannot be accommodated as the ones that are already there are tight [in the space]. I collected a great quantity of them and . . . they are [now kept] in a corridor outside the archive but they should not be there."[73] Ayala was replying to the king's request for documents concerning the descriptions of the Kingdom of Granada composed by the Catholic Monarchs. Ayala observed that this information came from different sources and explained that he had copied the relevant manuscripts so as to avoid

sending the originals, which might be misplaced or never be returned to Simancas, as often happened. Ayala pointed out the benefits of gathering other dispersed material in a similar fashion. The message provides an insight into the imminent need to expand the Simancas archive and also into procedures Ayala implemented for the copying and retrieval of information.

The Simancas archive became an instrumental office during this period—one that protected, stored, and controlled access to information. Philip not only controlled access to the archive; on occasion he also asked to be kept informed about who requested access and which papers they wished to consult. Access was often denied, as with a petition issued by the Marquis of Sarria.[74] Permission to consult documentation kept in Simancas could be granted only by the monarch.[75] Although Simancas accumulated vast quantities of records concerning royal councils pertaining to Philip's subjects, in the end, the royal archive functioned mostly for the benefit of the king. The procedure for access to the documentation was established further in the "Instructions for the Governance of the Simancas Archive" of 1588, which ordained that those who carried a royal order granting them access were required to pay a fee, as only archivists themselves were permitted to retrieve the documents in Simancas.[76]

Diego de Ayala continued to press for the expansion of the Simancas archive. The ever-increasing documentation generated by Philip II's court could no longer be housed in the existing space. In 1572, Ayala went to Madrid to collect more documents, and in 1573 he received an extraordinary amount of material. The Council of the Indies alone deposited fifty-three chests of papers, contributing to a total of eighty-two chests and more than one hundred loose documents. Ayala's persistence finally bore fruit, and the architect Francisco de Salamanca (ca. 1514–1573) was sent to Simancas to draw up plans

for expansion. The architect began his assessment but died before he could take over the direction of the work. His son Juan de Salamanca succeeded him as royal architect in Valladolid and also on the Simancas project. Juan de Salamanca drafted plans for the archive that he sent to the court in Madrid for its approval. In 1574, Juan de Herrera, along with the secretary Vázquez and the architect Gaspar de Vega, held a meeting to assess the proposal presented by Ayala and Salamanca. Herrera changed significant aspects of the design and, once approved by the king, it was sent back with instructions.[77] In 1575, the foundations of the expanded building were laid and the first stones of the walls were set in place, but both Gaspar de Vega and Juan de Salamanca died that year.

In 1576, Juan de Herrera sent Antonio de Pimentel to measure the woodwork required for the doors and windows. The works on the Aragón tower were initiated the same year, although in 1577 they were suspended.[78] On 24 April 1578, Herrera went to the site to oversee the expansion of the Simancas archive, which spanned the buildings outlined in figures 40–41. Herrera changed Salamanca's project once again, and Pedro Mazuecos the Elder was designated its new director.[79] With Herrera's new design, structures of the castle were demolished to erect two grand pavilions that significantly transformed the building, as the diagram in figure 42 illustrates.

Herrera's project forced the boundaries of the original castle to achieve regularity in the articulation of the central patio. An observation of the current floor plans of the building shows that the patio is not perfectly square (see fig. 43). However, the spatial configuration created by Herrera's design aimed to regularize the design of the castle; when the patio is photographed from one of the four faces, the optic interplay the architect implemented distorts the view to present what seems to be a geometrically sound square patio (fig. 44).

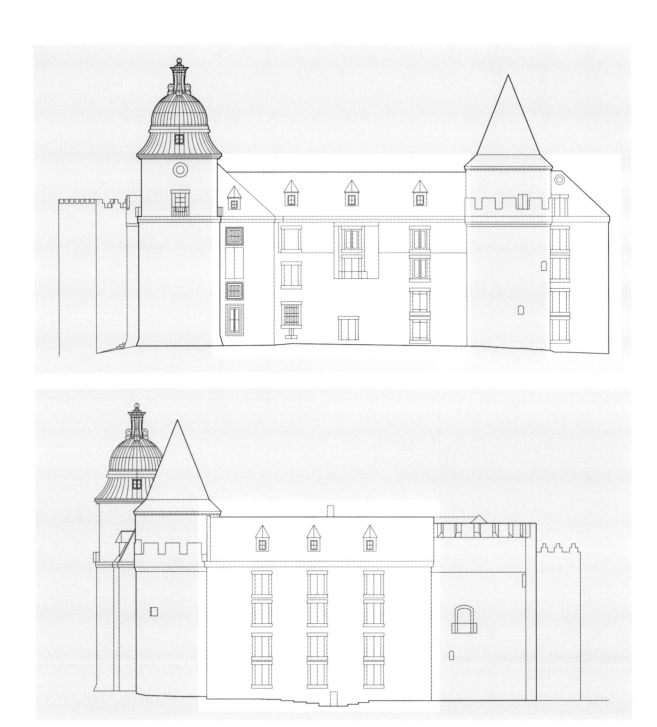

FIGURE 40 | Simancas archive, southeast elevation. External view of the pavilions designed by Juan de Herrera highlighted. Drawing by author and Harry Kirkham.

FIGURE 41 | Simancas archive, northeast elevation. Juan de Herrera's pavilion highlighted. Drawing by author and Harry Kirkham.

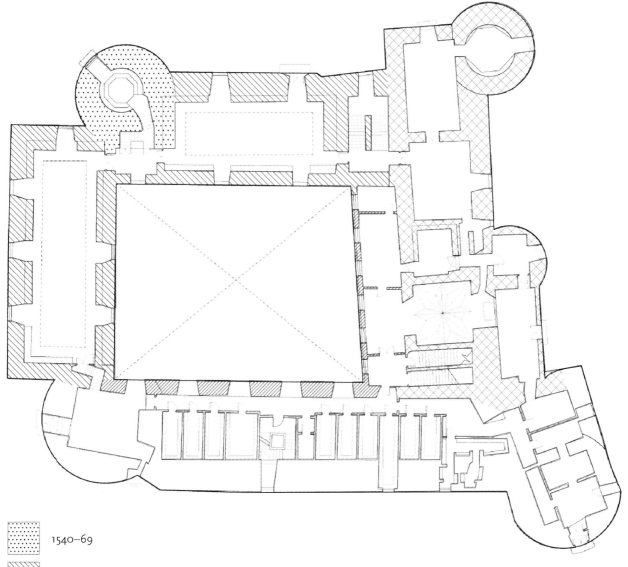

1540–69

Juan de Herrera, 1578

Francisco de Mora, 1589–98

Pedro Mazuecos completed Mora's design, seventeenth century

FIGURE 42 | Diagram showing the construction timeline for the Simancas archive superimposed on a floor plan of the first floor of the building. Drawing by C. Stebbing.

FIGURE 43 | Floor plans, Simancas archive. Diagram by author and Harry Kirkham.

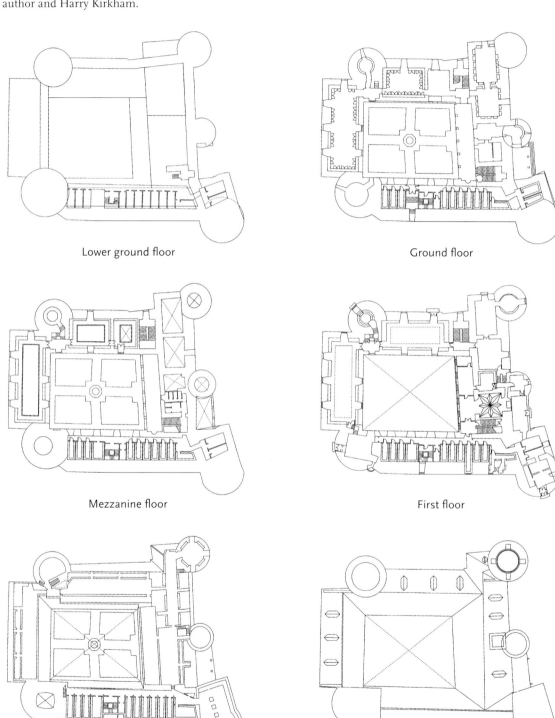

Lower ground floor

Ground floor

Mezzanine floor

First floor

Attic

Roof

Herrera borrowed all possible materials and structures from the extant building. The objective was to fulfill the needs of the archive and regularize the spaces by introducing Renaissance ideals of harmony and proportion. The architect prioritized the latter and demolished sections, including—when they could not be reused—thick structural walls. One of the pavilions planned by Herrera sits between the first tower of the archive that housed Charles V and Philip II's *cubos* and the tower of Aragon. The pavilion is located on the outer side of the primitive wall, and in designing this section other preexistent structures were dismantled (fig. 45). Juan de Herrera's fixation on squaring the patio introduced a Renaissance sensibility into the medieval castle. The configuration of this void space is significant in the architect's work, and it associates this project with some of his buildings elsewhere in Castile, such as the Lonja in Seville. The proportional systems found in Herrera's work were understood to encompass and represent divine notions, a belief that could be found in the works of Euclid, Llull, and Alberti, among others. An ordered, proportional, harmonious city or building was seen to correspond to an orderly society, which embraced notions of piety and closeness to God.

FIGURE 44 | Photograph of the patio in the Simancas archive. Photo: author.

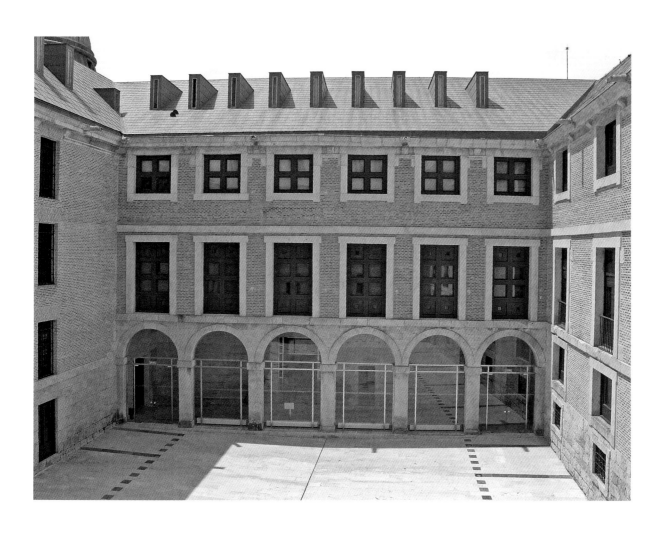

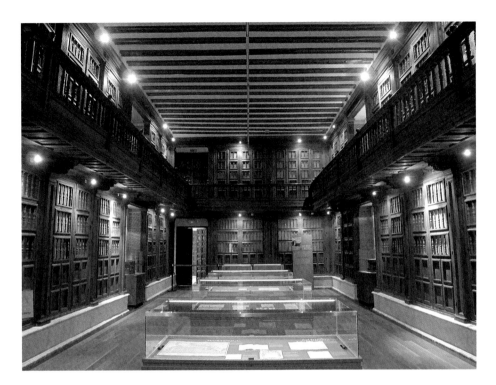

FIGURE 45 | Juan de Herrera's pavilion in the Simancas archive. Photo: author.

The architect's project, in short, squared the lines in the castle. This decision completely diverged from the proposal presented by Juan de Salamanca, in which all existing structures were to be reused. Herrera made space for the integration of new and old structures. One of the implications of Herrera's project was that the different heights of the existing well and the lower terrain between the two medieval fences were to be brought level. The new pavilions were built with different materials, too. The walls of the patio in Herrera's project were built with squared stone only up to a height of ten feet (just over three meters), and the rest of the walls, up to the roof, were constructed with lighter materials. In this way, the structure could support the weight of both the documentation and the wooden cabinets. The new rooms were not covered with vaults, as initially envisioned by Salamanca. Herrera modified the original plans, since vaults are a heavy roofing system, which he found problematic for the structural security of the edifice.

Instead, Herrera designed a flat structure made with wooden beams running perpendicular to the walls of the large chambers, and filled the space between each beam with small, lightweight brick vaults. The structure is still visible in the pavilions (fig. 45). In a letter the architect sent to Ayala in June 1578, he explained some of the changes the project underwent. Herrera explained the necessary demolition and changes in the design in the upper- and lower-level cabinets in the pavilions, concluding, "Given the multitude of cabinets I resolved they will all be wooden." Furthermore, he deemed the current vaulted rooms "dangerous for the papers," for they were not structurally sound. Herrera's solution introduced a flat ceiling "constructed with very good beams and small brick vaults," which would make the structure stronger and save time and money. Herrera also made substantial changes to the distribution of the windows: "some of the windows should be distributed so that [they] are in harmony with the chests and also give

light. To accommodate this, the windows that face the parapet walk have to be changed."[80] With these changes to the building, he not only made space to accommodate the incoming papers but also attempted to square the patio and regularize the illumination and the spatial harmony of the pavilions (see elevations, figs. 40 and 41). The woodwork of the windows included the necessary blinds for the protection of the papers.

The architect argued that the cost of demolition and other changes to the building would be balanced by the lower cost of the materials. It is impossible to prove whether his argument was correct, as the previous plans by Juan de Salamanca adapted the existing spaces. There is another aspect to Herrera's development. The majority of the building material was wood, not only for the cabinets but also for the beams of the roof. The design suited the conservation of documents and provided security from intruders. But the use of wood as the dominant material made the structure more vulnerable to fire than vaulting would have done. Thus on this occasion Herrera prioritized the reconfiguration of the space to implement a design according to other royal buildings. The distribution and scale of the windows, for example, display a studied composition: the two pavilions designated for the archival repositories and facing the patio had barred windows. These windows were more vulnerable to potential intruders; however, windows facing the parapet walk were not barred, since the external wall of the castle made access impossible. Windows on both sides of the pavilion present similar scales (figs. 40–41). The parapet windows were aligned with the windows in front (see the first floor plan in fig. 43). The quality of the "microsurgical" design for the new rooms that Herrera introduced resulted in the creation of spaces in which the light radiating from the windows maintains the harmonic rhythm of the pavilions. The opaque wooden cabinets lining the walls are thus interrupted by the luminous cavities of the

windows. Harmony in these pavilions is achieved by a combination of the light and the proportional relationship between the space, the wooden built-in cabinetry, and the distribution of windows. The regularization of the patio and the arrangement of windows were not the only challenges the architect encountered as he aimed to introduce classicism into the building. However, through optical illusion Herrera largely succeeded in designing spaces that created a sense of harmonic order and proportion.

Nevertheless, the principal objective of architectural expansion in Simancas was to fit form to function. The architectural and interior composition of the cabinets was bureaucratically motivated. These rooms were destined to house the documentation concerning Philip II's subjects, generated by the royal councils in particular, and the space had to function effectively. The pavilions project a sense of serene harmony. The décor is austere, and although the wooden cabinets show some carving, these details emphasize the quality of the design. The Simancas archive, as noted earlier, was reserved for the eyes of a handful of officials, and the cabinets are not as richly decorated as the cabinets found in the library at El Escorial. The visual appearance of El Escorial embodies Philip and his dynasty in a somewhat forceful manner, whereas the symbolic and representational character of the Simancas archive is subdued, for its design was determined by its necessary impregnability and above all its function. The Simancas architectural project has been considered a minor enterprise in Herrera's career; the architect showed less interest in Simancas than in other projects during this period. Herrera was especially invested in the grand cathedral he designed for Valladolid, which was only partially built.[81] At first glance, the Simancas project cannot compare to other buildings the architect designed. Simancas, however, possesses a particular nature that other buildings lack. It shows the processes by which existent spaces were

adapted and reused, and how the monarch and his officials, archivists, and royal architects—including Herrera—balanced continuity and change in architectural design.

The construction sequence of the pavilions during the years 1571 to 1588 has not been examined in any detail.[82] The memorandum sent from the court in Madrid to Francisco de Salamanca in 1571 for the expansion of the archive included a number of specifications for the design, including (1) detailed measurements of the castle, the barbican wall and the upper stories, (2) directions that new rooms had to be adjacent to the tower where the existing archive was located, (3) that new rooms should not affect the defensive system of the castle but should in fact enhance that feature, (4) that the walls had to be built of stone, and (5) that the roofing system had to be erected with brick vaults for all stories in the building, and the roof covered by a wooden structure with slate.[83] These specifications confirm that by changing the spatial configuration, Herrera also modified the fire-protection system. Herrera's design improved the spaces, as full adherence to these specifications would have resulted in rooms with poor illumination and ventilation. In 1583, the main staircase was built, and in the next few years the new premises were fitted out with furniture. The beautiful shelves were first built in the pavilions designed by Herrera and were imitated in the remaining chambers thereafter. The doors of the shelves were commissioned later, in 1589.[84]

Juan de Herrera's major intervention in the building converted a fortress into the royal archive of the Spanish king, thereby transforming the medieval building into what was in effect a functional office. The current reading room and the exhibition hall display the splendid wooden cabinets used for documentation, and are located in what would have originally been secluded spaces. The windows are smaller and fewer in number than in the area originally assigned for the offices.[85]

The royal architects Francisco de Mora and subsequently Pedro Mazuecos completed the design of the arched façade in the patio largely following Herrera's designs.[86] Architecture was a crucial tool for Philip II, and the Simancas archive was the epitome of a Castilian empire ruled by the machinery of an ordered state, an empire constrained by papers. The architectural form of Herrera's pavilions manifests this political agenda. The spaces and the interior décor were not designed for the admiration of visitors. On the contrary, the priority was the security of records, defense against intruders, and strict control of access. However, the architect still adhered to architectural principles of order, discipline, and rigor. These characteristics were embodied in the documents themselves and also mirrored in the elegant cabinets and ample pavilions, creating an archive so voluminous and rich, and designed in such an ordered and efficient manner, that it could only belong to a powerful ruler. The décor is plain and classical with no ornamentation, and exactly the design one would expect from an Austríaco-style building.

The Tabularium Caesaris *and Simancas*

In ancient Rome, a *tabularium* was an archive and the *tabularium caesaris* was the emperor's archive, a repository for imperial administration. The third architectural expansion of the archive during Philip's reign occurred at the same time that the king and his court issued the "Instructions for the Governance of the Simancas Archive" in 1588. These instructions outline how the archive was organized and its main functions, which echoed some of the characteristics that governed archives in ancient Rome. The instructions were inspired by a report that Cristóbal de Benavente, keeper of the archive in Torre do Tombo in Lisbon, had written for the king. The monarch requested this report when he visited the archive during his residency in Lisbon, as he had been previously impressed by

the royal Portuguese archive. With the Portuguese dynastic crisis of 1578, Philip sought documents in both archives, Simancas and El Tombo, that would legitimatize his claim to the Lusitanian monarchy. El Tombo proved more effective than his archive in Castile in providing the documentation that he required.

During this period, the archive in Torre do Tombo, which had been housed initially in the Tower of Ulysses in the Castle of Saint George in Lisbon, was extended from the original tower into some of the castle's rooms. These chambers were lost in the earthquake of 1755, and there are no known descriptions of them. With the obvious impact the organization of the Portuguese archive had on Philip's Portuguese succession, it is reasonable to believe that the Tombo archive's impression on the monarch influenced his attitude toward the archive in Castile. It is impossible to gauge from the evidence whether the architectural expansion of the Simancas archive during the late 1580s could have been inspired by the rooms of El Tombo. With regard to the organization, however, some of the regulations in the instructions of 1588 are copied from Benavente's report.[87] The instructions give exact information on how to manage the archive and the collections. There are also some remarks regarding the premises; for example, it was the monarch's wish that the perpetual deeds remain in the first two chambers built in the tower, the *cubos* of Charles V and Philip II. In this way, the royal collections would be preserved from fire, and the ruler's chambers distinguished from those containing his subjects' records through the spatial arrangement of the archive. These royal chambers, containing royal papers, were to have a new dedicated space built from 1588 onward.

The instructions regulated conservation practice in the archive. Some of the regulations were already in place in Simancas, while others had been borrowed from the Lusitanian counterpart. The instructions addressed every detail of the workings

of the archive, including the nature of the documentation and access. For instance, article no. 20 insisted on precautions regarding access to the documentation: "the people who request deeds in this archive should not be present while the [papers] are being searched for." The section devoted to personnel is enlightening; the officials and personnel in the archive had to preserve "fidelity, secrecy, and legality." Successive archivists could propose official appointments, but the Cámara de Castilla had to approve any archivist before he could take office.[88] The organization of the personnel appointed to the archive at Simancas presents similarities to the structure of the *tabularium* in ancient Rome.[89] In both repositories there was a clearly established hierarchy of positions that granted different levels of access to information and documentation.[90]

The king headed up the organization of the Simancas archive, followed by the Cámara de Castilla. Castile had the Royal Council of Castile, over which was positioned the supreme council, the Cámara de Castilla. This chamber was composed of a reduced and variable number of members: the president of the Royal Council of Castile, two or more of its officials, and a royal secretary. The Cámara dealt with matters regarding the interests of the king and acted independently from the Royal Council. The chamber was meant to be confidential, and was dedicated to advising the king in matters of *gracia y justicia*. This was the highest political *cámara*, and the one closest to the ruler.[91]

The Simancas archivists during this period were Diego de Ayala and his son Antonio. Only these men had access to the king's rooms, where the documentation regarding his lineage, rights, and *patronazgo real* were kept. The archivists had privileged access to documents not granted to the other officials, whose labor consisted in making copies of documents and who had access to the rooms where the documentation of the councils (the subjects' documents) were kept, namely, Herrera's pavilions. In addition, there was a porter, a cleaner, a guard,

and the governor of the castle. At the head of the ancient Roman *tabularium* was a magistrate, while the archivist was the *tabularius*, who had previously been *auditoris*, equivalent to archival assistants in Simancas. The *tabularius* appointments had to be approved, and both ranks had to swear loyalty and secrecy concerning the information and *tabulae* they managed.[92] The parallels between both organizations are manifest in this respect.

The similarities between the organizational structure and hierarchy of the ancient Roman and Simancas archives might have been unintended. Other analogies can be established with imperial Roman archives, and these are also worth mentioning. The archival system in ancient Rome was organized with different kinds of repositories for different types of documentation. The *sanctuarium Caesaris*, or *tabularium principis*, kept the documentation concerning the patrimony of the emperor; it was located in the Palatino, perhaps housed in the library (the double library of Greek and Latin books in the area Apollinis).[93] The purpose of this archive echoes that of the treasure-archive, connecting it with the first two chambers in Simancas. Despite these similarities and connections, further examination is required. A brief look into Roman archival administration suggests further correlations.

The *tabularium caesaris* was "a general archive for imperial administration, the emperor's correspondence, reports from provincial governors and the like."[94] The Roman provinces had their own repositories for provincial administration, and the local authorities had a *tabularium civitatis*.[95] Thus Rome was an empire ruled by a strong bureaucracy. The imperial Roman archive administered the provinces and included correspondence and instructions from the emperor, along with responses from the provinces. The Castilian empire was similarly ruled by correspondence, with instructions issued by the ruler and sent to the realms and subjects of his overseas empire. This was accompanied by the creation of a homogenous body of

legislation that aimed to regulate the vast imperial territories. The political organization of the Spanish empire, composed of a number of European kingdoms under the same ruler and with overseas viceroyalties, evokes the organization of the Roman Empire. As seen earlier, in his proposed decorative program for the royal chambers built in 1567–69, Diego de Ayala evoked the archival traditions of imperial Rome through the Latin texts he composed for entrance to the archive, although they were never painted (see figs. 37–38). The emulation of the archival structure of imperial Rome was probably not intentional but rather a reflection of the cultural continuities that endured from Roman Hispania into medieval and early modern Spain. Yet the parallels between these archives are significant.

One of the archivists' duties in Simancas was the collation of curiosities and memorable facts in a manuscript titled "Summary of Memorable and Curious Things." The monarch saw that the duties already undertaken by the archivist could be exploited for propagandistic purposes. He requested summaries of these "memorable and curious things," with a focus on military victories. The instructions also stated that archivists had to include documentary cross-referencing; information had to be easily traceable to the document in the archive that proved its authenticity. A shelfmark was thus added at the end of each historical note. In other words, archivists were asked to implement a referencing system to show the authenticity of the events recorded. In the world of Philip II, the papers housed in his archive held the ultimate power of proof, precisely because these papers were given legal status.

The King's Chambers: Francisco de Mora's Reforms, 1588–1598

Francisco de Mora continued with the plans initiated by Herrera in the Simancas archive. Mora informed Ayala in 1588 of the king's interest in

expanding the project to include the two remaining towers in the castle and the pavilions that connected them. The chapel was also to be renovated, although the ribbed vault would be preserved (fig. 46). The new expansion aimed to create chambers dedicated to the *patronazgo real*, as records had increased in number and did not fit into the initial two *cubicula*. The rooms for these collections would be built in the Bishop's Tower and adjacent chambers. Mora vertically extended the old Bishop's Tower and topped it with a spire (replaced in the eighteenth century). The highest and most secure premises in the building were again devoted to the king's most important documents. The archaic structure of the fortress would make space for a more advanced design, in consonance with the architecture of the period.

Between 1592 and 1593, the façade of the archive was finished, as was the interior staircase to the attics located beside the fifteenth-century chapel.[96] Mora drew eleven plans for the new project, but only a few survive. A letter containing detailed instructions to Diego de Ayala accompanied Mora's drawings.[97] A cross-section plan from this set of drawings is revealing (see fig. 47). The councils' collections would be deposited in the pavilions designed by Herrera, while the monarch's perpetual deeds were to be guarded in the original *cubicula* finished at the end of the 1560s. The elevation has some inaccuracies in relation to the height between the spaces, as Philip II's chamber was slightly more elevated than depicted in the plan. Nonetheless, a hierarchy is perceived, as the king's documentation is separated from the rest and located in the safest chambers.[98]

The Council of the Indies papers were located on the upper story, as this council generated vast quantities of records (fig. 47).[99] The lower rooms would be dedicated to accounts, revenue, taxation, and what was generally known as the treasury. There was an office on the ground floor beside the staircase. Documentation associated with the Indies was stored at the top of the building, in the most secluded section of the subjects' papers. The principal objective may have been to keep the collection in the same space, as it was too voluminous to be placed in Herrera's pavilions. The visual hierarchy is nevertheless evocative of the tremendous impact that America had on Castile. The copious amount of papers that the Council of the Indies alone generated is symptomatic of the vastness of the territories, their significance, and their role in creating a Castilian imperial identity. The space the Indies documentation took up in the Simancas archive is also reflective of the place viceregal America had in imperial administration. The monarch was at the top of this de facto empire, and Mora's project further emphasized these hierarchies through the spatial configuration of the building.

FIGURE 46 | Chapel vault, Simancas archive. Photo: author.

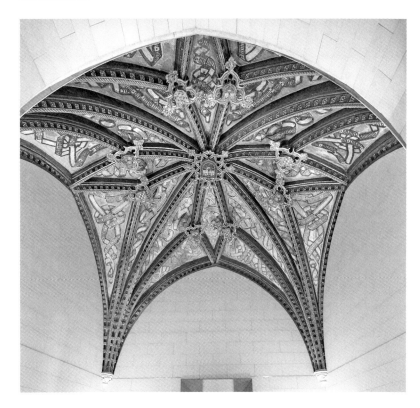

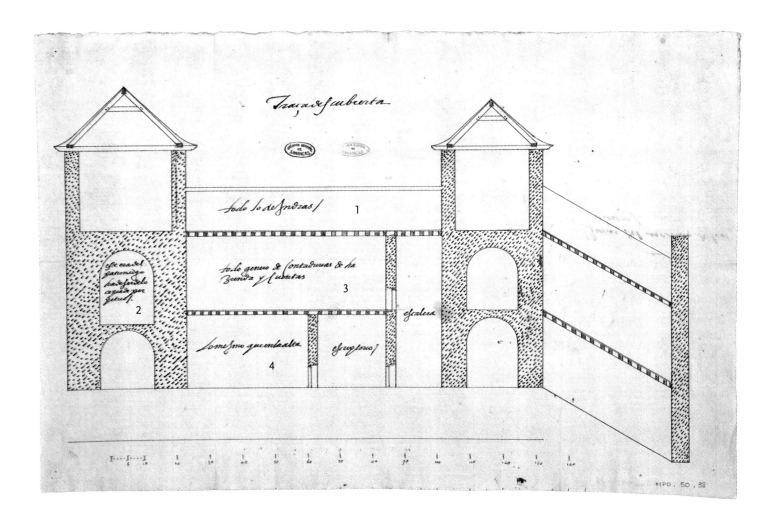

Traça defcubierta

1 — todo lo de Andras/

2 — *(handwritten text in arch)*

3 — todo genero de Contadurías de hazienda y Cuentas

4 — lo mesmo que enla alta

escalera

escriptorio/

FIGURE 47 | Francisco de Mora, cross section, elevation of the Simancas archive, ca. 1589. España, Ministerio de Cultura y Deporte, Archivo de Simancas, Mapas, Planos y Dibujos, 50, 38. Numbers on the drawing added by the author.

In December 1588, Diego de Ayala wrote to the royal secretary Juan Vázquez de Salazar (1530–1597). The archivist revealed some information regarding the development of the building, and how this might affect the king's papers: "two rooms very spacious, . . . eye-catching and strong; one for your *patronadgos*, and the other one for the [council of] state papers . . . which is the same as Juan de Herrera designed, and although . . . the chapter in the instruction . . . reads that the *patronadgo* shall remain where it is now . . . , it seemed to me these should be in the new rooms designed by Francisco de Mora."[100] Ayala's letter addressed some information that seemed contradictory in the "Instructions," in contrast to the developments of the building at the time. On 23 August 1588, Francisco de Mora had informed Diego de Ayala that the king had ordered him to continue with the works in the archive, and to finish the chambers for the new *patronazgo* and the Council of State papers. Mora stated that: "[King Philip II requested] both [rooms] had to be vaulted . . . and the design be very richly

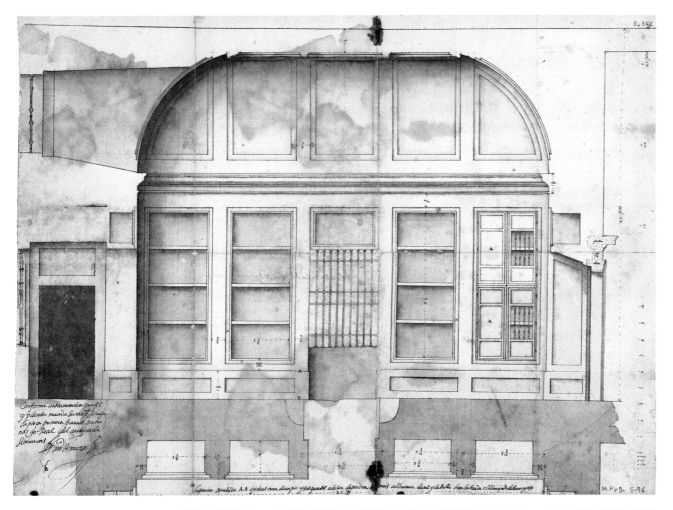

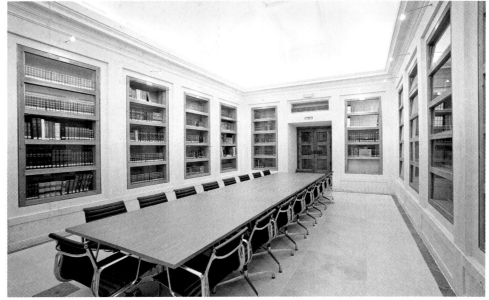

FIGURE 48 | Francisco de Mora, cross section of Patronazgo Real room, 1589. España, Ministerio de Cultura y Deporte, Archivo de Simancas, Mapas, Planos y Dibujos, 5, 96.

FIGURE 49 | Patronazgo Real room, designed by Francisco de Mora in 1589. Photo: author.

adorned, and these rooms for the *Patronazgo* and State [should be] built before beginning any other works [in the building]."[101] The new chambers were specifically vaulted for fire protection (figs. 48–49). This was the main concern, as the king also decided that these rooms were to be covered with lead for further security, the only rooms in the building to be so protected.[102]

These chambers are essential for an understanding of how the royal archive portrayed Philip II's rule. The monarch was closely involved in the design and configuration of these chambers. He also stipulated that a separate entrance and pathway be built to the archive, reserved only for monarchs. The *patronazgo* and allied collections were to be kept in the old Bishop's Tower and adjacent chambers. The chamber in the Bishop's Tower also has an octagonal floor plan, and here too space was created for a window by removing material from the wall. The design of these rooms can be observed in the plan (fig. 48). Mora vaulted all the rooms, as required by Philip II, and deployed an austere classical design. The text in the plan reads, "According to this section and floor plan his Majesty orders the first room of *Patronazgo Real* to be done. [signed] Francisco de Mora. . . . The marked base A.B. which height is of one foot and three quarters must be of stone the rest of brickwork of lime and brick well worked and the whitewash [must be done] with good plaster."[103] The project for the room stipulated in detail the materials, measurements, and scale of each element it contained. With the exception of the furniture of the cabinets, the room reflects Francisco de Mora's original design of 1589. The measurements of the distances between cabinets and other spaces in Mora's design show a proportional system that echoes some of Herrera's composition applied in other Austríaco buildings.[104] In the cross-section plan (fig. 48), for example, the length of the cavity carved in the wall for the cabinets is exactly double that of the rest of the fabric separating them, and

each volume in the elevation corresponds with the lines depicted in the vault. These proportional scales were decided with the harmony of the space in mind.

In 1591, Philip sent Mora to the archive at Simancas to supervise the work and to produce new plans. Philip wanted a passageway and staircase with direct access to the rooms containing the *patronazgo real*. This passageway created a private route for access to the royal chambers, without the need to use the patio leading to the main stairs, which every other official or visitor to the archive would use (figs. 50–51).[105] These new developments anticipated the royal visit of 1592. When Diego de Ayala learned that the king would visit the archive, he accelerated the work in the bishop's *cubo*, installing the roof so that it would be ready. It would, he claimed, be "one of the most eye-catching things in the world."[106] The Bishop *cubiculum* had four windows and cabinets inset in the same way as in the previous chamber of the *patronazgo real*. The king wished for this new *cubiculum* to be placed in the highest location, with views of the mountains, towns, rivers, and horizon.[107]

Philip's keen interest in creating alternate access to the building is crucial to understanding his view of ceremony as a vehicle for the display of kingship. In 1548, Charles V implemented Burgundian etiquette in the court at Castile. Philip embraced this etiquette and protocol to promote a courtly order of precedence. These ceremonial hierarchies

FIGURE 50 (*opposite, above*) | Francisco de Mora, second-floor plan showing the passageway and stairs to the king's rooms, ca. 1591. España, Ministerio de Cultura y Deporte, Archivo de Simancas, Mapas, Planos y Dibujos, 50, 35. Numbers on the floor plan added by the author.

FIGURE 51 (*opposite, below*) | Detail of second-floor plan of the Simancas archive today, including the bishop's *cubo*. Diagram by C. Stebbing based on a drawing by the author.

5, 367

MPD, 50, 35

asserted royal authority. During Philip's rule, ceremony and protocol were employed to "make kingship at once impressive and remote," and etiquette became more sophisticated and in many cases highly regulated.[108] One of the common characteristics of Philip's ceremonies was the increasing isolation of the ruler. The ceremony of the Order of the Golden Fleece at the Alcázar in Madrid in 1593, a year after the royal visit to Simancas, is a good example of the order of precedence at Philip's court. The ceremony was to last a few hours and included a reception, a meal, and Mass. After the official reception, Philip withdrew, as he felt indisposed, and left his heir as the master of ceremony. The accounts, however, tell us that the monarch observed the rest of the ceremony from a concealed space, in which he could see but would not be seen (*ver sin ser visto*). During the ceremony, he sent instructions to individual participants to ensure that etiquette adhered to the protocol. In this fashion, Philip asserted his royal presence and authority from a concealed space, which facilitated his distance from his subjects.[109] The new royal path created in the Simancas archive was a reflection of the ruler's desire to distance himself from his subjects and also of courtly ritual practices.

The king spent a few days reviewing documents in Simancas. An office was prepared for him in a room adjacent to the *patronazgo real* chambers (fig. 51, no. 6). Between this office and the chapel lay the temporary bedchamber where the king slept during his visit from 23 to 25 June 1592.[110] This bedchamber is identified in the original plan as the antechapel (see fig. 51, no. 5). The location and the spatial configuration of the chamber, connected as it is to both the chapel and the office, were not new in the royal chambers; the most famous model was in El Escorial Monastery, where the king's room allowed attendance at Mass in the basilica and was also adjacent to his office.[111]

Philip thoroughly examined the architectural progress at Simancas and also observed some

of the archival work. Although a new route was adapted so that he did not have to access the patio to reach his archival collections, he also visited the copyists in the administrative section of the castle. Philip was content with the new archival chambers, and he ordered the decoration of the *patronazgo* chambers with a series of mural paintings depicting the kings of Castile. A surviving sketch by Juan Pantoja de la Cruz (1553–1608) represents one of the figures that was to decorate this space (fig. 52).[112] The ruler was represented *all'antica* in a clear evocation of an ancient Roman emperor. The sculpture is depicted on a base in a niche with some framed decorations above it. The proposed style is different from other galleries of kings that had been created in royal residences previously. The famous room of the kings in the Alcázar of Segovia was destroyed in the nineteenth century, but some illustrations survive.[113] The style projected for this space in the Simancas archive, with the adoption of classicism in the proposed mural paintings, was in harmony with Mora's architectural design. The sketch evokes images of the Roman emperor Augustus and Pompeo Leoni's sculpture of Philip II in armor at the Prado. This project at Simancas never saw the light of day, but the ruler's interest in ornamenting the space with depictions of the kings of Castile is significant. The series would cover the whole room and would include his own portrait, not leaving space for future rulers, which demonstrates the ownership he took of the Simancas archive. This projected gallery also shows Philip II's interest in genealogy; in the case of Simancas, it was an exaltation of the royal dynasty. The documents kept in these chambers legitimized the right to rule for the monarchs in Philip's lineage. Philip had funded works on genealogy, since the European realms seized by the Spanish Habsburgs were gained on the pretense of inheritance. The politics of marriage devised by his ancestors provided Charles V, and then Philip II, with vast dominions. Philip's chambers in the

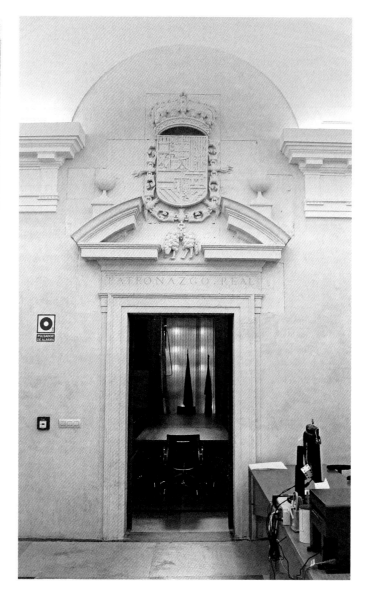

5,491

MPD, 65,123

archive were located where the most valuable documents were kept. To what specific use could the king put these deeds?

The most successful example of Philip II's use of documentation to benefit his dynasty was the use of archives in the lead up to the Iberian Union. The monarch requested a detailed list of documents from Ayala, and at the same time ordered his envoy in Lisbon, Cristóvão de Moura, to approach the *guardamor* of the Torre do Tombo

FIGURE 52 | Juan Pantoja de la Cruz's sketch for the Patronazgo Real room. España, Ministerio de Cultura y Deporte, Archivo de Simancas, Mapas, Planos y Dibujos, 65, 123.

FIGURE 53 | Patronazgo Real room, façade. Photo: author.

in Lisbon. The purpose of this diplomatic errand was to find convincing justification for Philip's rights to the Portuguese throne.[114] The application to Lisbon proved successful. However, an initially disappointing response from Ayala infuriated the king.[115] Philip managed to obtain the papers related to the marriage contracts that he and his court thought would prove his rights in the Portuguese succession more efficiently from Lisbon than from Simancas, which justified his discontent, although it must be remembered that major architectural works were under way in Simancas at the time. Ayala eventually sent Philip additional deeds, as requested, and the documentation gathered from both repositories supported Philip's claims.[116] The Portuguese succession was an extraordinary case of the practical utility of archives. The content of many of these documents, which—in the view of Philip's court—supported his claim to the Lusitanian throne, would be reflected in the ephemeral structures erected for the triumphal entry celebrated in Lisbon in 1581.

The façade erected for the new extension of the *patronazgo* premises is revealing (fig. 53). Its simplicity exemplifies the evolution of the royal architectural style in Castile during Philip II's rule. This classical façade employs a very pale stone and displays Philip II's coat of arms, sculpted by Juan de Arfe (1535–1603) and encircled by the chain of the Order of the Golden Fleece.[117] This followed the pattern of the earlier *patronazgo* rooms in the *cubiculum* at the Tower of Obras y Bosques, where the entrance was decorated with the monarch's arms. The expansion of the Simancas archive designed by Herrera was unadorned, ordered, and simple in form, responding to the proportions expected in a Renaissance building. However, Mora interrupted the curved pediment in this façade with Arfe's coat of arms. Both architects played with the scalcs of the architectural elements and through optical illusion impressed on the viewer a sense of the harmony within the space. Designing the façade for

this chamber was a challenge for Mora, as the spatial configuration did not allow him to center the façade with respect to the wall (fig. 53). Mora's Palacio Ducal in Lerma, designed in 1609, is regarded as his major architectural achievement, in which it can be perceived how his style departs slightly from that of his predecessors.

The façade of the principal gate of the castle, also designed by Mora, sits between two medieval towers (fig. 54). The architect intended to fit a classical arcade between the medieval structures. Despite his best efforts, the solution seems to be shoehorned into the space, as the classical proportion of the façade is disrupted by the contrasting structures that flank it. A closer observation of this façade and the arched façade in the castle's patio shows that they are similar. This façade also resembles the first two stories of the façade of San José in Ávila, designed by Mora in 1608. Here, the architect introduced a similar solution—three arches on the ground-level portico and a first-story recess with two flanking windows—instead of balconies, as at Simancas. Although the façade in Ávila used windows of a different size, the composition was essentially the same. The similarity is more evident in the façade of the church at the Royal Monastery of la Encarnación in Madrid, designed by Fray Alberto de la Madre de Dios in 1610.[118] The ground-level portico and the first story in the façade of this building employ the same design used at Simancas (except for the recess used as a substitute for one of the balconies). Mora's characteristic façades for these convents have been regarded as remarkably influential in the creation of a unique style for Carmelite churches. Saint Teresa of Ávila's works influenced the conception of this conventual architecture; the form had to be perfectly connected for the utility, the function (*utilitas*), of the building. Saint Teresa wished for architectural design that would create an environment fostering spiritual calmness and the seclusion necessary for devotion and contemplation. Therefore, any superfluous

FIGURE 54 | Elevation showing the façade with the arcade designed by Francisco de Mora for the Simancas archive. Drawing by author and Harry Kirkham.

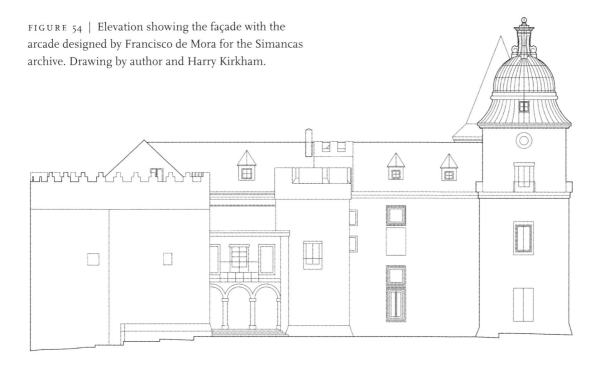

decoration was undesirable in her convents.[119] The solution Mora formulated for the royal archive in Simancas can be traced to the description of *utilitas* in architecture. The Simancas archive is a good model of rigorous and sober architectural design, a design defined and embodied by the function of the spaces.

Francisco de Mora's work at Simancas was the last major architectural project during Philip II's reign, bringing to an end decades of improvements to the fortress. Although work continued after Philip II's demise in 1598, the design had been approved under his order. It was only in 1599, under the direction of Diego de Praves, master mason of the cathedral in Valladolid, that the portico in the patio of the archive was begun. As for Herrera's pavilions, one of them would not be built until the seventeenth century.[120] Thus the architectural unity of the Simancas archive was not fully realized until after Philip's death. There were some deviations from the original project,

which have never hitherto been published. The royal order had established that the roofs of the pavilions and extension designed by Herrera were to be covered by slate. Funding for this work was not secured in the seventeenth century, and the accounts held in the archive show that kilns were firing tiles to cover the roofs of the pavilions.[121] Fragments of sixteenth-century ceramic tiles were found in the patio during the latest conservation work on the building (see fig. 55). These flat tiles were not as effective against rain as curved tiling or slate, but they could be produced more quickly and cheaply. Once they had been nailed to the roof, the tiles were painted shades of green and blue; as shown in figure 55, the unexposed section of each tile was left unpainted. There are no records in the archive that explain the decision to change the roofing material, but given the technique used, it is reasonable to assume that these tiles were an inexpensive and effective solution when roofing was required. While the current roofs have slate, it

was installed more recently to evoke the Austríaco heritage. Some images, such as the plans from Ventura Rodríguez's project for the archive in the eighteenth century and photographs taken during the past century, show some of the changes the roofs have undergone. The use of colored tiles in Simancas, and in particular the green and blue colors, also demonstrates the enduring and in-grained styles that coexisted with classicism in the wider Iberian peninsula. Tiles painted in similar shades appear prominently in Mudejar buildings; the amalgamation of designs, textures, and colors found at Simancas is a reflection of the nature of early modern Iberian art and architecture. In sum, the architectural history of the archive in the six-teenth century reflects the king's government and

FIGURE 55 | Fragments of tiles at the Simancas archive. Photo: author.

echoes the changes in Philip's administration as well as the architectural and broader visual design trends that dominated his world.

Archives and Memory: Simancas, Mirror of the Empire

During his residence in Madrid in 1583–84, Diego de Ayala gathered extensive documentation for the Simancas archive. He also suggested to the king the possibility of moving the archive to Madrid. Philip II replied, "the works in Simancas shall continue; as for now I do not want the move of the archive to be done."[122] Geoffrey Parker and more recently Arndt Brendecke have stated that the perceived efficiency of the king's archive gave the incorrect impression that the ruler knew virtually everything and that therefore his decisions were very likely to be right. In other words, the archives and the intelligence they embodied made Philip an omniscient ruler. The location of the archive has been seen as counterproductive, since it caused an insufficient flow of information. However, it is possible to argue that Philip II intended this ar-chive to be located far from his court. Charles and Cobos emulated other European repositories when they decided the initial location of the archive. Its function was to keep documents that were not used frequently. This suggests that historical interpretations that have viewed the function of Simancas as an office archive do not match the in-tentions of the monarchs. The permanent location of Simancas far from the court became a means by which to filter access to the information contained in its papers. Philip II could also control who ac-cessed which deed. The instructions of 1588 were very clear in terms of access, as every consultation had to be approved by the ruler himself.[123] The intangible and tangible barriers in the building, along with its remote location, assured security and secrecy. Documentation flowed in both direc-tions between Simancas and the court in Madrid.

Meanwhile, each council dealt with its own current affairs in its respective office, which held the necessary records. In theory, at least, once these matters were completed, the documentation had to be sent to the archive. In this way, the papers were first filtered at court and then deposited at Simancas. The network of archival repositories created by the Habsburgs was intended to manage the high volume of documentation and also to ensure adherence to the law.

The architectural evolution of the Simancas archive mirrors the history of the kingdom and the organization of the empire in a number of ways. The gradual transformation of the fortress into an archive reflected the evolution of the Crown of Castile into an overseas empire. Furthermore, the transition between the two different approaches to kingship of Charles V and Philip II is echoed in the building itself; the first archival spaces, merely grand strongboxes, the largest at the top of the Tower of Obras y Bosques, were followed by the reconfiguration of Philip II's *cubiculum*. The spatial configuration of both demonstrates similarities with a vernacular tradition that extended across Europe—the architecture of the treasure-archive. This type of archival architecture belonged to a realm with a peripatetic court and strong medieval organizational roots. Archives were treated much like treasures. The spatial configuration and décor of Philip II's *cubo* echoed styles elsewhere in Castile and the rest of Iberia. In this sense, the creation of the first archival chambers in Simancas lagged behind archival development in contemporary realms such as Aragon and Portugal. The increasingly bureaucratic nature of the state under Philip II made these two chambers obsolete, almost from the completion of the second chamber at the end of the 1560s. The chests that arrived from the court accumulated in these small chambers and soon outstripped the space available. The expansion of the archive thus aimed to introduce a new regularity and order. The existing two rooms

were essentially adapted to the spatial constraints of the fortress. With the new pavilions designed by Juan de Herrera, a new notion of imperial expansion was reflected in the interior design. Philip ruled his empire through the written word, and these new regularized spaces housed the papers of his expanding imperial dominions. In short, none of these chambers were built with the admiration of contemporaries in mind, but rather their archival function. Nonetheless, the ruler was preoccupied with his own image and that of his kingdom and dynasty in posterity. Herrera designed efficient offices that enabled the king's archive eventually to become one of the grandest in Europe. The Simancas archive was one of the symbols of Philip's power and authority.

The final improvements to the archive during the sixteenth century, as designed by Francisco de Mora, reflect the image of kingship that Philip II wished to display. The king monitored all improvements to his archive, but it was during this last intervention in the building that his role became most prominent. He visited the building himself and insisted on architectural arrangements to meet his ceremonial needs. Thus the royal pathway created for Philip was intended to serve only the king, his heir, and later Spanish monarchs. The passageway was complex, shoehorned into the building, and able to conceal the incoming royal visitor. After all, except for the royally designated archivist, only the king would have had access to the royal chambers, which were segregated from the pavilions where the collections from the councils were kept. The intention of the royal path was to reserve the king's space and preserve hierarchy and order of precedence.

In 1611, Sebastián de Covarrubias y Orozco defined memory not only as the human capacity for remembering (and the techniques used to do so) but also as including institutions and other pious foundations, like hospitals, as well as the sumptuous buildings and *majorats* created by

kings.[124] These buildings and deeds embodied the memory of the past because they conserved the noble actions of their founders in material form. The archive was the memory of the king, which sustained and "remembered" issues of political importance to him. It was also pertinent to the memory of his ancestors—and provided another way to perpetuate the achievements of his reign for posterity. The archive emulated the history of the emperors of ancient Rome. Philip's new chambers and the planned gallery of portraits embodied the ideals of his empire and of kingship. Juan Pantoja de la Cruz's drawing of the paintings for this gallery brings to mind the memorandum of Juan Páez de Castro: "In this third chamber [of the archive] could be [placed] ancient portraits. Julius Caesar dealing with those great things he commenced . . . such as the libraries . . . , Caesar Augustus with the three books he wrote . . . , Vespasian with the book that he did of the Roman Empire. . . . Above all of them the Caesar Majesty [Charles V] doing the greatest thing that was ever done, handing over to your majesty all your realms and domains." The gallery of emperors that Castro envisioned was located in the archival chamber of the premises he described to the king. He suggested including images of Roman emperors along with Charles V's abdication of the throne. The idea was to establish a link between both lines of imperial rulers, the ancient and the new. The planned gallery in Simancas aimed to present an idealized image of kingship in an *all'antica* style. In this sense, the emulation of ancient Rome was made manifest in the systematization of the bureaucratic state, the organization of the archive, and its visual display. Páez de Castro intended the holdings of this archive to include "the reports the ministers send, from these parts of Europe where your Majesty's Empire extends, to the Indies."[125] The Simancas archive kept the records of the Crown of Castile, along with the papers of other supranational institutions such as the Council of State, which dealt with many diplomatic affairs, along with those of the councils of war, of Flanders, and of Portugal. The gallery of the kings was to be in the chamber where both the *patronazgo real* and the Council of State papers were kept.

Philip II created the mausoleum of his dynasty in El Escorial, where L'Hermite also depicted genealogical trees adorning the panels between Leoni's bronze sculptures in the walls that flank the basilica's apse.[126] This genealogical ornamentation bolstered the authority of a dynasty whose empire was gained by inheritance and conquest in both Europe and America. The archive at Simancas was yet another critical link in this chain of royal buildings and decorations, intended to bequeath the memory of Philip's exploits to posterity. The compilation of history that the archivists were instructed to complete was focused on victories in war. It is not surprising that the planned gallery of portraits finished with the monarch: he was the one who achieved the "Universal Monarchy" through the symbolic and political union of the territories of the former Roman Hispania, that is, the Iberian Union, desired by every Iberian ruler before him.

The architecture of the royal archive at Simancas, both that which was completed and that which was never realized, is another excellent model through which to analyze how the periphery influenced the center of empire in Castile, and how its monarch viewed himself as the ruler of that empire.

The Global Empire and Its Circulations

PHILIP II AND THE IBERIAN UNION

Seventeen years after Philip II settled his court in Madrid, an unforeseen opportunity arose to expand his imperial dominions. The loss of King Sebastian of Portugal (r. 1557–78) in the Battle of Alcazarquivir in North Africa left Portugal with no direct heir to the throne. This dynastic crisis made Philip's ascension to the Lusitanian throne plausible. The strategy that Philip's court designed prior to his succession to the Portuguese throne included the renovation of his imperial image. The new imperial imagery integrated references to Philip's political supremacy and his responsibility as a defender of the Catholic faith. In these years, the imperial rhetoric at Philip's court reached its peak. There is extensive literature on the campaign that concluded in the period of the Iberian Union (1580–1640).[1] The union's impact on the representation of the monarch deserves closer examination, for it reflects the decorative programs that were implemented in royal buildings. This chapter charts the imagery that emerged as a consequence of the Iberian Union by considering Philip's grand ceremonial entry into Lisbon in 1581. I examine both the contemporary accounts and the images of the festival, and the integration of local and courtly visual trends in the ephemeral architecture erected across Lisbon for the occasion. I also analyze Philip II's role as a leading performer in the pageant and his dialogue with religious and lay elites, since these aspects of the ceremony provide new insights into the ways in which ruler and ruled negotiated their places at this particular political juncture. The manner in which design trends and images traveled across the Iberian world, the role that Philip played in creating them, and the local and wider contexts that conditioned the production and circulation of pan-Iberian visual culture are the central concerns of this book. This chapter charts these concerns through the lens of the ruler's imperial representation. This theme in relation to Philip's entry into Lisbon has never been examined before, and it is a useful way to explore the circulation of images in Iberia and beyond.

The Dynastic Crisis and Philip's Entry into Lisbon

At the end of the fifteenth century, both Portugal and Castile became the first European global empires of the early modern world, with relative control

over the trade routes to the Americas and Southeast Asia. Portugal and Castile had been rival kingdoms and were also necessary allies. In practical terms, they needed to support each other, as they shared navigation routes. The Canary and Azores Islands, for example, were strategic points for the reception and departure of vessels to America.

Events that concluded in Philip's accession to the Portuguese throne had been forged for generations. Dynastic marriages were common in this period, and the dream of uniting the Iberian Peninsula, ancient Roman Hispania, had captivated the imagination of rulers before the Habsburgs ascended to power. Iberian monarchs had routinely arranged dynastic marriages between heirs to the throne. Indeed, Philip's Portuguese grandfather, Manuel I of Portugal (1469–1521), almost saw the Iberian Union come to fruition during his reign.[2] Philip based his claim to the Lusitanian throne on the line of his Portuguese mother, Empress Isabella of Portugal (1503–1539). Charles V had married Isabella, the primogenital daughter of Manuel I of Portugal. Charles likewise encouraged his son and heir Philip to marry his cousin María Manuela, princess of Portugal (1527–1545). They married in Salamanca in 1543, but María Manuela died giving birth to Don Carlos, prince of Asturias (1545–1568). The Houses of Aviz and the Spanish branch of the Habsburgs had gradually established significant family relationships that strongly linked their lineages. Sebastian of Portugal was the son of Philip II's sister Joanna.

The correspondence between the Portuguese king and his Spanish uncle, particularly during Sebastian's reign of 1557–78, was prolific. In addition, they met in person in 1576, in the Monastery of Guadalupe near the border, to discuss issues of common interest. Philip wanted to negotiate the protection of the Atlantic maritime routes from pirate attack, among other matters. Sebastian wished to launch a crusade in North Africa as part of his aspiration to emulate the military exploits of his predecessors. Sebastian tried to gather funds and

allies for his campaign, and he hoped to persuade his uncle Philip to join him. However, the Spaniard was preparing a peace truce with the Ottomans in the Mediterranean.[3] When Sebastian fell in the campaign in 1578 without having produced an heir, Cardinal Henry, brother of John III of Portugal, was crowned king of Portugal. He died in 1580, leaving the matter of succession unresolved.[4] A few candidates disputed the right of succession; some of the most prominent claimants to the kingdom were Catherine, Duchess of Braganza; her nephew, the eleven-year-old Duke of Parma; António of Portugal, known as Prior of Crato; and Philip II of Spain. The only candidate able to dispute Philip II's appeal was António, an illegitimate grandson of Manuel I of Portugal. António gained support in the realm and was designated king of Portugal in 1580; his reign, however, was short.

Philip II and his court delivered studied pieces of political propaganda that aimed to justify the monarch's rights to the Portuguese throne. At the same time, Philip's numerous enemies inside and outside Portugal produced counterpropaganda against the Spaniard's candidacy.[5] The complex diplomatic strategy enacted for the Portuguese succession included an imperial discourse that enhanced the prominent role that Portugal would play in the Iberian Union and at the same time emphasized Philip II's right to the throne. Cristóvão de Moura (1538–1613) was one of Philip's envoys in Portugal. He dealt with important negotiations during the period prior to the military incursion. Moura was Portuguese, but he had been educated in the Castilian court. He became Joanna of Austria's confidant and was based in her household in Madrid.[6] Philip's strategy involved agents in Portugal as well as in his court and other European centers.

Philip maintained his correspondence with Portugal, expressing profound sorrow for the loss of his nephew. These letters were promptly followed by others offering his rule to the realm and stating a number of rights to the throne that his advisors meticulously assembled. Philip instructed

the Duke of Osuna on the message he wished to convey to King Henry of Portugal so that the matter of the succession to the Portuguese throne was resolved in his favor: "for the universal good of the vassals of that crown . . . I will look after all of them very gladly because of my great desire . . . that it is never necessary to come to hard measures with my own blood relatives, with my own nation, with my own children, whom I have in this place."[7] Philip considered himself the rightful heir and the ruler best suited to protect the realm. He preferred a diplomatic solution, although he would not hesitate to vanquish those who resisted his will. Philip was in tandem mobilizing his troops in preparation for a military campaign in Portugal. The crisis was not solved during King Henry's short reign (1578–80), and António of Portugal was designated king of Portugal on 19 July 1580. However, soon afterward, on 25 August, Fernando Álvarez de Toledo, Duke of Alba (1507–1582) defeated António's military contingent at the Battle of Alcântara near Lisbon. António resisted with his flotilla until the Azores defeat in 1583. Diplomacy, bribery, and an effective four-month invasion led by Alba gave Philip control over mainland Portugal. On 16 April 1581, the Courts of Tomar designated Philip II of Spain Philip I of Portugal (r. 1581–98). From this date Philip ruled an empire that was the largest known at the time, exceeding considerably that of his father. In 1581, Philip, now king of Portugal, progressed toward Lisbon.

The festival organized in Lisbon to solemnly receive him was thus the crowning event of the greatest accomplishment of his political career—a triumph in diplomacy (and bribery) and a conquest by war. This was the victory of the policy of dynastic marriages mastered by Philip II's Portuguese grandfather, Manuel I of Portugal, and his Castilian great-grandparents, the Catholic Monarchs. The festival, in the view of Philip and his court, was the celebration of the union of the Iberian Peninsula and its global dominions under a single ruler. If the Treaty of Tordesillas had divided the globe between these two realms, Philip was able to celebrate its reunion in Lisbon in 1581. The responsibilities that attended Philip's rule were significant, for the dominions over which he ruled were extraordinary. Philip's success in the Portuguese succession was seen as a sign that the ruler was predestined to govern the world and promulgate the Catholic faith. These were some of the themes boasted in the ephemeral structures built in Lisbon in 1581 for the ceremonial entry.

Early modern festivals in Europe were usually funded by local sources or by the region or realm hosting them.[8] In 1581, the Lusitanian capital was in turmoil, with outbreaks of the plague and the political instability characteristic of a postwar period.[9] Nevertheless, a ceremonial entry with fifteen triumphal arches and other artifacts took place on 29 June 1581. Philip wished to project a specific image through artistic display and studied visual etiquette during the pageant, one that aimed to combine the idea of a just, peace-seeking ruler with that of a mighty and powerful king, able to destroy all his enemies at once—including, or especially, those within his kingdom. The tense relationship evident in Philip's letter to King Henry in 1579 was to dominate the discourse between the ruler and the ruled in the pageant of 1581, in which both were negotiating their place in the new political tableau through their words and postures.

The festival of 1581 has attracted less attention than the ceremonial entry of Philip III into Lisbon in 1622. In the latter case, printed propaganda in the form of lavishly decorated festival books with exquisite prints contrasts with the austere printed sources of Philip II's entry of 1581.[10] Neither Afonso Guerreiro's nor Isidro Velazquez Salmantino's accounts included images, which has undoubtedly influenced the perception of the festival in the scholarly literature. However, Guerreiro's book contains a description of the measurements of the arches and the façades, and of the iconographic program, which was described by both chroniclers.[11]

The work of Fernando J. Bouza Álvarez on the cultural aspects of royal propaganda in early modern Iberia is essential reading. Among his publications on Portugal, some of the finest explore the ceremonial entries of the Habsburg period through the lens of the print culture and poetry.[12] Miguel Soromenho and Ana Paula Torres Megiani have studied diverse aspects of this festival. Soromenho has compared this ceremonial entry with that of 1619 and the funeral rites to mourn Philip II in 1598.[13] Torres Megiani has compared the ceremonial entries of 1581 and 1619, paying special attention to the notion of the absent ruler and festival books.[14] Annemarie Jordan Gschwend has recently published a series of essays concerning the ceremonial entries of sixteenth-century queens.[15] In general, works on the festival culture in Lisbon are largely essay-length.[16]

Nevertheless, the complexity of the discourses and narratives deployed in the entry of 1581 deserves further analysis. The array of ephemeral architecture and the decorative program it boasted provide an astounding source for interpretation. The accounts focus mostly on the Arch of the German Merchants and allied triumphal path; this was the largest ephemeral structure and also one with the richest decorative programs.[17] Furthermore, the large number of ephemeral structures erected for this festival was extraordinary for Lisbon and for many other capital cities at the time. I focus principally on the sections of the itinerary and ephemeral structure that exalted Philip's imperial image and those that explored the relationship between the ruled and ruler in the most prominent spaces of social encounter in the capital city, namely, the Terreiro do Paço and the Rua Nova dos Mercadores.

Waterborne Pageants and Warfare Representation: The River Tagus

The River Tagus was an essential part of festival culture during ceremonial entries in the capital long before Philip II arrived in 1581. The reception of Philip's sister Joanna of Austria in Lisbon in 1552 began on the Tagus.[18] On 29 June 1581, at 3:00 P.M., the king departed in his royal vessel from Almada and set sail for the Terreiro do Paço in Lisbon, sailing up the River Tagus. Profusely decorated boats with musicians playing on board escorted the king. Philip's departure was announced by the firing of guns from the coast, followed by the guns of the eleven vessels escorting the royal ship. Gunpowder smoke covered the sky; in combination with the incredible noise, onlookers appeared to be witnessing a battle rather than a celebration. Once the din died down and the smoke cleared, it was a clear day. Then the Castle of Saint George began with the blasting of its armament.[19]

The citizens of Lisbon not only welcomed the new king but also competed for the prize that the city council had promised to the most beautifully garlanded vessel. The winner was a vessel that imitated a "big fish." Rodrigues Soares describes a similar prize for the best-decorated building.[20] This is what Bouza has called a "poetic joust," showing that the dialogue between ruled and ruler was not unidirectional.[21] However, these competitions not only show the active participation of the local community but also demonstrate that Lisbon had an established festival culture prior to the arrival of Philip II, since the entries of the Habsburg queens Eleanor (1521) and Joanna (1552), come to wed Portuguese monarchs, involved similar prizes.[22] The vessel in which Philip sailed to the festival was provided by the city of Lisbon and was richly ornamented in a rich silk canopy for the occasion.[23] Velazquez Salmantino described the Terreiro do Paço on the occasion: "On the other side [of the Arch of the German Merchants at Terreiro do Paço], the women selling fruits and products from the orchards had planted trees and green herbs that perfumed [the air] nicely, and in the [same] area of the river bank [were placed] the inventions of the fishermen [i.e., the boats competing] to win

the prizes promised by the city."[24] The water festival's destination was the Terreiro do Paço. In this plaza stood lavish ephemeral architecture, and, adjacent to it on the river was anchored an array of richly decorated boats competing for the prize. The Terreiro do Paço, with its ephemeral architecture profusely decorated, acted as a backdrop to an exhibition of the local naval inventions. The fruit farmers had planted trees and aromatic herbs that perfumed the air. The intention was to showcase the richness and fertility of Lisbon and to create a festival atmosphere to assail the senses with perfume, color, music, and the noise of guns.

The closest image to what occurred that day on the Tagus is that of Philip III's entry in 1619. The book of this event is richly illustrated with etchings; the edition of 1622 is of particular interest (fig. 56). The painting at Weilburg Castle in Germany shows a panoramic vista of Lisbon on the occasion of the entry of 1619 (fig. 57).[25] Both the engraving in Lavanha's book, which was printed in both Spanish and Portuguese, and the anonymous painting show the Tagus with a number of galleys and smaller vessels. However, the participation of the locals in the waterborne festival is either subdued or segregated from royal participation. The naval inventions of 1619 were sophisticated artifices, and a number of large artificial sea creatures

FIGURE 56 | Ioam Schorquens (1595–1630), Philip III's entry into Lisbon, 1619. Etching. From J. B. Lavanha, *Viagem da Catholica Real Magestade del Rey D. Filipe II. N.S. ao reyno de Portugal e rellação do solene recebimento que nelle se lhe fez. S. Magestade a mandou escreuer* (Madrid, 1622), fol. 15v. Courtesy of the Biblioteca Nacional de Portugal.

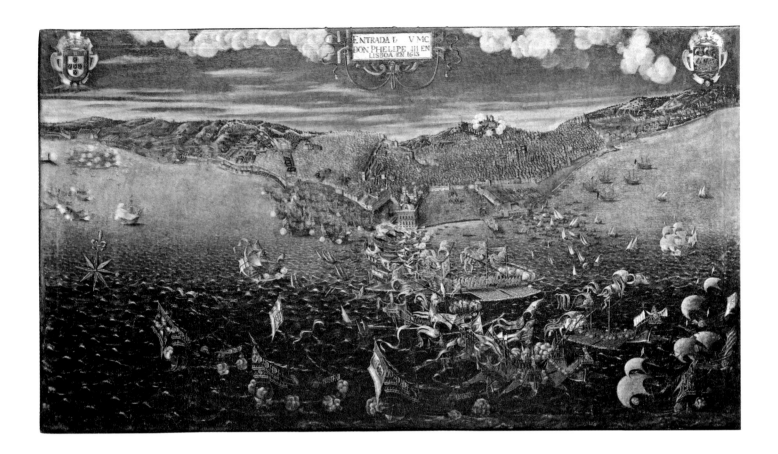

FIGURE 57 | Unknown artist, Philip III's entry into Lisbon. Oil on canvas, ca. 1619. Courtesy of Weilburg Castle, Weilburg, Germany.

navigated the Tagus during the military parade: "his Majesty enjoyed particularly some artificial fishes, [a] whale, [a] mermaid, [some] tunas and others that jumped on the water, and with music [coming from] inside of some of them, the river seemed a real paradise."[26] These creatures are discernible in the Weilburg canvas, which shows a number of small boats on the River Tagus just in front of the display of the maritime customs building. These are clearly segregated from the royal navy; this segregation also occurred in the entry of 1581. In a detail of this painting (fig. 58), a boat led by a crowned male figure with a trident in his hand can be identified as Neptune's carriage. On

the right side of this detail there is a giant *lagosta* (lobster) surrounded by tritons and a mermaid. The print of 1622 shows an idealized version of these sea creatures and Neptune's carriage, but on the other side of the scene, in front of the royal palace. In the print, the smaller boats are distributed among the royal navy ships flanking the royal galley, filling the space but also losing strength in the overall depiction. Both the segregation and the redistribution of the local boats show a clear visual hierarchy intended to reflect order or precedence in the water festival. The official accounts describing the river artifices in the festival of 1581 and earlier royal entries are not explicit about specifics, except that there were naval inventions imitating sea creatures. The sophistication of the artifacts deployed in 1619 was part of a long-standing tradition in waterborne celebrations and perhaps

an improvement on the earlier decorated boats. The inclusion of fantastical sea and mythological creatures evokes the legendary origins of the city described by poets and writers. Damião de Góis (1502–1574), for example, states in his description of Lisbon that tritons and mermaids once inhabited the banks of the Tagus.[27]

The aquatic performance is represented differently in these images. The Weilburg painting displays the galleys in squadron as described in the sources recording Philip II's entry of 1581 (fig. 57). The version in Lavanha's book, by contrast, does not emphasize this, and only a few galleys are shown firing their guns (fig. 56). The aquatic parade is profusely decorated in the painting, compared with the engraving in the book. The latter was the official account and in it the display of the

river has a more austere appearance. In the painting, great detail is used to emphasize the might of the fleet and its bellicose character. In the book engraving, only a few boats are firing their guns and the galleys do not appear decorated, as in the painted image. The difference in the use of guns may be because they represent different stages in the entry. In 1581, the firing stopped once the monarch's flotilla approached the pier at the Terreiro do Paço. Guerreiro wrote, "and all these composed a superb image of war in the entry."[28] Similarly, Antonio Escobar's contemporary account noted that the blasting of the artillery "emulated a war devastating the city."[29] The accounts of the entry of 1581 portray

FIGURE 58 | Detail of the Weilburg Castle painting. Courtesy of Weilburg Castle, Weilburg, Germany.

104

PHILIP II *of* SPAIN *and the* ARCHITECTURE *of* EMPIRE

a bellicose atmosphere in the river celebrations. In the accounts printed to celebrate Philip III's entry into Lisbon, the description of the water festival is exiguous and the writer passes over some details about activity on the river. The accounts of 1581, by contrast, display delight in describing the aquatic performance, especially the display of the artillery, as in the following verses by the poet André Falcão de Resende (1527–1599):

> Once his Majesty
> had boarded his galley,
> the thunder of artillery
> performed a *horrisonous* salute;
> the bellicose galleys
> [were] in an ordered squadron:
> the royal [galley], as the lady
> [and] patron, in their midst[30]

This poem evoked the military character of the water festival. In 1581, the royal galley was also accompanied by music, with royal musicians performing with slide trumpets.[31] The triumph began with an exaltation of the mighty power of the Spaniard. The conquest of Lisbon had occurred ten months earlier. Citizens of the Portuguese capital lamented the Lisbon assault commanded by Alba. Rodrigues Soares reported the profound sorrow that this assault caused in Portugal in a chapter of his manuscript that he titled "The Entry and Sack of Lisbon," and he compared this intervention with the infamous Sack of Rome in 1527.[32] However, the king's official historians gave a sanitized account of the events, in sharp contrast to Girolamo Conestaggio's condemnation of the ferocity of the troops.[33] There is surviving archival material reporting the state of Lisbon after Alba's assault.[34] The looting in Lisbon during the campaign and the prolonged military character of Philip's Portuguese residence in Lisbon is widely accepted among scholars.[35] Alba was not present for most of the 1581 festival, as he was reportedly suffering from gout. He only

appears saluting the ruler from a balcony in the royal palace at the end of the ceremony.[36] One may wonder whether his absence was a calculated political strategy, however, in that Philip may have wished to distance himself from the military campaign led by the duke.[37] This seems plausible, especially as Alba and his troops were associated with looting and brutality in the Portuguese campaign. Philip aimed to impose his authority on his new realm, but his image had to be that of a just ruler, one who would mete out justice evenhandedly and fight Portugal's enemies. These ideas are replicated in the festival decorations of 1581. The focus of Philip's military force included his enemies in Portugal, as accounts of the fete show. However, the enactment of royal justice was to be grounded in moral rights and nobility rather than brutality and looting. In short, Alba's diminished role in the festival may suggest that Philip wanted to dissociate himself from the duke's fearsome reputation. This would reinforce the close control Philip's entourage had over the kingly image the ruler was to project in his entry into the Portuguese capital. Philip's court aimed to balance the need to show military prowess and authority with the image of a generous and protective king who would bring peace and wealth to his Portuguese subjects.

The bellicose emphasis of the water festival in Lisbon was reflected in other contemporary images as well. Engravings depicting the battle in Lisbon and the assault by Alba's troops circulated in Europe. Philip II's acquisition of Portugal was an event of immense magnitude in European politics. Although the Weilburg canvas was painted many years later, it evokes the character of the river parade of 1581. The earlier engraving in Lavanha's book reinforced the military character of the river parade, in consonance with narrative accounts of the event.

In this depiction of the battle of Lisbon (fig. 59), the action on the Tagus is the central focus of the piece. Yet the image closely resembles the draw-

ings and descriptions of the water festival of 1581. If we imagine or "add" the festival structures by the dock to this print of the battle of Lisbon, it could serve as one of the sources for representations of the festival. The water performance in the Weilburg painting resembles closely this battle representation, and the canvas, as discussed above, echoes written accounts of the river festival of 1581. The performance and reenactment of sea battles in ceremonial entries and festivals of the period was common; indeed, famous naumachiae (ancient Roman spectacles representing naval battles) were staged in festivals.[38] During festivals, tapestries with these representations and other themes decorated streets, ceremonial halls, churches, and festival structures.[39] Battles were depicted in the ephemeral triumphal routes fabricated especially for festivals. For example, the temporary structures of Canto de' Bischeri for the ceremonial entry of Christine of Lorraine in Florence in 1589 featured statues of Philip II of Spain and Charles V, with images of the Battle of Lepanto and the defeat of the Turks near Vienna, respectively.[40] Sometimes, as in the case of Florence, the city streets were decorated to evoke the gallery of princely virtues that was a traditional feature of palatial architecture of the period.[41] These ephemeral structures imitated the spatial configuration and iconographical repertoire of the long galleries in royal palaces such as the Hall of Battles at El Escorial and the Hall of Realms at the Buen Retiro in Madrid.[42] The Lisbon entry of 1581 had panels with battle representations in the triumphal path erected between the Arch of the German Merchants and the Ribeira arches. Unfortunately, as noted above, no images of these have survived.

FIGURE 59 | Leonard Blümel, *The Conquest of Lisbon by the Royal Spanish Army,* 25 August 1580. Print originally titled *Die Belagerung von Lissabon* (1580). Courtesy of Zentralbibliothek Zürich, Department of Prints and Drawings / Photo Archive.

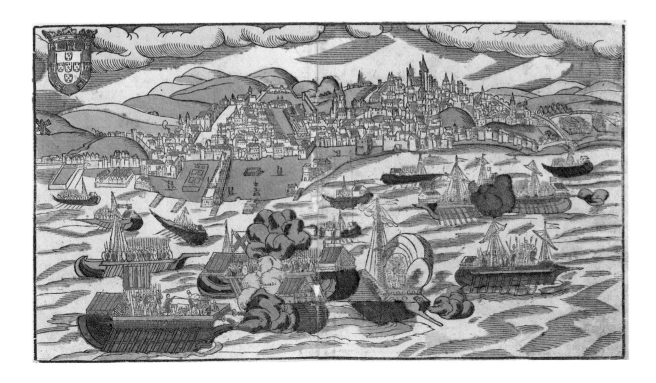

During the entry of Christine of Lorraine in 1589, Florence's Pitti Palace was the scene of the reenactment of a sea battle, this being a more sophisticated turn in the evocation of military victories in festivals. Naumachiae had obvious Roman roots and were dynamic visual dramatizations designed to reinforce the might of the ruling powers and the central role of war in early modern society.[43] Military parades in ceremonial entries sometimes featured little more than a gun salute, but in Lisbon in 1581 the aim was more ambitious. As noted above, the triumph of the prince was celebrated through the memory and depiction of his victories in war. The epic tone of the accounts of 1581 was intended to create an image of kingship that exalted Philip II's military power and asserted his control over Portugal.

The River Tagus was considered the "soul" of Lisbon and the epicenter of the Portuguese global empire, an empire connected via maritime routes to Africa, Asia, and America. Lisbon was one of the most important commercial centers in Europe in the sixteenth century. As Philip wrote in 1579, Lisbon was "the principal port and commercial [center] of everything because of the commodity of the port."[44] The aquatic festival simulated war but also presented Lisbon as the capital of the Atlantic; in the words of Damião de Góis, Lisbon was the queen of the ocean, emphasizing the port city's strategic role in the management of the Portuguese empire.[45] The cosmopolitan character of the Portuguese capital was also expressed in other accounts of the event. The Tagus was the aquatic stage for royal and official receptions in the city. The relationship and identification of Lisbon with the Atlantic Ocean was the basis for iconographical programs that celebrated the imperial achievements of the Habsburg dynasty, as displayed in the ephemeral architecture at the Terreiro do Paço. The Portuguese empire was conquered via the sea. This identification was also pertinent to the Castilian empire, as the Spanish had to conquer the ocean before reaching American soil. The Portuguese fleet was the "pillar" that sustained the imperial enterprise, and it therefore played a crucial role in royal receptions. The heroic connotations of the water festival on the Tagus therefore aimed to present the prestigious sea force of Iberia and its dominion of the Atlantic, now put to the service of King Philip.

A Festival for a Foreign King: Religious and Local Authorities in Lisbon

The authors of the festival program are unknown apart from the commission of the court architect Filippo Terzi.[46] Terzi had previously worked for King Sebastian and was appointed by Philip II as one of his court architects in Portugal. Juan de Herrera and Francisco de Mora went to Lisbon in 1581, although their direct involvement in the festival structures has not yet been established.[47] In addition to the festival, Philip asked for some work to be carried out on the Lisbon river palace before his arrival. When the king was in Almada, he received a committee of the local authorities, who begged him to postpone the festival by a few days as they were still finishing some structures. Philip agreed, but he went incognito to visit his riverfront palace.[48] This was not the first episode in which the ruler wished to see but not be seen. This ambiguous notion of royal presence would become an inherent practice of the Spanish Habsburgs.

One of the major omissions from the discussion of the architects and artists involved in the design of the pageant is the role of local designers. Guerreiro narrates how the *veedor de obras* in Lisbon was involved in the ceremony of the oath, in which the keys of the city were offered to Philip. The role of the *veedor de obras* was to supervise the construction works in the city, mostly those of the city council, such as a festival. Lucas da Silva was the *veedor de obras* and he handed the ceremonial golden keys to the *veedor* of the city, Filipe Aguiar, who bowed

FIGURE 60 | Itinerary of Philip II's entry into Lisbon. 3D model by author and Harry Kirkham.

to the king and presented them, saying: "This very noble and always loyal city of Lisbon gives your Majesty the keys to all its gates, and the loyal hearts of their residents, and their bodies, and goods, everything to serve you."[49] The majority of the temporary architecture erected for the festival of 1581 was funded by local guilds; notably, the Portuguese merchants in Lisbon had the Portas da Ribeira decorated (see figs. 60–61).[50] Greater attention to the local role and the economics of public rituals would shed much light on early modern ceremonial culture.

King Philip II expected to have a festival of great magnificence, wanting, as was traditional, for it to be funded by the city. On 25 May, barely a month before the reception, Philip wrote to the Lisbon authorities concerning the arrangements for the festivities.[51] He expressed his "anxiety" over some complaints in Lisbon that had come to his attention regarding the funding for the festival and stated that it was not his desire to oppress the citizens of Lisbon. In a second letter, dated 5 June, he suggested that the city should plan his entry in the customary Portuguese fashion, adding that he

was confident that the city would receive him in a manner appropriate to the occasion. This was in response to a letter in which the city authorities implied that it was not accustomed to staging such receptions and that they were costly.[52] However, Philip was aware of the Portuguese festival tradition, as he had been involved in some of the preparations for the ceremonial entry of his sister Joanna of Austria into Lisbon in 1552.[53]

This epistolary discussion was addressed in the pageant. Once the king arrived at the Portas da Ribeira, a member of the city council celebrated the ruler in a speech and stressed how the citizens hoped that he would ratify the privileges and liberties of the city. The *veedor* apologized for the postponement of the festival and begged for forgiveness for possible misunderstandings in the correspondence prior to the royal arrival. The local authorities feared that the Spanish ruler had read the city's limitations regarding the organization of

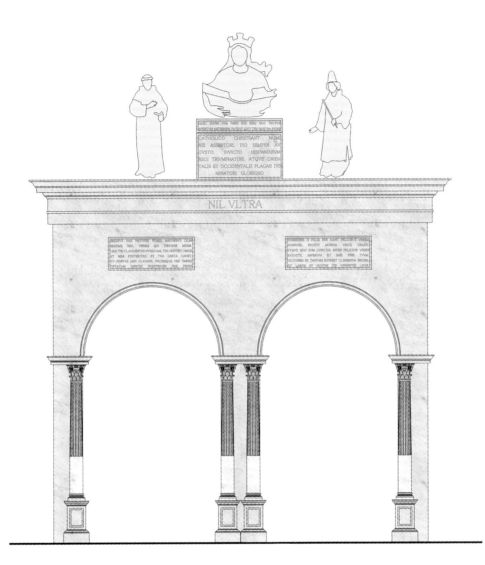

such a costly festival as hesitation or even reluctance to please him, though Philip responded by thanking the city authorities and agreed to maintain the city rights granted by his predecessors. The anxiety perceptible in the dialogue between the ruler and the ruled at the Portas da Ribeira in 1581 shows how tentative the city authorities were, given the political situation. Before the exchange of letters took place, the city of Lisbon had already signed a document of obedience to Philip II, and the local authorities had been invited to the Courts of Tomar and ratified Philip as king of Portugal.

The speech in the festival expressed the fears and expectations of the city of Lisbon regarding the abrupt change of dynasty.[54]

The iconographic repertoire of the Portas da Ribeira supported the speech of the local authorities. This important landmark was a city gate that had been decorated for the occasion (fig. 61). On top of the structure was placed a figure representing Lisbon, inspired by Francisco de Holanda's iconography,[55] flanked by the patrons Saint Vincent and Saint Anthony. The gate was decorated with motifs identified with the capital city, and the inscriptions

on the ephemera similarly emphasized the role Philip played at the festival. He was the king who finally "united" under his sole rule the Iberian Peninsula, which had been fragmented into different realms since the demise of Roman Hispania. Philip II was now the ruler of Iberia and its extensive and growing empire.[56]

The speech of the local authorities would not be the only occasion in which the ruler would be asked to participate. The religious authorities led by the archbishop had decorated the façade of the Sé cathedral. The iconographical program on the panel covering part of the façade of the temple was *La Iglesia Militante* (the Church Militant) in a holy war against infidels and heretics. At the top of the painting, the Holy Spirit illuminated the Virgin Mary flanked by the Apostles. The composition showed the Evangelists, representing the Catholic doctrine and defending the holy church. The pope was represented beside an armed king. Guerreiro identifies this ruler as Philip II, depicted here as the captain of the Catholic Church, whose duty it was to defend the purity of Christian doctrine against heretics and fight the advancement of the infidels. The archbishop of Lisbon, Jorge de Almeida, and the rest of the clergy had prepared the relic of the *sancto lenho* (holy cross), which Philip kissed with great emotion.[57] Philip was devoted to relics and a great collector of them.[58] The archbishop used his sermon to underscore the responsibilities of Philip as a Christian ruler and as a monarch to the Portuguese people. Furthermore, he asked the king to grant a general pardon for the rebels, to which the monarch replied that he would consider the suggestion but that it was still too early to do so. Rodrigues Soares described how the ruler had the followers of António executed, though official chronicles record the general pardon the monarch instituted after the Courts of Tomar.[59]

The theatrical "performance" staged by the ruler and the local and religious authorities of Lisbon

reflected their tense relationship. The local authorities tried to soften their communication with the ruler by adopting an apologetic tone. In the event, their financial struggle to fund the festival had been interpreted as hesitation to receive this new monarch. Once the ruler arrived, they feared the consequences. The archbishop felt that he was in a position to ask for the pardon of the rebels. Philip's reply to the archbishop describes the political context in which the festival took place. The monarch was acutely aware of the delicate position of his rule in Portugal, since even the capital of his realm had shown some "hesitation" in the preparation of his reception. António was still resisting defeat, his flotilla not far from the mainland. The realm needed Philip's presence so that he could establish his rule. There was no space for rebels, and those still lurking in his kingdom would need to be punished, along with their leader, António.

Images of Empire on the Waterfront

The king disembarked from his vessel at the Terreiro do Paço. However, the first piece of ephemeral architecture described in the chronicles was the Alfândega façade (fig. 62). This structure covered the maritime customs building. The Doric double-arched façade was in imitation of vetted marble. From this structure, a sequence of obelisks and statues on pedestals led to the magnificent Arch of the German Merchants, the largest and arguably most sophisticated structure in the fete.[60]

The Alfândega display was a poetic composition praising Philip's dominion over the oceans and Portugal's communion with the sea. The temporary display at the Alfândega rested on a podium. The podium linked this classical structure to the sequence of sculptures and obelisks.[61] The statues on the Alfândega dock were of Roman gods offering their dominions—the globe, the sea, and the heavens—to the most powerful emperor on earth, King Philip I of Portugal (II of Spain). Guerreiro

detailed the sequence of statues and obelisks connecting the Alfândega façade and the quay's arch (see fig. 62). The first sculpture, standing closest to the Arch of the German Merchants, was a statue of Janus in his traditional representation with two faces and offering two keys to Philip II (no. 1). The inscription read: "Here are my keys that open and close the gates of Heaven and those of War." This was followed by Fame in the form of a woman with a trumpet: "If the name of Philip resounds in Heaven, I carry his glory in my trumpet" (no. 2). Terminus was a half figure with no extremities: this god competed with Jupiter in authority, declining any vassalage to the king of Roman gods yet recognizing the greater authority of Philip's monarchy (no. 3). Terminus paid tribute to Philip's superiority with the inscription "Be the sun the limit of your realms, I yield to you, Jupiter bows to me." A winged Victory offered a palm to Philip (no. 4): "I used to wander the world with my wings, now I would stay eternally with you." Neptune offered his trident to Philip (no. 5): "If you command in West and East, you also command on the sea with my trident." Astraea, symbol of justice, handed her scales to Philip and with this gesture offered him her power (no. 6): "I give you this balance and this

kingdom, so you are its King, Father and Pillar."[62] The apotheosis of Philip II's imperial power was conveyed by the triumphal tone of the verses in the inscriptions. These deities were described as if they were "interacting" with Philip—that is, speaking directly to him. This was not the only instance in the festival in which writers evoked such ideas of nonliving things interacting with the living.[63] The main idea sent forth from all the statues and the verses inscribed on the pedestals was the surrender of these mighty gods to the superiority of Philip II as the foremost emperor. One by one, they offered their powers and loyalty to the new global ruler. In architectural terms, the classical façade and the podium adorned with statues and obelisks brought order to the riverfront. This façade could only be seen from the river, and as such it formed part of the major ephemeral redevelopment of the Terreiro do Paço occasioned for the ceremonial entry.[64] The presentation of alternate pairs of feminine and masculine deities on the river façade of the Alfândega was reminiscent of that of the Dii Consentes in the ancient Roman Forum.[65] The verses of the inscriptions on this structure were written in Italian and are heroic rhyming couplets in dodecasyllables (see fig. 62). The rest of the inscriptions were in Latin, the usual practice. The Italian inscriptions on the ephemera may have been intended to "charm" the king during his reception. According to Guerreiro, the permanent edifices around the Alfândega building were embellished with silk fabrics. He described these decorations as

FIGURE 62 | Hypothetical façade elevation of ephemeral decoration of the Alfândega building in Lisbon for the entry of 1581. Drawing by author and Harry Kirkham.

1. Janus. 2. Fame. 3. Terminus. 4. Victory. 5. Neptune. 6. Astraea.

1. Statue of Philip II.

2. Statue of Neptune.

3. Statue of Atlas.

4. Spanish Arms.

5. Flemish Arms.

6. Burgundian Arms.

7. Diana's Panel.

8. Janus's Panel.

9. *Retributio* Panel.

10. *Libertas* Panel.

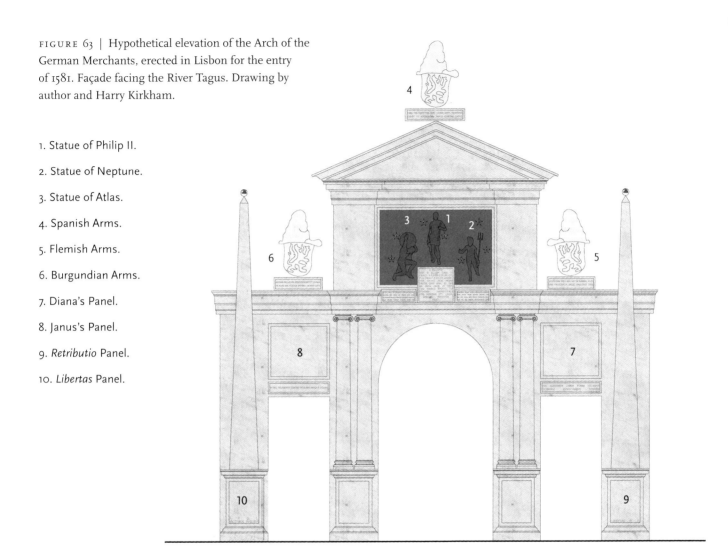

an *armaçom*, an archaism of *armação*, meaning a "simulated" or "false façade."[66] The verses in the inscriptions were specifically dedicated to the king's reception and may have been the work of a *versificatore*. This, in combination with the poor reviews received, even from the chroniclers who aimed to flatter Philip, diminishes the likelihood that a well-known writer wrote the verses.[67]

The Arch of the German Merchants was also a celebration of empire, both the old and newly incorporated dominions, and of the Habsburg lineage (fig. 63). This arch and its allied structures were by far the most sophisticated and finely finished ephemeral display in the festival. The iconographic lecture displayed in this great triumphal arch occupied most of Guerreiro's chronicle, with more than half the book devoted solely to the description of the ephemeral structures promoted by the German merchants. The main triumphal arch, described by Velazquez Salmantino as a fortress owing to its large dimensions, was profusely decorated on all faces (including interior passages and exterior walls). The chronicler provided a detailed account of the extended wooden quay especially

prepared to facilitate the reception of the monarch and his retinue.[68] The metric dimensions of the arch were monumental: the façade was between fourteen and fifteen meters in length, twelve meters in height, and about eight meters deep. The middle arch was between six and seven meters high, and the collateral entrances were four meters high, the middle arch being almost double the size of the others.[69]

In the years prior to Philip's accession to the Lusitanian throne, there was a proliferation of propaganda on both sides: those supporting the Spaniard's candidacy and those advocating one of the other pretenders. In the written culture of the period, this became what Bouza has called a "quills war," in which philosophers, jurists, and other learned men defended their positions. The propaganda war was not exclusive to print culture, as other arts and artists played their roles; poets such as Luis Franca, for example, wrote verse in support of Philip II's claim to the throne.[70] Many engravings, medals, and other works of art emerged in Philip II's court circle at this time. In the entry of 1581, a number of these images were adapted in the visual vocabulary displayed in the Arch of the German Merchants as well as in the decorative program of the "triumphal path" erected on the Terreiro do Paço. The direct identification of these motifs in the festival with those produced by the king's entourage further sustains the argument for the involvement of the court artists in these temporary structures. The side of the German arch facing the waterfront (fig. 63) featured a panegyric composition with persuasive images and inscriptions reinforcing the absolute power of Philip II as a global ruler. The artifice exalted the messianic mission of the ruler and his identification with the sun. The hierarchy of the artistic program, and therefore of the "narrative" of this façade, began at the top with the exaltation of Philip's power and global reach and concluded with the benefits and rewards that union brought to both realms.

The recess at the top of the structure (fig. 63, nos. 1–3) had its background painted blue with golden stars.[71] Inside was a naturalistic statue of Philip II, with real hair, clad in black with the imperial emblems and holding a scepter. The statue portrayed Philip as a commanding warrior demonstrating his force and might. It was flanked by the supporting figures of Atlas (no. 3) and Neptune (no. 2), whose nakedness was barely covered with red taffeta. The inscription beneath Philip read, "Philip II, King of Spain, pious son of the Emperor Caesar Augustus D. Charles V, . . . defending the saintly religion, spreading the Catholic faith around the world by sea and on land, keeper of the peace and justice. With an open temple [Philip] arrives to a Portugal gained by inheritance, with good laws and institutions."[72] The inscription may appear to be an extended "motto" for the festival, celebrating the imperial might of the Habsburg dynasty, including the acquisition of new territories and the promulgation of the Catholic faith. The inscription stated that Philip was the legitimate heir of the Portuguese throne and underscored his responsibility to protect his newly acquired realm. A number of motifs in the festival reiterated the justification of the ruler's rights to the Lusitanian throne.

The figures atop the structure were three lions, representing Spain (no. 4), Burgundy, and Flanders (nos. 5–6), with inscriptions regarding their submission to the king.[73] The statues beside Philip—Atlas and Neptune—were also allocated generous texts. Atlas: "My body is deteriorated because of my age and the immense *machina* I carry, incommensurate with my strength, defeated I leave it for you to carry on your shoulders. You are fit for it." Neptune: "Until now I commanded over the Oceans, now Philip I give you the scepter, and from now on there will be no more unpunished corsairs in this sea, neither robberies."[74] Neptune and Atlas were appropriated to Philip's dominion, thus deifying him as the new ruler of the world's

lands and oceans. Neptune's inscription also alluded to the protection Philip had promised to the Portuguese realm against piracy and also against the attacks of other European powers on Portuguese coasts and fleets.

The panels above the lateral passages in the German arch were decorated with paintings imitating bronze bas-reliefs. On the right-hand entrance (no. 7), Diana can be seen offering her empire to Philip. She was represented as a three-headed figure with bow and arrows, dominating three lions beneath: "TVO ILLVSTRATA LUMINE PONAM TOLLAMQUE. OCEANVM QVUOCVMQVE JUSSERIS" (Enlightened by your luminosity, I will calm and shake the ocean if you so command). In Guerreiro's view, Diana was offering her empire together with her dominion over hunting to the king.[75] The emblem may have been one in which Philip's radiance illuminated Diana's willingness to obey his rule and show how his "solar authority" was as mighty as hers. Diana would "calm or shake" the oceans under Philip's orders; again, this provides the image that the ruler aimed to convey in the pageant, combining not only power and peace seeking but also extraordinary might when required.

The "solar theme" and the exaltation of light embodied in the idea of Philip II's dominion continued in the panel on the left (no. 8). The god was Janus, represented with four faces rather than with two, as was customary. The god held a scepter pointing toward the "spectator" so that an eye could be perceived on the scepter's tip. Janus is shown leading the carriage of the sun with four horses. The sun's rays seem to be reflecting on the horizon and illuminating the painting. The emblematic language pinpoints how the sun illuminated the four continents that Philip II dominated—Asia, Africa, America, and Europe: "TV SOL SPLENDENS SEMPER VIGILANS ABSQVE OCASSV" (You are the luminous sun, which always guards without setting).[76] The solar qualities attributed to Philip in the imperial propaganda echo his global

and "absolute" power. The display evoked ideas of "enlightenment" that Philip brought to his dominions. This emblem of Philip had been minted previously in a medal designed by Jacome da Trezzo in 1555. The representation was exactly the same as in Girolamo Ruscelli's *Le imprese illustri* of 1566 (fig. 64).[77] In this earlier representation, Apollo is shown riding in a carriage. The god Apollo was traditionally associated with the young ruler, but the Apollonian reference is muted in the Lisbon representation, appearing in the four-faced Janus, an embodiment of the four continents known at the time.[78] The reference to the eye in the scepter's tip and the representation of Janus with four rather than two faces is reminiscent of other contemporary references, both visual and written, to the omniscience of Philip II, a monarch who ruled over four continents and was able to see, control, and protect his extensive realms.

The modification of the earlier engraving also affected the inscription: "IAM ILLUSTRABIT OMNIA," which translates as "Now he will enlighten all." Diana was the goddess of night and the sister of the sun god Apollo. The location of her panel in the arch's façade complements Janus's panel on the other side, in which the solar attributes are emphasized through Apollonian iconography. Diana serves as a "sisterly" guide to both the ruler and her counterpart on the other panel.

Janus opened and closed the gates of wars; thus the substitution of Apollo for him in the Lisbon emblem was intended to emphasize Philip II's military power and control over the globe. This highlighted the overall message that the ruler and his entourage aimed to project in the capital of his new realm. The idea of military power was combined with that of "good government"; his authority was legitimized through both ideas. In short, the panel exhibited the "luminous triumphal path" that the universal monarchy, and subsequently Portugal, had taken since Philip II had become commander. In Lisbon, the connotations were also intended to

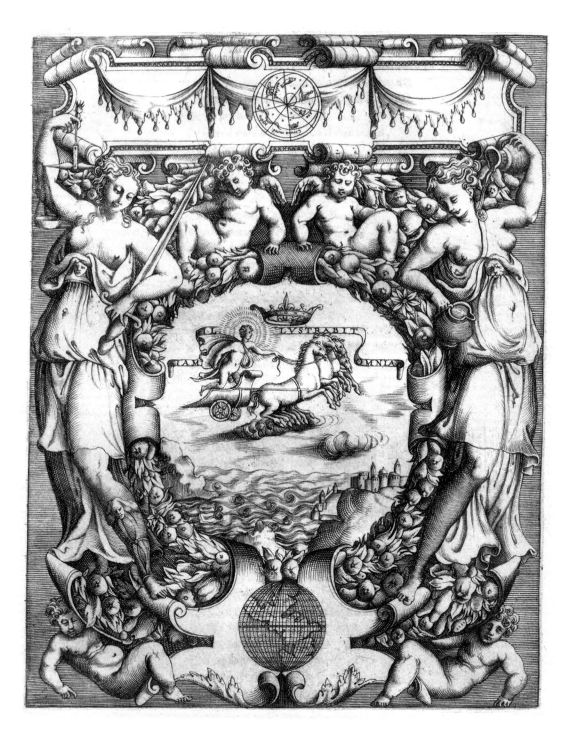

FIGURE 64 | Philip II's emblem. From Girolamo Ruscelli, *Le imprese illustri* (Venice, 1566), fol. 231v. Real Biblioteca del Monasterio de El Escorial, 42-v-48, 1. © Patrimonio Nacional.

FIGURE 65 (*opposite*) | *Philippvs IIII Dvx Brab. Hisp. II. Rex.* In A. van Baerland, *Chroniques des ducs de Brabant* (Antwerp, 1600). Courtesy of the Biblioteca Nacional de España.

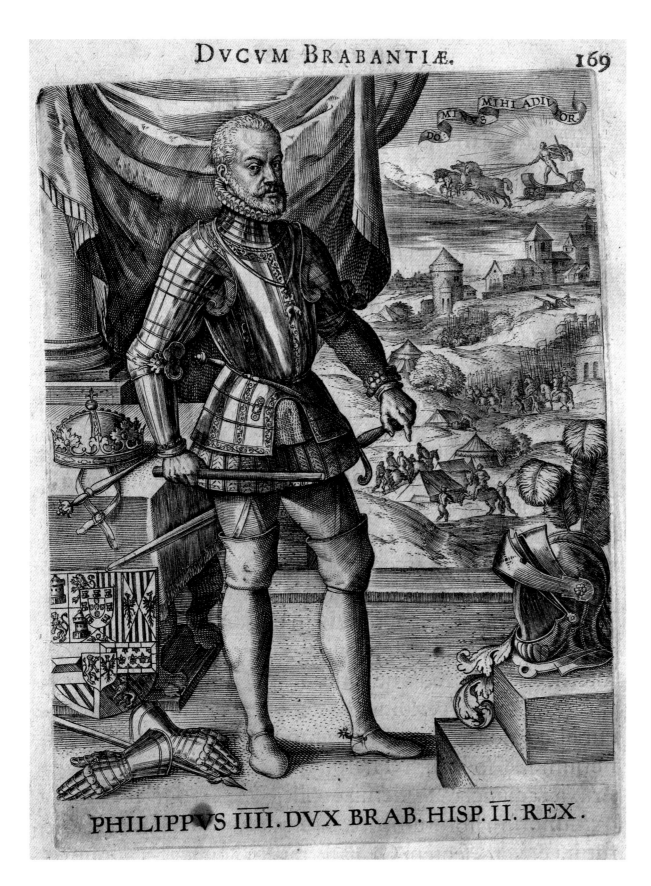

PHILIPPVS IIII. DVX BRAB. HISP. II. REX.

encompass Philip's increased territorial dominion. The king's emblem was modified and adapted throughout his reign. In a print from Adriaan van Baerland's *Chroniques des ducs de Brabant*, Philip is represented as the ruler of Brabant: the conquest of Portugal is shown in the background (fig. 65). The emblem at the top of Baerland's print highlights Philip's messianic mission as a global emperor and includes the inscription "DOMINUS MIHI ADIUTOR" (a fragment from Hebrews 13:6: "The Lord is my helper. I shall not be afraid"), in other words, "the Lord is on my side" or "I am guided by the Lord's designs."

The artistic representation of Philip after his seizure of Portugal was discussed in court circles. When the ruler's retinue was at Tomar in 1581, a Burgundian knight who was part of Cardinal Granvelle's entourage suggested that they could change the original motto in the emblem to "NIHIL NUMQUAM OCCIDIT." This was intended to embed the notion that Philip's universal monarchy was an empire on which the sun never sets.[79] Thus the ideas represented in the display at Lisbon evoked the idea of "illumination" with messianic connotations, in which the Catholic faith was viewed as the "light of the world." Philip, as its leader, therefore "enlightened" a civilization that embraced both the Christian faith and Roman (or classical) thought. This was in line with Renaissance notions formulated by Erasmus and other thinkers.[80] Thus the image of Philip II made him appear to be chosen by God to spread religion and rule the world. He was impelled to bring the "light" of a "Castilianized" civilization, with its particular religious and moral beliefs, to the rest of his lands. The Iberian Union and the immense expansion of the overseas dominions of Castile and Portugal gave Philip a strong sense that he was on a divine mission to become the leader of a Christian world. These ideas of empowerment and "new order" were reflected in the festival display at Lisbon and in the notion of "illumination" that Philip's rule brought to his empire.[81]

Visual culture associated with the imperial image of Philip II was also a source of inspiration for other motifs in the festival display. Lorenzo de San Pedro, in his *Diálogo llamado Philippino*, aimed to support Philip's claim to the Lusitanian throne. Bouza has rightly suggested that some of the emblems and imagery included in San Pedro's *Diálogo* may have appeared in some form in the ephemera of 1581.[82] In the Arch of the German Merchants, on the façade facing the Tagus, the pedestals supporting the obelisks (fig. 63, nos. 9–10) were also embellished with iconography simulating bronze bas-reliefs. Each pedestal had three decorated panels, two of them covered with elaborate iconography. The inner panel of the obelisk on the right (no. 9) had a representation of a carriage led by a woman with a scepter and three towers over her head. Above this, in the same panel, was another female figure on top of a cloud holding three crowns, and a third woman, who was seated beside the carriage, offering ears of wheat. Guerreiro wrote that these figures represented the kingdoms of Portugal, Castile, and Naples and Sicily and the rest of the Italian dominions.[83] The Latin inscription *Retributio* was a clear allusion to the reciprocal wealth that the Iberian Union was to bring to both realms. The emblem *Retributio* by San Pedro features the three graces exchanging symbols of Portugal and Castile (fig. 66). The panel at Lisbon displayed a more elaborate version of this emblem to convey the notion of reciprocity. This was one of Philip's promises to Portugal in his claim to the throne. Philip and his entourage argued not only that the monarch was the "rightful heir" but also that the union would bring wealth and stability to both kingdoms. The female figure carrying wheat has also been identified with Ceres.[84] This goddess, embodying the united Roman Hispania and likewise holding ears of wheat, was also present in the decorations for the wedding celebrations for Joanna of Austria in Lisbon in 1552.[85] The representation of a united Hispania or "Iberian" union in the form of Ceres also reinforced the symbolism

intended in both the drawing and the display of the arch. The motif exhibited in Lisbon in 1581 was more elaborate, though the idea was clearly inspired by the "dream" union of Hispania.[86] The festival's decorative program thus resorted to imagery that had been employed previously to evoke the sisterly reciprocity, collaboration, and support that both realms had pursued (paired with obvious rivalry) in the past. These enduring symbols of the relationship between Portugal and Castile were adapted to emphasize the themes of this particular fete.

Janus's replacement of Apollo in the Arch of the German Merchants is just one example of the adaptation of the imagery used to represent the ruler in the festival. In this panel, Janus, as noted, has four faces instead of the customary two and holds a scepter with an eye on the tip, conveying Philip's omniscience and his protection of—and control over—the two adjoining empires. This representation and the versions of the motto accompanying the carriage of Apollo (or Janus) flourished during this period, and they appear in portrayals of the ruler beyond Iberia and in other European realms, as discussed earlier.

The pedestal supporting the obelisk on the left-hand side of the same façade in the Arch of the German Merchants (fig. 63, no. 10) was embellished with a winged Fortune holding the sails of a vessel and shielding a navy beneath her legs. This represented the protection and fortune of the king's fleet between the West and East Indies. The inscription read, "BONA SPES," referring to the Cape of Good Hope circumnavigated by Bartolomeu Dias in 1488 and identified at that time as the dividing point between the Atlantic and Indian Oceans.[87] This painting was intended to highlight the place where the two fleets of the East and West Indies met on their navigation routes. The final part of the inscription read, "FORTUNA REGIS" (king's fortune), reinforcing similar ideas.[88] The panel on the same pedestal facing the waterfront showed an armed figure in a triumphal posture

FIGURE 66 | Lorenzo de San Pedro, *Retributio, or The Three Graces: Thalia, Euphrosine, and Aglaya.* Drawing, ink on paper. In San Pedro, *Diálogo llamado Philippino, donde se trata el derecho que la magestad del Rey Don Philippe, nuestro Señor, tiene al reyno de Portugal* (ca. 1579), fol. 256v. Real Biblioteca del Monasterio de El Escorial. © Patrimonio Nacional.

riding in a carriage drawn by three horses and holding in his right hand a Roman standard with the letters "S.P.Q.L." (i.e., the Senate and People of Lusitania). This figure also held a palm branch with the inscription "VICTORIA PHILIPPE" (Philip's victory), clearly evoking imperial Rome.[89]

The imagery employed in Lisbon in 1581 reached other parts of Europe and beyond. The representation of Philip II as a global ruler in the aftermath of the Iberian Union can be seen in a depiction of 1585 (fig. 67) that appeared in a chronicle of Philip II's Portuguese campaign by Johann Holzhammer, an Austrian observer. In the medallion on the left, the insignia embodies the global dimension of Philip's authority; the Latin inscription alludes to his realms in Spain and

Portugal and the West and East Indies, a common theme in the festival panels. The image depicts an armed Philip standing on a globe and brandishing his sword, dominating the oceans and surrounded by an assortment of diverse naval vessels. The medallion was a simulation of the globe with the sun and the moon painted in front of each other. Philip II was the commander of the world and his dominions were so vast that the sun and moon could illuminate both latitudes at the same time. The medallion may have been inspired by the iconography used at the 1581 ceremony. For instance, the armed statue of Philip dominating Atlas and Neptune, symbolizing the globe and the oceans, respectively, was located in the front upper-level recess of the Arch of the German Merchants facing

the waterfront, as discussed above (fig. 63, nos. 1–3). In this same façade, the "solar" dimension of Philip's authority, and the extension of his empire, was also stated in the iconography of the panels above the lateral entrances. The navy shows the dominion of the seas and the might of Philip's fleet, with associations with the water festival that took place on the Tagus in 1581. The inscriptions referring to the West and East Indies were used a few times on the arch.

The paired medallion on the right (fig. 67) resorts to the traditional representation of the "communion" of the realms via two adjacent coats of arms. The two shields together, topped by two lions uniting the world and the sea below, possibly represented the Cape of Good Hope. The Cape was the place where the two navies linked their maritime routes, and the armed soldiers wore the respective national costumes of Portugal and Castile. The Cape of Good Hope was also displayed in

FIGURE 67 | Johann Holzhammer, *King Philip II as World's Ruler* (Vienna, 1585). ANL/Vienna, codex 9865, fol. 4r. Courtesy of the Austrian National Library.

the Arch of the German Merchants, as mentioned earlier. The scales at the bottom of the right-hand medallion represent the Iberian Union (signed in the Courts of Tomar), which would work only as long as it was "balanced" and if the ruler maintained equity and justice.

The motif of two adjacent coats of arms was often employed in dynastic marriage negotiations and was reflected in the ephemeral displays erected to celebrate weddings. Images of the coat of arms of each spouse can be found in festivals in Europe and throughout the wider Iberian world. Allusions to such marriages appear in the visual culture promoted in the years prior to Philip II's accession to the Portuguese throne. For instance, the depiction of the emblem *Monarchia* (monarchy) in San Pedro's *Diálogo* is reminiscent of this imagery (fig. 68). *Monarchia* combines two ideas: the Iberian Union and Philip's global dominion, cemented by the acquisition of Portugal. The representation of the globe between two statues had also been used in the past. During Charles V's entry into Antwerp in 1549, there were similar representations. One of the arches had statues of Charles V and Philip flanking a globe at the top of the arch.[90] In Lisbon in 1581, a similar motif was employed in one of the pillars on the triumphal path erected on the Terreiro do Paço. In fact, Philip's role in the festival was not limited to his dialogue with the local authorities at the Portas da Ribeira or his conversation with the archbishop of Lisbon in the cathedral. To fully grasp the prominent role of images in the festival and how they accompanied the monarch's performance there, it is essential to examine the triumphal path erected on the Terreiro do Paço.

Reenacting the Triumph: Philip's Path to Glory

The processional route from the Arch of the German Merchants to the next arch consisted of a triumphal path that celebrated the Portuguese empire with a series of painted panels followed

FIGURE 68 | Lorenzo de San Pedro, *Monarchia.* Drawing, ink on paper. In San Pedro, *Diálogo llamado Philippino, donde se trata el derecho que la magestad del Rey Don Philippe, nuestro Señor, tiene al reyno de Portugal* (ca. 1579), fol. 275v. Real Biblioteca del Monasterio de El Escorial. © Patrimonio Nacional.

by a sequence of statues alternating with columns (fig. 69). The succession of columns and statues represented the Asian, American, and African lands that made up the Lusitanian overseas empire. These statues paid tribute to Philip II and represented some of the most important fortified cities and forts in the empire.

The large pillars that preceded the sequence of columns and statues were also topped with figures and inscriptions. The pillar on the right of the triumphal path (fig. 69, no. 4) was a statue representing Afonso de Albuquerque (ca. 1453–1515), "conqueror of India," clad as a *miles Christi* (soldier of Christ). According to Guerreiro, this display symbolized the many conquests achieved by Philip's Portuguese grandfather, King Manuel I

Top elevation:

1. CRESCIT RELIGIO panel.
2. DEI PROVIDENTIA panel.
3. IDOLATRIA EXPELLITVR panel.
4. MILES CHRISTI statue.
5. MILES CHRISTI inscription.
6. Goa statue.
7. Goa fortification.
8. Kochi statue.
9. Kochi fortification.
10. Diu statue.
11. Diu fortification.
12. Malacca statue.
13. Malacca fortification.
14. Ethiopia.

Lower side elevation:

1. FIDES PROPAGATVR panel.
2. PAX REGNANT panel.
3. TERRAS ASTREA REVISIT panel.
4. VNIVERSI GLOBUS statue.
5. VNIVERSI GLOBUS inscription.
6. Kannur statue.
7. Kannur fortification.
8. Chaul statue.
9. Chaul fortification.
10. Sri Lanka statue.
11. Sri Lanka fortification.
12. Ormus statue.
13. Ormus fortification.
14. Brazil statue.

FIGURE 69 | Elevations of both sides of the ephemeral triumphal path erected for Philip II's entry into Lisbon in 1581. Drawing by author and Harry Kirkham.

of Portugal, which were now under Philip's command. Similarly, the opposite pillar had statues of two women embracing a globe, joining their upper hands while holding crowns in their two lower ones. Guerreiro explained that the inscription on this pillar made reference to the dream of the union of Roman Hispania, accomplished only under Philip's rule: "The world was divided between your great-grandfather King Ferdinand of Castile and your grandfather Manuel King of Portugal. Now they are united in one, and you are the Lord of the East and West."[91] Both representations atop these pillars reinforced the imperial message carried by the riverfront façade of the Arch of the German Merchants. The reference to the Treaty of Tordesillas (the division agreed by Ferdinand and Manuel) and the success of the dynastic marriages promoted the idea of the divine destiny of Philip II's rule over Iberia and its empire. This symbolism of the union of the two monarchies and empires evokes the images present in San Pedro's and Holzhammer's manuscripts. Thus these themes were not only seen in Iberia; they also circulated in Europe and beyond. Bengali colchas and hangings made for the Portuguese market in the sixteenth and seventeenth centuries showcase some of these

themes as displayed in the festivals built for Philip II (1581) and also for his son and heir, Philip III of Spain, in 1619 in Lisbon.[92]

Colchas from the Indian subcontinent formed part of Lisbon ceremonial culture, and they often appear in the accounts of public rituals. In 1571, for the official reception of the papal legate, the streets of Lisbon were draped with hangings and colchas from diverse parts of the peninsula and the wider Portuguese world along the processional route.[93] The *Solomon Colcha with the Four Continents* at the Museu Nacional de Arte Antiga in Lisbon (inv. 2237) was made in Bengal, in the Hugli region, between 1610 and 1640. The imagery in the colcha is reminiscent of the images and texts present in Philip's entry into Lisbon in 1581, especially of the ephemeral waterfront display at the Terreiro do Paço. References to the four continents known at the time feature prominently in this colcha and also, as we have seen, in the entry of 1581. Such imagery was also featured in the official reception that Lisbon prepared for Archduke Ernest in 1593.[94] Solomon had also been employed in representations of Philip in festivals long before he ascended to the Portuguese throne; images of Solomon and the four continents were famously present on ephemera displayed in the entry into Antwerp of 1549.[95] In addition, Solomon features in the series of the kings of Judah in the Courtyard of the Kings at El Escorial Monastery. References to the zodiac, the predestination of Philip's rule in Portugal, and his messianic mission appeared in the festival of 1581. The lateral façade of the Arch of the German Merchants, facing toward the Alfândega, included this imagery, which was also present in this colcha and others produced in the sixteenth and seventeenth centuries in Bengal.[96] The imagery in these colchas reached the Indian subcontinent via prints and images brought by travelers. Bengali artists adapted the images that appeared in printed books, and when the books lacked images, as in some of the accounts of Philip's entry into Lisbon of 1581,

the artists reimagined the imagery described and adapted it to the art of embroidery in their colchas. The *Colcha with Triumphal Arch*, also produced in the Hugli region of Bengal circa 1624–50 and now at the Isabella Stewart Gardner Museum in Boston (inv. T20e4), is an extraordinary example, showing the wide circulation of the images produced in festivals of the period. The colcha displays portraits of kings and other scenes from the Habsburg festivals in Lisbon in 1581 and 1619. At the center of the piece, the Arch of the Flemish Merchants, erected in Lisbon's Rua Nova dos Mercadores in 1619 for the ceremonial entry of Philip II of Portugal (III of Spain) can be seen clearly outlined (fig. 70).[97]

FIGURE 70 | *Colcha with Triumphal Arch*, Bengal, seventeenth century. Courtesy of the Isabella Stewart Gardner Museum, Boston.

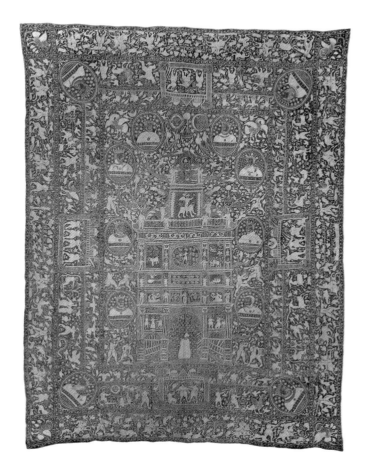

This is a unique piece; there are no other instances identified thus far in which an ephemeral arch erected temporarily in Lisbon was embroidered into a Bengali colcha. Both colchas are excellent models for analyzing the synthesis of Bengali artistic grammar and transregional influences. In the case of the *Colcha with Triumphal Arch*, the imagery came from a particular fete associated with the Habsburg king of Portugal.

Early modern textile production in both the Portuguese and the Spanish empires provides an excellent window onto pan-Iberian imagery in general and images related to the monarchy in particular. These colchas showcase the ways in which imagery traveled, and they reveal how local artists blended ingrained traditional techniques and local decorative motifs with pan-Iberian trends. As seen thus far, the Bengali colchas, the manuscripts, and the other images that emerged in the peninsula, Europe, and beyond showcased imagery that echoed Philip's Lisbon fete of 1581. Considered collectively, these images are a forceful reminder of the wide geographical impact of this political event, and above all that the image of the king reverberated throughout disparate regions of his empire and beyond.

Philip's role in the pageant, and the enormous efforts of the festival organizers to craft an ideal classical cosmos in which to celebrate his triumph, emerges most clearly in the triumphal path erected in the Terreiro do Paço to connect the façade of the Arch of the German Merchants to the city and the Portas da Ribeira (fig. 69). An analysis of one of San Pedro's drawings, *Trivmpho Primero Imperial* (first imperial triumph), and its sequence of statues and columns over pedestals shines some light on Philip's expected performance at the pageant.[98] In this drawing, an armored Philip II rides a horse (fig. 71). Philip is presented as the *miles Christi*, or soldier of Christ, as in Albuquerque's statue. San Pedro's drawing shows the triumphal paraphernalia traditionally employed in festivals, such as the canopy and accompanying cohort. The most

prominent text in the image takes the form of a Latin rhyme and praises the victories of Philip's ancestors against barbarians and the seizing of the Portuguese empire under Philip's rule, which allowed him to propagate the Catholic faith. Texts are found on the king's canopy and in the standards carried by the damsels and the indigenous peoples in the drawing. One of these standards represents Iberia, the united Hispania, on which the Portuguese arms are arranged in the center, flanked by the arms of Castile and Aragon (the standard is carried by the damsel on the right).[99] This imagery was also present in the triumphal path. People from Africa, America, and Asia are also depicted in San Pedro's image, carrying the royal standards of Ethiopia and the West and East Indies ("India Occidentalis" and "India Orientalis"). These depictions emphasize the global imperial dominions in Africa, America, and Southeast Asia under the monarch's rule.

Philip's retinue is reminiscent of the sequence of statues over pedestals representing the Portuguese dominions erected in the triumphal path on Terreiro do Paço (see fig. 69). These statues were of damsels (or nymphs, as Guerreiro described them), representing a number of cities or territories that had been under Portuguese control and were then incorporated in Philip II's empire. The triumphal path was designed as a reenactment of the imagery incubated in the years prior to Philip II's accession to the throne. For the image of the triumph to succeed, it was necessary that Philip ride his horse under a canopy, as he had done in Lisbon in 1581. In other words, Philip, his retinue, and the classical statues and columns together composed the ideal microcosmos created temporarily for his triumph in Lisbon. The composition of the triumph was made by pairing a nymph with a column, respectively embodying the capital city of the region and the fortress erected by the Portuguese. The inscription on each device took the form of a rhyme in Latin. The cities or regions represented were the Portuguese dominions in

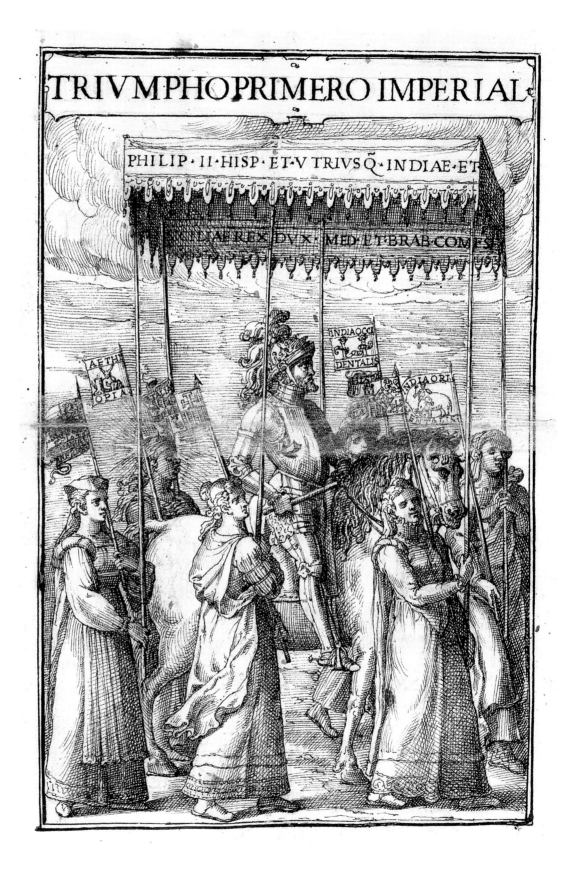

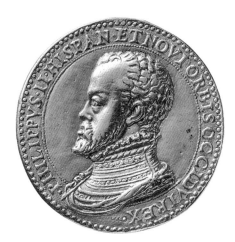 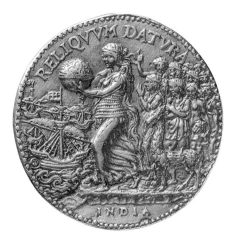

FIGURE 72 | G. P. Poggini, medal of Philip II, cast and chased silver, ca. 1559–62. Courtesy of Martijn Zegel, Teylers Museum, Haarlem, Netherlands.

the Indian subcontinent, including Goa, Kannur, Cochin, Chaul, Diu, and Ceylon (modern-day Sri Lanka). They also included Malacca (now in Malaysia), the old Kingdom of Ormus in the Persian Gulf, Ethiopia as a representation of the African ports, and Brazil for territories in America.

In early modern festivals, all participants in such pageantry had a role to fulfill, and the main character was played on this occasion by the king himself. At the beginning of the proceedings, he was received by the firing of the guns. The chroniclers' narratives describe how, once Philip reached the Terreiro do Paço, each of the Roman deities "spoke" to the monarch in succession, as if they were interacting with him.[100] This was achieved through the inscriptions in combination with their iconography and the objects they carried. These were seen to "express" the "dialogue." As Philip moved through the pageant, this "conversation" with living and nonliving things continued. The paintings and statues not only recited the basis for Philip's claim to the Portuguese monarchy; they also visually emphasized some of the means by which he had succeeded, including the might of his armed forces in the conquest. Furthermore, the festival accounts also described in detail Philip's discussions with the local authorities and then with

the archbishop of Lisbon. In both exchanges, the parties negotiated the terms and roles in the new political tableau. The pageant became a liminal space in which inanimate things, such as the sculptures and paintings, "interacted" with the ruler as animate, that is, people, did too. In the triumphal path, the statues of nymphs "declaimed" verses directly to Philip. This was a process by which each dominion was able to pay homage to the foremost global ruler.

The association of female figures, damsels or nymphs, with the wealth of the Indies and Philip II's kingly image had been seen previously. It is, for example, illustrated in a letter from medalist Gianpaolo Poggini (1518–1582) to Cósimo I de Médici in 1562 about the symbolic meaning of a medal he had designed for Philip II circa 1559. As was customary, the medal includes a portrait bust of Philip II, and an inscription that presents Philip as the commander of the world encircles his portrait (fig. 72). On the reverse of this medal, a female figure holds a globe and is intended to embody the Indies; Poggini described this side as "a reverse of India,"

for which I dressed men and women with the clothes they wear in Peru, as you see, and

that animal which resembles both a camel and a sheep [a llama] I have portrayed from one which is alive here, and I have included it because it is a rare animal and a useful one, since like ours it gives wool, milk and meat, and it bears loads like an ass. I have shown it burdened with bars of silver. The woman who bears the half globe as an offering represents the province of India as my Lord Gonzalo Pérez is pleased to interpret it. But I prefer to identify her as Fortune or Providence. The idea was mine in the first place, then I discussed it with my Lord and good friend Gonzalo Pérez. It seemed to him a good idea and he spent much effort working on the motto and refining the representation, with the help of many learned men at this court. And accordingly I executed it.[101]

In this letter to Cósimo, Poggini refers to Gonzalo Pérez, still royal secretary to the king before his fall from royal grace, and clearly illustrates the imagery of the medal. Similar representations of the Indies were displayed in the Lisbon ephemera of 1581, and a figure of Providence featured in a prominent location in the Arch of the German Merchants. These images were seen in the light of a visual culture associated with Philip II's imperial representation that had circulated for years, and which was accentuated in the lead-up to the designation of Philip as the king of Portugal. This iconographic repertoire reemerged in the festival decorations, significant sections of which had been planned by court designers who were familiar with the imagery. These images, as seen earlier, circulated across Europe, the Iberian world, and beyond. The continuities found in the visual repertoire associated with Philip and displayed on the ephemeral structures is manifest. In addition, the significance of the images and texts described in the ephemera (which can be traced via a rich and varied array of media, including medals, textiles, and paintings,

among others) shows that they are essential for a full understanding of the ephemeral structures, the built environment, and the visual arts more generally in the period.

The "praise of the prince" was among the most significant tasks of artists and writers in the theoretical thinking of the period and crucial in early modern pageantry. The prince, the king, was a representative figure, an image, and as such had to fulfill his role in the cosmos in a "divinely ordained system of the universe."[102] The perfect ruler in early modern Europe was embodied in the notion of the Christian prince as theorized by philosophers and theologians. Philip II was presented in the ceremonial entry as a global emperor with a divine mission to save the world. The ruler in this pageant fully embodied the notion of the universal monarch envisioned by the thinkers of the time. In this case, Philip's empire surpassed the European limits of Dante's vision. By adding the "souls" and lands from the West and East Indies, he was able to emulate the Christian mission of a Renaissance prince painted by Erasmus in his *Speculum Principis* (1516).[103]

The chronicles describe a number of inanimate characters; in the ideal urban space purposely built in the streets of Lisbon for the festival, these figures came "alive" through their postures and inscriptions.[104] The integration of classical architecture and art with the extant building fabric of Lisbon was intended to create an imaginary classical world for the occasion. This was most visible on, but not restricted to, the Terreiro do Paço. Although no image survives, a detail of the same expansive urban riverfront square in the Weilburg canvas (fig. 57) offers a glimpse of the transformation this space underwent during royal receptions. Ultimately, the combination of the living and still "performers" in the festival with this temporary ideal space had "pseudo-divine" connotations that confirmed the triumphal image of the king as a worldwide ruler.[105]

The role and use of images in public rituals has received extensive attention. Portraits, effigies, and statues made ad hoc or displayed in processions or royal and religious ceremonies have been proved to have had a significant impact on their audiences. The uses of the simulacra of the king in America, for example, or the proven performative function of images in sixteenth-century Venice, are some excellent examples of the role the inanimate has on the living in public festivals.[106] The accounts of the Lisbon festival of 1581 show that the ruler performed his role in the reenactment of his imperial triumph in the Lusitanian capital city, and for his role to succeed in the pageant, he required the company of the statues that flanked him and "spoke" to him as he progressed through the festival itinerary. In the ephemeral triumphal path that took Philip from the Arch of the German Merchants to the Portas da Ribeira, he progressed riding his horse and dressed in black "in the Portuguese style," under a canopy.[107] Statues of nymphs embodying disparate regions of the Portuguese empire "accompanied" him on his progress. In short, both the statues and the personalities that progressed with him formed part of the theatrical cast.

The public rituals and royal ceremonies that concerned Philip's accession to the Portuguese throne were highly mediated. The monarch's costumes during the official meeting of the Courts at Tomar that designated him king of Portugal and the reception in Lisbon are illustrated in two different sources. In a letter to his daughters, Philip mentioned his dislike of the proposed attire for the Courts at Tomar, but it seemed to have been the traditional royal dress in Portugal, and his entourage thought it would appeal to his Portuguese subjects. Philip's appearance for the Courts at Tomar is portrayed in a canvas kept at the San Carlos Museum in Mexico City. In this canvas, Philip II, who had recently been widowed following the death of his latest wife, Queen Anna of Austria, insisted on wearing a black hat as a sign of his mourning.[108] The only other surviving visual representation of Philip II during his trip to Portugal was included in Lavanha's book of the entry of Philip III into the city in 1619. This was a detail of the façade erected by the guild of the stonemasons in 1619 that featured a sculpture of Philip II. The festival account claimed that this was the attire Philip sported in the entry of 1581.[109] A witness reported that he was "clothed in brocade, with the scepter in his hand" and described the ruler as resembling King David.[110] The ruler's attire for these ceremonial occasions was intended to reinforce his authority and at the same time influence the loyalty of his Portuguese subjects through the use of traditional fabrics and designs that would appeal to their image of kingship.

The Duties of a Christian Ruler

The messianic mission to "save the world" was embedded in Philip II's duties as monarch. This divine pursuit had been part of the moral and religious code established by his predecessors, through his royal ancestors from Portugal, Castile, and Austria. This section examines the artistic display devoted to Philip II's lineage and his duties as a Christian ruler. Most of the particular motifs regarding his lineage were present on the façade of the Arch of the German Merchants that looked toward the city (fig. 73, no. 2). This façade had an iconographical program devoted to Philip's son and heir, Diego, and to the glory of his lineage. It emphasized the recognition of Diego as the heir of Philip and prince of Portugal. The repertoire began at the top of the arch with a number of recommendations to Diego respecting his duties as a future monarch. The rest of the façade boasted Habsburg imperial symbols. A winged representation of Providence raised her arms toward the sky, holding in her hands two squares imitating stone (fig. 73, no. 4).[111] These "marbles" have inscriptions

FIGURE 73 | Hypothetical elevation of the Arch of the German Merchants erected in Lisbon for the entry of 1581. Façade facing the city. Drawing by author and Harry Kirkham.

1. Diego.

2. Emperor Charles V.

3. Philip I of Castile.

4. Providence.

5. Mercury.

6. Hercules.

7. Charles V.

8. Inquisition.

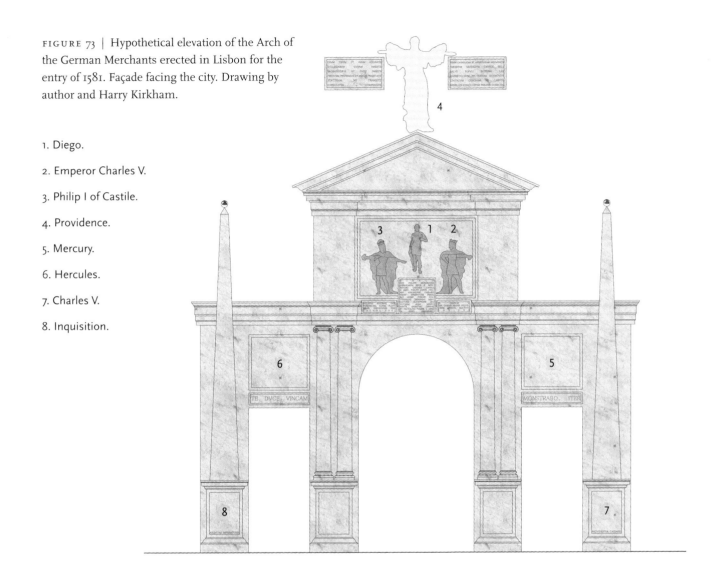

advising the young prince. Beneath this figure was a panel with additional figures: in the center stood Diego (no. 1), flanked by his grandfather Charles V (no. 2) and his great-grandfather Philip I of Castile and Archduke of Austria (no. 3).

In the painting beneath the prince, a nymph, identified as "princess of Lisbon," offers a jewel to foster faith and love in fruitful marriages that would result in offspring who would perpetuate the dynasty. The nymph also holds two shields intertwined with the arms of Portugal and the Algarve,

symbolizing the acceptance of Diego as heir to the Lusitanian throne.[112] The "providential" advice in the form of inscriptions on the squared "stones" carried by Providence above read as follows (no. 4): (1) DEUM TRIUM ET UNUM ADORATE (Adore God as a trinity and one); (2) ECCLESIARUM CURAM HABETE (Protect the Church [Take care of the Churches]); (3) SACERDOTIBUS VT PATRI PARETE (Obey the priests as your father); (4) PIE-TATEM PROPINQUIS ET AMICIS PRAESTATE (Be merciful with relatives and friends); (5) STATERAM

NE TRANSITE (Do not contravene the equality of justice); (6) CUPIDITATES COMPESCITE (Restrain disordered thoughts); (7) FIDEM CATHOLICAM ET APOSTOLICAM PROPUGNATE (Defend the Catholic and Apostolic Faith); (8) VIRGINUM VES-TALIVM CUSTOS ESTO (Be the guardian of the nuns); (9) SALUS POPULI SUPREMA LEX (The health [welfare, good, salvation, felicity] of the people should be the supreme law [a widely cited maxim from Cicero's *De legibus* 3.3.8]); (10) HAE-RETICORVM proterviam EXTINGUITE (Extinguish the contumacy of the heretics); (11) CIVITATUM CORONAM NE CARPITE (Do not divest the privileges of the cities); (12) REBELLES CONCILIORVM FRAENO COERCITE (Restrain with advice the vanquished rebels).[113]

The "instruction" to the young prince summarized the messianic mission of the dynasty. Guerreiro's translation of the Latin inscriptions into Portuguese reveals that he slightly edited the text to cater it to the occasion. The heir and his dynasty were the incarnation of the *fidei defensor*, predestined to spread and protect the Catholic faith. The last two instructions are particularly representative of this political juncture and were aimed at Philip (not Diego). The City of Lisbon was expecting and hoping that the ruler would ratify his acquired rights, as the speech declaimed at the foot of the arch erected by the city council (the Portas da Ribeira) would emphasize. The last instruction carried by Providence resonated with the archbishop of Lisbon's request during the Mass at the cathedral, in which he begged Philip to pardon the rebels. Philip's Portuguese subjects thought this message carried by the image of Providence was for them, insisting that the ruler take their advice in handling the punishments reserved for those who had supported, or still supported, António.

Inscriptions below the painted figures of Diego, Philip, and Charles V reiterated the dominions they had acquired during their respective reigns and the responsibilities that these carried.[114] The

inscription beneath Diego showed his ancestry from the Austrian branch of the family down to Frederick III (1415–1493). This panel celebrated the Habsburg dynasty and its genealogy.[115] If it were true that God had blessed the accession of Philip II not only to the Lusitanian throne but also to the largest empire ever known, it followed that the monarch had a number of responsibilities to meet, and so would his successors. Like the façade facing the Tagus, the decorative program on this façade extended to the panels atop the lateral entrances (nos. 5–6) and the pedestals supporting the obelisks (nos. 7–8). The program explored the iconography of Charles V in order to present him as the role model for Philip II and his heir. The "instructions to the Christian prince" briefly summarized in the inscriptions bore a resemblance to some of the advice on pious and divine matters that Charles gave Philip upon his abdication in 1555.[116] The rest of this façade emphasized the fame Charles V had bequeathed to the Habsburgs, which Philip II had aggrandized with the Portuguese succession. Representations of Mercury and Hercules highlighted Philip and Charles as Christian rulers and models in the art of ruling whom Diego would emulate.[117] In this display, Diego was provided with detailed instructions on how to be the leader of Christendom and how to become worthy of ruling the world, in the manner of his predecessors. The message of the façade was another means to praise Philip, as Diego was not present (and indeed he would not succeed Philip, for he died in infancy). This façade established a strong relationship between Philip's dynasty and its messianic mission. As seen earlier, Philip II was also represented as a shepherd and pastor leading the flock on the lateral façade of the Arch of the German Merchants, and some of this imagery is also found in the Bengali colchas, which came to highlight the ruler's messianic mission.

The paintings on the six panels located along the triumphal path, which preceded the sequence

of statues examined earlier, represented victorious battles and themes that emphasized Philip II's role as *fidei defensor*. The first panel both praised the propagation of the Catholic faith by Charles V and Philip II against Muslims and Lutherans and also emphasized the relentless expansion of religion in the West Indies. The inscription read: "CRESCIT RELIGIO. PLVS VLTRA" (Religion grows further beyond). On this panel was written "FIDES PROPAGATVR" (the Faith is propagated).[118] In becoming king of Portugal, Philip II was duty bound to defend the realm, becoming not only its leader but also its hero. The notion of the monarch's Christian duty and self-sacrifice for the realm was explored in the festival through heroes of ancient Rome such as Marcus Curtius. These representations formed part of the interior decoration of the passageways of the Arch of the German Merchants. Pliny the Elder narrated the oracle that augured that Rome would be safe only if "courage" was sacrificed, hence Marcus Curtius, Pliny says, threw himself over a precipice. The ephemera in the festival emphasized that Philip was ready to make the same sacrifices for the people of Portugal.[119] The model of imperial Rome was echoed at every opportunity to establish the desired triumphal grammar. Philip II had participated in numerous festivals before, but this triumphal entry had special connotations. He began his journey to Portugal while Alba was still campaigning for the conquest of the realm. The monarch did not engage in the battlefield, but he followed events closely as he made his way to Lisbon. After the victory at St. Quentin at the beginning of Philip's rule, the Portuguese war was the closest involvement the monarch had in one of the military campaigns fought by his forces. At St. Quentin, Philip's father, the late emperor, had led the campaign; this time, Philip was the ruler, and the Portuguese succession was his own achievement and would grant him fame in posterity.[120] Historians, lawyers, and philosophers at his court emphasized his rights to the

Lusitanian throne, since the Portuguese succession had to be gained by rightful inheritance. As seen earlier, this theme appeared in a variety of forms in Lisbon in 1581. In this way, Philip's entourage aimed to craft an image of the monarch in the Lusitanian affair that would promote a favorable narrative of Philip's reign and secure his fame in posterity.

The significance of the Iberian Union on contemporary representations of the monarch was exploited in the decorations deployed at the festival, and it reverberated elsewhere. Evocations of ancient Rome and Philip's heroes, as seen in the festival, were also reinvented in the seal adopted after he was crowned king of Portugal (fig. 74). On one side of the seal Philip II is represented as a Roman emperor, seated on his throne. The accompanying inscription, although damaged and unclear, reads "PORTUGALLIA," which unequivocally identifies the period in which it was created. On the other side, Philip is shown riding a unicorn and brandishing his sword in a combative attitude, defending Christendom from its enemies. Emblems with similar content appear in San Pedro's manuscript and also in the festival decorations of 1581. The costume Philip is shown wearing on the seal echoes those of classical antiquity. The new arms of the monarch are displayed on both faces of the seal, where the shield of Portugal is found amid the arms of Castile and Aragon. The seal is kept in the Vatican Secret Archive and was probably sent to the pope to commemorate Philip's Portuguese succession. Similar imagery appears in a well-known medal that presents Philip II as "NOVI ORBIS REX" (The new king of the orb). In this medal, coined in Lima, Philip is shown riding the orb, and an inscription reads: "Non Sufficit Orbis" (The world is not enough), words originally written by the ancient Roman poet Juvenal for Alexander the Great.[121] This image from Peru further indicates that Philip's image in the aftermath of his accession to the Lusitanian throne was circulated

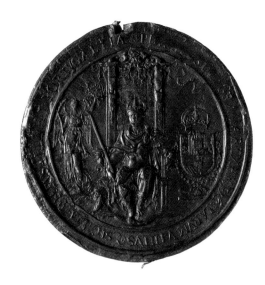

FIGURE 74 | Seal of Philip II after his succession as king of Portugal. Fondo Sigilli staccati, 6. © 2019 Archivio Segreto Vaticano.

much more widely than previously imagined. Some of these images and inscriptions were also employed in the funeral ceremonies held to mourn his death in 1598.

Intellectuals and theologians had explored the notion of "emperor of the Indies" in relation to Philip II's monarchy, and these ideas were reflected in the imagery that emerged during his reign and were also present in the festival of 1581. Juan Ginés de Sepúlveda (1494–1573), for example, in his *De regno et regis officio*, a treatise on good government dedicated to Philip II, argued that God had chosen the Spanish monarchy to "bring the inhuman into the sphere of the human." The author adapted Aristotle's postulates on slavery, which divided realms into different types: those equipped to practice civil government, those fitted to manage their own affairs only but not suited to exercise rule over others, and finally "barbarians," whose traditions infringed God's natural law.[122] In the festival of 1581, the visual repertoire not only justified expansion overseas and the incorporation of Portugal into Philip II's empire but also conveyed the notion of a common consciousness of superiority. This belief, as reflected in the image of the ruler, was promoted in the festival decorations and in representations of Philip II following the Iberian Union. As seen earlier, emblems such as Jacome da Trezzo's initial design of the carriage of Apollo and its inscription were adapted for the festival. The new design and inscription aimed to encompass the recent expansion of the empire and also the messianic mission of the ruler. In the same manner, efforts by contemporary thinkers to morally justify territorial expansion in the Americas were now applied to the Portuguese empire. For this reason, the triumphal discourse exhibited in the festival was accompanied by a lecture on Catholic morals in order to justify the divine selection of Philip II and his dynasty to rule the world.

"A Portrait of the World": The Rua Nova dos Mercadores

Philip II's reception in Lisbon in 1581 was celebrated in a significant number of ephemeral structures funded by local guilds, as noted above. While the display in the Terreiro do Paço had an extensive triumphal grammar associated with the monarch, the ephemera within the city fence celebrated not only Philip's triumph but also the city of Lisbon. The first of the structures to make a clear reference

to the city was the Portas da Ribeira, which had been decorated with a temporary façade (fig. 61). The old gate was transformed into a triumphal arch, the permanent structure constrained to a double-arched structure. This gate, as seen earlier, had been funded by the local authorities and aimed to identify the city of Lisbon. It was at the foot of this arch that the speech by the city authorities was declaimed. The inscriptions on the façade underscored Philip II's role as the ruler who had finally achieved the dream of Roman Hispania (i.e., a united Iberia). From this arch the procession progressed toward the cathedral, passing a number of arches with rich iconographical displays that transformed the streets of Lisbon. The procession toward the cathedral was made through the medieval street network of Lisbon, where temporary classical arches stood at the junction of streets for their embellishment. This was the case for the twin arches built at the intersection of the Ruas de São Crispim and Madalena for the Lisbon fete of 1581, which boasted similar architectural design. They were funded by the guilds of hatmakers (*sombrereros*), hatband makers (*sirgueros*, from the Portuguese *sirgueiros*), and confectioners. A panel atop each arch was decorated with a painting, which, according to Velazquez Salmantino's interpretation, evoked the riches of the Tagus and of Lisbon. The route to the cathedral along this street mounted a steep hill.[123] These arches, erected at the intersection of two narrow streets and built to a monumental scale, were designed to take advantage of the hill to impress the viewer. This triumphal architecture ordered the space within the inner fence area of the festival itinerary, thereby transforming it into an ideal scene according to Alberti's treatise. In the relevant passage, Alberti cites Tacitus regarding the construction of triumphal arches: "That the squares and the crossroads of the most principal streets [shall] be embellished with arches constructed in the entry of these streets, because it is the arch [that is the best element to usc] by

those who are knowledgeable of the [Roman] Empire."[124] These arches, and other ephemeral structures in the pageant, aimed to fulfill the imperial urban order recommended in theoretical treatises in the period. In this case, the location of classical arches enhanced the theatrical role of the ephemera. These novel designs contrasted sharply with the extant urban fabric of Lisbon at the time. Reforms in the legislation for design of residential architecture had been enacted long before Philip's arrival.[125] In fact, regulations for building activity in Lisbon preceded similar regulatory mechanisms in Madrid. However, as in other cities in the Iberian world, these new designs coexisted with ingrained traditions in the building and design of houses (see chapter 1).[126]

The climax of the celebrations took place in the Rua Nova dos Mercadores.[127] Ephemeral classical façades and triumphal arches were erected along the famous street for the occasion. This *rua* was one of the main ceremonial spaces in the city, and in the pageant of 1581 it witnessed a number of lavish apparatuses and inventions. As in the rest of the processional route, these sumptuous ephemeral decorations—which boasted architectural design at the forefront of transregional design trends—contrasted with the building fabric, where *casas con andares de resalto* (houses with protruding stories) dominated the streetscape, including the Rua Nova dos Ferros (see fig. 75).[128] This street was so crowded that the procession had difficulty progressing. Guerreiro reported that the king saw a surprising display of structures, along with masses of people on foot and at the balconies and windows. "The streets and windows were decorated with rich brocades and silks and fine hangings that endowed them with splendour . . . worthy of the triumph of such a . . . monarch," Guerreiro tells us.[129] The chronicler mentioned that the walls of some of the buildings on this street were adorned with *armaçaoes*, temporary façades often made of wood and covered with painted fabric (sometimes

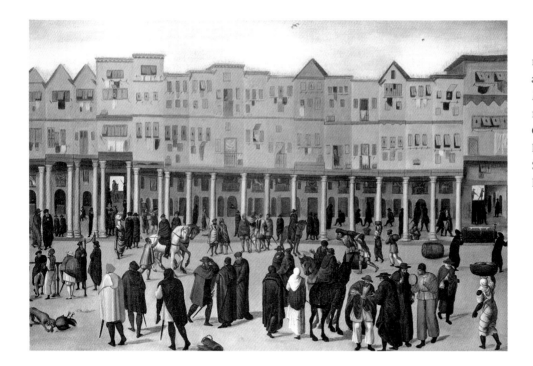

FIGURE 75 | Unknown artist, *Rua Nova dos Mercadores*, Lisbon, ca. 1570–90, detail. Rossetti Collection at Kelmscott Manor. Courtesy of the Society of Antiquaries of London.

the fabric was nailed onto the façade, covering all or part of the building).

Rodrigues Soares recounted the competition that the city council had established for the best-garlanded façade on the route, which was similar to the prize the city council had established for the best-decorated boat on the Tagus.[130] These incentives aimed to foster the embellishment of the town for the royal reception and stimulate the participation of citizens. In Guerreiro's words, the Rua Nova was so colorful that it was a *retrato de todo o mundo* (a portrait of the whole world).[131] The cosmopolitan character of Lisbon had been praised by contemporaries, including Philip himself, who saw the city's port as the commercial center of "everything."[132] If Terreiro do Paço was the royal stage par excellence, then the Rua Nova dos Mercadores was not only the commercial center but also one of the most important spaces of social encounter in Lisbon. Guerreiro's description may seem hyperbolic; however, a closer examination of the space, the ephemeral displays, and some of

Philip's interactions with the people on the Rua Nova and elsewhere on the route bear out Guerreiro's statement. The painting of the Rua Nova dos Mercadores, kept in the collections of the Society of Antiquaries (London) at Kelmscott Manor, offers a glimpse not only of the urban fabric that dominated Lisbon's main street and the townscape of the city in the sixteenth century, but also the bustling commercial activity that characterized the Rua Nova. The Spanish dramatist Tirso de Molina (1579–1648) described the avenue in similar terms: "There is a street which contains the greatness and wealth of the east, so much so that the king told me that there is a merchant there who, incapable of counting the money, measures it by the bushel."[133] Many other writers described the Rua Nova and, like Molina, they tended to emphasize those things that impressed visitors most: the variety of goods sold and the crowds of people. The classical ephemera, the hangings and rich fabrics decorating buildings, and the *armaçaoes* on some of these edifices would have transformed the space during

the festival of 1581, though existing buildings, as in the case of Terreiro do Paço, would still have been visible.

The space crowded with people and the façades with hangings and fabrics from the East, paired with the contrasting ephemera and existing architecture, would have presented a condensed version of the diversity of the realm and its empire. For this festival, the Rua Nova was an example of visual and spatial amalgamation, distinguished by the richness of the origin of the fabrics on display, a variety only a few cities in the Iberian world could match. With the addition of the ephemeral displays and hangings, it became a showcase of pan-Iberian visual trends as well as of the architecture and symbols that identified the Lusitanian capital city and its traditions. In short, the visual arrangement of this ceremonial space was a product of cultural synthesis, as were the other buildings, streets, and cities in Philip's empire.

The Rua Nova fashioned a great variety of ephemeral structures. The silversmiths' guild erected a façade that accounts claim was made of silver. The magnificent structure was composed of a double-arched triumphal arch with Ionic columns topped by three obelisks and two oval panels with one eagle each. The theme of this arch was the Castilian and Portuguese union, including allusions to the lineage of kings in the form of a genealogical tree similar to those that emerged in Philip II's court between 1579 and 1581.[134] The goldsmiths' guild erected a large structure composed of a column that supported a monumental statue of Justice emphasizing the monarch's virtues. There were more lavish ephemeral structures in the Rua Nova, including known landmarks in the street such as the arch in the Porta da Moeda and the façades in the Poço da Fotea and the Chafariz, among others. Collectively considered, the number of structures built in the Rua Nova alone matches or surpasses those erected in other cities for festivals in this period.

As discussed above, ephemeral displays were often employed by festival patrons to praise the king and also to communicate their wishes and demands to him. In Lisbon, the dialogue between Philip and the civil and religious Lisbon authorities was the product of a negotiation between parties and was carefully staged for the festival (and the written accounts thereof). Interaction between ruler and ruled was not restricted to ruling elites— it also involved other participants. For example, a group of women (*regatonas*) sang and danced for the king when the procession reached the Rua Nova. Once their performance had concluded, one of them unexpectedly told Philip that they were happy to receive him and swear loyalty to him, but only until Sebastian of Portugal returned; she added that, upon Sebastian's return, Philip would have to go back to Castile. The impromptu intervention seems to have made the king smile broadly (*se sonrió mucho*). Delighted with the dances, Philip commissioned a painting of them, which either has been lost or has not yet been identified.[135] Neither Guerreiro nor Velazquez Salmantino recorded this episode; they had their own agendas (aimed especially at pleasing their patrons), and decided not to recount the *regatona*'s direct interaction with the monarch. That spontaneous exchange is a useful reminder that festivals had different meanings depending on the status of the viewers and their position and location in the pageant.

Guerreiro's account, and often also Velazquez Salmantino's, followed each of Philip's glances, conveying the impressions and emotional impact that the ephemeral structures, music, and diverse commemorations had on him. The monarch admired the songs and music staged by the stonemasons' guild in the only *tableaux vivants* of the festival, at the Fangas da Farinha, a structure erected in the vicinity of the Rua Nova.[136] The festival of 1581 featured a large number of triumphal arches—the previous royal entry of Philip's sister, Joanna of Austria, for example, had only one, and

boasted numerous *tableaux vivants* instead. This shows a "classical shift" in the design of ephemeral displays that was not only the product of a change in artistic taste but also a reflection of the triumphal character of the festival. The apparently half-built structure of the *tableau vivant* at the Fangas de Farinha had a wooden stage on which a number of masons performed a scene in which they pretended to be at work on the pediment of the façade. They sang to the rhythm of their hammers under the orders of a master mason. The façade of the apparatus had statues imitating marble at the top of each corner, which the chroniclers described "as a woman with a laurel wreath and holding a book," probably a representation of Clio, the muse of history. The chroniclers recounted that Philip was delighted with the performance.[137] Unfortunately, this song has not been recorded in any known accounts; the writers were more interested in conveying the monarch's emotional response to the performance.

The Entry *of* 1581 *and Its Visual Reverberations*

As we have seen, the decorative program of the Arch of the German Merchants showcased the vigorous imperial supremacy of the Habsburg dynasty. The façade facing the city exalted Philip II's lineage and his role in the propagation and defense of the Catholic faith and the empire. In this sense, the iconographic program of the festival, and especially the iconography of the façade facing the river, supported the image that Philip aimed to project in his new realm. The military parade staged on the Tagus only reinforced the power of the ruler and the message he had prepared for Portugal. The dialogue exchanged between the king and the city's ruling powers, both lay and religious, highlights the tense moment in the dynastic transition. In the month before his arrival, Philip informed the city authorities of his decision to make Lisbon the temporary residence of his court.[138] The king would not enter the city in passing but, on the contrary,

he wished to stay, although in the end Philip stayed only until his rival António had been defeated. His intention was clearly to establish his rule through government and by vanquishing his enemies within the kingdom.

That only a couple of months before his arrival the city was anxious about the organization of the royal festival is enlightening. The ruler interpreted this anxiety as hesitance. This made the situation tense, and Philip's letters concerning this matter of mounting the festival contained subtle threats, along the same lines as his earlier correspondence concerning the Portuguese succession. Many of the structures were unfinished, yet their high number is extraordinary when compared with previous festivals staged in Lisbon. It is indeed astounding that the city managed to erect up to fifteen arches and façades for Philip's arrival in 1581. Reviews of their quality were mixed, but the reviewers were biased, especially given the political climate. The local authorities aimed to please the king and compensate for the dramatic political events and "misunderstandings" prior to his arrival. There may have been an element of fear, as it seems logical that no one in the city was in a position to challenge Philip directly. It is clear now that the festival was the product of a common effort on the part of royal designers and local powers. Lisbon's local guilds, lay and religious authorities, military and religious orders, and foreign communities were able to reverse the formerly tense situation with the construction of a festival that Philip II would cherish: it is widely known that the ruler kept a painting in the Alcázar in Madrid depicting the arches built for him in Lisbon.[139] In fact, the Lisbon festival of 1581 surpassed any earlier royal entry and transformed the festival culture of the capital for years to come. The royal designers implemented an iconographical program that resorted to the emblems and ideas used to represent the ruler, but these were adapted to embrace the imperial expansion and the message they aimed to transmit to his enemies. The combination of local festival traditions and the

extent of iconography deployed in the structures suggest that there was an established ceremonial culture far beyond what thus far has been believed to exist.

The festival in Lisbon followed a program (especially in the river parade) that supported the image that Philip as ruler and military commander wished to portray. The wishes, concerns, and fears of the local authorities were expressed too, not only through discourses but also in the art displayed. For example, the *chafariz* (fountain) in the Rua Nova dos Mercadores was covered by an immense decorated façade. A female figure personifying Victory presided at the apex of the apparatus. The central panel was painted with Temperance carrying the Portuguese flag and dominating Desire, personified as a man trying to "eat" the earth. On the left-hand panel was Time, with an inscription that read, "the power of fame is subject to the free will of Time, which discovers all badness." The last panel represented Fame, who in combination with Mexerico (translated as "tattle" or "gossip") would divulge everything, "saying more than is expected."[140] This display was intended to warn the king of the dangers inherent in his power and dominion over the world. Didactic recommendations like these were common in early modern festivals, but on this occasion the "lecture" was presented in "direct language," with not-so-subtle barbs. There was no reference to Philip II's good government at all, or any other flattering messages. The iconography emphasized the direct tone of the inscriptions: the only kingdom represented was Portugal, whose arms appeared on a flag carried by Victory. In short, the scene was presented as Victory trying to calm the greed of man who wanted to eat the earth. Earlier on, we saw how much of the artistic program was devoted to the exaltation of Philip II's domination of the world. Here, it is strange that there was no explicit statement that would exempt Philip from any relationship with this "greedy character." This might have been a form of visual contestation or a warning to the ruler. Teófilo Ruiz has

argued that Castilian and Aragonese festivals were a space of contestation and protest, too.[141] In the end, this demonstrates that the festival portrayed not only the king's wishes but also, even when chroniclers tried to minimize them, the expectations of Philip's Portuguese subjects.

The ephemeral structures, the design of which was imbued by classical notions of order and proportion, blended with the residential building fabric of Lisbon. The synthesis of both, especially in the Rua Nova dos Mercadores, offers a glimpse of the Lusitanian empire Philip was to rule. The hangings and textiles that decorated the balconies and façades of buildings came from disparate parts of the Portuguese world and were a reflection of the commodities sold in the shops of the Rua Nova and adjacent streets. The circulation of precious objects and fabrics created in Africa, Asia, and America for the Portuguese market and elsewhere in the empire and beyond is a good analogy for the circulation of images of the king. The Iberian Union fostered the renovation of Philip's kingly image. Imagery and texts about Philip were adapted to encompass the incorporation of Portugal and its dominions into the already extensive territories under Philip's rule. More important, the images created in the years before Philip's designation as king of Portugal were not only displayed in the festival structures of 1581 but also featured in manuscripts, prints, paintings, textiles, and written accounts in Europe, America, and Asia. These artifacts emerged during his reign and even after, as seen in the seventeenth-century Bengali hangings, for example. Many were echoed in the funerals staged in cities across the Iberian world to mourn his death in 1598.

Philip's role in the 1581 pageant deliberately appealed to these ideals of universal authority. The spatial location of the decorations on the Arch of the German Merchants and triumphal path were part of an orderly and coherent program. The triumphal path had special relevance since it recalled the drawing *Trivmpho Primero Imperial* from San

Pedro's *Diálogo*. Philip reenacted this triumph in the 1581 pageant. The chroniclers, especially Guerreiro, described the pageantry as if Lisbon had become an ideal "imaginary world" for a semi-divine ruler. The temporary architecture echoed this triumphal language through its profusely decorated arches and façades. The performance of triumph followed an orderly etiquette in which "inanimate" and "living" actors fulfilled their respective roles. Accounts avoided references to any notes of possible discord in the celebrations. The intention was to present Philip as a quasi-divine figure equipped to rule Portugal and the globe.

Ultimately, this festival had no parallel in any other celebration staged before in the city, and Lisbon presented itself as one of the most prominent capital cities on this side of the Atlantic coast. In fact, Granvelle suggested that Philip II make Lisbon his permanent residence, giving rise to rumors that the capital of the empire might move from Madrid to Lisbon.[142] One of the most important themes of Philip III's entry into Lisbon in 1619

was the presentation of Lisbon as the perfect metropolis for the empire.[143] Portugal saw this possibility as a way of bringing the wealth of the empire to the city and the realm.

Lisbon grew to become one of the most strategic cities of the empire, and Philip entrusted Filipo Terzi and Juan de Herrera with the design of a new tower at the Paço da Ribeira (the royal palace in Lisbon).[144] Unfortunately, the building was badly damaged by the earthquake of 1755. Other major reforms in the urbanism and architecture of the city were undertaken during Philip's reign. The monastery of São Vicente de Fora survived the disaster of 1755. In the eighteenth-century cityscape depicted on tiles, the imposing tower erected under Philip's order is clearly visible (fig. 76). São Vicente de Fora and other important buildings in the city, such as the Se cathedral, Saint George's Castle, and the Terreiro do Paço can all be identified. These new developments were not completed until after Philip's reign, yet they became a testament of his legacy for the city. Before the disaster, the riverfront tower and the monastery were prominent in the city's urban landscape, thus stating the presence of Philip's patronage and projecting Habsburg authority.

FIGURE 76 | Cityscape of Lisbon, ca. 1700. Courtesy of the Museu Nacional de Azulejo, Portugal.

Chapter 4

On History and Fame

PHILIP II'S KINGLY IMAGE AND THE SPANISH MONARCHY

In his *Tesoro de la lengua castellana*, Sebastián de Covarrubias y Orozco defines history as a narration of the events of the past that should be written by an author who was an eyewitness to those events. He concedes that historians unable to witness events firsthand can also rely on good original sources. Covarrubias evokes Pliny the Elder's histories and concludes with a reference to *libros historiados*, history books that also contain "figures in drawing or print" that illustrate the stories in the text.[1] Covarrubias concisely describes the relationship between word and image in written and visual chronicles of history in Castile, an imagery that is critically important to understanding ephemeral and permanent architecture in this period. Furthermore, Covarrubias's view on history writing and recording echoes notions of memory and history seen in the discussion of the Simancas archive in chapter 2 and in the chronicles of Philip's journey to Portugal and his entry into Lisbon, discussed in chapter 3. Among the historiographical traditions in the sixteenth-century Spanish court, Charles V and his entourage favored a history that celebrated

the *res gestae* (Latin for "things done") and thus exalted the deeds and major accomplishments of the ruler. The history of the realm (*historia pro patria*), on the other hand, was favored by the courts of Castile that from 1523 requested the expansion of the existing chronicle of the kingdom from the monarch.[2] Philip II inclined toward the *historia pro patria*—that is, the history of the realm—over personalized histories centered on the ruler.[3] After all, the monarch had rarely been involved in military campaigns during his reign, and the grand narratives of the military hero better suited Charles V's military career. Philip II refused any kind of biographical work that would be perceived as vain, for vanity was a mortal sin. However, his views on the function of history evolved over time, as history was indeed useful to counteract the negative accounts of his reign and rule that circulated in Europe and elsewhere. Girolamo Conestaggio's account of the Portuguese succession, for example, famously characterized Philip as a usurper. It is not surprising that Velazquez Salmantino's printed chronicle of the royal progress into

Portugal and the Lisbon entry tried to mitigate the damage to Philip's reputation.[4] In a similar vein, Philip promoted the work of Antonio de Herrera y Tordesillas (1549–1625/26), a prolific author whose writings included histories of Portugal, a general history of the world, and a description of America. The literature has paid some attention to history writing and also to visual representations of history.[5] However, the relationship between written and visual histories and, above all, the image of the universal monarch as reflected in his funeral accounts deserve further scrutiny.

This chapter examines written and visual chronicles of warfare and funeral accounts that emerged upon Philip's death to explore the construction and circulation of the image of the universal monarch. I offer a new reading of the fresco cycle in the Hall of Battles at El Escorial as a work of history. The literature has contextualized the sixteenth-century battle scenes in the Hall of Battles with history books, tapestries, and paintings in the royal collections.[6] My contribution expands this discussion by comparing methods of pictorial copy, replication, and history recording employed at the Hall of Battles with other examples in the Spanish court and elsewhere in Castile. I focus in particular on the *Higueruela* scene that famously depicts John II of Castile's victorious battle over the Kingdom of Granada in 1431. This fresco has received less attention than the other scenes in the hall, for there was no known copy of a fifteenth-century battle image to which it could be usefully compared.[7] In this chapter I compare *La Higueruela* to a little-known drawing of the Battle of Jimena that occurred in 1431 as part of the same campaign; this drawing, like the fresco at El Escorial, is also a copy of an original.[8] This has enabled me to establish a parallel between the hall and practices beyond the Spanish court. This comparison, I contend, shows that the scenes in the fresco cycle project a historical narrative that celebrates the history of the realm and the royal dynasty, and also illustrates

that trends in visual chronicles of history transcended court circles. Furthermore, an analysis of how the themes depicted in the frescoes at the Hall of Battles are reflected in Philip's funeral orations strengthens the case for reading the hall as a work of history and also demonstrates that the channels that fostered architectural, visual, and cultural circulations were well established by the end of Philip's reign.

The monarch commissioned these paintings in the Hall of Battles beginning in 1584, and the frescoes represent some of the triumphs of his forces as well as John II of Castile's defeat of Granada in 1431. While the fresco cycle was complete before Philip's death, some of the themes treated in these paintings were later reflected in the repertoire displayed in many of the monarch's funeral ceremonies. The meaning embodied in these scenes and Philip II's role in them can be interpreted as *fidei defensor* (defender of the faith) against Islam, in the *Battle of La Higueruela* fresco; hegemony in Europe with the victory over France, in the scenes of the St. Quentin campaign, after which the Peace of Cateau-Cambrésis (1559) was ratified; and finally the accomplishment of global empire with the unification of the Iberian Peninsula under Philip's sole rule, embodied in the frescoes of the battles at the Azores.[9] Why were the events and themes narrated in the hall present, sometimes with explicit detail, in funeral accounts that mourned Philip II's death? The second part of this chapter explores the projection of Philip's kingly image in the funerals celebrated to mourn his death and the role that repetition played in enabling imperial circulations. Upon Philip's death, fragments of his life were presented in sermons, funeral services, and ephemeral architecture erected to mourn his loss. Elegies, sonnets, and printed and manuscript accounts underscored aspects of his personality and religious devotion. Funeral chronicles provided a curated narrative of Philip's biography that recounted his kingly achievements and heroic deeds,

the *res gestae*, and these, together with other aspects of his royal image, were reflected in a plethora of documents and ephemera.[10]

With the death of Philip's father, the late Holy Roman emperor Charles V's *res gestae* was portrayed not only in the funeral in Brussels but also in the many funerals in absentia that were staged in cities across Iberia, Europe, and America. The richness of the material produced for Charles V's funerals has received extensive scholarly attention.[11] However, the funerals that commemorated the loss of Philip II deserve further scrutiny, as they have never been comparatively considered before. The sheer number of funeral chronicles, sonnets, panegyrics, and eulogies makes a comprehensive comparative analysis unfeasible. Nevertheless, the manuscript and printed sources examined for the present chapter offer a window on the way the life of the ruler was mourned across cities and towns in Iberia, Europe, and the wider world. To this end, this chapter explores the circulation of images, mottos, and attributes that had been associated with Philip during his reign against the way these are present in funeral accounts. This study does not intend to question whether the narrative of these funeral accounts was directed under the umbrella of the court in Madrid. Earlier chapters in this book have shown that the way ideas, designs, and knowledge traveled across the empire cannot be explicated only via the center-periphery dynamic. It has already been established that Philip is not known to have promoted any biography of his life during his lifetime. The fact that several histories and ideas with regard to Philip and also those found at the Hall of Battles are replicated in many funerals is the product of coeval networks of knowledge, as illustrated in earlier chapters of this book. While the vast majority of accounts examined provide a favorable image of the monarch, the images of rule associated with Philip were indeed the product of political propaganda. There were also significant countercurrents promoting a negative vision of the monarch and his rule, which has fed the Spanish Black Legend; this trend has persisted for generations and still informs portrayals of the king in popular culture today.[12]

From a close reading of numerous funeral accounts, it is evident that the content is repetitive; the genre (eulogies, panegyrics, and so forth) that recites the life of the monarch and remarks on his piety and religious devotion is one that invites replication. Analyzing curated biographies of the ruler present in an array of funeral accounts that retell analogous narrations of Philip's life and reign would *a priori* seem a particularly tedious undertaking. I have thus made a careful selection of funeral accounts and considered the role that repetition played in cementing an image of the monarch in locales within and beyond Philip's empire. I argue that the reiteration of imagery that had been associated with the ruler for decades further demonstrates the imperial circulations present in the period.

Visual Chronicles of History and the Hall of Battles at El Escorial

The Hall of Battles in El Escorial Monastery is a long gallery covered in frescoes commissioned by Philip II. The dimensions of the space are spectacular: the hall is almost sixty meters long, six meters wide, and eight meters high, with a rectangular floor plan. The space is completely decorated and the height of the vault emphasizes the monumentality of the hall. The light entering the hall is filtered through a series of windows facing the perfectly squared cloister on the south side of the monastery. This gallery is one of the most remarkable spaces in El Escorial, located adjacent to the choir of the basilica (fig. 77). The building itself is the prime example of the Austríaco style in architecture developed by Philip II and his architects. The longest fresco in the hall depicts the Battle of La Higueruela of 1431 against the Kingdom of

FIGURE 77 | Hall of Battles, El Escorial, location and distribution of scenes. Photos © Patrimonio Nacional. Plan and diagram by author and Harry Kirkham.

Clockwise from right: The Hall of Battles, general view; three details of La Higueruela; detail of La Higueruela, Granada City.

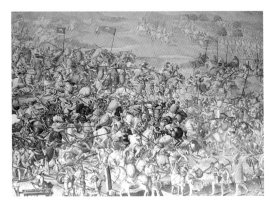

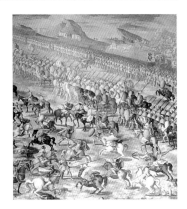

1. The Battle of La Higueruela.

2. The Siege of St. Quentin.

3. The Battle of St. Quentin, 10th of August 1557.

4. The Seizure of St. Quentin.

5. The Taking of Chatelet.

6. Movement of the Troops on the way to Ham.

7. Conquest of Ham.

8. First Scene. Battle of the Gravelines.

9. Second Scene. Battle of the Gravelines.

10. Philip II's camp, Doullens.

11. Naval Battle of San Miguel de las Azores, 1582.

12. Spanish Landing on the Island of Tercera, 1583.

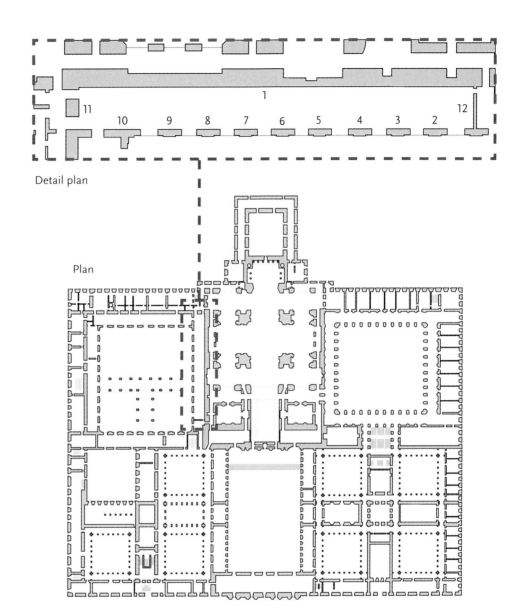

Detail plan

Plan

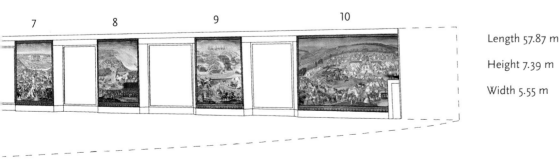

Length 57.87 m

Height 7.39 m

Width 5.55 m

Granada, and completely covers the wall adjacent to the basilica. Facing this, in the wall panels between the nine windows of the chamber, a number of scenes represent Philip II's victories in the Netherlands and France, including the famous Battle of St. Quentin (1557). The remaining walls are painted with frescoes of the battles of the Azores (1582–93). These naval battles vanquished António Prior de Crato's pretensions to the Lusitanian throne and further established Philip as the ruler of the largest European monarchy ever known. The battles represent some of Philip II's triumphs and those of his ancestors; Philip was present in the battles that gave the victory to his father at St. Quentin, and as monarch he ruled over the struggle against the forces commanded by António for the Portuguese succession. ·

The frescoes were painted between 1584 and 1591, and the team of artists entrusted with the work came to El Escorial as assistants to the Genoese painters Luca Cambiaso (1527–1585), known as Luquetto da Genova, and Giovanni Battista Castello (1509–1579), known as Il Bergamasco.[13] Lazzaro Tavarone (1556–1641) was an apprentice to Luquetto and Orazio Cambiaso was his son; Fabrizio Castello (1562–1617) was Il Bergamasco's son and Niccolò Granello (1553–1593) was his stepson. Before this commission, the team of artists had already painted the majority of the ceilings at the monastery during this period.[14] The first section to be decorated was the vault, on which work began in December 1584. It was completed the following year by Tavarone, Orazio Cambiaso, Castello, and Granello.[15] The *Battle of La Higueruela* fresco was begun in January 1587. In 1590, Granello, Castello, and Tavarone were commissioned to paint the *War of St. Quentin* and the battles of the Azores and Terceira Island, following the designs in the canvases painted by Rodrigo de Holanda.[16]

The scenes in the Hall of Battles are well organized in the space, *La Higueruela* occupying the

longest wall adjacent to the basilica, as noted. The east headwall fresco depicts the naval battle of San Miguel de las Azores of July 1582, in which the French fleet supporting António was defeated. The west headwall displays the scene of the Spanish forces landing on the island of Terceira in July 1583. The battles of the Portuguese campaign were both painted by Granello. The first scene painted by Castello was the siege of St. Quentin by Philip II's troops (fig. 77, no. 2). The following panel, also by Castello, displays the Battle of St. Quentin on 10 August of the same year (no. 3). The third panel, also depicted by Castello, shows the seizure of St. Quentin on 27 August (no. 4); Philip II's tent appears in the foreground embellished with the royal arms. The fourth panel shows the taking of Chatelet in September 1557 (no. 5). The following panel was painted by Tavarone, and shows Philip's troops on their way to Ham (no. 6). The next scene is the conquest of Ham, also in September, again painted by Tavarone (no. 7). The next two panels show the Battle of Gravelines in two scenes. This battle took place on 13 July 1558 (nos. 8–9 and fig. 78). The last panel adjacent to the headwall shows Philip II's camp outside Doullens (fig. 77, no. 10).

There is extensive literature concerning El Escorial; however, the publications focusing on this hall are slim by comparison. The oeuvre of the Spanish historian, theologian, and poet Fray José de Sigüenza (1544–1606), an eyewitness to the development and decoration of El Escorial, is one of the most significant contemporary sources for the study of both the palace-monastery and the hall.[17] In 1932, Julián Zarco Cuevas published an important contribution that charted the commission of the paintings and the artists involved and contextualized the material history of the Hall of Battles.[18] Jonathan Brown's extended essay, published as a short monograph, was the first systematic study of the hall; he aptly proposed that the fresco cycle could be interpreted as a cultural artifact.[19] An article by Jesús Sáenz de Miera examined the

Erasmian influence on Sigüenza's writings concerning warfare.[20] Carmen García-Frías Checa's significant contribution includes the identification of some of Rodrigo de Holanda's battle drawings that were used as models for the scenes of the St. Quentin campaign.[21] Agustín Bustamante García published a series of important essays on the Hall of Battles and the representation of warfare at the Spanish court.[22] Rosemarie Mulcahy's article on the representations of the Battle of Lepanto (1571) has established some connections with the frescoes in the Hall of Battles. In a similar vein, Krista de Jonge's work has shown that the spatial configuration of the hall corresponds to the long galleries used for the display of images celebrating military victories in other European palaces.[23] Research on the gallery has generally taken the form of short essays within lengthier works on broader topics.[24] While there have been significant contributions on the Hall of Battles, then, a wider comparative analysis of this palatial gallery as a work of history and site of memory would repay further scrutiny.

The frescoes depicted on the walls of the chamber emulate tapestry and were often described as "painted tapestry" by contemporary witnesses. The "emulation" of tapestry is easily perceived in the corners and borders of the frescoes and was not a new technique.[25] The architecture, cities, and forts depicted in the scenes, the attire of the troops in the French campaign, and the squadron formations, military tactics, and weapons, among other details, display clear differences from the fresco depicting the Battle of La Higueruela. These distinctions are no surprise, as the battles represented in the hall and the original drawings that were the frescoes' basis were created more than a century apart. Nevertheless, the language and composition of the frescoes appear to be somehow visually concordant. This visual harmony becomes apparent when the viewer enters the gallery, as no single battle scene or character stands out in the field of vision from another, thanks to the visually

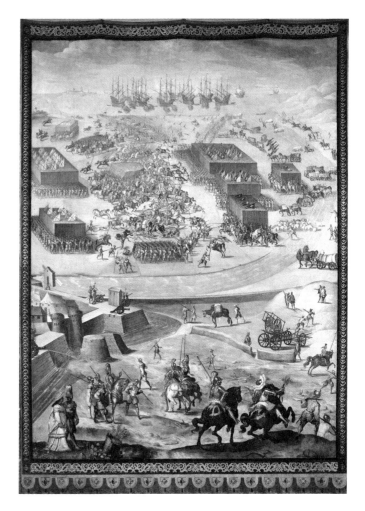

FIGURE 78 | Hall of Battles, El Escorial. Second scene of the Battle of Gravelines. © Patrimonio Nacional.

monotonous historical narrative deployed by the artists in the cycle (fig. 79). The chosen perspective allows for the study of topographical and geographical aspects as well as of the subscenes within the same frame. The high-angle view is more forced in the panels showing the French battles, as the space of the wall is constrained by the balconies, whereas *La Higueruela* has the longest wall and thus portrays the battle sequence along a continuum. The total ensemble maintains an aesthetic coherence by deliberately refraining from highlighting one battle over another. The significant differences between the battlefields become perceptible when the

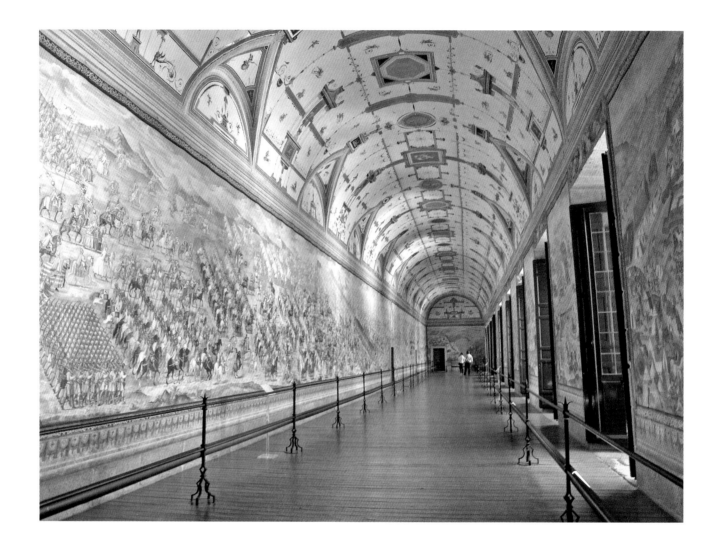

FIGURE 79 | Hall of Battles, El Escorial. © Patrimonio Nacional.

viewer pays attention to the images, and these disparities provide a sense of historical accuracy, as a testament to the value of the images depicting the victories achieved by the Castilian army and their allies. The same visual language can be found in the background scenes of a different battle painting genre, as seen in some secondary scenes of cartoons by Jan Cornelisz Vermeyen (ca. 1504–1559) for the Tunis tapestry series, and it is also present in Wyngaerde's and Rodrigo de Holanda's depictions of battles.[26] These are all models from the sixteenth century, however, so how can *The Battle of La Higueruela* be understood in relation to the other frescoes in the Hall of Battles?

The Battle of La Higueruela took place in early July 1431 and was a remarkable victory for the Christian forces in the war against the Kingdom of Granada. When a large painted cloth (*sarga*), a grisaille depicting John II of Castile's victory in this battle probably painted shortly after the event, was found in an old chest in the Alcázar of Segovia, Philip II decided not only to restore the piece but also to have it copied. In December 1584, he wrote to the prior of El Escorial, announcing that he had commissioned the decoration of the "gallery in the

Queen's chamber."[27] The artists who would paint the fresco were Lazaro Tavarone, Orazio Cambiaso, Fabrizio Castello, and Niccolò Granello. The same year, the king wrote to Sigüenza about the theme selected for the fresco: the Battle of La Higueruela. The selection of this battle for the fresco was for the purpose of preservation; the intention was to copy the old *sarga*.[28] The original fifteenth-century grisaille found in the chest at Segovia has been attributed to Florentine sculptor and painter Dello di Niccolò Delli (ca. 1403–ca. 1470), commonly known as Dello Delli, as the artist worked for the court of the Castilian king between 1433 and 1445.[29] There is evidence that Fabrizio Castello restored the *sarga*, as he was paid for "a [restoration of a] painting of the war of Granada [depicted on] a big canvas, [that he had restored] according to the instruction given to him, . . . and painted 'newly' what was necessary in it."[30] This renovation of the *sarga* aimed at restoring it, the description of the work suggests, so the introduction of new features in the *sarga* was thought to complete damaged sections of the original. In addition, Orazio Cambiaso drew a copy of the original *sarga*, probably an initial sketch on the wall of the Hall of Battles. The artists commissioned to paint the *Battle of La Higueruela* fresco were given strict instructions: "they are obliged to paint the scene according to the costumes and weapons, and everything else as it is depicted . . . on the canvas given as a model."[31]

The commission clearly stipulated that the frescoes had to copy Rodrigo de Holanda's work with utmost accuracy; they were "to maintain the colors and squadrons that they have been given in the drawings and canvases painted by Rodrigo de Olanda."[32] In his famous *Sumario*, the royal architect Juan de Herrera discussed the painting of the Hall of Battles and in particular the quality of the transposition of the fifteenth-century image of *La Higueruela* onto the wall (he called the space the "Royal Private Gallery" and not the Hall of Battles; the latter title was adopted much later):

10. Royal Private Gallery. In this Gallery, completely covering the wall of the church, is painted the battle called the Higueruela, in which the King John II defeated the Moors of Granada in the same Vega, it is [painted] just as it happened, and in the order it happened . . . , and the clothing of the knights, and horsemen, and the squadrons . . . as it was then; it was taken from a depiction in a canvas that was found in an old tower in the Alcázar of Segovia . . . it was one hundred and thirty feet long, the painting was made in the same period the battle occurred . . . His Majesty ordered it to be painted in this gallery, so that this [rare] antiquity was conserved, [as it] is very lustrous and esteemed.[33]

Herrera explained the process and is emphatic regarding the accuracy of the copy in the gallery compared to the original; he underscores the painstaking work the team of Genoese painters undertook and their capacity for transferring in minute detail the attire and details of the troops.[34] Two of the significant values Herrera attributed to the fifteenth-century grisaille were its antiquity and accuracy as a historical record of the battle. It was so esteemed that Philip decided it should not only be repaired but also that a copy of it would be created for conservation, and thereby he commissioned a grand fresco for the gallery. Sigüenza, who was also an eyewitness of the painting of the hall, gave an account of the execution of the fresco cycle:

It imitates two pieces of tapestry, hung with hooks, . . . so natural [in style], that it [has] misled many, [some] even tried to lift [the "tapestry"], . . . it is called the Battle of La Higueruela. . . . As here in the gallery it is colorful—where it was not in the original canvas, which was of clear and black wash drawings—. . . everything is so natural and

so well reproduced that it is very fine to view. They [the artists] enlarged the figures [a little bit from] those in the original. . . . On the other side [is a fresco of] . . . the siege of St Quentin . . . where a different type of militia is depicted. . . . In the headwalls are the two incursions . . . Azores and . . . the Isla Tercera . . . where warfare at sea and the form of the boats are also shown, . . . so well imitated. . . . The ceiling and vault of the gallery are very well built and decorated with grotesques.[35]

Sigüenza concurs with Herrera on the quality of the copy of *La Higueruela* and tells of the diverse types of warfare represented. Although the original piece was a grisaille, the new frescoed version on the gallery would be painted in vibrant colors. The fifteenth-century *sarga* measured 130 Castilian feet long, or approximately 36.4 meters, but the fresco was almost twice that size, almost sixty meters in length. The art of war of Philip II's Castilian ancestor was honored in the fresco of the *Battle of Higueruela, while* the wars of Philip II's time were portrayed in *The Battle of St. Quentin*, a sample of the art of war performed on land and at sea as reflected in the Azores campaign.

As noted, the name of the gallery changed later and did not become known as the Hall of Battles until the eighteenth century. Philip II referred to the space as "the gallery in the Queen's chamber"; another letter from 1589, during the period in which the gallery was still being decorated, refers to it as the "gallery of the battle."[36] However, in most contemporary sources it is called either the "King's chamber" or the "Queen's chamber." In 1764, in his description of the monastery, Fray Andrés Ximenez referred to the chamber as the "hall of the battles," a name used from then onward.[37] The unfixed nature of the gallery's original name has prompted some scholars to question the coherence of the gallery's pictorial program as well as the political and symbolic aim of the

fresco scenes painted there.[38] However, evidence has shown that as the hall acted as a permanent space for ceremonial apparatus, the painted tapestries there made the gallery particularly apt for courtly life.[39] Philip III of Spain's children enacted tournament games in the hall, and the fresco cycle served as both an educational and commemorative space. The use of the painted narratives in education was not new, as the pictorial program of the library at El Escorial also served to educate courtiers in the liberal arts. While access to El Escorial was strictly limited, when the royal family was not in residence, authorized visitors were allowed to take a particular route through the complex, and the hall preceded the access to the palace. The hall was thus a space for royal representation and commemoration. The multiple uses of the hall are exemplified by the fact that Philip IV's bed was at one point installed in this room, and in 1607 a theatrical comedy was represented in the space.[40] The literature has convincingly shown that the hall corresponds to the prototype of long palatial galleries in Europe that served as a venue for recreation in inclement weather.[41] John Brown and John H. Elliot, in their study of the Hall of Realms at Philip IV's Buen Retiro Palace, have argued that the Hall of Battles at El Escorial can be classified as a "hall of princely virtue," in which the *res gestae*, in this case military victories of the monarch or prince, were celebrated and narrated artistically.[42] Thus the Hall of Battles has been compared to the Hall of Realms at the Buen Retiro Palace, a gallery whose decorative program aimed to celebrate the rule of the monarch and the triumphs and history of the realm.[43]

The fresco cycle at the Hall of Battles is one of the very few warfare representations in the monastery and the only one frescoed in the building; not surprisingly, religious subjects are predominant in the artistic collections and decoration of the monastery. The choice of battles, with the absence of Lepanto and the Tunis campaign from the hall,

complicates interpretations. The apparently odd selection of battles in the ensemble at the gallery has been long discussed in the literature, and I will not attempt here to provide a theory that would explicate the monarch's choice. A contextualization of the hall and El Escorial within the collections of Philip's royal palaces and also within wider visual and cultural trends in Iberia and elsewhere is, however, useful. Other royal palaces, such as Valsain and El Pardo, had magnificent programs devoted to battles and representations of war, and inventories show that there were many others in the royal collections.[44] The use of battle painting as a historical genre in the sixteenth century is illustrated in Jakob Cuelbis's description of the Alcázar in Madrid in 1599, in which he explained that a great hall in the palace had been decorated with a series depicting the victories of Charles V in Germany, along with some images of St. Quentin, very likely drawn by Wyngaerde and painted for Philip and Charles V on that campaign.[45] The Palace of El Pardo was also decorated with important Habsburg battles, including Vermeyen's canvases of the War of Saxony, which were hung below a series of royal portraits in the main hall. The space thus combined the images of victorious battles and a celebration of the Spanish monarchy.[46]

The ways in which tapestry collections (including those depicting warfare) were displayed for royal ceremonies at court show that the full sets were rarely displayed in a single space. Individual tapestries were often taken from their original sets and displayed in a seemingly arbitrary fashion—a piece with a religious subject could be placed beside a battle scene or a mythological subject. Examples like this proliferate both in commemorations that occurred in Philip II's royal palaces and also in festivals in cities, and they show that tapestries were used for an array of purposes and events and also ad hoc on theater stages mounted for festivals. In the case of palatial spaces, full tapestry sets were often too large for the walls even of monumental palatial galleries and halls. The tapestries on display at court had not always been commissioned by Philip; tapestries that he had inherited from his ancestors were often hung beside more recent works. While scholarly readings of full tapestry sets as a single coherent unit are insightful and necessary, it is also important to consider how viewers enjoyed and used these images.[47] Evidence has shown that finding a fifteenth-century image beside two sixteenth-century sets is consonant with practices in other palatial spaces. In light of how tapestry collections were hung in palatial chambers, and given that battle scenes are presented in sequential order as full frescoed "tapestry" sets in the Hall of Battles, it is perhaps time to reconsider our understanding of what visual coherence meant with regard to these images and courtly display practices.

The battle representations at El Escorial's Hall of Battles not only form a work of visual history that engages with written traditions in Spain and echoes other images in the royal collections; they also create a site of memory of the realm. The *sarga* of the Battle of La Higueruela was found shortly after Philip II had become the king of Portugal, a period in which Philip's imperial image was exalted both theoretically and artistically. This is significant, for Philip was seen to have completed the dream of uniting the Iberian Peninsula, the former Roman Hispania, which Christian kings had desired for generations. Finding a grisaille of such quality would have been a timely reminder of the long journey, and the battles, both military and political, that monarchs before him had endured in pursuit of that imperial dream. That the selection of battle scenes at the Hall of Battles took place over time is a useful reminder that the hall is better understood in the context of the palaces and collections in the Spanish court and beyond. The identification of the Hall of Battles as a "hall of princely virtue" is in line with the thinking of Philip II's entourage in this period. As seen earlier, in the artistic display of Philip's triumphal entry into Lisbon

in 1581, the line between triumphal and Christian grammar in imperial discourse was very fine. In fact, Philip II's image as a global ruler was intrinsically allied with the responsibilities attributed to a Christian ruler.

Philip was not always successful in attracting artists to the Spanish court. Titian was famously his favorite painter; however, the frescoes in the hall cannot be compared to any of the canvases painted by the Venetian master. In fact, the visual language of the frescoes is found in other cycles, such as the depiction of the Tunis campaign in the Estufa of the Alhambra (ca. 1537) or the series of the Saxon Wars in the palace of Oriz (1540–47) and some of the frescoes at El Viso. However, the manner in which the battles were displayed in the hall was considered out of fashion, particularly when compared to the paintings and tapestries Philip commissioned in this period. Visual narratives were present in the city views that populated the walls of Philip's royal palaces, including El Escorial, and they also dominated festival decorations. Temporary triumphal paths mounted for ceremonial entries and festivals often included battle scenes that sometimes deployed the same visual language found in the hall at El Escorial.[48] In addition, the expertise the Genoese team of artists had gained with Luquetto and Il Bergamasco was suited for the royal commission to copy the battle scenes found in the fifteenth-century *sarga* and Holanda's drawings. Carmen García-Frías Checa has solidly demonstrated that the Higueruela fresco represents visually what was recorded in the chronicles of John II of Castile.[49]

The conundrum with *La Higueruela* is the lack of surviving fifteenth-century representations of battles in the Iberian Peninsula that present a similar naturalism and language. The magnificent fifteenth-century Pastrana tapestry series, probably woven in the Tournai workshop, deploys a completely different approach to battle representation. Surviving tapestries commissioned by John II of

Castile around 1435–50 and probably woven in a workshop in the southern Netherlands—namely, the *Seven Scenes from the Story of the Seven Sacraments* series—show John's investment in royal representation, yet these pieces display a different visual language and composition from the fresco in the Hall of Battles.[50] However, a little-known set of drawings of battles have survived that seem to be copies of mural paintings that decorated the palace of the *corregidor* and other public buildings in Jerez de la Frontera. While the settings and histories these drawings narrate focus on a locale far from courtly circles, one of them depicts the siege of Jimena and its castle that took place some months before the Battle of La Higueruela in 1431 and formed part of the same campaign. Marshal Pedro García Herrera commanded an expedition to the frontier city of Jimena at the beginning of March that year, and his victory was decisive for the subsequent defeat of the Kingdom of Granada at La Higueruela in July. John II of Castile had sent García Herrera to fight along the frontier of Jerez only a year earlier.[51] The drawing *Siege of Jimena* (fig. 80) shows the battle from a high-angle view, though the perspective is not entirely similar to that of the *Battle of La Higueruela* at El Escorial. The drawing is limited to a rectangular frame of modest dimensions (310 by 436 mm), instead of the visual narrative afforded by the original *sarga* and reflected and enlarged in the fresco in the hall.

The composition of *Siege of Jimena* includes subscenes separated by depictions of landforms that organize the visual narrative in the form of vignettes. The drawing, though constrained by the rectangle, still offers a view of the battlefields, the sequence of the battle, and the soldiers in the same monotonous visual language seen in the *Battle of La Higueruela*, in which the military commander is not enlarged or brought to the foreground. The drawing is executed in ink on laid paper, and it was subsequently pasted onto another sheet of paper, with an inscription in the original that read, "N° 4°

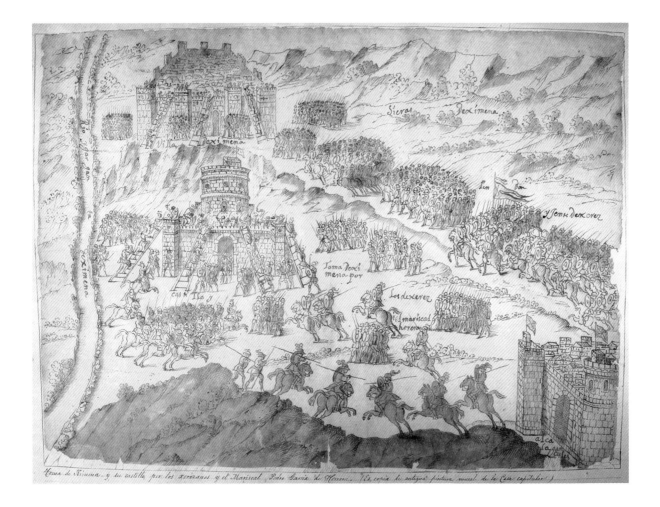

Toma de Gimena y su castillo por los xerezanos y el mariscal Pedro García Herrera." There is a note on the drawing that tells us that this was a copy of a mural painting in the city council house (*casas capitulares*). The words in the drawing point to important landmarks in the area or leading characters in the campaign.[52] A comparison of the *Battle of La Higueruela* and the *Siege of Jimena* shows some apparent similarities; for instance, the soldiers in the squadrons rest their lances on their shoulders (figs. 81a–81b). In the paintings of the French and Portuguese campaign in the Hall of Battles, the squadrons hold the lances perfectly aligned while the soldiers hold them straight. The artists depicted these in a compact manner, giving the impression

FIGURE 80 | Unknown artist, *Siege of Jimena* (1431), late seventeenth century. Ink on paper, 310 × 436 mm. Biblioteca Municipal de Jerez, R. 27210. Courtesy of the Biblioteca-Archivo Municipal de Jerez de la Frontera.

that the lances formed perfect quadrangular packs. The *Higueruela* fresco is evidently superior to the *Siege of Jimena* drawing—for example, the horses include alternative postures and movements that are only tentatively profiled in the drawing. The drawing technique of the figures is more advanced in the *Higueruela* scene, as are many other details, for the drawing of the *siege of Jimena* was, in the end, a preparatory sketch for a painting. At the Hall of Battles, the artists employed known techniques

to transfer the image onto the wall. Nevertheless, both images take a similar approach to representing the battle, such as the attention to topographical detail (more accurate in *La Higueruela*) and the higher angle chosen to depict the battlefield, and both, crucially, were copies of originals. The *Siege of Jimena* has no date, although the paper used was only circulated in the Iberian Peninsula at the end of the seventeenth century.[53]

The series of drawings to which the *Siege of Jimena* belongs was intended to exalt the role of the knights and people of Jerez in the war against Granada. These battles occurred in the fourteenth and fifteenth centuries and the images were a way for the city to reclaim their role in the Christian historical narrative of the so-called reconquest.

The collection of drawings is currently composed of eight battle scenes, including the attacks on the Gigonza (1371) and Asilha (1509) in North Africa; a note on the drawings claims that the battle scenes in Jerez were copied in order to preserve both the images and the memory of the city and ancestry, but were these also considered visual historical records of the battles, as the *La Higueruela* fresco was? The written accounts of the siege of Jimena can be traced in two written sources: the *Crónica de Don Juan II*, also the main textual source for the *Battle of La Higueruela*, and the manuscript known as *Libro del Alcázar de Jerez*.[54] Both chronicles concur, with the exception of very small details, on the events of the siege of the city of Jimena and the attack on its tower; as with the chronicles of the

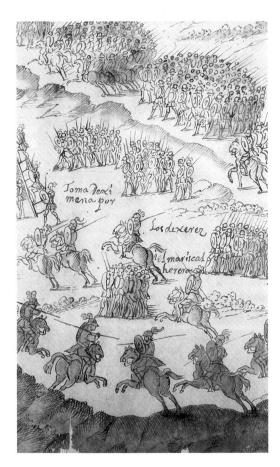 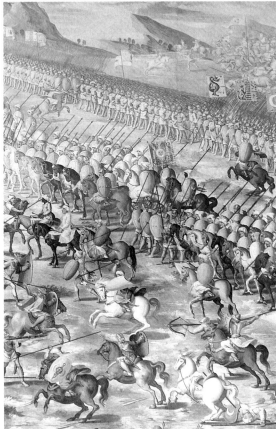

FIGURE 81a | Unknown artist, *Siege of Jimena* (1431), late seventeenth century, detail. Ink on paper, 310 × 436 mm. Biblioteca Municipal de Jerez, R. 27210. Courtesy of the Biblioteca-Archivo Municipal de Jerez de la Frontera.

FIGURE 81b | *Battle of La Higueruela*, 1587, detail. Fresco. Hall of Battles, El Escorial. Image courtesy of Wikimedia Commons (Ian Pitchford), edited by author.

Battle of La Higueruela, the narrative and visual accounts of the Jimena siege provide almost identical versions of the sequence of the battle. A fragment of the text describes the taking of the large tower in the central foreground of the drawing, known as the castle and the *homenaje* tower in the historical account:

> Close to the castle wall, the Christians heard the sentinel saying he had heard sounds of people, so [the Christians] had to lie on the ground [hidden] for over half an hour. . . . Fortunately, in this time the flags were changed, at this moment the attackers took advantage and reached the wall, and [then] laid a ladder between two towers. The first ones to step up were the soldiers, [they] were discovered and fought with the moors until they locked [the moors] in the *homenaje* tower . . . the fortress was defeated and the Marshal could enter it [victorious] at the dawn of the 12th. This same day the Christians went to fight the town, defeating it too.[55]

The scene of the taking of the castle and tower is very close indeed to the drawing, which intends to project a sense of historical accuracy, much like the frescoes at the Hall of Battles. However, an archaeological dig has unearthed results that challenge the drawing's accuracy: the large circular tower depicted in the drawing, which still forms part of the defensive system of the castle in Jimena, seems to have been built at the start of the sixteenth century (see fig. 80). There were military structures on the same site before this tower was erected, and it would not be surprising if future archaeological digs identified traces of structures that correspond to the fifteenth-century textual historical accounts. The written account of the battle refers to the castle and *homenaje* tower: these kinds of towers in the region were often found separated from city walls, although the written account does not describe the tower. Some of the landforms in the drawing were

intended to separate portions of the action rather than to accurately illustrate the natural site. The location of the river and other topographical and architectural details in the drawing are fictional. Until more archaeological evidence is found to prove otherwise, this drawing seems to have been modernized to represent the circular tower that stood in Jimena at the time that the anonymous patron commissioned the drawings. Alternatively, the drawing might have been re-created on the basis of the written record and made long after the battle. The artist knew that there were a river, a castle, and a walled city, but their arrangement does not correspond to medieval Jimena (*Xemina*). The tower depicted in the drawing seems to have been completed in the first third of the sixteenth century, at the earliest.[56] As the drawings in Jerez are devoted to successful military campaigns led by local knights, they are unlikely to relate to John II's court; however, the mere existence of the drawings in Jerez, and the manner in which they were displayed on public buildings, raises further questions. Were murals of frontier battles found elsewhere in the Iberian Peninsula? It has been argued that there was no state patronage in fifteenth- and sixteenth-century Castile of the crusade against Granada and North African kingdoms.[57] This question is well beyond the scope of this chapter, but the fact that both images underwent a copying process that aimed not only to preserve the visual record but also to celebrate the history of the cities and the realm sheds light on early modern notions of history, memory, and fame.

The local historian Bartolomé Gutiérrez, who wrote a two-volume history of the city in the eighteenth century, suggested that the images of the battles copied in the drawings in Jerez were originally found in the form of murals in a number of the city's public buildings in the fourteenth and fifteenth centuries.[58] Some of these paintings were displayed on building exteriors, though the murals seem to have deteriorated significantly; one of them was restored in situ in 1676.[59] A note

on another drawing in the set explains that an anonymous patron commissioned drawings as the scenes deteriorated: "I commissioned these drawings in case there was an opportunity to paint them [on canvas] for my sons, or for them to commission these paintings, as there cannot be better delight than in the exploits of their grandparents, relatives and compatriots, so they could keep them in the Hall in the Calle Francos, or in [the house] in front of the Alcázar."[60] The aim of the anonymous patron in Jerez, who might have been linked to the knights involved in some of the battles through aristocratic ancestry, was also to preserve the images of the victorious battles as a memory of the military exploits of his predecessors. Gutiérrez tells us that the eleven large canvases that reproduced the battles in the drawing series were displayed in the main hall at the townhouse of Juan de Gallegos.[61] He not only confirms the note found on the drawing but also the history of the murals. They were copied in a way and for purposes that echo palatial galleries of princely virtues. Similar practices are also found in grand Renaissance palaces such as El Viso, but as these drawings show, other cases can be found well beyond courtly and aristocratic cycles. This set of drawings is indeed rare, for, as mentioned earlier, with the exception of *La Higueruela* at El Escorial, there are very few surviving representations (of copies thereof) of contemporary battles before the sixteenth century.

Covarrubias explained that a chronicle (*crónica*) is commonly considered a linear historical account that narrates the life of a king or kings, and his words recall Alfonso X's *Siete partidas*, which taught that kings and princes must read or listen to the chronicles and deeds of their predecessors in order to learn what conduct to emulate and what to avoid.[62] Covarrubias reflects the thinking of the period and establishes a relationship between memory and history, as also seen in the discussion of the Simancas archive in chapter 2. The conservation and celebration of *La Higueruela* (and also

the drawing of Jimena) reflects the same understanding of visual chronicles as a site of memory, particularly when displayed in commemorative spaces. It is unknown whether an artist accompanied John II's entourage to make sketches of the Battle of La Higueruela (like Vermeyen in Tunis or Holanda in St. Quentin). The reign of John II was marked by civil war, and chroniclers played an important role in crafting the image of the king against his enemies. The chronicles of John's reign ended up being written by four different historians, and while the circumstances are more problematic than the obvious aim of propaganda, it was nevertheless the duty of historians at court to witness and report on significant events.[63] The battle took place in July 1431, and so if Dello Delli was the author of the famous *sarga*, he could only have begun it in 1433 or after, once he had come to work for the ruler in Castile. Thus the author of the grisaille either visually reproduced the scene after the written chronicle or used someone else's drawings of the battle. The scenes at La Higueruela are displayed as an uninterrupted narrative of a kind that had not been seen or recorded in Iberia before but is famously present in Trajan's Column in Rome. Little is known of the whereabouts of Delli, though we know that before arriving in Castile he lived in Florence, Siena, and Venice, and Giorgio Vasari in his *Vita* states that Dello Delli was as expert in *cassone* (chest) painting. Mid-fifteenth-century Florentine *cassoni* depicted jousts and battles. Some chests display illustrations of Rome, including Trajan's Column; this suggests that if Delli or a contemporary painted the *sarga* for John II, he was likely to have known this type of uninterrupted narrative.[64] Commissioned artworks depicting grand warfare in Castile are scant; the bas-reliefs in the choir of the Toledo Cathedral were executed a few years after the *sarga* would have been painted. Juan de Borgoña painted the Campaign of Oran for Cisneros in 1514. The visual structure of Borgoña's fresco is reminiscent of visual hierarchies

found in the *Siege of Jimena* drawing. With regard to the style of *La Higueruela*, the fresco surely retains much of the substance of the original *sarga*, as explained by Herrera and Sigüenza. Both the fresco at El Escorial and the drawing attest to copying practices of the period: if the image of the *sarga* was not reproduced on the basis of the chronicle, then sketches made in the battle of 1431 were then copied into a *sarga* a few years later and finally transferred into a fresco 150 years after the first sketch was made. Furthermore, the role of these images in creating sites of memory gives us intimations of the value that Philip ascribed to the history of the realm. The deployment of a monotonous visual narrative as a way to mimic textual sources, I would argue, is intended. This was a way to show continuity in the Christian mission of Philip's lineage as defenders of the Catholic faith.

It would be tempting to argue that the deployment of the same visual narrative in the contemporary battle aimed to maintain aesthetic coherence in the hall. However, we know that the artists were required to follow Rodrigo de Holanda's depictions of the French battles. There are some surviving letters in which the young King Philip related his thoughts after the victory over France at St. Quentin: "our Lord with his great kindness has wanted to give me these victories in very few days and in the beginning of my reign, which gives me great honor and reputation."[65] Sigüenza believed that the victory at Gravelines had proved to Henry II of France that "God fought for Spain's cause, giving many victories to the Emperor Charles V and beginning to favor so openly his son Philip."[66] At the beginning of Philip's rule, it was considered prudent for the king to be present in battle, even if only in the background.[67] In time, Philip's idea of the role of the ruler in warfare evolved; the king believed that absenting himself from the battlefield was the most appropriate course. In victory, he would still gain glory and fame, but in defeat the sense of failure would be greater.[68] Philip was no

military commander, as his father had been, and the visual narrative in the Hall of Battles suited his view of the role of the monarch in war and also of how history should be recorded.[69]

Philip and his court concurred with Covarrubias's definition of history; in a letter from 1569, Páez de Castro tells the historian Jerónimo Zurita (1512–1580) that the king had told him that history should be written "solely on the basis of approved and authenticated sources."[70] Philip famously included a specific requirement regarding the writing of history in the "Instructions for the Governance of the Simancas Archive," issued in 1588. Archivists were to compile a "summary of memorable and curious things" on a yearly basis, their veracity supported by the archival collections. All of the entries in this written summary had to be fully referenced; that is, the description of an event had to correspond to an "authenticated" document on which the "shelfmark," or archival reference, was included. This method was intended to facilitate the retrieval of the supporting documents. The most important events to be recorded in this compilation were the military victories of the realm. Philip's preference for a history that focused on the realm and dynasty of kings, and in particular on military victories, and his order that the Simancas archivists make this annual "summary," supports my contention that the visual language deployed in the fresco cycle at the Hall of Battles was intended to construct a site of memory. In the fresco, Philip II paid tribute to his predecessors' bravery in the crusade against infidels. If the frescoes at the hall are understood as a visual chronicle of history and site of memory, they also embody a number of notions that were crucial in Philip's reign. Thus the ideals behind these victories can be identified as the crusade against the infidel represented at La Higueruela, the campaign that culminated in the victory at St. Quentin, showcasing Spanish European supremacy in the multilayered consequences of the Peace of Cateau-Cambrésis, and finally, the

Iberian Union extending to global dominion. This supremacy also carried great responsibilities, such as the defense and expansion of the faith and the safeguarding of his numerous vassals. These ideals were present in many of the funeral accounts that mourned the passing of the Spanish monarch, and a comparative analysis of them in relation to the hall and Philip's reign offers a window on the reputation and fame of the monarch.

Funerals and the Fame of the Universal Monarch

In his *Tesoro de la lengua castellana o española*, Covarrubias defined the verb *to defame* (*disfamar*) as the act of divulging information, whether good or bad, though he clarified that in the Castilian language this term often referred to the communication of calumnies and infamy.[71] Covarrubias defined fame (*fama*) as the communication of all that is good; thus a man can have good or bad "fame." He cited book 4 of Virgil's *Aeneid* to illustrate how the "ancients painted fame in the form of a damsel, flying in the sky with unfolded wings and playing a trumpet."[72] Fame, in the visual form recounted by Virgil via Covarrubias, was present on ephemera in Philip II's triumphal entry into Lisbon in 1581. Indeed, fame was a recurring theme in many festivals, especially those that celebrated triumphs, where it was showcased as a way to praise a prince or other dignitary. Some of the major themes embodied in the ephemeral art and architecture in 1581 in Lisbon were present in other fetes organized for the ruler and his representatives. In the entry of Archduke Ernest of Austria (1553–1595) into Antwerp in 1594, the Arcus Triumphalis Lusitanorum (Arch of the Portuguese) celebrated Portugal, Philip, and the Iberian Union (fig. 82). The ephemeral arch was profusely decorated on all of its façades and interior spaces. The front and back façades were recorded by artists and illustrated in the festival booklet.[73] On the main façade

of the Arcus Triumphalis Lusitanorum, the figure of Neptune carrying an armillary sphere tops the apparatus, and representations of Mauritius, Ethiopia, Brazil, and India convey the wealth and extent of the Portuguese empire, echoing the triumphal path erected in Lisbon in 1581. As in Lisbon, Neptune and nymphs embodying regions of the Lusitanian empire bowed to the prowess and global authority of their monarch. On top of the back façade of the Arch of the Portuguese in Antwerp, the realm's arms appeared, held by tritons. Famous rivers from the four continents across which the Portuguese empire extended were also depicted. Figures representing the Ganges and the Hydaspes (now Jhelum River) on the Indian subcontinent, the Tagus in Portugal, and the Río de la Plata in Brazil celebrated Philip's Portuguese dominions (fig. 83). References to Philip's dynasty and the lineage of Portuguese kings were also present on both façades of the arch. The Portae Triumphalis Hispaniorum (Spanish Triumphal Gates) preceded the Arch of the Portuguese and had three major façades (hence the plural *portae*) that were also illustrated in the festival booklet.[74] The apparatus was profusely decorated with themes that figured not only in the Lisbon entry but also in other festivals. Some of this imagery had been associated with Philip for decades. The carriage of Apollo, for example, which had been depicted ridden by Janus in the Lisbon fete in 1581, was painted on a panel on top of the lateral façade (fig. 84). Apollonian references reflected ideas of illumination that had been employed in Philip's royal image during his rule and reflected his reign in the flattering manner his court had devised. The monarch's numerous enemies propagated a very different image of the king, however, one that has endured for centuries.

Four years after Archduke Ernest entered Antwerp, Philip passed away at the Monastery of El Escorial on 13 September 1598. Funerals for the ruler were celebrated in the monastery, across the

FIGURE 82 | Arcus
Triumphalis Lusitanorum,
main façade, erected for the
entry of Ernest, Archduke of
Austria, into Antwerp, 1594.
© British Library Board. All
rights reserved / Bridgeman
Images.

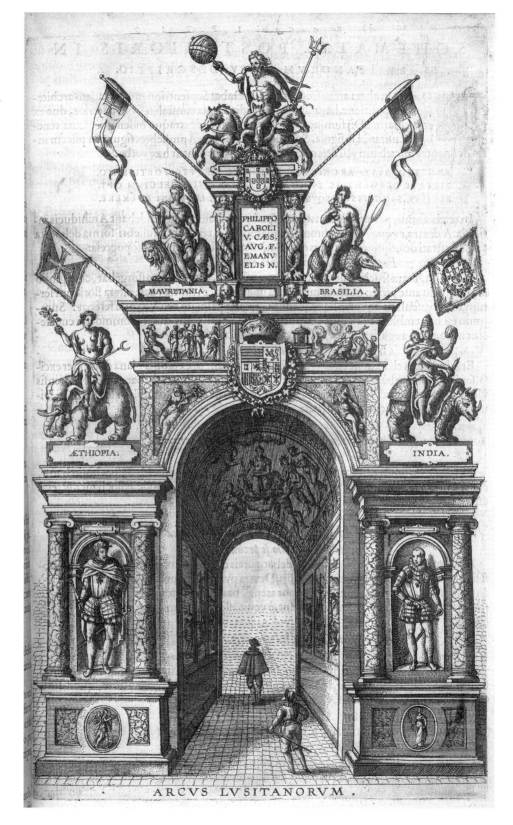

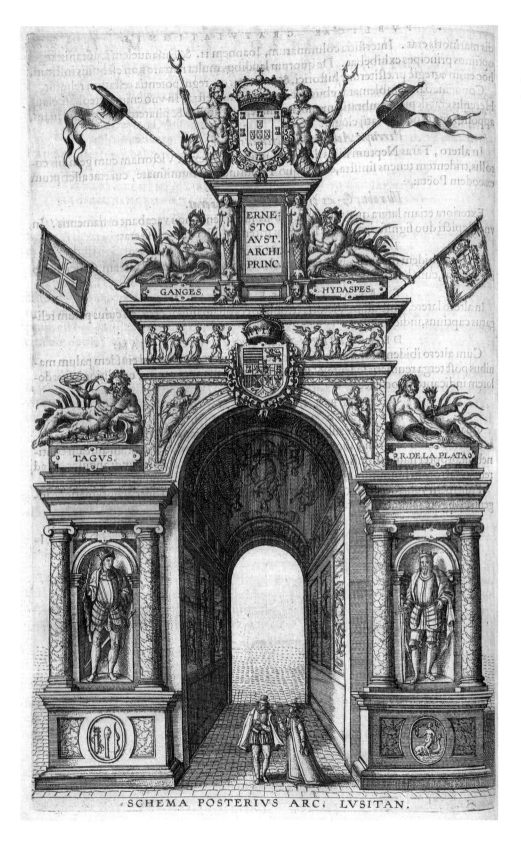

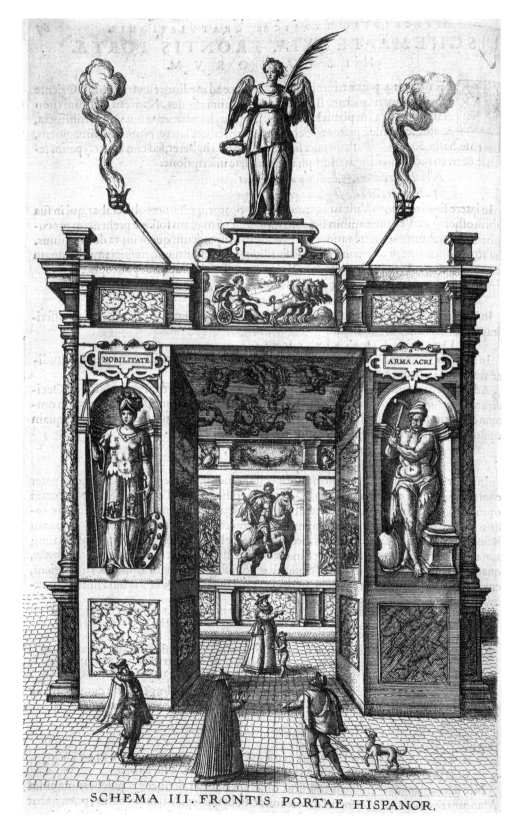

peninsula, and in Europe and the wider world.[75] Most of the surviving chronicles and manuscripts in his imperial dominions as well as in the realms under Habsburg influence gave a particularly favorable version of his life and glorified his reign. In his *Tesoro de la lengua castellana*, Covarrubias defined glory (*gloria*) as "fame that is aggrandized through [someone's] good actions, virtues and kindness."[76] This concept of glory captures the tone employed to narrate Philip's life in the many funeral services held throughout his empire, but there were dissenters. Girolamo Conestaggio presented Philip as a usurper of the Portuguese throne in an account that was translated and printed in English in 1600.[77] Numerous printed books and pamphlets survive, containing the exequies to honor Philip; however, this printed material does not provide evidence of the full geographical scope and magnitude of these celebrations. Funerals for Charles V had likewise been celebrated throughout his imperial dominions. In many cases, such as the catafalque erected in Mexico City for his funeral, ephemeral structures had an impact on the dissemination of pan-Iberian architectural trends (see chapter 1). The commemoration of the monarch's death was promptly followed by the proclamation of the new king, which ensured the continuation of Habsburg rule.[78]

The funerals to mourn Philip II's death in Florence in 1598 were an occasion to exploit visually the biography of the ruler. A series of impressive canvases displayed in the Basilica di San Lorenzo depicted his life from his birth in Valladolid in 1527 to the Iberian Union, among other themes.[79] Philip's disastrous decisions and campaigns, such as the defeat of the Armada, were avoided, but the weddings with his four wives, including Mary Tudor, were illustrated. The perception of Philip II elsewhere in Europe was very different, and most of the funeral depictions were negative; Covarrubias and other supporters called them mere defamations. The French poet, dramatist, and historian Pierre de Mathieu (1563–1621) wrote a less than flattering elegy. Mathieu's emphasis on Philip's piety and devotion to the Catholic faith was contrived to present the ruler as a religious zealot, making him directly responsible for the death of his primogenital son, the unfortunate Don Carlos. The Portuguese episode was presented as the usurpation of a title to which he had no claim. The wars in the Low Countries were, in Mathieu's view, a consequence of Philip's unjust decision making and lack of political ability. Mathieu called the defeat of the Spanish Armada God's punishment for Philip's greed. His elegy, which only briefly mentioned the Spanish victory at St. Quentin (1557), presented Philip II in the mode of the Black Legend. Philip was a "dark," overly ambitious ruler, a religious fanatic who spent most of the time secluded in his monastery-palace El Escorial.[80]

The flattering Florentine version of Philip's accomplishments was no less biased, blatantly omitting Philip's failures and defeats. Florence wished to present itself as an enduring ally of the Habsburgs. The lavish funeral in the Basilica di San Lorenzo, a palatine church and the mausoleum of the Medici family in Florence, took place only six months after the monarch's death. San Lorenzo had been the location of many illustrious funerals, most notably those of the Medici family; it was also the site of Michelangelo's funeral in 1564. By the time Philip II's funeral was held there, Florence had a well-established festival culture in which ephemeral displays were often recycled and adapted for an array of commemorations.[81] The funerals that preceded Philip's in San Lorenzo are important precedents of some of the images used at Philip's ceremony. The exaltation of the ruler focused on many aspects of Philip's life, including his education and his tour with his father as a young prince. Of the canvases, only one is dedicated to Philip's known sojourn to the Low Countries in 1548, and two paintings focus

on the receptions in Genoa and Milan. While the Milanese reception lacked the political significance of other cities on Philip's tour, the emphasis on Milan was intended to remind viewers that the Medici had sent a large and successful diplomatic entourage to that city, impressing Philip and his retinue with lavish gifts. The scenes depicted in the paintings served to narrate Philip's life and *res gestae* as much as they emphasized the Medici's relationship with the Spanish court. The Medici used funerals for foreign monarchs to underscore their prominent role in the European and international political scene.[82]

In the display at San Lorenzo, twenty-four paintings narrated the life and rule of Philip from his birth to the peace treaty signed with France only a few months before his death. Only thirteen canvases survive; however, some drawings depict the scenes of the lost paintings. The first seven canvases displayed scenes that visually narrated Philip's birth and youth. Charles V's abdication and the gradual transfer of political power to Philip were also part of the visual panegyric. The political history of the reign was showcased in a series of scenes that focused on three main themes, namely, the war against the Turks in the Mediterranean, the conquest of Portugal, and the creation of a global empire. The last scene was dedicated to the Peace of Vervins (2 May 1598) with France. While this treaty favored France, the Florentine canvas presented it as a sign of Philip's political ability and his last heroic deed.[83]

The Portuguese campaign that led to the union of the kingdoms of Portugal and Spain was prominent in the pictorial cycle at San Lorenzo. An inscription in the funerary ensemble inside the church read, "LUSITANIAM, ET ADIACENTES INSULAS SUCCESIONE" (Succession to Portugal and adjacent isles). This is a reference to the victory in mainland Portugal and the control over the Azores.[84] The naval victories in the battles of the Azores and Terceira (1582–83) in the Atlantic,

which crushed António of Portugal's pretension to the throne, were also celebrated in the frescoed paintings on the headwalls at the Hall of Battles at the Monastery of El Escorial. Among the king's major achievements in the Portuguese succession, there was a scene dedicated to his triumphal entry into Lisbon in 1581 by the Florentine painter Cosimo Gamberucci (1562–1621), a disciple of Santo di Tito (1536–1603), titled *The Entry of Philip II into Lisbon* (fig. 85).[85] In his account of the Florentine funeral, Vicenzo Pitti tells us that this was the eighteenth canvas in the series.[86] In Gamberucci's painting, the king rides his horse under a ceremonial canopy; however, no ephemeral structures are visible, nor is there any recognizable building that would identify Lisbon or the temporary structures erected in 1581. The artist chose to portray a generic ceremonial entry; this image could be located in any city or town and thus the canvas could be

FIGURE 85 | Cosimo Gamberucci, *L'ingresso di Filippo II a Lisbona*, 1598. Tempera on canvas, 217 × 268 cm. Courtesy of the Uffizi Gallery, Florence.

adapted and recycled for any other funeral of a ruler or dignitary if required.[87] The central image of the canvas is Philip flanked by a retinue of courtiers. On the right-hand side of the scene, a pageant on horseback announces the arrival of the king with a trumpet, and at the opposite end of the canvas Gamberucci painted local observers, including a child whose pointing hand directs the viewer's gaze to the image of the monarch at the center of the painting. With the king at the center and a clear visual distinction between the monarch's retinue and the local observers, the composition establishes visual hierarchies that echo the social stratification of festivals at the time. The scene also engages the viewer: the child's pointing hand guides the observer, and Philip's gaze is directed at the audience. The painter further emphasized the intended interaction with the public through some of the members of the royal retinue, whose eyes also gaze at the viewer. These figures are in close proximity to the king, flanking him on both sides; the courtier holding the pole of the canopy, for example, looks directly at the viewer, as do the men on horseback. These pictorial conventions were common in early modern visual culture, particularly in festivals, where images played a performative role.

The spatial arrangement of the canvases at San Lorenzo would have aided the engagement of the audience. Giovan Battista Mossi's etching of the decoration of the Florentine church shows the monumental scale of the funerary ephemera and the role played by the canvases within the space. The etching *Interior of San Lorenzo for the Funeral of Philip II*, now at the Albertina in Vienna, shows how the series of scenes and other ephemeral decorations dominated the interior of the church (fig. 86). The interior walls of the church, draped with dark textiles and skeleton figures, or *memento mori*, were a reminder of the transient nature of life. The images also reminded viewers of the vanity of earthly existence, a common feature of

funerary traditions in San Lorenzo, as we see in other etchings of state funerals that took place there.[88] The location of the canvases below the arches of the church would have allowed observers to engage with the scenes easily. Their arrangement invited the visitors to follow an orderly route within the church, mirroring a palatial gallery of princely virtues or an ephemeral *via regia* (royal path or road) created for triumphal entries and other festivals. In this manner, viewers were able to admire the scenes on the canvases that narrated Philip's life and rule, above all his pious life and contribution to the expansion and defense of the Catholic faith in Europe and beyond.

Pitti remarked on Philip's virtues—piety, prudence, and "la suprema conservacione della Religione Cristiana" (the supreme conservation of the Christian religion).[89] This included the evangelization of the indigenous population in America and the defense of Europe and the Mediterranean against the Turks.[90] The victory over France at St. Quentin at the beginning of Philip's reign was celebrated. "World dominion" achieved through the Iberian Union under his sole rule was also lauded. On the long cenotaph were the words "CATHOLICAE RELIGIONIS PROPVGNATORI" (promulgation of the Catholic faith), which celebrated, in tandem with other imagery, the propagation of the Catholic faith through conquest, imperial expansion, and the protection of Philip's Christian subjects. In Castile, the "reconquest" per se was not believed to have been accomplished until Philip III decreed the expulsion of the Moriscos in 1609.[91] Philip II's struggle for control of the Mediterranean against the Ottoman Empire was pursued through both war and truce. With the Rebellion of the Alpujarras (1568–71), the "heretics" and their potential danger were a source of concern for the Christian population in the Iberian Peninsula. Therefore, the safeguarding of good Christian subjects was also considered the responsibility of the ruler. It is not surprising that

Disegno quinto; Prospettiua della Chiesa stando in Coro e veduta verso le porte

themes related to the struggle against "heresy" and the perceived "infidel" also emerged in the funeral in Florence.[92]

The Neapolitan funeral oration honoring Philip II by Giulio Cesare Iulii Caesaris exalted the dynastic glory of the House of Habsburg.[93] The royal lineage was one of the key themes of the oration, which presented the genealogy of kings who preceded Philip II. The oration summarized Philip's major achievements and glories, his *res gestae*. The first attribute to be praised was Philip's active role as *fidei defensor* and his interest in the safeguarding of the "true" religion, a reference to the defeat of the Ottoman Empire. The peace with Henry II of France was associated with the victory at St. Quentin, although this time the exaltation of

FIGURE 86 | Giovan Battista Mossi, *Interior of San Lorenzo for the Funeral of Philip II*, 1598. Etching, 28.4 × 38.2 cm. Albertina Museum, Vienna, inv. no. DG2014/104/5. Courtesy of the Albertina Museum.

military exploits was substituted for praise of the Peace of Cateau-Cambrésis. The Iberian Union was another key theme. Comparisons with contemporary rulers also had a place, including the powerful Ottoman emperor. Caesaris described Philip II's empire as the most extensive and powerful on earth. The expansion of Philip II's realms strengthened the promulgation of religion: "Philippi Maxima Relligio."[94] The oration also emphasized Philip's attributes and virtues, such as prudence and justice.

Not only was the oration in Naples printed, but the funeral was also commemorated with a lengthy chronicle describing in detail the ephemeral structures erected to mourn the king's death. The imperial image displayed in the ephemera and monumental catafalque at the funeral in Naples included allegories that had been associated with Philip for years. The ephemera particularly exalted the global connotations of his imperial dominions through a celebration of the Iberian Union. There were inscriptions with allusions to Trezzo's medal of 1555 with its allegories of light and reason (also used by Ruscelli in 1566): "IAM ILLUSTRABIT OMNIA" (Now he shall enlighten all).[95] The propaganda celebrating the Iberian Union was also expressed in the famous sentence "NON SUFFICIT ORBIS" (the world is not enough), Alexander the Great's motto, employed for Philip at the time of the Portuguese succession, which is echoed in the medal minted in Lima in 1583.[96] This is significant, as it further demonstrates the circulation of images, mottos, and ideas regarding the monarch across cities in the Iberian world.

The imperial discourse deployed in the artistic program at Naples is very detailed, and there is a direct allusion to the conquest of Granada and the Iberian struggle against the "infidels" in the peninsula. The defeat of St. Quentin was also displayed in a painting, and the battles of the Azores and Terceira Island were glorified with an inscription that read, "Britanicus, Gallicisque Navibus Prope Terzeiras Insulas Demersis, et Expugnatis," a direct allusion to the defeat not only of António's fleet but also of the vessels that France and England sent to aid the Portuguese.[97] In short, the funeral in Naples was a celebration of Philip II's empire and the victory of his campaigns and those of his ancestors. The fresco cycle at the Hall of Battles celebrates the same themes. The fresco depicting the Battle of La Higueruela of 1431 not only evokes this particular campaign but notably perpetuates the narrative of the Christian "reconquest" that had been forged by Philip's predecessors over generations. In the funeral and also in the Hall of Battles, these victories against the Kingdom of Granada were presented as some of the greatest achievements of the lineage of Castilian kings from which Philip was descended. Philip II's victories in the Netherlands and France, including at St. Quentin (1557) and in the Portuguese campaign, were, as seen earlier, also depicted in frescoes in the Hall of Battles.

The magnificent catafalque erected in the Cathedral of Seville is another good model through which to explore the image of the ruler. Artists of the status of Francisco Pacheco participated in the creation of the ephemera in Seville. In his *Arte de la pintura*, the painter explained that he had painted "histories, hieroglyphics, and figures" in the catafalque. Pacheco also asserted that the ephemera in Seville honoring Philip II surpassed the decorations at Michelangelo's funeral in Florence.[98] The ruler's virtues and abilities as a leader of Christendom were explored in a number of hieroglyphics in the Sevillian catafalque. Mottos under the hieroglyphics summarized Philip's good government: "Fides Publica," a ruler who had been granted the loyalty of his subjects; "Aeternitas Imperii," an empire in perpetuity; "Orbis protectori," protector of the globe; "Securitas Publica," achieved by the king's prudence in government; "Aequitas Augusta," the idea of justice that dominated his realms; "Turcis Devictis," the Turks defeated; and, following imperial discourse, "Omnia Lege Pari," the same law for all, which Philip had implemented across his empire.[99] In the catafalque, images representing all the realms Philip had ruled glorified the manner in which the monarch had governed, inherited, conquered, or colonized each territory. Biblical references to the Old and New Testaments, as in other funerals, also appeared in the ephemera in Seville. Many other cities in Castile and Aragon printed laudatory panegyrics and eulogies recounting the exequies they had organized to mourn the death of the monarch.

The printed material was mostly dedicated to his heir, Philip III, or his representative as a way to show the loyalty of the realm, viceroyalty, or city.

Filiberto Belcredi wrote the oration that was delivered and printed in Pavia in 1598. It opened with the solar and luminescent aspects embodied in the allegorical representation of Philip II.[100] Belcredi symbolically crowned Philip the "King of the Indies" in the title: "potentissimo re delle Espagna, e dell Indie, Filippo II."[101] References to Philip's global dominion were exalted along with his promulgation of the faith. Belcredi listed Philip's achievements as defender of the faith in the war against Lutherans, noting also how he "cleansed" Spain of the "moors" and expanded his lands in the Americas. The oration presented Philip's education as the best among contemporary rulers, and focused on his learning in philosophy, ethics, arts, and religion, among other subjects. His competence as a monarch was praised and his lineage exalted. It is not surprising that Belcredi also glorified the expansion of Philip's imperial dominions through the Iberian Union. He even justified Philip's major failures, such as the unrest in Flanders. Belcredi explained that Philip had taken good measures but that the situation was beyond anyone's control. He justified Philip's actions and explained that the rebels had caused all the problems. He made reference to the war against the Turks and celebrated the victory at St. Quentin.[102]

Belcredi glorified the Monastery of El Escorial for its magnificent architecture, which he described as a "beautiful construction . . . [a] World's miracle, the edifice, known as El Escorial, completed with an incredible magnificence in honor of Saint Lawrence and in memory of the Church, and St Quentin."[103] Images and news of the grand palace-monastery the monarch was building at El Escorial had been circulated during its construction. Rodrigo de Holanda's drawing *The King of Spain's Howse* of 1576 captures the development of the monumental fabric. Holanda

shows the "inventions" Herrera designed to move the materials, and the construction site bustling with masons and other workers. The monastery would be completed in a mere twenty-one years: construction began in 1563 and by 1584 it was finished, which is astounding for a building of this magnitude. Once complete, images of El Escorial notably circulated through the prints that Pierre Perret (ca. 1555–1625) published in tandem with Juan de Herrera, who had been granted permission to print them.[104] A collection of prints titled *Summario y breve declaración de los diseños y estampas de la fábrica de San Lorenzo del Escorial* was published in 1589. Herrera summarized his ambitions in the *Summario*: "In order to satisfy those wishing to know about the greatness of the building of San Lorenzo el Real del Escurial, I have undertaken, although with much labor and expense, to publish this building in various drawings representing many of its parts, so that everything that is in it and its organization may be seen more fully and with greater clarity."[105] The *Summario* follows the Italian tradition of architectural prints that preceded it; however, the level of detail is so ambitious as to surpass its precedents. The images of the floor plans, façades, and general vista aimed to show the monumentality and magnificence of El Escorial and presented a level of accuracy never seen before.[106]

The role of royal architects in the creation of the monastery is unquestionable; however, El Escorial is indissolubly attached to Philip II and his image. The illustrated cover of Luis Cabrera de Córdoba's *Filipe Segundo, rey de España* (Madrid, 1619), for example, also by Perret, shows Philip wearing armor and drawing his sword to protect the enemies of Catholicism. The composition embodies Philip's messianic mission as the light of the world and defender of the faith. The motto reads: "The first priority is religion."[107] The book cover also presents an image of the Monastery of El Escorial in the background: by this time it was recognized

sufficiently to feature in this way, for it had become a symbol of Philip's fame and Christian mission.

For Philip's funeral in Portugal, an enormous catafalque was erected in the Jerónimos Monastery in Belem. The funeral took place in the monastery rather than in the cathedral in Lisbon, as the monastery allowed the designers to create a larger ephemeral structure. The monumental catafalque was inspired by the ephemera designed by Francisco de Mora for Philip's funeral at El Escorial.[108] The *Relação das exequias*, printed by Pedro Crasbeeck in Lisbon, described the funeral in Lisbon to mourn the king and to proclaim his heir, including a detailed account of the catafalque's architectural design. In the sermon, the Dominican preacher Manoel Coelho praised Philip's good governance over his extensive territories. According to Coelho, Philip was the "greatest monarch the world had seen . . . as he was not only king of Spain & [ruled over] most of Italy, & many other states, and many provinces on the East, & on the West, & for a long time [he was] King, 42 years in Castile, Aragon, Naples, & Sicily, 18 [years] in Portugal, 5 [years] in England." The account summarizes Philip's marriages and illustrates his relationship with other European kingdoms as somewhat harmonious. Coelho explained that the struggle in the Low Countries and Germany was caused by heresies and that Philip had only tried to guide those Christian souls back to the true faith, as he had done in England. Coelho's hyperbolically favorable description of Philip's mission in those countries evoked the image of the monarch as a shepherd guiding his flock. This imagery was seen in one of the lateral façades of the Arch of the German Merchants (facing the Alfândega building) in Lisbon in 1581. Although ideas of illumination associated with Philip's religious mission had been circulating for years, they were emphasized after the Courts of Tomar (1580) that crowned him king of Portugal. The Dominican preacher avoided any direct discussion of the Armada or other major disasters that

affected Portugal directly, such as the attacks on its coasts and imperial dominions. The protection of Portugal had been one of Philip's promises when he took the Lusitanian throne, a promise he was unable to keep. Coelho instead focused on Philip's piety and devotion. He compared the virtues of his reign and his actions with those of some of the kings of Judah, particularly Solomon and David.[109] Funerals were also held in other churches in Lisbon and in other cities and towns in Portugal.

In Francisco Fernández Galvão's funeral sermon at the Church of the Holy Cross in Lisbon, the *capelão* (chaplain) also compared the lives of the kings Solomon and David to the virtuous life Philip had lived.[110] Representations of the kings of Judah had been employed in festivals held in Philip's honor during his life, namely, the entry into Antwerp with his father, later the emperor Charles V, in 1549, where Charles was associated with David and Philip with Solomon. Similar imagery and inscriptions were displayed in Philip's ceremonial entry into Lisbon in 1581 and were echoed in the Bengali colchas embroidered for the Portuguese market (see chapter 3). The kings of Judah also appeared in the Corpus Christi procession of the confraternity of the Holy Sacrament from the Church of São Julião in Lisbon in 1582.[111] Philip had been invited to the procession, and he and his sister, the empress Maria of Austria (1528–1606), who was in Lisbon at the time, observed the procession from the royal palace, in premises that had a view onto the Rua Nova dos Mercadores.[112]

The kings of Judah are also famously found in the Courtyard of the Kings (Patio de los Reyes) at El Escorial, the façade of which boasts a series of statues of these kings with inscriptions devised by the humanist Benito Arias Montano (1527–1598) (fig. 87). While the texts of the other statues reinforced Philip's image as defender of the faith, the inscriptions for David and Solomon emphasize the divine mission Philip had fulfilled in building the monastery. David's inscription is "OPERIS

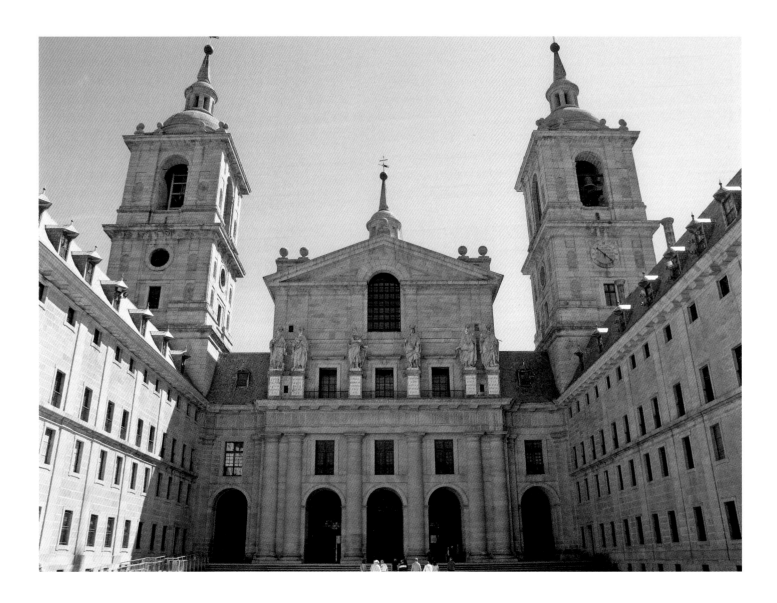

EXEMPLAR A DOMINO RECEPIT" (He received the design of the work from the hands of the Lord), and Solomon's, "TEMPLUM DÑO [DOMINO] AEDIFICATUM DEDICAUIT" (He dedicated the building of the temple to the Lord). The location of these statues is significant: they were placed at the center of the composition, on top of the frieze over the entrance to the basilica, an entrance that emulated a triumphal arch. The façade echoes some of the ephemeral displays that had employed similar imagery during Philip's reign; however, the

FIGURE 87 | Façade of the Basilica of El Escorial, Courtyard of the Kings. Photo: Javier Fergo.

iconography of the kings of Judah was widely employed by most European courts of the period.

Nevertheless, Philip's funerals also echoed some of the most relevant political events of his reign, above all those that could be glorified. In Castile and Aragon, many cities commemorated the loss of the ruler, and the catafalque in Seville was decorated lavishly.[113] This was also the case in

Madrid, Coruña, Murcia, Zaragoza, Barcelona, and Valladolid, among other places, where ephemeral structures, especially catafalques, were erected. Fray Alonso Cabrera's sermon in Madrid presented the Battle of Lepanto (1571) as a sublime form of divine intervention.[114] Juan Iñíguez de Lequerica compiled and printed the sermons preached at a number of funerals in Castilian and Aragonese cities. These sermons exalted the religious aspects of Philip's model life as a Christian ruler.[115] The city of Murcia, for example, printed an extensive account of the exequies they funded to commemorate the loss of the monarch and erected a monumental *túmulo* (tomb). The account focused as much on promoting the city's devotion, and that of its elites, to the deceased ruler and his heir as to the description of the funeral rites.[116] Similar services were held elsewhere: in Seville, the commemoration was delayed because of disputes concerning the order of precedence.[117] For local elites in particular, it was a matter of some significance that their place in the funeral celebrations be ensured, for this reflected their social status, which in turn was likely to be reproduced in the printed accounts. Sermons in Murcia used the kings of Judah and the Old Testament in similes about Philip's good government and piety. The victory at St. Quentin was celebrated. The sermons made direct mention of the Iberian struggle against the Kingdom of Granada and Philip's wars against "heretics" in Europe and the Turks in the Mediterranean.[118] In short, funerals throughout Iberia and Europe made use of similar images and themes, often tailored to the interests and wishes of their own locale.

The Inquisition also staged grand funerals in New Spain to mourn the king's death. The catafalque erected in Mexico City had a richly complex composition, with myths and religious allegories related to the king. The only contemporary battle featured in the ephemera there referred to Philip's victory against the Turks.[119] Philip's triumphal

image was explored through passages from the Bible and classical works by Ovid and Pliny, reflecting the city's rich and long-standing festival culture.[120] References to King David and Roman emperors evoked imperial themes and Philip's messianic status. Philip's defense of the postulates of the Council of Trent was celebrated as a symbolic act that proved he had fulfilled his duty as *fidei defensor*. These are themes, in sum, that were also explored in funerals on the other side of the Atlantic.[121] The ceremony organized by the Inquisition aimed to reinforce royal authority and ensure its continuity. In America, the presence of authority was embodied in the viceroy and, in the funeral in Mexico City, also in the Inquisitor.[122]

The constellation of sonnets, eulogies, and funeral accounts that recited the life and achievements of the ruler were also tools for self-fashioning that allowed these locales to promote themselves, especially if the exequies were printed. Images and references from both the biblical and classical repertoires, along with those coined during Philip's reign, were reiterated in the decoration of numerous catafalques or declaimed in sermons that were then printed. A comprehensive study of Philip's funerals is an impossible undertaking within the obvious constraints of the present chapter and book. However, the preliminary analysis of a number of carefully selected funeral accounts has proved a useful means of examining the circulation of images and the way cities and towns projected their place within the hierarchy of cities in the empire. Some of the cultural artifacts circulated in the imagery that emerged with the Iberian Union (chapter 3), the creation of a network of imperial archives (chapter 2), and the use of an architectural lexicon for the design of residential architecture (chapter 1). Thus the wider contextualization and comparison of images and buildings, among other materials and themes, has advanced our understanding of pan-Iberian circulations during Philip II's reign.

EPILOGUE

After Your Highness takes under her yoke many barbarian towns and nations with strange tongues, and with the conquering of them, they will need to receive the laws that the conqueror puts on the conquered and with those, our language.

—Nebrija, *Gramática de la lengua castellana*

The Spanish scholar Antonio de Nebrija (1441–1522) explained his imperial vision to the Catholic Monarchs in this passage, and in his famous assertion that "language has always been the companion of empire."[1] Susan V. Webster has recently employed Nebrija's famous statement to discuss the contributions made not only by the Spanish ruling elites but also by native architects and artists in America.[2] The analysis in the first two chapters of this book concurs with Webster's assessment of Nebrija's postulate. Nebrija was commenting on the manner in which the Roman Empire had imposed its authority on its vast dominions. The Spanish empire under Philip II emulated ancient Rome in imposing authority and administrating the benefits of the empire. Its imperial discourse was implemented in the legislative codification of the empire under the banner "one law for all." The imperial paradigm was reflected in the body of legislation on domestic architecture and urbanism that emerged in Madrid's court in the first decades of its designation as the seat of court. In this period, the ruler built palaces that echoed his

authority, and bestowed his favor on the erection of religious buildings. In tandem with these developments, Philip, his entourage, and local authorities envisioned an urban fabric that would form the backdrop of this grand urban scenery. In Madrid, houses would be visually uniform and would present a variety of scales to reflect social hierarchy in the townscape of the capital city. Through analysis of the body of legislation issued by the Spanish court for America, a clear imperial grammar can be discerned on both sides of the Atlantic. This ideal urbanism aimed to be both practical and efficient, as expected from an empire under the rule of Philip II of Spain; it was influenced by the classical tradition of ancient Rome and was motivated to evangelize the souls of the American subjects. Furthermore, housing legislation reflected the ceremonial needs of early modern Iberian cities. Cities across the Iberian world negotiated these imperial mandates and synthesized construction technologies and materials that performed well in their particular contexts, and integrated pan-Iberian trends that reflected transregional architectural design

at the forefront of their time. While the imperial urban and architectural vision for domestic architecture would not entirely succeed, the efforts that were made offer useful insights for an understanding of Philip II's world.

Philip was decisive in his promotion of urban legislation in Madrid, personally reviewing many building applications. Successive modifications of the regulations on domestic architecture are an enlightening guide to the intentions of the court regarding the aesthetic configuration of Madrid. In addition, the description of a housing prototype in each of the three major regulations of the era is instrumental to the development of architectural drawings of these houses, which in turn provide further insights into the legislation. In addition, this book has identified for the first time a number of original drawings that show that Habsburg urbanism in Madrid, in particular residential architecture, developed earlier than previously believed.

The strong links between American urbanization processes and the developments in peninsular Castile have been illustrated here through domestic architecture for the first time. Instead of exploring only imperial policies, I have examined how some cities negotiated royal orders and local needs and the mechanisms they established for development control. Further, the diverse social background of the people involved in the building trade on both sides of the ocean shows that Spaniards, Amerindians, and *alarifes* of Mudéjar and *Morisco* descent, among others, contributed to the creation of a common architectural lexicon. While I have been able to include only a limited number of examples in this book, it would be useful to study other cities through residential architecture and not only via palaces and religious architecture. A comparative study of vast scope would require scholarly collaboration and would need to rely on techniques that historians of vernacular architecture have employed in the past, such as geographic

information systems and other data-mining tools. Subjects, after all, inhabited houses, and the study of these residences may illustrate urban dynamics for which other buildings provide no evidence.

This book has demonstrated that early modern architecture and urbanism on both sides of the Atlantic formed part of the same field of thought and activity at Philip's court. There is also scope for further research on the important role of the monarch's entourage in the development of these ideas. I have briefly explored the roles of some officials at Philip II's court. As court members were appointed to different councils during their careers, their involvement in particular councils, such as that of the Indies and that of Castile, forces us to reassess their influence on decisions made throughout Philip's dominions. The role that these people played at court and also across viceregal America seems to be crucial for an understanding of their influence in the governance and administration of cities across the empire. Particularly pressing is to further the study of not only the social and political influence of court members but also the prominent role that Amerindians, free, enslaved, and freed peoples and other religious and racial minorities played in cities and imperial structures. In other words, researching the lives and contribution of a diverse array of agents and peoples is the way in which we will begin to fully grasp how the architecture of the Iberian empires functioned.

Ultimately, as stated by Nebrija, law was a means of imposing authority, and legislation would be uniform in Philip's world. Whether the legislation was fully implemented or not would depend on the particular locale and region. However, control of the built environment and the configuration of the city were implemented through the same principle of uniformity. This also affected the Habsburg network of archives, which were governed by similar regulations in both peninsular Castile and the imperial domains. This codification

and organization of the empire was sustained through a strong administrative apparatus, embodied in the Simancas archive.

I have argued that the architectural evolution of the archive at the Simancas fortress reveals in microcosm the history of the realm and the organization of the empire in the sixteenth century. Furthermore, coexisting Iberian visual trends and the evolution of the Austríaco style during Philip's reign can be discerned in the architecture of the archive. The king bureaucratized the administration of his lands as a way to impose his authority over vast and far-flung territories. The gradual transformation of the fortress into an archive mirrored the conversion of the Crown of Castile into an overseas empire. Transatlantic imperial expansion affected the center of Castile both in urban legislation and in the way it was administered. Thus the architecture of the Simancas archive, both that which was completed and that which was never realized, is a perfect model through which to see how the periphery affected the center of empire, and also how Castile and its monarch viewed themselves, respectively, as a global empire and ruler.

This book has also contextualized the Simancas chambers within a vernacular tradition for the construction of archives in the early sixteenth century. This tradition expressed itself in the first development of the archive in the two *cubicula* adapted in the fortress. There were two major expansions of the archive thereafter, one designed by Juan de Herrera in the 1570s and the other by Francisco de Mora in the 1580s. The two developments transformed the building into the most modern archive in Europe at the time. The spaces created by Herrera to store administrative documents, such as the collections of the councils, had no contemporary equivalent. The sober design of the pavilions aimed to balance light and space through accurate techniques of proportion and, when necessary,

forced or "artificial" perspective. The results were impressive. Mora's new rooms for the king's papers deployed an evolved Austríaco style; the elegance of the chambers was of royal status. Philip's visit to the archive in 1592 presented the architect with new challenges. The king wished to have his own access to the archive, and therefore an independent route within the castle was designed solely for his use. This passage can be seen as an "architectural maze" within the building. The king's requirement for this "royal" access links it to the notion of majesty that was sustained during Philip's reign, through which the monarchy distanced itself from its subjects. The "gallery of kings" envisioned in Simancas evoked the "galleries of illustrious men"; here, the portraits were inspired by imagery of ancient Roman emperors. In short, both legislation and the artistic representation planned and deployed in the archive at the Castle of Simancas mirrored the notions of kingship, empire, and authority imposed during Philip II's reign. While the history and creation of archives have been the focus of recent attention, historians of architecture have yet to develop the field. More research is particularly pressing in the case of buildings and spaces that held the papers of empires and powerful states. A comparative study of the spatial configuration of the archive in Simancas and the architectural expansion of archives elsewhere in Europe, viceregal America, and Portuguese India in the seventeenth century would be significant and a welcome addition to my own contribution on the circulation of design trends.

The imperial image of the ruler has traditionally been explored by analyzing the arts of his reign and particularly those under Philip's patronage. In the case of Philip's triumphal entry into Lisbon in 1581, I have examined three major themes concerning the notion of empire and how they affected the manner in which Philip II was portrayed: artistic triumphal language, the king's role in the festival,

and the duties and responsibilities of the Christian ruler. These themes demonstrate how the image of the ruler was designed to embody the grandeur of his imperial achievements, and specifically to include the new reality of the Iberian Union, which made him as a global ruler. At the same time, the décor and dialogue displayed and performed in the festival revealed the king's tense and complex relationship with his new realm. In the end, the court's political discourse regarding Philip's image as a global ruler was combined with local concerns and interests. These issues were deployed through a highly sophisticated visual etiquette in the pageant and its artistic program.

Some further lines of research emerge from this festival that would be worth pursuing in the future. I have been unable to study most of the arches funded by local guilds, for example. The citizens of Lisbon deployed an impressive artistic program in these arches, which was intended to reflect not only their traditions and pay homage to the new ruler but also to express their demands and fears. These ephemeral displays could be compared with some of the traditional festivals staged in Lisbon prior to Philip's arrival. Likewise, neither Sebastian I's court nor the strong influence of Francisco de Holanda's work on the arches inside the city fence erected in 1581 have been sufficiently studied. A study of a city port like Lisbon, a major center for transcontinental commercial exchange, comparable with Seville or Goa (Old Goa now), requires a wider contextualization, an engagement with the rest of the world. In addition to the study of commodities from Asia, Africa, and America that were sold in the city's markets, further transoceanic comparative analysis regarding rituals, art, and architecture are desirable lines of research.

The union of the Portuguese and Spanish Crowns was of major importance for Philip II, and it also transformed the political position of the Iberian empire in Europe. Images of Philip in the aftermath of his accession to the throne of

Portugal circulated across the Iberian world. The final chapter of this book explores notions of history and fame with regard to the fresco cycle at the Hall of Battles at El Escorial and Philip II's funeral services. The fresco cycle is at once a work of history, a ceremonial space, and a site of memory. More important, the themes depicted on the walls of the Hall of Battles were reiterated in the funeral chronicles, sermons, and eulogies written upon the king's death. It is significant that the sonnets, sermons, and other funeral rites shared and replicated most of the royal imagery that had been forged during Philip's reign. A more exhaustive engagement with the funerals commemorating the monarch's death would be a very useful means of understanding the pan-Iberian flow of images in this period; a study of this scope would require scholarly collaboration.

The present book has shown that information exchange was prominent in the Iberian system, that the wider contextualization of buildings and objects is significant to gaining a better picture of Philip's world, and that imagery and architectural and visual trends circulated widely. In sum, studying the exchange of ideas and trends is a useful means of exploring how the periphery of empire affected its center. Further explorations of connected histories of empire, architecture, and visual trends would shed new light not only on our understanding of globalization processes, but also on our perception of the buildings at the heart of empire and its political power.

GLOSSARY

Note: all terms are in Spanish unless otherwise indicated.

alamedas: a grove of poplars, or a tree-lined avenue or space (see paseos).

alarife: "one who understands the art of building," a mason, from the Arabic *arīf*, "expert."

Alcázar: royal palace, from the Arabic *al-qaṣr*, "the castle."

Andalusi or Andalusian: from or relative to Al-Andalus. Andalusia is also Spain's southern region.

aparejo toledano: masonry composed of a mixture of bricks and stones with mortar and divided into rectangular boxes on the wall by bricklayers. It is found particularly in areas of Castile; likely to be a derivation of the Roman *opus mixtum*.

aposento: seat (as in seat of court).

Archivum Arcis (Latin): treasure room.

armação (Portuguese): a temporary façade, often made from a wooden structure covered with painted canvas or textile.

artesonado and *armadura*: carved and pieced wooden ceiling panels that were often inlaid, painted, and gilded.

bajareque: wattle-and-daub walls, very flexible and made with cane and reed.

Cámara de Castilla: Chamber of Castile, the chamber closest to the king in the council system of the Spanish monarchy. The presidents of the Council of Castile and Council of the Indies formed part of this chamber.

Camino Real: Royal Way in New Spain, a road that linked the Port of Veracruz with Puebla and Mexico City.

Caños de Carmona: a Roman aqueduct, rebuilt by the Almohads, that brought potable water from Carmona to the city of Seville. The aqueduct was active in the early modern period and remained in operation until 1912.

casa: house or dwelling. *Casas comunes, casas principales*, and *casas reales* can be translated as common houses, principal houses, and royal houses, respectively.

casa a la malicia: malfeasance house.

cassone (pl. *cassoni*) (Italian): painted chest.

choza: hut or shack with thatched roof.

ciudad de los Españoles: city of the Spaniards, as opposed to a *ciudad de los Indios* (city of the Indians). In America, the Council of the Indies sought to segregate the Spanish and Amerindian population by creating distinct cities and towns.

colcha: embroidered hanging often made with rich fabrics and intricately decorated.

corregidor: royal representative in Spanish cities.

cubo: from the Latin *cubiculum*, a building or chamber with a central floor plan.

doncellas: maidens.

emplentas: sections of *tapial* normally premade in one block.

entera noticia: complete knowledge and intelligence.

escudos: Spanish currency of gold or silver.

gracias or *privilegios*: royal privileges granted by the Crown.

historia pro patria (Latin): the history of the realm.

La Iglesia Militante (Portuguese): the Church Militant.

Junta de Obras y Bosques: The Royal Works and Forests Board or Committee oversaw the construction of palaces and castles, including their gardens, and also controlled forests and hunting on royal estates.

Junta de Policía de Madrid: Committee of Public Works in Madrid.

lagosta (Portuguese): lobster.

libros historiados: history books that also contain "figures in drawing or print," the images of which correspond to the stories in the text.

naumachiae (Latin): mock naval battles usually enacted in festivals and triumphs.

ornato y policía: embellishment and order, normally applied to a city or town.

Pan-Iberian: referring to the Iberian Peninsula and all the former colonial territories that formed part of the Spanish empire (including Portugal in the period 1580–1640).

paseos: promenades, enlarged public walking spaces, usually lined with trees.

patio: interior courtyard of a house or other building.

patronazgo real: royal properties; also royal control over church and lands.

petate: a bedroll or hanging, from the Náhuatl term *petlatl*. *Petates* were woven from the fibers of the petate palm.

pie and Castilian *vara*: units of measure in early modern Castile, a *pie* was equal to about 0.278

meters and a *vara* was between 0.7 and 0.9 meters.

pieça: literally "a piece of something"; in construction, a room.

quincha: from the Quechua term *qincha*, a traditional construction technique that employs wood and cane or giant reeds to make an earthquake-proof framework that is covered in mud and plaster.

Real Hacienda: Royal Treasury. The Consejo de Hacienda was created in 1523 by Charles V and controlled rents and other business of the realm.

regalía de aposento: a fee or royalty imposed in Castile in the Middle Ages when the court was temporarily resident in a city or town. It required homeowners either to cede half their properties temporarily to members of the court or, alternatively, to pay a tax.

Relaciones Geográficas: questionnaires sent to all cities and towns in both Iberia and the Americas to gather information on landscape, resources, population, spiritual and political matters, architecture, and many other matters.

res gestae (Latin): literally "things done"—that is, written or visual histories that exalted the deeds and major accomplishments of the ruler.

retributio (Latin): reciprocity.

sarga: painted cloth.

Schatzkammer (German): treasury, treasure chamber, or treasure vault.

soportales: arcades.

tabularium (Latin): in ancient Rome a *tabularium* was an archive and a *tabularium caesaris* was an archive for imperial administration, the emperor's correspondence, reports from provincial governors, and the like.

tapia walls: rammed-earth walls.

verdugadas: rows of bricks.

ver sin ser visto: to see but not be seen.

villa: a town, often a small town.

visitador: inspector at court.

visitador de aposento: an inspector of the *regalia de aposento* administrative processes at court.

visitadores of the Indies: envoys (inspectors) from the king to viceregal America whose principal objective was to investigate whether the legislation issued at the court was properly enacted. A *visitador* of the Council of the Indies investigated council affairs.

yesería: architectural decoration made by carving plaster.

zaguán: entrance hall within a house.

NOTES

Introduction

1. See Zalama Rodríguez, "Ceremonial Decoration of the Alcázar."

2. On the Honors series (Patrimonio Nacional, series no. 8), see ibid., 50.

3. Ibid., 50–51.

4. See Amelang, "New World in the Old"; Hamann, "Mirrors of Las Meninas."

5. Pereda, "Response: The Invisible?"

6. On the integration of the Islamic past into sixteenth-century Spanish art, see, for example, Fuchs, *Exotic Nation*; Robinson, *Imagining the Passion*; Urquízar-Herrera, *Admiration and Awe*.

7. See Fernández-González and Trusted, "Visual and Spatial Hybridity."

8. Gérard Powell, *De castillo a palacio*, 51–57; Barbeito, *Alcázar de Madrid*, chaps. 1 and 2.

9. Nieto Alcaide, Checa Cremades, and Morales, *Arquitectura del Renacimiento*, 254.

10. See Villalpando's introduction to Serlio, *Tercero y quarto libro*, 2.

11. Wilkinson-Zerner, "Planning a Style for the Escorial," 38, 47. The first translation of Alberti's treatise into Castilian was commissioned by Philip II at the recommendation of Juan de Herrera and printed in 1582 as Alberti, *Diez libros de arquitectura*.

12. *De arquitectura*, Biblioteca Nacional de España, Madrid (hereafter BNE), MS 9681, fol. 4; Wilkinson-Zerner, "Planning a Style for the Escorial"; Marías Franco with Bustamante, "Tratado inédito de arquitectura," 41–57.

13. Escobar, "Francisco de Sotomayor."

14. Philip's correspondence often addressed the work he planned on several palaces; see, for example, Archivo General de Simancas (hereafter AGS), Casa Real, Obras y Bosques, folders 247–50, among others.

15. Barbeito, "Felipe II y la arquitectura." On the Junta de Obras y Bosques, see Díaz González, *Real Junta de Obras y Bosques*.

16. Portuondo, *Secret Science*, 79–90.

17. For an assessment of Valencia's contribution to the development of Madrid, see Escobar, *Shaping of Baroque Madrid*. For Juan Gómez de Mora, see, for example, Tovar Martín, *Juan Gómez de Mora*.

18. Wilkinson-Zerner, *Juan de Herrera*, 90.

19. Philip ordered the introduction of a slate roofing system explicitly in imitation of roofs in Flanders. Nieto Alcaide, Checa Cremades, and Morales, *Arquitectura del Renacimiento*, 256.

20. On Justi, see Wilkinson-Zerner, *Juan de Herrera*, 33–36; on the Black Legend, see, for example, Pérez, *Leyenda Negra*.

21. See Kubler, *Portuguese Plain Architecture*, among others.

22. Mulcahy, "Philip II: Madrid and Elsewhere."

23. Wilkinson-Zerner and Brown, *Philip II and the Escorial*, 9.

24. Mulcahy, "Philip II: Madrid and Elsewhere," 127.

25. See, for example, ibid.; Parker, *Felipe II*, 956–83. On Philip as a patron of the arts, see particularly Checa Cremades, *Felipe II: Mecenas*; Checa Cremades, *Felipe II: Un monarca*; Mulcahy, *Philip II of Spain*; Marías Franco, *Largo siglo XVI*; and Wilkinson-Zerner, *Juan de Herrera*.

The bibliography is vast; other works are cited elsewhere in this book.

26. See Fernández-González, "Imagining the Past."

27. See Prescott, *Reign of Philip the Second*; Parker, *Felipe II*, 980–83. The most recent biographies are Parker, *Imprudent King*; Parker, *Felipe II*; Parker, *Grand Strategy of Philip II*; and Ball and Parker, *Cómo ser rey*.

28. Edelmayer, *Philipp II*; Kamen, *Escorial*; Rodríguez Salgado, *Changing Face of Empire*; Sánchez-Molero, *Aprendizaje cortesano de Felipe II*; Escudero, *Felipe II*; Bouza Álvarez, *D. Filipe I*; Kagan, *Clio and the Crown*. See also Cabrera de Córdoba, *Felipe Segundo, rey de España*; Édouard, *Empire imaginiaire de Philippe II*, among many others.

29. Checa Cremades, *Felipe II: Mecenas*; Mulcahy, *Decoration of the Royal Basilica*; Mulcahy, *Juan Fernández de Navarrete*; Mulcahy, *Philip II of Spain*; Llaguno y Amírola and Ceán Bermúdez, *Noticias de los arquitectos*; Kubler, *Building the Escorial*; Marías Franco, *Arquitectura del Renacimiento*; Marías Franco, *Largo siglo XVI*; Kagan and Marías Franco, *Urban Images of the Hispanic World*; and Rivera Blanco, *Juan Bautista de Toledo*.

30. Wilkinson-Zerner, *Juan de Herrera*. For other studies of Juan de Herrera, see, for example, Ruiz de Arcaute, Anasagasti, and Ortega Vidal, *Juan de Herrera*; Aramburu-Zabala Higuera and Gómez Martínez, *Juan de Herrera y su influencia*; and Sánchez Cantón, *Librería de Juan de Herrera*.

31. See, for example, all by Bouza Álvarez, *Imagen y propaganda*; *Cartas de Felipe II*; *Felipe II y el Portugal*; and *D. Filipe I*.

32. See Gérard Powell, *De castillo a palacio*; Checa Cremades, *Real Alcázar de Madrid*; Barbeito, *Alcázar de Madrid*; and Alvar Ezquerra, *Felipe II y la corte*.

33. Escobar, *Shaping of Baroque Madrid*.

34. Alvar Ezquerra, *Nacimiento de una capital europea*; Sieber, "Invention of a Capital."

35. The *real cédula* of 1565 was published in Díez Navarro, *Alegación fiscal por el derecho*, 21–33. See also, both by Íñiguez Almech, "Límites y ordenanzas de 1567" and "Juan de Herrera y las reformas."

36. See Escobar, *Plaza Mayor y los orígenes*, chap. 6.

37. Rodríguez de Diego, *Instrucción para el gobierno*; Rodríguez de Diego and Rodríguez de Diego, "Archivo no solo para el rey." See also Grebe *Akten, Archive, Absolutismus*.

38. See Schaub, *Portugal na monarquia hispánica*; Ramada Curto, *Cultura política*; Cardim, *Cortes e cultura política* and *Portugal unido y separado*; Bouza Álvarez, *Imagen y propaganda* and "Retórica da imagem real"; Soromenho, "*Ingegnosi ornamenti*"; and Torres Megiani, *Rei ausente*.

39. See Brown, *Sala de las Batallas*. Other publications are cited in full in chapter 4.

40. An exception is the Pastrana tapestry series; see Checa Cremades, "Language of Triumph."

Chapter 1

1. The epigraph to this section is from Cabrera de Córdoba, *Filipe Segundo, rey de España*, 218. See also Escobar, "Francisco de Sotomayor," 362.

2. Escobar, *Plaza Mayor y los orígenes*, 29.

3. For a more extensive discussion, see Fernández Álvarez, *Establecimiento de la capitalidad*.

4. Sánchez-Molero, "Madrid y la corte itinerante."

5. Prince Philip, letter concerning urban reform around the Church of San Juan, 25 July 1544, AGS, Casas y Sitios Reales, folder 247, file 1, fols. 1–2.

6. Ibid., folder 248, fol. 70 (20 January 1559).

7. Reyes Leoz, "Evolución de la población."

8. See Escobar, *Shaping of Baroque Madrid*.

9. See, for example, Sieber, "Invention of a Capital"; Alvar Ezquerra, *Nacimiento de una capital europea*.

10. The report is found in AGS, Casas y Sitios Reales, folder 247, file 1, no. 257, "*Memorias de las Obras de Madrid* (ca. 1565)." See Alvar Ezquerra, *Nacimiento de una capital europea*, 193–94; Rivera Blanco, *Juan Bautista de Toledo*, 231–32; and Escobar, "Francisco de Sotomayor," 364–65.

11. Alvar Ezquerra, *Nacimiento de una capital europea*, 208. The tree planting aimed to add vegetation and to bolster already existing gardens. On Philip's interest in gardens, see, for example, Sociedad Estatal, *Jardín y naturaleza*; Luengo, *Aranjuez, utopía y realidad*.

12. Íñiguez Almech, "Juan de Herrera y las reformas"; Wilkinson-Zerner, *Juan de Herrera*, 106–7.

13. See a transcription of the bylaw in Escobar, *Shaping of Baroque Madrid*, 225–29.

14. The *real cédula* of 1565 was published in Díez Navarro, *Alegación fiscal por el derecho*, 23–26. The transcription of the ordinances enacted in 1567 is found

in Íñiguez Almech, "Límites y ordenanzas de 1567."
See also Sieber, "Invention of a Capital," 153–55; Alvar
Ezquerra, *Nacimiento de una capital europea*, 199–200,
216–26; Íñiguez Almech, "Juan de Herrera y las refor-
mas," 107–8.

15. Marín Perellón, "Planimetría general de Madrid";
Molina Campuzano, *Planos de Madrid*.

16. For a brief analysis of building permits granted
under the legislation, see Martínez Bara, *Licencias de
exención*; González García, "De ornato y policía."

17. Tovar Martín, "Urbano y lo suburbano" and "Plaza
Principal de Madrid."

18. On the unsuccessful development of Madrid, see
Wilkinson-Zerner, *Juan de Herrera*, 154–58. On architec-
tural developments in seventeenth-century Madrid, see
Tovar Martín, *Arquitectura madrileña del s. XVII* and *Juan
Gómez de Mora*.

19. Copies of the *Ordenanzas de descubrimiento, nueva
población y pacificación de las Indias dadas por Felipe II, el
13 de Julio de 1573*, can be found in the Archivo General
de Indias and elsewhere; see Crouch, Garr and Mundigo,
Spanish City Planning; Sieber, "Invention of a Capital,"
127–89.

20. Covarrubias y Orozco, *Tesoro de la lengua
castellana*, fol. 207v.

21. Díez Navarro, *Alegación fiscal por el derecho*, 23–26;
Molina Campuzano, *Planos de Madrid*, 123–30.

22. For further details on the visual re-creations, see
Fernández-González, "Imagining the Past."

23. Martínez Bara, *Licencias de exención*, 7; González
García, "De ornato y policía," 106.

24. Íñiguez Almech, "Límites y ordenanzas de 1567,"
6–7.

25. A residence near the Plaza Mayor, for example,
had a façade of only around 4.25 meters in length; see
ibid., 32; González García, "De ornato y policía," 103.
Madrid, like other contemporary cities in Iberia, such
as Seville, also had its share of "minimal houses." See
Blasco Esquivias, *Casa*, 1:38–39.

26. Sieber, "Invention of a Capital," 159; González
García, "De ornato y policía," 106.

27. Juan de Herrera to Mateo Vázquez, 25 March 1582,
quoted in Íñiguez Almech, "Juan de Herrera y las refor-
mas," 33. Herrera wrote again the following year of his
concerns about the poor architectural state of Madrid;
see Fernández-González, "Architectural Hybrids," 13.

28. Díez Navarro, *Alegación fiscal por el derecho*, 26–28.

29. Copies found in the Archivo Histórico Nacional,
Consejos Suprimidos, Consultas de Gracia, folders
4.407–15. Martínez Bara religiously annotated the
king's input in his *Licencias de exención*. This collection
includes only brief information on the permits. The
Archivo de la Villa in Madrid houses a substantial collec-
tion regarding building activity in the city (e.g., the *Libro
de Licencias* of 1587).

30. Espinosa was one official among many in the
circle of allies his uncle forged at Philip's court; see
Bermudez, *Regalia del aposentamiento de corte*, 109.

31. In 1577, for example, the king asked for a report on
a petition by Alfonso de Montufa to do some work on a
house in Calle de las Fuentes. Martínez Bara, *Licencias de
exención*, 11, 17.

32. Wilkinson-Zerner, *Juan de Herrera*, 157. In 1597,
the monarch requested that all such petitions be sent
to the Junta de Obras; see Martínez Bara, *Licencias de
exención*, 24, 27, 33, 83, 86.

33. Martínez Bara, *Licencias de exención*, 25.

34. Ibid., 21.

35. Díez Navarro, *Alegación fiscal por el derecho*, 23–26;
Escobar, *Plaza Mayor y los orígenes*, 221n72. See also
Fernández-González, "Architectural Hybrids."

36. AGS, Escribanía Mayor de Rentas, Exenciones de
Aposento, folder 2, file 13. The plan is included, but not
addressed in any detail, in Álvarez Terán, *Mapas, planos
y dibujos*, 642. A collection with *aposento* exemptions
processed by Laguna and Gaytán de Ayala in 1589–90 is
found in AGS, Escribanía Mayor de Rentas, Exenciones
de Aposento, Casas de Aposento.

37. AGS, Escribanía Mayor de Rentas, Exenciones de
Aposento, folder 2, file 13, fols. 13, 15.

38. Pablo de Laguna was a cleric and jurist who held
several offices and rose to prominence in the Espinosa
circle. He was a judge at the Real Chancillería of
Granada, an inspector of the Real Hacienda, Council
of the Inquisition, governor of the Council of Hacienda
(1592–95), president of the Council of the Indies (1595)
and bishop of Córdoba (1603–6). See Gómez Bravo,
Magistral de la Catedral de Córdoba, 571; González Dávila,
Teatro de las grandezas, 481–82.

39. Luis Gaytán de Ayala was a *procurador* in the
courts of Castile of 1573 and held the appointment of
corregidor of Madrid in 1579–83 and 1587–92. By 1589 he

had become a knight and major bookkeeper of the Order of Santiago and of the Royal Treasury. He later became a member of the Committee of Public Works in Madrid, created in 1591. He was one of the great promoters of the Plaza Mayor in Madrid; see Escobar, *Shaping of Baroque Madrid*.

40. Molina Campuzano, *Planos de Madrid*, 120–68; Marín Perellón, "Planimetría general de Madrid."

41. Marín Perellón, "Planimetría general de Madrid." Laguna also created an inventory of houses in Madrid; see AGS, Contaduría Mayor de Hacienda, inventory nos. 69 and 70. Molina Campuzano, *Planos de Madrid*, 136.

42. Molina Campuzano, *Planos de Madrid*, 136.

43. *Corrales* were also encouraged in the legislation issued in 1584; see González García, "De ornato y policía."

44. Feliciano and Ruiz Souza, "Al-Andalus and Castile."

45. Díez Navarro, *Alegación fiscal por el derecho*, 193.

46. Tovar Martín, *Arquitectura madrileña del s. XVII*, 453.

47. This drawing is partially reproduced but not analyzed in Fernández-González, "Imagining the Past."

48. "Memorandum from Pedro de Herrera y Lintorne regarding *aposento* exemption, Valladolid, 27th May 1604," AGS, Cámara de Castilla, folder 893.

49. Sigüenza, *Historia de la Orden de San Geronimo*, discurso 19; Wilkinson-Zerner, *Juan de Herrera*, 47, 48, 51.

50. González García, "De ornato y policía," 107.

51. Barbeito, *Alcázar de Madrid*, 37.

52. "Elevation of a house for Gregorio Tapia with three stories, Valladolid 1608," AGS, Cámara de Castilla, Diversos de Castilla, folders 40–55. Agustín de Pedrosa was an "alarife de la villa y corte y criado del rey." See Marías Franco, *Arquitectura del Renacimiento*, 211–12.

53. "Application for the exemption of *aposento* duties by Rodrigo de Herrera y Ribera for a house he owned in Calle Nuestra Señora de Loreto in Madrid, 1608," AGS, Cámara de Castilla, folder 937.

54. "Drawing Casa de Miguel Rodríguez," BNE, Reservado, Goya, shelfmark DIB/14/45/7; see Tovar Martín, *Juan Gómez de Mora*.

55. See the introduction on *De arquitectura*, Albertian thought, and Philip. See also Blasco Esquivias, *Arquitectos y tracistas*, 78–85.

56. Solano, *Normas y leyes*, 12–13.

57. Fernández-González, "Architectural Hybrids," 15.

58. Deagan and Cruxent, *Archaeology at La Isabela*, 111–13.

59. Fort et al., "Use of Natural Building Stone."

60. See Puerta de Fuencarral, in Tovar Martín, *Arquitectura madrileña del s. XVII*, 722.

61. Rebollo Matías, *Plaza y mercado mayor*, 323–38; Wilkinson-Zerner, *Juan de Herrera*, 152–54; Escobar, *Shaping of Baroque Madrid*.

62. Bustamante García, *Arquitectura clasicista*, 27.

63. Llaguno y Amírola and Ceán-Bermúdez, *Noticias de los arquitectos*, 193.

64. Rebollo Matías, *Plaza y mercado mayor*, 196, 95, 195, 207.

65. Ibid., 208–9.

66. Solano, *Normas y leyes*, 23.

67. See Fernández-González, "Architectural Hybrids," 15; see also Palm, *Arquitectura y arte colonial*.

68. Fernández-González, "Architectural Hybrids," 14–16.

69. Morales Padrón, *Historia de Sevilla*, 42, 43.

70. Albardonedo Freire, *Urbanismo de Sevilla*, 173.

71. Morales Padrón, *Historia de Sevilla*, 43.

72. For an overview of Sevilian domestic architecture, see Falcón Márquez, *Casas sevillanas desde la Edad Media*.

73. Morgado, *Historia de Sevilla*, fol. 47v.

74. Albardonedo Freire, "Fuentes legales sobre construcción," 7.

75. See the discussion in Fernández-González, "Architectural Hybrids," 8–9.

76. Albardonedo Freire, "Fuentes legales sobre construcción," 7; Rebollo Matías, *Plaza y mercado mayor*, 208–9; Gutiérrez, *Arquitectura colonial*, 14; and Terán Bonilla, "Gremios de albañiles," 341–55. See also Fernández-González, "Architectural Hybrids," 8–9.

77. Albardonedo Freire, "Fuentes legales sobre construcción," 8. On the *casa principal* in Castile, see Blasco Esquivias, *Casa*, 1:46–47.

78. Crouch, Garr, and Mundigo, *Spanish City Planning*, 2.

79. Hardoy and Aranovich, "Urban Scales and Functions."

80. On Ovando, see, for example, Poole, *Juan de Ovando*.

81. Torres Mendoza, *Colección de documentos inéditos*, 528–29.

82. Ibid., 529. Crouch, Garr, and Mundigo translate this passage "all of one type for the sake of the beauty of the town." *Spanish City Planning*, 17.

83. Fernández-González, "Architectural Hybrids," 17. A local version of *tapial* is also found in Havana, but not

in Santiago de Cuba, as the city is located in a region with high seismic activity.

84. Ibid., 18.

85. Ibid.; San Cristóbal Sebastián, *Casa virreinal limeña*; Crespo Rodríguez, *Arquitectura doméstica*, 63–64; Rodríguez-Camillon, "Quincha Architecture."

86. Crespo Rodríguez, *Arquitectura doméstica*, 231–44. Apart from the documentation cited by Emilio Harth-Terré, there is little evidence of the use of *tapial* in Lima; see Harth-Terré, "¿Cómo eran las casas en Lima?"

87. Archivo General de Indias, Patronato, 171, no. 2, r. 7. Cited in many sources, e.g., Solano, *Cuestionarios para la formación*, 79–80.

88. Brendecke, *Empirical Empire*, 2. On the Council of the Indies and governance, see also Gaudin, *Penser et gouverner le Nouveau-Monde*.

89. Acuña, *Relaciones geográficas del siglo XVI*, 188; López Guzmán, *Territorio, poblamiento y arquitectura*, 205.

90. See López Guzmán, *Territorio, poblamiento y arquitectura*, 205.

91. Flat roofs were suitable owing to the climate in Cholula and were found on many houses in Andalusia.

92. A *petate* is a bedroll or hanging.

93. López Guzmán, *Territorio, poblamiento y arquitectura*, 206.

94. Ibid., 206, 208–9.

95. Ponce Leiva, *Relaciones histórico-geográficas*, 187–221.

96. Gutiérrez, *Arquitectura y urbanismo*, 343–50.

97. Terán Bonilla, "Gremios de albañiles," 350.

98. Donahue-Wallace, *Art and Architecture*, 83.

99. See Mundy, *Death of Aztec Tenochtitlan*.

100. Gutiérrez et al., *Casa cusqueña*, 3–8.

101. Kagan and Marías Franco, *Urban Images of the Hispanic World*.

102. Crouch, Garr, and Mundigo, *Spanish City Planning*, 9; Jamieson, *Domestic Architecture and Power*, 51.

103. Morrill, *Casa del Deán*, 51–66.

104. Ibid., 53, 62–65.

105. See esp. Mundy, *Death of Aztec Tenochtitlan*.

106. Webster, *Quito, ciudad de maestros*, 23.

107. See Fernández-González, "Architectural Hybrids."

108. Webster, *Quito, ciudad de maestros*, 39.

109. See Fernández-González and Trusted, "Visual and Spatial Hybridity."

110. Gómez Renau, "Alarifes musulmanes en Valladolid."

111. There are two manuscript versions of the "Sesto libro" and some printer's proofs of the illustrations made in France. I am citing here the manuscript at the Bayerische Staatsbibliothek in Munich, "Sesto libro," fol. 48r.

112. Serlio, *Sebastiano Serlio on Architecture* and *Serlio on Domestic Architecture*.

113. Escobar, *Shaping of Baroque Madrid*, 196.

114. Kubler, *Mexican Architecture*, 76.

115. Crouch, Garr, and Mundigo, *Spanish City Planning*, 29.

116. Íñiguez Almech, "Juan de Herrera y las reformas," 107.

117. Philip wrote to the city of Lisbon, for example, urging city officials to disinfect and clean the town. Arquivo Municipal de Lisboa (hereafter AML), Historico, codex 58, livro I, rei-D. Filippe I, fs. 13, 14 May 1581.

118. Julia, Ringrose, and Segura, *Madrid: Historia de una capital*, 53–62.

119. See Morán Turina and Checa Cremades, *Casas del rey*; Alvar Ezquerra, *Nacimiento de una capital europea*.

120. Alvar Ezquerra, *Nacimiento de una capital europea*, 28.

121. "Memorandum Written by Philip II with Instruction for the Developments in Aranjuez, 20 June 1563," British Library, MS Add. 28350, no. 17.

122. López de Hoyos, *Real apparato y sumptuoso recibimiento*. See also Lopezosa Aparicio, "Fiesta oficial y configuración de la ciudad."

123. Sánchez Cano, "Festeinzüge in Madrid," 171–204.

124. Sieber, "Invention of a Capital," 171.

125. On urban interventions and ritual in Madrid, see Sánchez Cano, "Festival Interventions"; Rio Barredo, *Madrid, urbs regia*.

126. Blasco Esquivias, *Casa*, 1:216.

127. Covarrubias y Orozco, *Tesoro de la lengua castellana*, fol. 103v.

128. Lopezosa Aparicio, *Paseo del Prado de Madrid*; Luque Azcona, "Virreyes y cabildos"; Albardonedo Freire, "Alameda, un jardín público"; and Durán Montero, "Alameda de los descalzos."

129. Sieber, "Invention of a Capital," 105.

130. A transoceanic comparative examination of the *Relaciones Geográficas* in relation to extant structures would offer an insightful picture.

131. Brendecke, *Empirical Empire*, 2, 11, 289.

132. Restall, "Renaissance World from the East."

133. See, all by Escobar, *Shaping of Baroque Madrid*, chap. 6; "Church: Place (Spain)"; and "City (Spain)."

134. For the junta, see Díaz González, *Real Junta de Obras y Bosques*. The junta also managed royal forests, among other properties.

135. Cabrera de Córdoba, *Filipe Segundo, rey de España*, 304–5.

136. See especially Kagan and Marías Franco, *Urban Images of the Hispanic World*.

137. Ezquerra Revilla, "Justicia y gobierno en el siglo XVI," 93–94.

138. Plaza Bores, *Guía del Archivo General*, 29.

139. Escudero, *Felipe II*, 44; Brendecke, *Empirical Empire*, 98–100.

140. Plaza Bores, *Guía del Archivo General*, 34.

141. For Juan Rodríguez de Figueroa, see Cabrera de Córdoba, *Filipe Segundo, rey de España*, 304–5. For Francisco Tello de Sandoval, see Leon Pinello, *Tablas cronológicas*, 4–5. See also Schäfer, *Consejo real y supremo*, 334. For the Council of the Indies under Philip II's rule, see Schäfer, *Consejo real y supremo*, 107–76.

142. The 1566 instructions from Philip II to Gastón de Peralta, Marqués de Falces, can be found at http://www.biblioteca.tv/artman2/publish/1566_385 /Instrucci_n_del_Rey_Felipe_II_al_Virrey_de _Nueva_E_1175.shtml. The viceroy responded the following year with a full report on the state of Mexico City, available at http://www.biblioteca.tv/artman2 /publish/1567_345/Memorial_del_Virrey_de_Nueva _Espa_a_Gast_n_de_Pera_1020.shtml.

143. Brendecke, *Empirical Empire*, 163.

144. For a full list of members, see Ramos, "Crisis indiana y la Junta Magna"; Merluzzi, "Religion and State Policies."

145. Brendecke, *Empirical Empire*, 165, 142.

146. Philip II to the viceroy of New Spain, Martín Enríquez de Almanza. 1568, at http://www.biblioteca.tv /artman2/publish/1568_384/Instrucci_n_de_Felipe_II _al_Virrey_de_Nueva_Espa_a_1166.shtml.

147. See Escudero, *Hombres de la monarquía*; Brendecke, *Empirical Empire*, 174.

148. Escudero, *Hombres de la monarquía*, 129.

149. "Letter from García de Castro to His Majesty in relation to the cities Santa Marta, Cartagena, and Nombre de Dios, 13th June 1564"; "Letter from García de Castro to His Majesty, City of Kings, 1566"; "Letter from García de Castro to the Council of the Indies, Lima,

1567," all in Levillier, *Gobernantes*, 5–6, 152, and 248, respectively.

150. Escudero, *Hombres de la monarquía*, 133, 189.

151. Schäfer, *Consejo real y supremo*, 334.

152. Poole, *Juan de Ovando*, 138–60.

Chapter 2

1. Cabrera de Córdoba, *Filipe Segundo, rey de España*, 368.

2. Parker, *Grand Strategy of Philip II*, 13.

3. Cabrera de Córdoba, *Filipe Segundo, rey de España*, 368.

4. See Lazure, "Possessing the Sacred."

5. See Fray Francisco Diago's praise of the royal archive of Aragon of 1603 on the website of the Archivo de la Corona de Aragón, at http://www.mecd.gob.es /archivos-aca/exposiciones-virtuales/expo-patronato /elogios.html.

6. On Iberia, see Navarro Bonilla, *Imagen del archivo*. On Europe, see, for example, Corens, Walsham, and Peters, *Archives and Information*.

7. On Simancas, see Jose Luis Rodríguez de Diego's notable contributions, particularly *Memoria escrita de la monarquía*, *Instrucción para el gobierno*, and, with J. T. Rodríguez de Diego, "Archivo no solo para el rey." See also Grebe, *Akten, Archive, Absolutismus*; Head, *Making Archives in Early Modern Europe*, 225–32.

8. An abridged version of this chapter that examined only the two chambers of Charles V and Philip II, respectively, was previously published as Fernández-González, "Architecture of the Treasure-Archive." The present chapter expands considerably this earlier essay and also incorporates new material into the discussion of these two chambers.

9. Francisco de Cobos to Juan Vazques de Molina, Madrid, 26 June 1540, AGS, Cámara de Castilla, folder 247.

10. Rodríguez de Diego, *Memoria escrita de la monarquía*, 84.

11. Cortés Alonso, "Ordenanzas de Simancas."

12. González Mateo, "Primeras consultas." I thank Fernando Bouza for bringing this article to my attention.

13. Plaza Bores, *Guía del Archivo General*, 18.

14. Cobos instigated repairs to the fortress in the years leading to the creation of the archive as well. Rodríguez de Diego, *Memoria escrita de la monarquía*, 82–85.

15. During this period, the castle was still used as a prison. AGS, Cédulas de la Cámara, libro 2, fol. 36, and Cámara de Castilla, folder 160, fol. 49, also cited in Plaza Bores, *Guía del Archivo General*, 21.

16. "Diego de Ayala to Philip II concerning the Building Works in the Archive Chambers (1567)," AGS, Archivo de Secretaría, folder 5, file 1, fols. 5–16.

17. García-Frías Checa, *Carlos V en Yuste*, 154. I thank Geoffrey Parker for bringing this book to my attention.

18. Martínez García, "Archivo de Simancas."

19. González Amezúa, "Archivo de Simancas"; Rodríguez de Diego, *Memoria escrita de la monarquía*.

20. "Registry of borrowings and incoming documents, 1363–1630," Archive of the Crown of Aragon, Colección Memoriales, 51, fols. 74v–75r.

21. Plaza Bores, *Guía del Archivo General*, 20.

22. Brenneke, *Archivistica contributo alla teoria*, 154.

23. Casanova, *Archivistica*, 353.

24. Brenneke, *Archivistica contributo alla teoria*, 187–89.

25. Ibid., 187; Stolz, *Geschichte und Bestände*.

26. Coppens, "Bureau des Archives."

27. Brenneke, *Archivistica contributo alla teoria*, 155–56.

28. Schäffler, "'Hohe Registratur.'" For the cabinets, see Archivschrank, Zeichnung im Staatsarchiv Würzburg, MS 43.

29. Casanova, *Archivistica*, 360–61. Pope Sixtus IV (1471–84) assembled the archives in the Castel Sant'Angelo. Boyle, *Survey of the Vatican Archives*, 58–60.

30. Ghidoli Tome, "Sala Tesoro."

31. Aliberti and Gaudioso, *Affreschi di Paolo III*.

32. Azevedo and Baião, *Arquivo da Torre do Tombo*, 5, 6, 9.

33. Zozaya Montes, "Archivo de la Villa de Madrid."

34. Pírez Fernández, *Casa Archivo General de Simancas*, 17–18, 62, 64.

35. On Philip II's visit to Torre do Tombo, see BNE, MS 6743, fols. 266–310. There are two samples, dated 1583, in AGS, Archivo de Secretaría, folder 21, file 1, cited in Rodríguez de Diego, *Instrucción para el gobierno*, 56, and also in BNE, MS 8.180, fol. 89, cited in Bouza Álvarez, *Cartas de Felipe II*, 15, and also in Dias Dinis, "Relatorio do seculo XVI."

36. Brenneke, *Archivistica contributo alla teoria*, 270, 267.

37. Impey and Parnell, *Tower of London*, 87–89.

38. Brenneke, *Archivistica contributo alla teoria*, 382, 412.

39. Ibid., 161.

40. Ladero Quesada and Cantera Montenegro, "Tesoro de Enrique IV."

41. Checa Cremades, *Inventories of Charles V*.

42. Guadalupe Zamora, "Tesoro del Cabildo Zamorano."

43. Carrero Santamaria, "Capilla de los arzobispos."

44. "Francisco de Mora to Diego de Ayala concerning the works in Simancas Archive, 1588," AGS, Archivo de Secretaría, folder 7, file 379.

45. Ennes, *Secção ultramarina da Biblioteca Nacional*, 42–44, 237, 257.

46. *Recopilación de las leyes de los reynos de Indias*, vol. 2, title 1, law no. 3.

47. Bouza Álvarez, *Communication, Knowledge, and Memory*, 39.

48. *Recopilación de las leyes de los reynos de Indias*, vol. 2, title 1, law no. 31.

49. Diego de Ayala to Philip II, November 1567, AGS, Archivo de Secretaría, folder 5, files 22–23.

50. AGS, Patronazgo Real, Libros copias, 7, 107.

51. AGS, Sección Estado, folder 21, fol. 194, also cited in Plaza Bores, *Guía del Archivo General*, 27.

52. Covarrubias y Orozco, *Tesoro de la lengua castellana*, fol. 83.

53. Plaza Bores, *Guía del Archivo General*, 28–30.

54. The organization of the collections may have emulated the Spanish archive in Rome kept by Juan Verzosa (1523–1574); see Rodríguez de Diego, *Memoria escrita de la monarquía*, 108.

55. AGS, Archivo de Secretaría, folder 6, fol. 2, no. 1, also cited in Plaza Bores, *Guía del Archivo General*, 33; and Pírez Fernández, *Casa Archivo General de Simancas*, 15–20.

56. AGS, Archivo de Secretaría, folder 6, fol. 2, no. 1.

57. Rodríguez de Diego and Rodríguez de Diego, "Archivo no solo para el rey," 464–66.

58. "Archive expenses between 1564 and 1568," AGS, Archivo de Secretaría, folder 6, fol. 2, also cited in Plaza Bores, *Guía del Archivo General*, 33.

59. Pírez Fernández, *Casa Archivo General de Simancas*, 68.

60. "Memorandum concerning the archive from Diego de Ayala to Zayas," August 1567, AGS, Archivo de Secretaría, folder 5, file 1, fol. 5.16.

61. Ibid. An incomplete version of this letter is cited in Plaza Bores, *Guía del Archivo General*, 33.

62. "Letter from Diego de Ayala to Zayas, 1567," AGS, Archivo de Secretaría, folder 5, file 1, fol. 21.

63. AGS Archivo de Secretaría, folder 5, file 1, unfoliated. The Latin text says that the drawing was made in 1583. The sheet is located in the same folder as the rest of the documents describing the works of the 1560s and refers to the program envisioned by the archivist in this period. There are two possible explanations: either Ayala confused the year in the Latin text or, perhaps more likely, he considered reviving the idea for this decorative project later (in 1583). This was a momentous period, as the main staircase giving new access to the archive was completed in 1583. If the second explanation is correct, Ayala may have thought that gaining Ambrosio de Morales's support would strengthen his case.

64. Barbeito, *Alcázar de Madrid*, 42–48. For the Alcázar in Madrid, see also Gérard Powell, *De castillo a palacio*; Checa Cremades, *Real Alcázar de Madrid*.

65. Alonso Ruiz, "Alcázar de Madrid."

66. See Fernández-González and Trusted, "Visual and Spatial Hybridity."

67. Gómez Renau, "Alarifes musulmanes en Valladolid"; Gómez Renau, *Comunidades marginadas en Valladolid*.

68. "Letter from Diego de Ayala to Zayas, 1567," AGS, Archivo de Secretaría, folder 5, file 1, fol. 21.

69. See Pacioli, *De divina proportione*.

70. AGS, Archivo de Secretaría, folder 6, fol. 2, also cited in Plaza Bores, *Guía del Archivo General*, 33.

71. Plaza Bores, *Guía del Archivo General*, 28.

72. Parker, *Grand Strategy of Philip II*, 69.

73. "Letter from Diego de Ayala to the King, 1571," AGS, Cámara de Castilla, folder 2157, fol. 191.

74. AGS, Archivo de Secretaría, folder 21, file 1, also cited in Rodríguez de Diego, *Instrucción para el gobierno*, 72.

75. Rodríguez de Diego, *Instrucción para el gobierno*, 71–72.

76. Ibid., 113.

77. Plaza Bores, *Guía del Archivo General*, 34–35; Pírez Fernández, *Casa Archivo General de Simancas*, 12, 16–17.

78. Plaza Bores, *Guía del Archivo General*, 35–36; Pírez Fernández, *Casa Archivo General de Simancas*, 16–17. For another summary of Juan de Herrera's input into the development of Simancas, see Ortega Vidal, "Hacia un catálogo razonable," 87–91.

79. Wilkinson-Zerner, *Juan de Herrera*, 122–27.

80. Juan de Herrera to Diego de Ayala, 9 June 1578, AGS, Archivo de Secretaría, folder 5, file 1, fol. 213, cited briefly in Plaza Bores, *Guía del Archivo General*, 17; and Pírez Fernández, *Casa Archivo General de Simancas*, 12.

81. Wilkinson-Zerner, *Juan de Herrera*, 33–35.

82. "Memorandum on the Works for Simancas Archive, 1578," AGS, Archivo de Secretaría, folder 7, file 213, Mapas, Planos y Dibujos, no. 214. See also Llaguno y Amírola and Ceán Bermúdez, *Noticias de los arquitectos*, 264–69, 323–30; Simons and Godoy, *Discurso del Sr. Juan de Herrera*, 182–86.

83. Llaguno y Amírola and Ceán Bermúdez, *Noticias de los arquitectos*, 264–65.

84. Plaza Bores, *Guía del Archivo General*, 34–35; Pírez Fernández, *Casa Archivo General de Simancas*, 14–16.

85. Rodríguez de Diego and Rodríguez de Diego, "Archivo no solo para el rey."

86. Pírez Fernández, *Casa Archivo General de Simancas*, 105.

87. Rodríguez de Diego, *Instrucción para el gobierno*, 22.

88. Ibid., 22, 111, 100.

89. Muñiz Coello, "Elaboración, conservación y custodia," 379.

90. Fernández Romero, "Tabvlarivm."

91. Escudero, "Consejo de Cámara de Castilla."

92. Muñiz Coello, "Elaboración, conservación y custodia," 379.

93. Ventura Villanueva, "Edificios administrativos."

94. Berger, *Dictionary of Roman Law*, 729.

95. Fernández Romero, "Tabvlarivm."

96. Plaza Bores, *Guía del Archivo General*, 41–43.

97. "The Count of Chinchón to Diego de Ayala, 4th of February 1589," AGS, Archivo de Secretaría, folder 6, fol. 358. Also cited in Plaza Bores, *Guía del Archivo General*, 41; Pírez Fernández, *Casa Archivo General de Simancas*, 71.

98. AGS, Mapas Planos y Dibujos, no. 50–038.

99. Cortés Alonso, "Organismos productores de documentación." Quantitative data show the astonishing volume of documentation generated by the institutions created to govern the Indies.

100. AGS, Archivo de Secretaría, folder 6, files 1–355, summarized in Plaza Bores, *Guía del Archivo General*, 41; Pírez Fernández, *Casa Archivo General de Simancas*, 71.

101. AGS, Archivo de Secretaría, folder 6, file 1, fol. 101, summarized in Plaza Bores, *Guía del Archivo*

General, 41; Pírez Fernández, *Casa Archivo General de Simancas*, 71.

102. AGS, Archivo de Secretaría, Obras, folder 1, file 373. Also cited in Plaza Bores, *Guía del Archivo General*, 42, and Pírez Fernández, *Casa Archivo General de Simancas*, 72.

103. AGS, Mapas, Planos y Dibujos, no. 05–096.

104. See, for instance, Wilkinson-Zerner, *Juan de Herrera*, 51.

105. Both letters from Francisco de Mora to Diego de Ayala of 1592 are at AGS, Archivo de Secretaría, Obras, folder 1, files 411 and 424. Also cited in Pírez Fernández, *Casa Archivo General de Simancas*, 86.

106. "Diego de Ayala to Philip II's secretary, 13 May 1592," AGS, Archivo de Secretaría, Obras, folder 1, file 413. Also cited in Plaza Bores, *Guía del Archivo General*, 42.

107. Pírez Fernández, *Casa Archivo General de Simancas*, 72.

108. Elliot, *Imperial Spain*, 154; see also the essays in Checa Cremades and Fernández-González, *Festival Culture*; de Jonge, García García, and Esteban Estríngana, *Legado de Borgoña*.

109. Zalama Rodríguez, "Ceremonial Decoration of the Alcázar." There were other times when it was considered beneficial for subjects to see the king in the flesh, as in the entry into Lisbon prepared for Philip II in 1581.

110. AGS, Archivo de Secretaría, folder 7, file 417, fol. 1; Cook, *Jornada de Tarazona*, 21; Plaza Bores, *Guía del Archivo General*, 45; Sáenz de Miera, *Pasatiempos de Jehan Lhermite*, 155–56.

111. This can be seen in Herrera's plan of the monarch's room in the monastery. López-Vidriero Abello, *Trazas de Juan de Herrera*, 47. Charles V's bedchamber at Yuste had a similar spatial configuration, as did Joanna of Austria's chamber in the Descalzas Reales in Madrid.

112. Plaza Bores, "Juan Pantoja de la Cruz."

113. Villalta, *Statuas antiguas*; Ávila, *Libro de los retratos*.

114. Bouza Álvarez, *Imagen y propaganda*, 121–25.

115. AGS, Archivo de Secretaría, folder 6, fols. 249–50, cited in Rodríguez de Diego, *Instrucción para el gobierno*, 55n161.

116. "Compilation for the Portuguese Succession," including genealogical trees, AGS, Sección Estado, folder 422, file 1579. See also ibid., folders 5, 7, 8, 9, and 10.

117. AGS, Archivo de Secretaría, folder 6, file 2, fol. 22; Rodríguez de Diego, *Memoria escrita de la monarquía hispánica*, 154.

118. Blasco Esquivias, "Utilidad y belleza," 153.

119. Ibid., 146–47.

120. Plaza Bores, *Guía del Archivo General*, 36.

121. See "Cuentas de Obras 1574–1594," AGS, Archivo de Secretaría, folders 54–55; "Cuentas de Obras 1594–1630," ibid., folders 56–57; "Cuentas de Obras 1584–1675," ibid., folders 58–59.

122. Plaza Bores, *Guía del Archivo General*, 40.

123. Rodríguez de Diego, *Instrucción para el gobierno*, 72.

124. Covarrubias y Orozco, *Tesoro de la lengua castellana*, fol. 545.

125. Páez de Castro, *Memoria a Felipe II*, 40.

126. Sáenz de Miera, *Pasatiempos de Jehan Lhermite*, 652–53. These decorations were later replaced.

Chapter 3

1. On the Iberian Union, see, for example, Schaub, *Portugal na monarquia hispánica*; Bouza Álvarez, *Imagen y propaganda*; Ramada Curto, *Cultura política*; Cardim, *Cortes e cultura política*; Bouza Álvarez, *Felipe II y el Portugal*; and Cardim, *Portugal unido y separado*.

2. Bouza Álvarez, *Imagen y propaganda*, 124–32.

3. Kamen, *Enigma del Escorial*, 199.

4. Jordan Gschwend, "Cardinal Infante Henry."

5. See, for example, *Treatise Succession*, British Library, MS Add. 8709; San Pedro, *Diálogo llamado Philippino*.

6. Vasconcellos, *Sucession del Señor Rey Don Filipe*, 5. Also see AGS, Sección Estado, folder 397 (Moura's correspondence), and folder 398 (documents concerning Philip II's rights to the Portuguese succession).

7. Philip II of Spain to the Duke of Osuna (1579), quoted in Cowans, *Early Modern Spain*, 113. An abridged version of this chapter was previously published as Fernández-González, "Negotiating Terms." The present chapter considerably expands (and at times corrects) this earlier essay.

8. On Portugal, see, for example, Castel Branco, *Arte efémera em Portugal*; Barreto Xavier, Bouza Álvarez, and Cardim, *Festas que se fizerão pelo cazamento*; Alves, *Entradas régias portuguesas*, 50–67; and Araujo, *Lisboa*.

9. A month before his arrival, Philip II wrote to the city authorities with concerns about hygiene. "Livro 1º rei-D. Filippe I," AML, codex 58, fol. 12.

10. Escobar, *Recopilacion de la felicissima jornada*; Vasconcellos, *Sucession del Señor Rey Don Filipe*; Velazquez Salmantino, *Entrada que en el reino*; Guerreiro,

Festas que se fizeram. Guerreiro's copy, used here, is from El Escorial's library and is paginated differently from other copies; an incomplete version of the book was reprinted in 1950. See also Rodrigues Soares, *Memorial de Pero Rois Soares*; Conestaggio, *Uniting of the Kingdom*; and the anonymous account *Relación de la Jornada que hizo Felipe II desde Santarem hasta Lisboa* at the BNE, MS 12026, among others.

11. Fernández-González, "Imagining the Past."

12. See particularly, all by Bouza Álvarez, *Imagen y propaganda*, 58–92; *Portugal no tempo dos Filipes*; *D. Filipe I*; *Felipe II y el Portugal*; and "Retórica da imagem real."

13. Soromenho, "*Ingegnosi ornamenti*" and *Joyeuse entrée*.

14. Torres Megiani, *Rei ausente*.

15. See, all by Jordan Gschwend, "Ma meilleur soeur"; *Catarina Áustria*, 35–37, 39–55; "'Cosa veramente di gran stupore.'"

16. Lavanha's book on the entry into Lisbon in 1619, *Viage de la catolica magestad*, is also an important source, as this entry imitated many aspects of the festival of 1581. (Only one copy of the 1619 Spanish edition of Lavanha's book is extant; the 1622 Portuguese edition is more often cited by scholars. All of my note citations of this work are from the original 1619 Spanish edition.) It would be impossible to cite the many articles on this event in any comprehensive fashion, but see Cardim, "Jornada de Portugal"; de Jonge, "Kunst van het efemere"; Vetter, "Einzug Philipps III"; Kubler, *Portuguese Plain Architecture*, 105–27; and Fernández-González, "Representación de las naciones."

17. See Fernández-González, "Imagining the Past."

18. Jordan Gschwend, "'Cosa veramente di gran stupore.'"

19. Guerreiro, *Festas que se fizeram*, 11.

20. Rodrigues Soares, *Memorial de Pero Rois Soares*, 193.

21. Bouza Álvarez, *Felipe II y el Portugal*, 38.

22. Jordan Gschwend, "'Cosa veramente di gran stupore'" and "Ma meilleur soeur."

23. Teixeira Marques de Oliveira, *Fontes documentais de Veneza*, 212.

24. Velazquez Salmantino, *Entrada que en el reino*, 120.

25. See Flor, *Praça universal*; and, earlier, Soromenho, *Joyeuse entrée*; Gehlert, "Esplendida vista de Lisboa."

26. Serrano de Vargas y Ureña, *Entrada en publico*, 3.

27. Ruth, *Lisbon in the Renaissance*, 10–12.

28. Guerreiro, *Festas que se fizeram*, 12.

29. Escobar, *Recopilacion de la felicissima jornada*, 109.

30. See A. Falcão de Resende, *Romance da entrada del rey Philippe o primeiro em Portugal em Lisboa*, in Bouza Álvarez, *Portugal no tempo dos Filipes*, 95. The term *horrisonous* couples *horrendous* or *horrid* with *unisonous* to convey the storm of noise produced by all galleys firing their guns at once. I have adapted the poem slightly to make it comprehensible in English.

31. Velazquez Salmantino, *Entrada que en el reino*, 120.

32. Rodrigues Soares, *Memorial de Pero Rois Soares*, 179.

33. See Conestaggio, *Uniting of the Kingdom*. The conflicting descriptions of the military incursion became a propaganda war; see, for example, the conflicting versions in Rodrigues Soares, *Memorial de Pero Rois Soares* and Velazquez Salmantino, *Entrada que en el reino*, 56–57.

34. AGS, Sección Estado, folder 426. This bundle is devoted almost entirely to the military incursion in Portugal.

35. See Valladares Ramirez, *Conquista de Lisboa*.

36. Velazquez Salmantino, *Entrada que en el reino*, 141; Guerreiro, *Festas que se fizeram*, 59–60.

37. I thank John H. Elliot for suggesting this idea. Our discussion of this question had a significant impact on this section of the chapter.

38. See Shewring, *Waterborne Pageants and Festivities*.

39. For some examples, see the essays in Checa Cremades and Fernández-González, *Festival Culture*.

40. Blumenthal, *Theater Art of the Medici*.

41. De Jonge, "Espacio ceremonial."

42. Brown and Elliot, *Palace for a King*, 156–63.

43. Blumenthal, *Theater Art of the Medici*.

44. Bouza Álvarez, *Imagen y propaganda*, 114.

45. Ruth, *Lisbon in the Renaissance*, 3.

46. Soromenho, "*Ingegnosi ornamenti*," 21.

47. Ibid.; Segurado, "Juan de Herrera em Portugal"; Jordan Gschwend, "Portuguese Royal Collections," 12.

48. Guerreiro, *Festas que se fizeram*, 11–12.

49. Ibid., 28. Philip had designated Filipe Aguiar *veedor de la cidade* on 21 January 1581. AML, Historico, Chancelaria Régia, livro 1º de D. Filipe I, doc. 5, fol. 27.

50. Velazquez Salmantino, *Entrada que en el reino*, 133.

51. Philip II to the city authorities in Lisbon, AML, livro 1º Festas, fol. 103. One of these letters is cited in Torres Megiani, *Rei ausente*.

52. AML, livro 1º Festas, fol. 105.

53. Jordan Gschwend, "'Cosa veramente di gran stupor,'" 187.

54. For Lisbon's city electors' acceptance of their new ruler, see AML, codex 58, livro 1, rei-D. Filippe I, fol. 1. The king invited the electors of Lisbon to participate in the courts of Tomar, which ratified him as Philip I of Portugal. Ibid., fol. 2.

55. Holanda and Alves, *Da fábrica que falece*.

56. Guerreiro, *Festas que se fizeram*, 26.

57. Ibid., 49–51.

58. Lazure, "Possessing the Sacred."

59. Rodrigues Soares, *Memorial de Pero Rois Soares*, 193.

60. Although both Guerreiro and Velazquez Salmantino clearly stated that the decoration was composed of pyramids, the shape described was of obelisks. See Guerreiro, *Festas que se fizeram*, 13; Velazquez Salmantino, *Entrada que en el reino*, 121.

61. Guerreiro, *Festas que se fizeram*, 13. In Philip III's entry of 1619, a number of sculptures over pedestals are described at the pier on the river, and the material used to imitate the marble was wax; see Lavanha, *Viage de la catolica magestad*, 9. This may also have been the case for the entry of 1581.

62. Guerreiro, *Festas que se fizeram*, 13–15.

63. On living and nonliving things in festivals and early modern culture, see, for example, Van Kessel, *Lives of Paintings*; Osorio, *Inventing Lima*.

64. Guerreiro, *Festas que se fizeram*, 14.

65. Although the relationship between the display in Lisbon and the statues in the ancient Roman Forum may be a coincidence, the emulation of classical architectural order was surely intended. Varro Reatinus, *Res Rustica*, in Cato and Varro, *On Agriculture and Res rustica*, 162.

66. Guerreiro, *Festas que se fizeram*, 14.

67. I thank Maria Ines Aliverti for her insights on this ephemeral structure.

68. Velazquez Salmantino, *Entrada que en el reino*, 119–20.

69. Guerreiro, *Festas que se fizeram*, 15. The arch erected by the German merchants for Philip III in 1619 was similar to the arch of 1581, and at least part of the structure was probably recycled.

70. Bouza Álvarez, *Felipe II y el Portugal*, 15, 22.

71. Only some of the colors of the arch, such as this recess, are documented, and most of the panels imitated bronze bas-reliefs. No further information was given

for the rest of the arch except that it imitated stone; see Velazquez Salmantino, *Entrada que en el reino*, 121.

72. Guerreiro, *Festas que se fizeram*, 16.

73. See ibid., 17; Velazquez Salmantino, *Entrada que en el reino*, 122.

74. Guerreiro, *Festas que se fizeram*, 16.

75. Ibid., 17.

76. Ibid.; Velazquez Salmantino, *Entrada que en el reino*, 123.

77. Ruscelli, *Imprese illustri*, 216. The medal is found at the Victoria and Albert Museum in London, cat. no. 6759–1860; see also Attwood, *Italian Medals, c. 1530–1600*.

78. For the Apollonian aspects associated with Philip II's representation, see Checa Cremades, *Felipe II: Mecenas*, 100–109; Tanner, *Last Descendant of Aeneas*, 223–48; and Mínguez Cornelles, *Reyes solares*, 89–98.

79. Bouza Álvarez, *Imagen y propaganda*, 85.

80. Erasmus, *Education of a Christian Prince*, 3.

81. See, for example, Rodríguez Salgado, *Felipe II*.

82. Bouza Álvarez, *Imagen y propaganda*, 86.

83. Guerreiro, *Festas que se fizeram*, 18. Velazquez Salmantino's account omits any reference to this panel.

84. Although the identification of the three graces from Horace's tradition were the three goddesses Thalía, Euphrosina, and Aglaya, in sixteenth-century Iberian iconography, Ceres is normally represented holding ears of wheat. See Horace, *Poesias lyricas*, 4.

85. Jordan Gschwend, "'Cosa veramente di gran stupor,'" 200–201.

86. Guerreiro, *Festas que se fizeram*, 17.

87. The dividing point is Cape Agulhas.

88. Guerreiro, *Festas que se fizeram*, 18; Velazquez Salmantino, *Entrada que en el reino*, 123.

89. Guerreiro, *Festas que se fizeram*, 18; Velazquez Salmantino, *Entrada que en el reino*, 123.

90. See the arch in Grapheus, *Triumphe d'Anvers*, 86.

91. Guerreiro, *Festas que se fizeram*, 31; see also Fernández-González, "Representación de las naciones," 426.

92. See Karl, *Embroidered Histories*.

93. Ibid., 70.

94. Ibid., 200.

95. Calvete de Estrella, *Felicissimo viaie*.

96. For the colcha, see Karl, *Embroidered Histories*, 200; for the festival, Bouza Álvarez, *Imagen y propaganda*, 87.

97. Karl, *Embroidered Histories*, 215–22.

98. Biblioteca Universidad Salamanca, MS 2092. This image is also found in Bouza Álvarez, *Imagen y propaganda*, 70.

99. Bouza Álvarez, *Imagen y propaganda*, 71.

100. See, for example, Guerreiro, *Festas que se fizeram*, 13–15.

101. Kubler, "Medal by G. P. Poggini."

102. Watanabe-O'Kelly, "Early Modern Festival Book," 10.

103. Strong, *Art and Power*, 66.

104. For a study of the Renaissance notion of "parallel worlds" and imaginary "spaces," see Mazzotta, *Cosmopoiesis*, 25–52.

105. Pagden, *Lords of All the World*, 46.

106. Osorio, *Inventing Lima*, 81–102; Van Kessel, *Lives of Paintings*.

107. Guerreiro, *Festas que se fizeram*, 29.

108. Bouza Álvarez, *Cartas de Felipe II*, 35.

109. Lavanha, *Viage de la catolica magestad*, 47.

110. Parker, *Imprudent King*, 271, plate 37.

111. Guerreiro described these as "epitaphs." Guerreiro, *Festas que se fizeram*, 19.

112. The outline of this figure has not been included in the drawing. Ibid.

113. The numbering is my own addition. Ibid.; Velazquez Salmantino, *Entrada que en el reino*, 125.

114. Guerreiro, *Festas que se fizeram*, 20; Velazquez Salmantino, *Entrada que en el reino*, 126. Philip I read: "philippvs avstriae, dvx bergvndiae, comes flandriae, hispaniarvm rex catholicvs." Charles V read: "d. carolvs v. imp. caesar semper avgvst. germ. africvs, asiaticvs, indicvs." Philip I read: "Philip of Austria Duke of Burgundy, Count of Flanders and Spanish Catholic King." Charles V read: "D. Charles V., Cesar always August Emperor of Germany, Africa, Asia and Indies."

115. Guerreiro, *Festas que se fizeram*, 20; Velazquez Salmantino, *Entrada que en el reino*, 125.

116. See Ball and Parker, *Cómo ser rey*.

117. Guerreiro, *Festas que se fizeram*, 21; Velazquez Salmantino, *Entrada que en el reino*, 126.

118. Guerreiro, *Festas que se fizeram*, 26, 27.

119. Ibid., 24; Velazquez Salmantino, *Entrada que en el reino*, 127.

120. Checa Cremades, *Felipe II: Un monarca*, 270.

121. Parker, *Imprudent King*, 276, plate 39.

122. Pagden, *Lords of All the World*, 100.

123. Velazquez Salmantino, *Entrada que en el reino*, 135.

124. Alberti, *Diez libros de arquitectura*, 247.

125. See Carita, *Lisboa Manuelina*.

126. Fernández-González, "Modelo Digital."

127. On the Rua Nova, see Jordan Gschwend and Lowe, *Global City*.

128. Fernández-González, "Modelo Digital."

129. Guerreiro, *Festas que se fizeram*, 52.

130. Rodrigues Soares, *Memorial de Pero Rois Soares*, 193.

131. Guerreiro, *Festas que se fizeram*, 52.

132. Bouza Álvarez, *Imagen y propaganda*, 114.

133. See Jordan Gschwend and Lowe, *Global City*, 7.

134. See, for example, San Pedro, *Diálogo llamado Philippino*, xcviv [*sic*: i.e., 94].

135. Bouza Álvarez, *Imagen y propaganda*, 58.

136. Guerreiro, *Festas que se fizeram*, 52; Velazquez Salmantino, *Entrada que en el reino*, 141.

137. Guerreiro, *Festas que se fizeram*, 58; Velazquez Salmantino, *Entrada que en el reino*, 141.

138. Philip II to the city authorities, June 1581, AML, codex 58, livro 1, rei-D. Filippe I, fol. 12.

139. This painting hung in the hall of the Alcázar where the king held public audiences, but it was lost in the fire of 1734. See Marcos de Dios, "Itinerario hispánico."

140. Guerreiro, *Festas que se fizeram*, 56, 57.

141. See Ruiz, *King Travels*.

142. Bouza Álvarez, "Lisboa sozinha, quase viúva."

143. Lavanha, *Viage de la catolica magestad*, 8–9.

144. Kubler, *Portuguese Plain Architecture*, 80–82.

Chapter 4

1. Covarrubias y Orozco, *Tesoro de la lengua castellana*, fol. 473r. On *libros historiados*, see, for example, Montoya Martínez, *Libro historiado*.

2. Kagan, *Clio and the Crown*, 63–64. The courts referred to none other than the *Estoria de España*, originally completed during the reign of King Alfonse X of Castile "in the thirteenth century."

3. On *historia pro patria*, see Kagan, *Clio and the Crown*, 94–123.

4. See Conestaggio, *Uniting of the Kingdom*; and Velazquez Salmantino, *Entrada que en el reino*.

5. On history, see, for example, Cuesta Domingo, *Antonio de Herrera y su obra*; Braun, *Juan de Mariana*. On visual chronicles of history in Spain, see Pallos and

Carrió-Invernizzi, *Historia imaginada*. On the Palace of El Viso, see López-Vidriero Abello, *Entre España y Génova*. On images of warfare, see Hale, *Artists and Warfare in the Renaissance*; Kliemann, *Gesta dipinte*; García García, *Imagen de la guerra*; and Cabañas Bravo, López-Yarto Elizalde, Rincón García, *Arte en tiempos de guerra*.

6. See Brown, *Sala de las Batallas*; Bustamante García, *Octava maravilla del mundo*, 672–732; Bustamante García, "Espejo de las hazañas"; Bustamante García, "De las guerras con Francia"; Bustamante García, "Hechos y hazañas"; García-Frías Checa, "Nueva visión de la Sala de Batallas"; García-Frías Checa, "Sala de Batallas"; and García-Frías Checa, "Series de batallas."

7. Other than the Pastrana tapestry series, which presents a different visual composition, preventing a successful comparison to *La Higueruela*. On the Pastrana and the Tunis tapestries, see Checa Cremades, "Language of Triumph."

8. This drawing is one of a series of battle drawings kept at the Biblioteca-Archivo Municipal de Jerez de la Frontera in Spain.

9. Feliciano and Ruiz Souza, "Al-Andalus and Castile."

10. Checa Cremades, *Felipe II: Mecenas*, 451–59; Parker, *Felipe II*, 957–68.

11. Scholarship on Charles V's funerals has concluded that his obsequies (1558–59) defined royal funerary culture in sixteenth-century Europe. See, for example, Jacquot, *Fêtes et cérémonies*; and Sociedad Estatal, *Fiesta en la Europa*.

12. See Pérez, *Leyenda Negra*.

13. On Genoese artists in Spain and the court, see the essays in Boccardo, Colomer, and Di Fabio, *España y Génova*; Newcome, "Fresquistas genoveses en El Escorial."

14. See, for example, García-Frías Checa, "Artistas genoveses"; Campos y Fernández de Sevilla, "Frescos de la Sala de las Batallas"; and Sáenz de Miera, "Reflejos y ecos de Erasmo," among others.

15. Zarco Cuevas, *Pintores italianos*, 71–73.

16. Ximenez, *Descripción del Real Monasterio*, 167–68.

17. Sigüenza, *Historia de la Orden de San Geronimo*, 2:688.

18. Zarco Cuevas, *Pintores italianos*, 71–73, 148, 126–28.

19. Brown, *Sala de las Batallas*. See also Prast, "Sala de las Batallas"; Balao González, "Restauración de la Sala de las Batallas."

20. Sáenz de Miera, "Reflejos y ecos de Erasmo."

21. See, all by García-Frías Checa, "Nueva visión de la Sala de Batallas"; "Sala de Batallas"; and "Series de batallas," among others. For additional drawings that may have inspired the St. Quentin scenes, see Martens, "Pierre-Ernest de Mansfeld."

22. See, all by Bustamante García, *Octava maravilla del mundo*, 672–732; "Espejo de las hazañas"; "De las guerras con Francia"; and "Hechos y hazañas."

23. Mulcahy, "Celebrar o no celebrar"; de Jonge, "Espacio ceremonial."

24. This is the case with Henry Kamen's reading of the Hall of Battles as a symbol of peace rather than victory; see his *Enigma del Escorial*, 221–48. See also Bury, "'Galerías Largas' de El Escorial"; Checa Cremades, *Felipe II: Mecenas*, 366–67.

25. Brown, *Sala de las Batallas*, 37; Checa Cremades *Felipe II: Mecenas*, 367; Reinhardt, "Tapisserie feinte."

26. On the Tunis tapestries, see Horn, *Jan Cornelisz Vermeyen*; Seipel, *Kriegszug Kaiser Karls V*; and Domínguez Ortiz, Herrero Carretero, and Godoy, *Resplendence of the Spanish Monarchy*. On Holanda's battle drawings of St. Quentin, see Newcome, "Fresquistas genoveses en El Escorial," and on Wyngaerde, see, for example, Kagan, *Spanish Cities of the Golden Age*; Kagan and Marías Franco, *Urban Images of the Hispanic World*.

27. Brown, *Sala de las Batallas*, 57.

28. Ibid., 71; Herrera, *Sumario y breve declaracion*, 18.

29. Sáenz de Miera, "Reflejos y ecos de Erasmo," 115.

30. Zarco Cuevas, *Pintores italianos*, 119.

31. Campos y Fernández de Sevilla, "Frescos de la Sala de las Batallas," 196; Zarco Cuevas, *Pintores italianos*, 127.

32. Zarco Cuevas, *Pintores italianos*, 84–87.

33. Herrera, *Sumario y breve declaracion*, 18.

34. Ibid.

35. Sigüenza, *Historia de la Orden de San Geronimo*, 688.

36. Zarco Cuevas, *Pintores italianos*, 83.

37. Ximenez, *Descripción del Real Monasterio*, 417.

38. See Kamen, *Enigma del Escorial*, 225, and a counterargument in Parker, *Felipe II*, 881, 983.

39. Bustamante García, "Espejo de las hazañas," 200–206.

40. Pérez de Tudela Gabaldón, "Primeros años del príncipe don Felipe."

41. Brown, *Sala de las Batallas*, 14; de Jonge, "Espacio ceremonial."

42. Brown, *Sala de las Batallas*, 45; see a discussion of the Hall of Realms at El Buen Retiro in Brown and Elliot, *Palace for a King*, 156–62. Kamen seems to be the only scholar to disagree; see his *Enigma del Escorial*, 244.

43. See, for example, Kagan, "Imágenes y política"; Roe, "Iupiter Hispano, España invicta."

44. García-Frías Checa, "Series de batallas," 137. Lepanto is currently on display at El Escorial in the canvases painted by Cambiaso and acquired by Philip II from Antonio Perez's possessions around or after 1585. Mulcahy, "Celebrar o no celebrar," 9.

45. García-Frías Checa, "Series de batallas."

46. Ibid., 141.

47. See, for example, Zalama Rodríguez, "Ceremonial Decoration of the Alcázar."

48. See the discussion in chapter 3 of Christine of Lorraine's entry into Florence of 1589 and the triumphal path that displayed scenes of Lepanto and Charles V's defeat of the Turks near Vienna.

49. García-Frías Checa, "Series de batallas," 138–39.

50. On Pastrana, see Checa Cremades, "Language of Triumph," 19–40; on the *Story of the Seven Sacraments*, now at the Metropolitan Museum of Art in New York, see, for example, Cavallo, *Medieval Tapestries*, 156–73.

51. Clavijo Provencio and Puerto Castrillón, "Notas sobre Jerez."

52. It reads, "river and gorge of Ximena, town of Ximena, Mountain range of Ximena, Standard and People of Jerez, Castle and Siege of Ximena by the [people] of Jerez and the Marshal Herrera, Alcala Gancules." In the drawing, Ximena is spelled Jimena and Alcalá de los Ganzules is given as Alcalá de los Gazules in the Cádiz province. See *Serie de dibujos de batallas medievales*, Biblioteca-Archivo Municipal de Jerez de la Frontera.

53. Clavijo Provencio and Puerto Castrillón, "Notas sobre Jerez."

54. The *Libro del Alcázar* is a sixteenth-century manuscript that narrates important episodes in the history of the city of Jerez. See Ferrador, *Libro del Alcázar*.

55. Clavijo Provencio and Puerto Castrillón, "Viaje al mundo," 234.

56. Tabales Rodríguez, "Programa de investigaciones arqueológicas," 10.

57. Bustamante García, "Hechos y hazañas," 112.

58. Gutiérrez, *Continuación de la historia*, 200. For the catalogue entries on the drawings, see Puerto Castrillón, "Viaje al mundo."

59. Gutiérrez, *Continuación de la historia*, 200.

60. Puerto Castrillón, "Viaje al mundo," 210.

61. Gutiérrez, *Continuación de la historia*, 126, 200.

62. Covarrubias y Orozco, *Tesoro de la lengua castellana*, fol. 358.

63. Kagan, *Clio and the Crown*, 42.

64. See, for example, Bambach, "Delli Brothers"; Pope-Hennessy and Christiansen, "Secular Painting in Fifteenth-Century Tuscany."

65. Quoted in Sáenz de Miera, "Reflejos y ecos de Erasmo," 113.

66. Ibid., 114.

67. Sáenz de Miera, *De Obra "insigne" y "heroica,"* 36.

68. Kamen, *Philip of Spain*, 61–62.

69. Kliemann has distinguished three main categories of Italian battle scene in fresco painting: (1) the painted chronicle, (2) biographical fresco cycles, and (3) genealogical history paintings. The works in the Hall of Battles fall into the first category. Kliemann, *Gesta dipinte*, 4–8.

70. Juan Páez de Castro to Jerónimo Zurita, 30 January 1569, in Kagan, *Clio and the Crown*, 103.

71. Covarrubias y Orozco, *Tesoro de la lengua castellana*, fol. 322v. *Disfamar* is the old Castilian spelling of *difamar*.

72. Ibid., fol. 396r.

73. Boch, *Descriptio publicae gratulationis*. See also Davidson and Van der Weel, "Introduction," 492–95; translations of sections of the book are found at 496–574.

74. Boch, *Descriptio publicae gratulationis*, 72, 75, 61, 63, 65.

75. For a discussion of funerary culture at El Escorial, including Philip II's death and funeral, see Eire, *From Madrid to Purgatory*, 255–368.

76. Covarrubias y Orozco, *Tesoro de la lengua castellana*, fol. 439v.

77. Conestaggio, *Uniting of the Kingdom*.

78. On the role of royal funerals in the creation of an urban geography of Habsburg authority, see Osorio, "Ceremonial King." See also Kantorowicz, *King's Two Bodies*.

79. The canvases are now kept at the Uffizi Gallery. See the essays in Bietti, *Glorias efímeras*.

80. Mathieu, *Elogio a la vida y la muerte*, in the Real Biblioteca del Palacio Real de Madrid.

81. Mamone, "Teatro de la muerte."

82. Menicucci, "Sol de España."

83. Ibid., 71.

84. Pitti, *Essequie della sacra cattolica*, 21.

85. Borsook, "Art and Politics at the Medici Court III"; Borsook, "Addendum to the Funeral."

86. Pitti, *Essequie della sacra cattolica*, fol. 48.

87. See Borsook, "Art and Politics at the Medici Court IV."

88. Mamone, "Teatro de la muerte," 35.

89. Pitti, *Essequie della sacra cattolica*, 11.

90. On the representation of Amerindians at the Florentine funeral, see Markey, *Imagining the Americas*, 144–45.

91. On the Moriscos, see, for example, Perry, *Handless Maiden*; García-Arenal and Wiegers, *Expulsion of the Moriscos*.

92. See Checa Cremades, "Felipe II y la representación."

93. Caesaris, *Oratio in obitu Philippi II*, 23. The scholarship on Naples's festivals is too vast to cite comprehensively, but see Antonelli, *Cerimoniale del viceregno . . . 1503–1622* and *Cerimoniale del viceregno . . . 1650–1717*; Galasso, Quirante, and Colomer, *Fiesta y ceremonia en la corte*.

94. Caesaris, *Oratio in obitu Philippi II*, 24, 25, 27.

95. Caputti, *Pompa funerale in Napoli*, 13.

96. Ibid., 14. Geoffrey Parker has analyzed this motto in his biographies; see, for example, *Imprudent King*, 276, plate 39.

97. Caputti, *Pompa funerale in Napoli*, 39–40 (Granada), 41–42 (St. Quentin), 56–58 (Azores and Terceira).

98. Gallego, *Visión y símbolos*, 141n54.

99. Gerónimo Collado, *Descripción del túmulo*, 39–41.

100. Belcredi, *Oratione funebre per lo catolico*, 1. On the solar imagery associated with Spanish rulers, see Mínguez Cornelles, *Reyes solares*.

101. Belcredi, *Oratione funebre per lo catolico*, 1.

102. Ibid., 4–5, 12–19, 32, 36, 21–23.

103. Ibid., 23.

104. Cervera Vera, "Privilegio concedido por Gregorio XIII."

105. This text is transcribed and translated from the original in old Castilian; I have maintained the author's spelling. Wilkinson-Zerner, *Juan de Herrera*, 108.

106. Wilkinson-Zerner and Brown, *Philip II and the Escorial*, 9.

107. See, for example, Parker, *Imprudent King*, 80, plate 13.

108. Soromenho, "*Ingegnosi ornamenti*," 36.

109. Crasbeeck, *Relação das exequias*, 15.

110. Ibid., 26.

111. Velazquez Salmantino, *Orden que te tuvo*; see also Van Kessel, "Making of a Hybrid Body."

112. Velazquez Salmantino, *Orden que te tuvo*, 15.

113. Gerónimo Collado, *Descripción del túmulo*.

114. Cabrera, *Sermón*, 22–23.

115. Iñíguez de Lequerica, *Sermones funerales*.

116. Torre, *Reales exequies*.

117. Gallego, *Visión y símbolos*, 141.

118. Torre, *Reales exequies*, 53–55.

119. Ribera Florez, *Relación historiada*, 51.

120. On the use of allegories and hieroglyphics in New Spain, see, for example, Mínguez Cornelles, "Imágenes jeroglíficas" and *Reyes distantes*.

121. See, for example, Ribera Florez, *Relación historiada*, 5–6, 15.

122. In other ceremonies, such as the American funerals for Charles V, the viceroy played the part of Philip II. Pagden, *Lords of All the World*, 139.

Epilogue

1. The epigraph is from Nebrija, *Gramática de la lengua castellana*, 13. Both statements have been cited many times before. See Kagan, *Clio and the Crown*, 16.

2. Webster, *Lettered Artists*, 8.

BIBLIOGRAPHY

Manuscripts and Printed Books Before 1800

Alberti, L. B. *Los diez libros de arquitectura de Leon Baptista Alberto: Traduzido de Latin romance [. . .].* Madrid, 1582.

Almela, J. A. *Las reales exequias y doloroso sentimiento que la muy noble y muy leal ciudad de Murcia [. . .] Don Philippe de Austria, II [. . .].* Valencia, 1600.

Ávila, H. *Libro de los retratos de los reyes.* Madrid, 1594.

Baerland, A. van. *Chroniques des ducs de Brabant.* Antwerp, 1600.

Belcredi, F. *Oratione funebre per lo catolico e potentissimo re delle Espagna, e dell Indie, Filippo II.* Pavia, 1598.

Bermudez, J. *Regalia del aposentamiento de corte, su origen y progreso, leyes, ordenanzas, y reales decretos, para su cobranza, y distribucion [. . .].* Madrid, 1738.

Boch, J. *Descriptio publicae gratulationis, spectaculorum et ludorum, in adventu Sereniss[imi] Principis Ernesti Archiducis Austriae, Ducis Burgundiae, Comitis Habsp[urgi] aurei vellleris equitis [. . .].* Antwerp, 1595.

Cabrera, A. *Sermón que predicó Fray Alonso Cabrera [. . .] en las honras de [. . .] Felipe Segundo [. . .] que se hizo en la Villa de Madrid.* Madrid, 1589.

Cabrera de Córdoba, L. *Filipe Segundo, rey de España.* 1619. Edited by J. Martínez Millán and C. Morales. Salamanca, 1998.

Caesaris, I. *Oratio in obitu Philippi II hispaniarum regis catholici.* Naples, 1598.

Calvete de Estrella, J. *El felicissimo viaje del [. . .] Príncipe don Phelippe [. . .], desde España a sus tierras de la Baxa Alemana: [. . .] Estados de Brabante y Flandes.* Antwerp, 1552.

Caputti, O. *La pompa funerale fatta in Napoli [. . .] Filippo II di Austria.* Naples, 1599.

Cato the Elder and Varro Reatinus. *On Agriculture and Res rustica.* Translated by W. D. Hooper and H. B. Ash. Cambridge, MA, 1934.

Charles V. *The Advice of Charles the Fifth, Emperor of Germany and King of Spain, to His Son Philip the Second upon His Resignation of the Crown of Spain to His Said Son.* London, 1670.

Cicero. *The Republic and The Laws.* Edited by J. G. F. Powell and N. Rudd. Translated by N. Rudd. Oxford, 2008.

Coecke van Aelst, B. P., and Cornelius Grapheus. *Le triumphe d'Anvers, faict en la susception du Prince Philips, Prince d'Espaign[e].* Antwerp, 1550.

Conestaggio, G. *The Historie of the Uniting of the Kingdom of Portugall to the Crowne of Castill [. . .].* London, 1600.

Covarrubias y Orozco, S. de. *Tesoro de la lengua castellana o española.* Madrid, 1611.

Crasbeeck, P. *Relação das exequias d'el rey Dom Filippe nosso senhor, primeiro deste nome do reys de Portugal.* Lisbon, 1599.

De arquitectura. Ca. 1550. Biblioteca Nacional de España, MS 9681.

Díez Navarro, A. *Alegación fiscal por el derecho y regalías de la de real aposento de corte.* Madrid, 1740.

Erasmus. *The Education of a Christian Prince with the Panegyric for Archduke Philip of Austria.* Edited by L. Jardine. Cambridge, UK, 1997.

Escobar, A. *Recopilacion de la felicissima jornada que la catholica real magestad del rey don Phelipe nuestro señor hizo en la conquista del reyno de Portugal* [. . .]. Valencia, 1583.

Escolano de Arrieta, P. *Práctica del consejo real en el despacho de los negocios* [. . .]. Vol. 2. Madrid, 1796.

Folchi, A. *Orazione d'Antonio Folchi sopra le lodi della cattolica maesta del re di Spagnia don Filippo II d'Austria* [. . .]. Florence, 1599.

Gómez Bravo, J. *Magistral de la Catedral de Córdoba: Catálogo de los obispos de Córdoba.* Vol. 2. Cordova, 1778.

González Dávila, G. *Teatro de las grandezas de la Villa de Madrid: Corte de los Reyes Católicos de España.* Madrid, 1623.

Guerreiro, A. *Das festas que se fizeram na cidade de Lisboa, na entrada de el-rei D. Filipe, primeiro de Portugal.* Lisbon, 1581.

Herrera, J. *Sumario y breve declaracion de los diseños y estampas de la fabrica de San Lorencio el Real del Escurial.* Madrid, 1589.

Herrera y Tordesillas, A. *Cinco libros de Antonio de Herrera de la historia de Portugal y conquista de las Islas de los Açores en los años 1582 y 1583.* Madrid, 1591.

Horace. *Poesias lyricas de Q. Horacio Flacco.* Madrid, 1783.

Iñíguez de Lequerica, J. *Sermones funerales en las honras del rey nuestro señor don Felipe II* [. . .]. Madrid, 1601.

Lavanha, J. B. *Viage de la catolica magestad del rey Don Felipe III* [. . .] *a su reino de Portugal y relación del solemne recibimiento* [. . .]. Madrid, 1619.

———. *Viagem da Catholica Real Magestade del Rey D. Filipe II. N.S. ao reyno de Portugal e rellação do solene recebimento que nelle se lhe fez. S. Magestade a mandou escreuer* Madrid, 1622.

López de Hoyos, J. *Real apparato y sumptuoso recibimiento con que Madrid* [. . .] *rescibio a la serenisima reyna dª Ana de Austria.* Madrid, 1572.

Mathieu, P. de. *Elogio a la vida y la muerte del rey catholico Don Phelipe 2º.* Ca. 1599, translated and copied in the seventeenth century. Real Biblioteca del Palacio Real de Madrid, MS II-1149.

Morgado, A. *Historia de Sevilla, en la cual se contienen sus antigüedades, grandezas y cosas memorables en ella acontecidas desde su fundación hasta nuestros tiempos.* Seville, 1587.

Nebrija, A. de. *Gramática de la lengua castellana.* Salamanca, 1492.

Pacioli, L. *De divina proportione.* Venice, 1509.

Páez de Castro, J. *Memoria a Felipe II sobre la utilidad de juntar una buena biblioteca.* Ca. 1555. Real Biblioteca Monasterio de El Escorial, 55-VII-26.

Pérez de Herrera, C. *Discurso a la católica y real magestad del rey don Felipe [II]* [. . .] *se le suplica que, considerando las muchas calidades y grandezas de la Villa de Madrid, se sirva de ver si* [. . .] *mereciesse ser corte perpetua* [. . .]. Madrid, 1597.

———. *Elogio a las esclarecidas virtudes* [. . .] *del rey* [. . .] *Felipe II* [. . .] *y de su exemplar y christianissima muerte* [. . .]. Madrid, 1604.

Perret, P. *Diseños de toda la fabrica de San Lorenzo el Real del Escurial, con las declaraciones de las letras, numeros y caracteres de cada uno.* Madrid, 1587.

Philip II. *Memorandum Written by Philip II with Instructions for Aranjuez.* 20 June 1563. British Library, MS Add. 28350, no. 17.

Pitti, V. *Essequie della sacra cattolica real maesta del re di Spagna D. Filippo d'Austria celebrate dal serenissimo D. Ferdinando Medici* [. . .] *nella città di Firenze.* Florence, 1598.

Porreño de Mora, B. *Dichos y hechos de el señor rey Don Phelipe Segundo, el prudente* [. . .]. Madrid, 1666.

Privileges Conceded by the Kings of Portugal. 1585. Biblioteca da Ajuda, Lisbon, MS 49/II/46 BA, 730, 55–57.

Recopilación de las leyes de los reynos de Indias mandada a imprimir y publicar por la magestad católica del rey Don Cárlos II. Madrid, 1681.

La regla y establecimientos de la cavalleria de Santiago del Espada, con la historia del origen y principio della. Madrid, 1627.

Relación de la jornada que hizo Felipe II desde Santarem hasta Lisboa. Biblioteca Nacional de España, MS 12026.

Relación de lo que pasó en la honras fúnebres que Felipe III mandó hacer por su padre el rey Felipe II, en San Jerónimo de Madrid (17 October 1598). Biblioteca Nacional de España, MS 18718/78.

Ribera Florez, D. *Relación historiada de las exequias funerales* [. . .] *del rey D. Philippo II hechas por el ribunal del Santo Oficio de la Inquisicion desta Nueva España y sus provincias, y yslas Philippinas* [. . .]. Mexico City, 1600.

Rodrigues Soares, P. *Memorial de Pero Rois Soares.* Transcribed by M. Lopes de Almeida. Lisbon, 1953.

Ruscelli, G. *Le imprese illustri.* Venice, 1566. Real Biblioteca Monasterio de El Escorial, 42-v-48. Enc. Esc.

Sagredo, D. de. *Medidas del romano.* Toledo, 1526.

San Pedro, L. de. *Diálogo llamado Philippino, donde se trata el derecho que la magestad del Rey Don Philippe, nuestro Señor, tiene al reyno de Portugal.* Ca. 1579. Real Biblioteca Monasterio de El Escorial, &-III-12. Olim: IV-N-6. Olim: IV-C-11. Also in Biblioteca Universidad de Salamanca, MS 2092.

Serie de Dibujos de Batallas Medievales. Biblioteca-Archivo Municipal de Jerez de la Frontera, R. 27210.

Serlio, S. *Sebastiano Serlio on Architecture: Books VI and VII of "Tutte l'opere d'architettura et prospetiva."* Translated by V. Hart and P. Hicks. New Haven, 2001.

———. *Serlio on Domestic Architecture.* Edited by M. N. Rosenfeld. New York, 1978.

———. "Sesto libro d'architettura: Delle habitationi fuori e dentrodelle città." Lyon, 1547–50. Bayerische Staatsbibliothek, Munich, Codex Icon 189.

———. *Tercero y quarto libro de architectura.* Translated by F. de Villalpando. Toledo, 1552.

Serrano de Vargas y Ureña, J. *Entrada en publico y recibimiento grandioso de la magestad del catolicismo rey don Felipe nuestro senor en la insigne, noble y leal ciudad de Lisboa.* Seville, 1619.

Sigüenza, J. *Segunda [-tercera] parte de la historia de la Orden de San Geronimo: Dirigida al rey nuestro señor, don Philippe III.* 2 vols. Madrid, 1600–1605.

Torre, D. de La. *Las reales exequies, y doloroso sentimiento, que la muy noble y muy leal ciudad de Murcia hizo en la muerte del muy catholico rey, y Señor Don Philippe de Austria [. . .].* Valencia, 1600.

A Treatise Concerning the Succession of Portugal, 1578–1580. British Library, MS Add. 8709.

Vasconcellos, A. M. *Succession del Señor Rey Don Filipe Segundo en la corona de Portugal.* Madrid, 1639.

Velazquez Salmantino, I. *La entrada que en el reino de Portugal hizo la S. C. R. M. de Don Philippe, invistissimo rey de las Españas, segundo de este nombre, primero de Portugal [. . .].* Madrid, 1581.

———. *La orden que te tuvo en la solemne procession que hizieron, los devotos cofrades del Santísimo Sacramento de la yglesia del señor S. Julian [. . .].* Lisbon, 1582.

Vergara Barona, A. *Latini sermonis, et eloquentiae apud inclytā academiam vallisoletanam primarij oratio in funere Philippi II [. . .].* Valladolid, 1599.

Villalta, D. *De las estatuas antiguas.* Madrid, 1590.

Ximenez, A. *Descripción del Real Monasterio de San Lorenzo del Escorial: Su magnifico templo, panteon y palacio; Compendiada de la descripcion antiqua.* Madrid, 1764.

Publications After 1800

Acuña, R., ed. *Relaciones geográficas del siglo XVI: Antequera II.* Mexico City, 1982.

Ainsworth, P. "Contemporary and 'Eyewitness' History." In *Historiography in the Middle Ages,* edited by D. Mauskopf Deliyannis, 249–76. Leiden, 2003.

Albardonedo Freire, A. J. "La alameda, un jardín público de árboles y agua: Origen y evolución del concepto." *Anuario de Estudios Americanos* 72, no. 2 (2015): 421–52.

———. "Fuentes legales sobre construcción: Las *Ordenanças* de Sevilla (1527)." In *Actas del Tercer Congreso Nacional de Historia de la Construcción,* edited by A. Graciani, S. Huerta, E. Rabasa, and M. Tabales, 1–12. Seville, 2000.

———. *El urbanismo de Sevilla durante el reinado de Felipe II.* Seville, 2002.

Albuquerque, M. *A Torre do Tombo e os seus tesouros.* Lisbon, 1990.

Alcocer y Martínez, M. *Guía del investigador: Archivo General de Simancas.* Valladolid, 1923.

Aliberti, F. M., and E. Gaudioso. *Gli affreschi di Paolo III a Castel Sant'Angelo: Progetto ed esecuzione, 1543–1548.* Rome, 1981.

Alonso García, F. *El correo en el Renacimiento: Estudio postal del archivo de Simón Ruiz (1553–1630).* Madrid, 2004.

Alonso Ruiz, B. "El Alcázar de Madrid: Del castillo Trastámara al palacio de los Austrias (Ss. XV–1543)." *Archivo Español de Arte* 87, no. 348 (2014): 335–50.

Alvar Ezquerra, A. *Felipe II y la corte de Madrid en 1561.* Madrid, 1985.

———. "Fuentes históricas de Madrid en el reinado de Felipe II." In Comunidad de Madrid, *Primeras jornadas sobre fuentes documentales para la historia de Madrid*, 167–72. Madrid, 1988.

———. *El nacimiento de una capital europea: Madrid entre 1561 y 1601*. Madrid, 1989.

Álvarez Terán, M. C. *Mapas, planos y dibujos (años 1503–1805)*. Vol. 1. Valladolid, 1980.

Alves, A. M. *As entradas régias portuguesas: Uma visão de conjunto*. Lisbon, 1986.

Amador de los Ríos, J., J. de La Rada, and C. Rosell. *Historia de la villa y corte de Madrid*. 4 vols. Madrid, 1978.

Amelang, J. "The New World in the Old? The Absence of Empire in Early Modern Madrid." *Cuadernos de Historia de España* 82 (2008): 147–64.

Andrés, G. "Ordenación urbanística de Madrid dada por Felipe II en 1590." *Anuario del Instituto de Estudios Madrileños* 12 (1976): 15–31.

Añón Feliú, C. "Paisaje y urbanismo trascendente de Felipe II." In Martínez Ruiz, *Madrid, Felipe II y las ciudades*, 2:213–31.

Antonelli, A., ed. *Cerimoniale del viceregno spagnolo di Napoli, 1503–1622*. Naples, 2015.

———. *Cerimoniale del viceregno spagnolo e austriaco di Napoli, 1650–1717*. Naples, 2012.

Aramburu-Zabala Higuera, M. Á., and J. Gómez Martínez, eds. *Juan de Herrera y su influencia: Actas del simposio*. Santander, 1993.

Araujo, R. *Lisboa: A cidade e o espectáculo na epoca dos descobrimentos*. Lisbon, 1990.

Arenillas, J. A. *Del clasicismo al barroco: Arquitectura sevillana del siglo XVII*. Seville, 2005.

Attwood, P. *Italian Medals, c. 1530–1600, in British Public Collections*. London, 2003.

Azevedo, P., and A. Baião. *Arquivo da Torre do Tombo: Sua historia*. Lisbon, 1905.

Balao González, A. "La restauración de la Sala de las Batallas." In *El Monasterio del Escorial y la pintura*, edited by F. J. Campos y Fernández de Sevilla, 605–22. Madrid, 2001.

Ball, R., and G. Parker. *Cómo ser rey: Instrucciones del emperador Carlos V a su hijo Felipe, mayo de 1543*. Madrid, 2014.

Bambach, C. C. "The Delli Brothers: Three Florentine Artists in Fifteenth-Century Spain." *Apollo* 161, no. 517 (2005): 75–83.

Barbeito, J. M. *Alcázar de Madrid*. Madrid, 1992.

———. "La capital de la monarquía, 1535–1600." In *Madrid: Atlas histórico de la ciudad, siglos IX–XIX*, edited by V. Pinto Crespo and S. Madrazo Madrazo, 32–39. Madrid, 1995.

———. "La corte barroca, 1600–1665." In *Madrid: Atlas histórico de la ciudad, siglos IX–XIX*, edited by V. Pinto Crespo and S. Madrazo Madrazo, 40–47. Madrid, 1995.

———. "Felipe II y la arquitectura: Los años de juventud." In *Felipe II: Un príncipe del Renacimiento*, edited by F. Checa Cremades, 83–103. Madrid, 1998.

Barreto Xavier, Â., F. J. Bouza Álvarez, and P. Cardim, eds. *Festas que se fizerão pelo cazamento do rei D. Affonso VI, 1666*. Lisbon, 1996.

Berger, A. *Encyclopedic Dictionary of Roman Law*. Philadelphia, 2008.

Bietti, M., ed. *Glorias efímeras: Las exequias florentinas de Felipe II y Margarita de Austria*. Madrid, 1999.

Blasco Esquivias, B. *Arquitectos y tracistas (1526–1700): El triunfo del barroco en la corte de los Austrias*. Madrid, 2013.

———, ed. *La casa: Evolución del espacio doméstico en España*. 2 vols. Madrid, 2006.

———. "El cuerpo de Alarifes de Madrid: Origen, evolución, extinción del empleo." *Anales del Instituto de Estudios Madrileños* 28 (1990): 467–94.

———. "Madrid, utopía y realidad de una ciudad capital." *Madrid Revista de Arte, Geografía e Historia* 1 (1998): 47–72.

———. "Utilidad y belleza en la arquitectura carmelitana: Las iglesias de San José y La Encarnación." *Anales de Historia del Arte* 14 (2004): 143–56.

Blumenthal, A. R. *Theater Art of the Medici*. Dartmouth, 1980.

Boccardo, P., J. L. Colomer, and C. Di Fabio, eds. *España y Génova: Obras, artistas y collectionistas*. Madrid, 2004.

Borsook, E. "Addendum to the Funeral of Philip II." *Mitteilungen des Kunsthistorischen Institutes in Florenz* 14, no. 2 (1969): 248–50.

———. "Art and Politics at the Medici Court IV: Funeral Décor for Henry IV of France." *Mitteilungen des Kunsthistorischen Institutes in Florenz* 14, no. 2 (1969): 201–34.

———. "Art and Politics at the Medici Court III: Funeral Décor for Philip II of Spain." *Mitteilungen des Kunsthistorischen Institutes in Florenz* 14, no. 1 (1969): 91–114.

Bouza Álvarez, F. J. *Cartas de Felipe II a sus hijas*. Madrid, 1998.

———. *Communication, Knowledge, and Memory in Early Modern Spain*. Philadelphia, 1999.

———. *Del escribano a la biblioteca*. Madrid, 1992.

———. *D. Filipe I*. Lisbon, 2005.

———. *Felipe II y el Portugal dos povos: Imágenes de esperanza y revuelta*. Salamanca, 2011.

———. *Imagen y propaganda: Capótulos de la historia cultural de reinado de Felipe II*. Madrid, 1998.

———. "Lisboa sozinha, quase viúva: A cidade e a mudança da corte no Portugal dos Filipes." *Penélope: Revista de História e Ciências Sociais* 13 (1994): 71–94.

———. *Portugal no tempo dos Filipes: Política, cultura, reprentações (1580–1668)*. Lisbon, 2000.

———. "Retórica da imagem real: Portugal e a memória figurada de Filipe II." *Penélope: Revista de História e Ciências Sociais* 4 (1990): 19–58.

Boyle, L. E. *A Survey of the Vatican Archives and of Its Medieval Holdings*. Toronto, 1972.

Braun, H. *Juan de Mariana and Early Modern Spanish Political Thought*. Aldershot, 2007.

Brendecke, A. "*Arca, archivillo, archivo*: The Keeping, Use, and Status of Historical Documents About the Spanish Conquista." *Archival Science* 10 (2010): 267–84.

———. *The Empirical Empire: Spanish Colonial Rule and the Politics of Knowledge*. Berlin, 2016.

Brenneke, A. *Archivistica contributo alla teoria ed alla storia archivistica europea*. Milan, 1968.

Brown, J. *La Sala de las Batallas de El Escorial: La obra de arte como artefacto cultural*. Salamanca, 1998.

Brown, J., and J. H. Elliot. *A Palace for a King: El Buen Retiro and the Court of Philip IV*. New Haven, 2003.

Bunes Ibarra, M. A., Y. Maes de Wit, and D. Rodrigues. *Las hazañas de un rey: Tapices flamencos del siglo XV en la Colegiata de Pastrana*. Madrid, 2010.

Bury, J. "Las 'Galerías Largas' de El Escorial." In *IV centenario del Monasterio de El Escorial: Las Casas Reales; El Palacio*, 21–36. Madrid, 1986.

Bustamante García, A. *La arquitectura clasicista del foco vallisoletano (1561–1640)*. Valladolid, 1983.

———. "De las guerras con Francia: Italia y San Quintín." *Anuario del Departamento de Historia y Teoría del Arte* 21 (2009): 47–68.

———. "Espejo de las hazañas: La historia en el Monasterio de El Escorial." *Cuadernos de Arte e Iconografía* 4 (1991): 197–206.

———. "Hechos y hazañas: Representaciones históricas del siglo XVI." In *El modelo italiano en las artes plásticas de la Península Ibérica durante el Renacimiento*, edited by M. J. Redondo Cantera, 99–130. Valladolid, 2004.

———. *La octava maravilla del mundo: Estudio histórico sobre el Escorial de Felipe II*. Madrid, 1994.

Butzer, K. W., and E. K. Butzer. "Domestic Architecture in Early Colonial Mexico: Material Culture as (Sub)text." In *Cultural Encounters with the Environment: Enduring and Evolving Geographic Themes*, edited by A. B. Murphy, D. L. Johnson, and V. Haarmann, 17–36. Lanham, MD, 2000.

Cabañas Bravo, M., A. López-Yarto Elizalde, and W. Rincón García, eds. *Arte en tiempos de guerra*. Madrid, 2009.

Cámara Muñoz, A. "Modelo urbano y obras en Madrid en el reinado de Felipe II." In *Madrid en el contexto de lo hispánico*, edited by Universidad Complutense de Madrid, Departamento de Historia del Arte, 2 vols., 1:31–48. Madrid, 1994.

Campos y Fernández de Sevilla, F. J. "Los frescos de la Sala de las Batallas." In *El Monasterio del Escorial y la pintura*, edited by F. J. Campos y Fernández de Sevilla, 165–210. Madrid, 2001.

Cañeque, A. *The King's Living Image: The Culture and Politics of Viceregal Power in Colonial Mexico*. New York, 2004.

Capdequi, O. *España en América: El régimen de tierras en la época colonial*. México City, 1959.

———. *Historia del derecho español en América y del derecho indiano*. Madrid, 1968.

Cardim, P. *Cortes e cultura política no Portugal do antigo regime*. Lisbon, 1998.

———. "La jornada de Portugal y las cortes de 1619." In *La monarquía de Felipe III*, edited by J. Martínez Millán, 4:900–946. Madrid, 2008.

———. *Portugal unido y separado: Felipe II, la unión de territorios y la condición política del reino de Portugal*. Valladolid, 2014.

Carita, H. *Lisboa Manuelina: E a formação de modelos urbanísticos da época moderna (1495–1521)*. Lisbon, 1999.

Carrero Santamaria, E. "La capilla de los arzobispos, el tesoro y la torre de don Gómez Manrique en la catedral de Santiago de Compostela." *Anuario del Departamento de Historia y Teoría del Arte* 9–10 (1997–98): 35–51.

Carrillo de Huete, P. *Crónica del halconero de Juan II*. Madrid, 1946.

Casanova, E. *Archivistica*. Siena, 1928.

Castel Branco, J., ed. *Arte efémera em Portugal*. Lisbon, 2001.

Cavallo, A. S. *Medieval Tapestries in the Metropolitan Museum of Art*. New York, 1993.

Cervera Vera, L. "Privilegio concedido por Gregorio XIII a Juan de Herrera para imprimir y vender sus estampas de El Escorial." *Academia: Boletín de la Real Academia de Bellas Artes de San Fernando* 58 (1984): 79–99.

Checa Cremades, F. *Felipe II: Mecenas de las artes*. Madrid, 1992.

———, ed. *Felipe II: Un monarca y su época*. Madrid, 1998.

———. "Felipe II y la representación del poder real." *Anales de Historia del Arte* 1 (1989): 121–39.

———, ed. *The Inventories of Charles V and the Imperial Family*. 3 vols. Madrid, 2010.

———. "The Language of Triumph: Images of War and Victory in Two Early Modern Tapestry Series." In Checa Cremades and Fernández-González, *Festival Culture*, 19–40.

———, ed. *El Real Alcázar de Madrid: Dos siglos de arquitectura y coleccionismo en la corte de los reyes de España*. Madrid, 1994.

Checa Cremades, F., and L. Fernández-González, eds. *Festival Culture in the World of the Spanish Habsburgs*. Aldershot, 2015.

Civil, P. "Culture et histoire: Galerie de portraits et 'Hommes Illustres' dans l'Espagne de la deuxième moitié du XVI siècle." *Mélanges de la Casa de Velázquez* 26, no. 2 (1990): 5–32.

Clavijo Provencio, R., and C. Puerto Castrillón. "Notas sobre Jerez." *Revista Historia de Jerez* 7 (2001): 266–69.

———. "Viaje al mundo de la investigación." *Revista Historia de Jerez* 8 (2002): 233–35.

Clayton, L. A. *Bartolome de Las Casas and the Conquest of the Americas*. London, 2010.

Colegio Oficial de Arquitectos de Madrid, ed. *Cartografía de la ciudad de Madrid: Planos históricos, topográficos y parcelarios de los siglos XVIII, XIX y XX*. Madrid, 1979.

Comunidad de Madrid, Dirección General de Patrimonio Cultural, ed. *Primeras jornadas sobre fuentes documentales para la historia de Madrid*. Madrid, 1988.

Cook, E. *Jornada de Tarazona*. Madrid, 1879.

Coppens, H. "Bureau des archives (1773–1794)." In *Les institutions du gouvernement central des Pays-Bas Habsbourgeois (1482–1795)*, edited by M. Aerts, E. Baelde, H. Coppens, H. de Scheper, H. Soly, A. K. L. Thijs, and K. van Honacker, 404–11. Brussels, 1996.

Corens, L., A. Walsham, and K. Peters. *Archives and Information in the Early Modern World*. Oxford, 2018.

Cortés, H., and A. Padgen. *Letters from Mexico*. New Haven, 2001.

Cortés Alonso, V. "Las ordenanzas de Simancas y la administración castellana." In *Symposium de historia de la administración (1) actas*, 197–224. Madrid, 1983.

———. "Organismos productores de documentación en las Indias en el siglo XVI: Las audiencias y el consejo de Indias; Documentación y archivos." In *IV jornadas científicas sobre documentación de Castilla e Indias en el siglo XVI*, edited by S. Cabezas Fontanilla and M. M. Royo Martínez, 61–85. Madrid, 2005.

Cowans, J. *Early Modern Spain: A Documentary History*. Philadelphia, 2003.

Crespo Rodríguez, M. D. *Arquitectura doméstica de la ciudad de los reyes (1535–1750)*. Seville, 2005.

Crouch, D. P., D. J. Garr, and A. I. Mundigo. *Spanish City Planning in North America*. Cambridge, MA, 1982.

Cuesta Domingo, M. *Antonio de Herrera y su obra*. Segovia, 1998.

DaCosta Kauffman, T., C. Dossin, and B. Joyeux-Prunel. *Circulations in the Global History of Art*. Aldershot, 2015.

Davidson, P., and A. van der Weel. "Introduction: The Entry of Archduke Ernst of Austria into Antwerp in 1594 in Context." In *"Europa Triumphans": Court and Civic Festivals in Early Modern Europe*, edited by J. R. Mulryne, H. Watanabe-O'Kelly, and M. Shewring, 2 vols., 1:492–574. Aldershot, 2004.

Deagan, K. A., and J. M. Cruxent. *Archaeology at La Isabela: America's First European Town.* New Haven, 2002.

De Jonge, K. "Espacio ceremonial: Intercambios en la arquitectura palaciega entre los Países Bajos borgoñones y España en la alta edad moderna." In de Jonge, García García, and Esteban Estríngana, *Legado de Borgoña*, 61–90.

———. "De kunst van het efemere: Portugees-Vlaamse feestarchitectuur in de zestiende eeuw." *Vlaanderen Jaargang* 40 (1991): 157–62.

De Jonge, K., B. J. García García, and A. Esteban Estríngana, eds. *El legado de Borgoña: Fiesta y ceremonia cortesana en la Europa de los Austrias (1454–1648).* Madrid, 2010.

Del Re, N. "The Vatican Secret Archives." *Court Historian Journal* 5, no. 2 (2000): 127–39.

Dias Dinis, A. J. "Relatório do sóculo XVI sobre o Arquivo Nacional da Torre do Tombo." *Anais de la Academia Portuguesa de Historia* 2, no. 17 (1968): 117–58.

Díaz González, F. J. *La Real Junta de Obras y Bosques en la época de los Austrias.* Madrid, 2002.

Domínguez Compañy, F. *Ordenanzas municipales hispanoamericanas.* Madrid, 1982.

Domínguez Ortiz, A. *Instituciones y sociedad en la España de los Austrias.* Barcelona, 1985.

Domínguez Ortiz, A., C. Herrero Carretero, and J. A. Godoy, eds. *Resplendence of the Spanish Monarchy: Renaissance Tapestries and Armor from the Patrimonio Nacional.* New York, 1991.

Donahue-Wallace, K. *Art and Architecture of Viceregal Latin America, 1521–1821.* Albuquerque, 2008.

Durán Montero, M. A. "La Alameda de los Descalzos de Lima y su relación con las de Hércules de Sevilla y la del Prado de Valladolid." In *Andalucía y América en el siglo XVII: Actas de las III jornadas de Andalucía y América*, vol. 2, edited by B. Torres Ramírez and J. J. Hernández Palomo, 171–82. Seville, 1985.

Edelmayer, F. *Philipp II: Biographie eines Weltherrschers.* Stuttgart, 2009.

Édouard, S. *L'empire imaginaire de Philippe II: Pouvoir des images et discours du pouvoir sous les Habsbourg d'Espagne au XVIe siècle.* Paris, 2005.

Eire, C. M. N. *From Madrid to Purgatory: The Art and Craft of Dying in Sixteenth-Century Spain.* Cambridge, UK, 2002.

Elliot, J. H. *Imperial Spain.* London, 1963.

———. *Spain and Its World, 1500–1700.* London, 1990.

———. *Spain, Europe, and the Wider World, 1500–1800.* New Haven, 2009.

Ennes, E. *A secção ultramarina da Biblioteca Nacional: Inventários.* Lisbon, 1928.

Escobar, J. "Architecture in the Age of the Spanish Habsburgs." *Journal of the Society of Architectural Historians* 75, no. 3 (2016): 258–62.

———. "Church: Place (Spain)," and "City (Spain)." In *Lexikon of the Hispanic Baroque: Transatlantic Exchange and Transformation*, edited by E. Levy and K. Mills, 51–55, 61–64. Austin, TX, 2013.

———. "A Forum for the Court of Philip IV: Architecture and Space in Seventeenth-Century Madrid." In *The Politics of Space: European Courts, ca. 1500–1750*, edited by M. Fantoni, G. Gorse, and M. Smuts, 121–38. Rome, 2009.

———. "Francisco de Sotomayor and Nascent Urbanism in Sixteenth-Century Madrid." *Sixteenth Century Journal* 35, no. 2 (2004): 357–82.

———. "Map as Tapestry: Science and Art in Pedro Teixeira's 1656 Representation of Madrid." *Art Bulletin* 96, no. 1 (2014): 50–69.

———. *The Plaza Mayor and the Shaping of Baroque Madrid.* Cambridge, UK, 2003.

———. *La Plaza Mayor y los orígenes del Madrid barroco.* Madrid, 2009.

Escudero, J. A. "El consejo de cámara de Castilla y la reforma de 1588." *Anuario de Historia del Derecho Español* 67, no. 2 (1997): 925–41.

———. *Felipe II: El rey en el despacho.* Madrid, 2002.

———. *Los hombres de la monarquía universal.* Madrid, 2011.

Ezquerra Revilla, I. J. "Aportación al estudio de la junta de policía (1590–1601)." In *Homenaje a Antonio Domínguez Ortiz*, edited by J. R. Vázquez Lesmes, 257–82. Madrid, 2004.

———. "Justicia y gobierno en el siglo XVI: El consejo real de Castilla durante el reinado de Felipe II (1556–1598)." PhD diss., Universidad Autónoma de Madrid, 1999.

Falcón Márquez, T. *Casas sevillanas desde la Edad Media hasta el barroco*. Seville, 2012.

Feliciano, M. J., and J. C. Ruiz Souza. "Al-Andalus and Castile: Art and Identity in the Iberian Peninsula." In *Companions to the History of Architecture*, vol. 1, *Renaissance and Baroque Architecture*, edited by A. Payne, 527–57. Hoboken, NJ, 2017.

Fernández Albaladejo, P. "Lex regia aragonensium: Monarchie composée et identité des royaumes durante le règne de Philippe II." In *Idées d'empire en Italie et en Espagne (XIVe–XVIIe siècle)*, edited by F. Crémoux and L. Fournel, 145–72. Rouen, 2010.

Fernández Álvarez, M. *El establecimiento de la capitalidad de España en Madrid*. Madrid, 1962.

———. *Felipe y su tiempo*. Madrid, 1998.

Fernández-González, L. "Architectural Hybrids? Building, Law, and Architectural Design in the Early Modern Iberian World." In "Visual and Spatial Hybridity in the Early Modern Iberian World," edited by L. Fernández-González and M. Trusted, special issue, *Renaissance Studies* 34, no. 4 (2019–20). https://doi.org/10.1111/rest.12589.

———. "The Architecture of the Treasure-Archive in the Early Modern World: The Archive at the Simancas Fortress, 1540–1569." In *Felix Austria: Lazos familiares, cultura política y mecenazgo artístico entre las cortes de los Habsburgos*, edited by B. J. García García, 61–101. Madrid, 2016.

———. "Imagining the Past? Architecture and Public Rituals in Early Modern Lisbon, Madrid, and Valladolid." *Bulletin of Spanish Visual Studies* 3, no. 2 (2019): 1–17.

———. "O modelo digital da pintura da Rua Nova: Recreando a arquitetura quinhentista de Lisboa." In Gschwend and Lowe, *Cidade global*, 78–83.

———. "Negotiating Terms: King Philip I of Portugal and the Ceremonial Entry into Lisbon in 1581." In Checa Cremades and Fernández-González, *Festival Culture*, 87–113.

———. "La representación de las naciones en las entradas triunfales de Felipe II y Felipe III en Lisboa (1581–1619)." In *Las corporaciones de nación en la monarquía hispánica (1580–1750): Identidad, patronazgo y redes de sociabilidad*, edited by B. J. García García and O. Recio Morales, 413–50. Madrid, 2014.

Fernández-González, L., and F. Checa Cremades. "Introduction." In Checa Cremades and Fernández-González, *Festival Culture*, 1–18.

Fernández-González, L., and M. Trusted. "Visual and Spatial Hybridity in the Early Modern Iberian World." In "Visual and Spatial Hybridity in the Early Modern Iberian World," edited by L. Fernández-González and M. Trusted, special issue, *Renaissance Studies* 34, no. 4 (2019–20). https://doi.org/10.1111/rest.12588.

Fernández Romero, I. "Tabvlarivm: El archivo en época romana." *Anales de Documentación* 6 (2003): 59–70.

Ferrador, M. *El libro del Alcázar: Memorias antiguas de Jerez de la Frontera ahora impresas por primera vez*. Jerez, 1939.

Flor, P., ed. *Praça universal de todo o orbe: Uma vista de Lisboa de 1619*. Lisbon, 2019.

Foronda y Aguilera, M. *Estancias y viajes del Emperador Carlos V: Desde el día de su nacimiento hasta el de su muerte; Comprobados y corroborados con documentos originales*. Madrid, 1914.

Fort, R., M. Álvarez de Buergo, E. M. Perez-Monserrat, M. Gomez-Heras, M. J. Varas-Muriel, and D. M. Freire. "Evolution in the Use of Natural Building Stone in Madrid, Spain." *Quarterly Journal of Engineering Geology and Hydrogeology* 46, no. 4 (2013): 421–28.

Franco Mata, M. A. "Aspectos iconográficos sobre contiendas entre Cristianos y Musulmanes en el bajo Medioevo." In *Arte en tiempos de guerra*, edited by M. Cabañas Bravo, A. López-Yarto Elizalde, and W. Rincón García, 37–50. Madrid, 2009.

Fraser, V. *The Architecture of Conquest: Building in the Viceroyalty of Peru (1535–1635)*. Cambridge, UK, 1990.

Fuchs, B. *Exotic Nation: Maurophilia and the Construction of Early Modern Spain*. University Park, 2011.

Gachard, L. P. *Correspondance de Philippe II sur les affaires des Pays-Bas pub. d'après les originaux conservés dans les archives royales de Simancas [. . .]*. Brussels, 1848.

Galasso, G., J. V. Quirante, and J. L. Colomer, eds. *Fiesta y ceremonia en la corte virreinal de Nápoles (siglos XVI y XVII)*. Madrid, 2013.

Gallego, J. *Visión y símbolos en la pintura española del siglo de oro*. Madrid, 1984.

García-Arenal, M., and G. Wiegers, eds. *The Expulsion of the Moriscos from Spain: A Mediterranean Diaspora*. Leiden, 2014.

García Bernal, J. J. "Memoria funeral de los Austrias: El discurso histórico y las noticias políticas en las exequias sevillanas de los siglos XVI y XVII." In de Jonge, García García, and Esteban Estríngana, *Legado de Borgoña*, 613–704.

García-Frías Checa, C. "Artistas genoveses en la pintura decorativa de grutescos del monasterio de San Lorenzo de El Escorial." In Boccardo, Colomer, and Di Fabio, *España y Génova*, 113–28.

———. *Carlos V en Yuste: Muerte y gloria eterna*. Madrid, 2008.

———. "El Monasterio de El Escorial y sus colecciones artísticas." In Checa Cremades, *Felipe II: Un monarca*, 213–33.

———. "Una nueva visión de la Sala de Batallas del Monasterio de El Escorial tras su restauración." *Reales Sitios: Revista del Patrimonio Nacional* 155 (2003): 2–15.

———. "Sala de Batallas del Monasterio de El Escorial." *Restauración and Rehabilitación* 52 (2001): 26–35.

———. "Las series de batallas del Real Monasterio de San Lorenzo de El Escorial: Frescos y pinturas." In García García, *Imagen de la Guerra*, 135–70.

García García, B. J., ed. *La imagen de la guerra en el arte de los antiguos Países Bajos*. Madrid, 2006.

Gaudin, G. *Penser et gouverner le Nouveau-Monde au XVIIe siècle, l'empire de papier de Juan Díez de la Calle, commis du Conseil des Indes*. Paris, 2013.

Gehlert, A. "Uma esplendida vista de Lisboa no Castelo de Weilburg." *Monumentos, Revista Semestral do Patrimonio Construído e da Reabilitação Urbana* 28 (2008): 208–13.

Gérard Powell, V. *De castillo a palacio: El Alcázar de Madrid en el siglo XVI*. Bilbao, 1984.

Gerónimo Collado, F. *Descripción del túmulo y relación de las exequias que hizo la ciudad de Sevilla en la muerte del rey don Felipe Segundo*. Seville, 1869.

Ghidoli Tome, A. "La Sala del Tesoro in Castel Sant'Angelo, ambiente ed arredo: Note e riflessioni in occasione del restauro." *Archivum Arcis* 3 (1991): 203–8.

Goldenberg Stoppato, L. "Los lienzos con historias de la vida de Felipe II." In Bietti, *Glorias efímeras*, 155–212.

Gómez Renau, M. M. "Alarifes musulmanes en Valladolid." *Al-Andalus Magreb: Estudios Árabes e Islámicos* 4 (1996): 223–38.

———. *Comunidades marginadas en Valladolid: Mudéjares y Moriscos*. Valladolid, 1993.

González Amezúa, A. "El archivo de Simancas y la historia de España." *Revista Nacional de Educación* 54 (1945): 11–30.

González García, J. L. "De ornato y policía en Madrid: Casas principales y ordenación viaria en el Renacimiento." *Anales de Historia del Arte* 7 (1997): 99–122.

González Mateo, M. V. "Las primeras consultas en el archivo de Simancas." *Revista Bibliográfica y Documental* 1 (1947): 485–87.

Grebe, M. A. *Akten, Archive, Absolutismus? Das Kronarchiv von Simancas im Herrschaftsgefüge der spanischen Habsburger (1540–1598)*. Frankfurt, 2012.

Gruzinski, S. *The Mestizo Mind: The Intellectual Dynamics of Colonization and Globalization*. London, 2002.

———. *Les quatre parties du monde: Histoire d'une mondialisation*. Paris, 2004.

Guadalupe Zamora, M. L. "El tesoro del Cabildo Zamorano: Aproximación a una biblioteca del siglo XIII." *Studia Historica: Historia Medieval* 1 (1983): 167–80.

Guerrero, L. F. "Patrimonial Rammed Earth Structures at the Sierra Nevada, Mexico." In Mileto, Vegas, and Cristini, *Rammed Earth Conservation*, 117–24.

Gutiérrez, B. *Continuación de la historia y anales [. . .] ciudad de Xerez de la Frontera, libro segundo*. Jerez, 1887.

Gutiérrez, R. *Arquitectura colonial teoria y praxis (s. XVI–XIX): Maestros, arquitectos, gremios, academia y libros*. Buenos Aires, 1980.

———. *Arquitectura y urbanismo en Iberoamérica*. Madrid, 2010.

Gutiérrez, R., P. Acevedo, G. M. Viñuales, E. Acevedo, and R. Vallin. *La casa cusqueña*. Buenos Aires, 1981.

Hamann, B. E. "The Mirrors of Las Meninas: Cochineal, Silver, and Clay." *Art Bulletin* 92, nos. 1–2 (2010): 6–35.

Harth-Terré, E. "¿Cómo eran las casas en Lima en el siglo XVI?" *Mar del Sur* 10 (1950): 26.

Head, R. C. *Making Archives in Early Modern Europe: Proof, Information, and Political Record-Keeping, 1400–1700.* Cambridge, UK, 2019.

Holanda, F., and J. F. Alves. *Da fábrica que falece à cidade de Lisboa (1571).* Lisbon, 1984.

Impey, E., and G. Parnell. *The Tower of London: The Official Illustrated History.* London, 2000.

Íñiguez Almech, F. "Juan de Herrera y las reformas en el Madrid de Felipe II." *Revista de la Biblioteca, Archivo y Museo,* nos. 59–60 (1950): 3–108.

———. "Límites y ordenanzas de 1567 para la Villa de Madrid." *Revista de la Biblioteca, Archivo y Museo,* no. 69 (1955): 3–38.

Izquierdo Álvarez, S. "Felipe II y el urbanismo moderno." *Anales de Geografía de la Universidad Complutense* 13 (1993): 81–107.

Hale, P. *Artists and Warfare in the Renaissance.* New Haven, 1990.

Hardoy, J. E., and C. Aranovich. "Urban Scales and Functions in Spanish America Toward the Year 1600: First Conclusions." *Latin American Research Review* 5, no. 3 (1970): 57–91.

Horn, H. J. *Jan Cornelisz Vermeyen: Painter of Charles V and His Conquest of Tunis.* 2 vols. Doornspijk, 1989.

Jacquot, J., ed. *Fêtes et cérémonies au temps de Charles V.* Vol. 2 of *Les fêtes de la Renaissance.* Paris, 1960.

Jamieson, R. W. *Domestic Architecture and Power: The Historical Archaeology of Colonial Ecuador.* New York, 1999.

Jordan Gschwend, A. "Cardinal Infante Henry of Portugal." In *The Dictionary of Art,* edited by J. Turner, 2:874–75. London, 1996.

———. *Catarina Áustria: A rainha colecionadora.* Lisbon, 2012.

———. "'Cosa veramente di gran stupore': Entrada real y fiestas nupciales de Juana de Austria en Lisboa." In de Jonge, García García, and Esteban Estríngana, *Legado de Borgoña,* 179–240.

———. "'Ma meilleur soeur': Leonor of Austria, Queen of Portugal and France: The Queen's Ceremonial Entry into Lisbon." In Checa Cremades, *Inventories of Charles V,* 3:2573–74.

———. "Portuguese Royal Collections (1505–1580): A Bibliographic and Documentary Survey." Master's thesis, George Washington University, 1985.

Jordan Gschwend, A., and K. J. P. Lowe. *A cidade global: Lisboa no Renascimento.* Lisbon, 2017.

———. *The Global City: On the Streets of Renaissance Lisbon.* London, 2015.

Julia, S., D. Ringrose, and C. Segura. *Madrid: Historia de una capital.* Madrid, 2008.

Juliana Colomer, D. "Fiesta y urbanismo: Valencia en los siglos XVI y XVII." PhD diss., University of Valencia, 2017.

Kagan, R. L. *Clio and the Crown: The Politics of History in Medieval and Early Modern Spain.* Baltimore, 2009.

———. "Imágenes y política en la corte de Felipe IV de España: Nuevas perspectivas sobre el Salón de los Reinos." In Pallos and Carrió-Invernizzi, *Historia imaginada,* 101–20.

———. *Spanish Cities of the Golden Age: The Views of Anton van den Wyngaerde.* Los Angeles, 1989.

Kagan, R. L., and F. Marías Franco. *Urban Images of the Hispanic World, 1493–1793.* New Haven, 2000.

Kamen, H. *El enigma del Escorial: El sueño de un rey.* Madrid, 2009.

———. *The Escorial: Art and Power in the Renaissance.* New Haven, 2010.

———. *Philip of Spain.* New Haven, 1997.

Kantorowicz, E. *The King's Two Bodies: A Study in Mediaeval Political Theology.* Princeton, 1957.

Karl, B. *Embroidered Histories: Indian Textiles for the Portuguese Market During the Sixteenth and Seventeeth Centuries.* Vienna, 2016.

Kliemann, J. *Gesta dipinte: La grande decorazione nelle dimore italiane dal quattrocento al seicento.* Milan, 1993.

Konetzke, R. *Süd- und Mittelamerika I: Die Indianerkulturen Altamerikas und die Spanisch-Portugiesische Kolonialherrschaft.* Frankfurt, 2004.

Kubler, G. *Building the Escorial.* Princeton, 1982.

———. "A Medal by G. P. Poggini Depicting Peru and Predicting Australia." *Mitteilungen des Kunsthistorischen Institutes in Florenz* 11, nos. 2–3 (1964): 149–52.

———. *Mexican Architecture of the Sixteenth Century.* New Haven, 1948.

———. *Portuguese Plain Architecture: Between Spices and Diamonds, 1521–1706*. Middletown, CT, 1972.

Ladero Quesada, M. A., and M. Cantera Montenegro. "El tesoro de Enrique IV en el Alcázar de Segovia, 1465–1475." *Historia, Instituciones, Documentos* 31 (2004): 307–51.

Ladero Quesada, M. A., and I. Galán Parra. "Las ordenanzas locales en la corona de Castilla como fuente histórica y tema de investigación (siglos XIII al XVIII)." *Anales de la Universidad de Alicante, Historia Medieval* 1 (1982): 221–43.

Lazure, G. "Possessing the Sacred: Monarchy and Identity in Philip II's Relic Collection at the Escorial." *Renaissance Quarterly* 60, no. 1 (2007): 58–93.

Leon Pinello, A. *Tablas cronológicas de los reales consejos supremo y de la cámara de las Indias Occidentales [. . .]*. Madrid, 1892.

Levillier, R., ed. *Gobernantes del Perú, cartas y papeles, siglo XVI: Documentos del Archivo de Indias*. Vol. 3. Madrid, 1921.

Llaguno y Amírola, E. de, and J. A. Ceán Bermúdez. *Noticias de los arquitectos y arquitectura de España desde su restauración*. Vol 2. Madrid, 1829.

Lockhart, J. *Of Things of the Indies: Essays Old and New in Early Latin American History*. Stanford, 1999.

López Guzmán, R. *Territorio, poblamiento y arquitectura: Mexico en las relaciones geográficas de Felipe II*. Granada, 2007.

Lopezosa Aparicio, C. "Fiesta oficial y configuración de la ciudad: El caso del madrileño Paseo del Prado." *Anales de Historia del Arte* 12 (2002): 79–92.

———. *El Paseo del Prado de Madrid: Arquitectura y desarrollo urbano en los siglos XVII y XVIII*. Madrid, 2005.

López Torrijos, R. "Arte e historia común en el Palacio del Viso." In Boccardo, Colomer, and Di Fabio, *España y Génova*, 129–38.

———. "Las pinturas de la torre de la estufa o del peinador." In *Carlos V y la Alhambra*, edited by P. A. Galera Andreu, 107–29. Granada, 2000.

López-Vidriero Abello, M. L. *Entre España y Génova: El palacio de don Alvaro de Bazán en El Viso*. Madrid, 2009.

———. *Las trazas de Juan de Herrera y sus seguidores*. Madrid, 2001.

Luengo, A. *Aranjuez, utopía y realidad: La construcción de un paisaje*. Madrid, 2008.

Lupher, D. A. *Romans in a New World: Classical Models in Sixteenth-Century Spanish America*. Ann Arbor, 2006.

Luque Azcona, E. J. "Virreyes y cabildos en la gestión de alamedas y paseos: El caso de la ciudad de México y su contextualización con otros centros urbanos de la España peninsular y la América hispana." *Revista de Indias* 76, no. 267 (2016): 355–78.

Luz Lamarca, R. *Francisco de Mora: Gran arquitecto clasicista del Renacimiento, 1552–1610*. Madrid, 2008.

———. *Francisco de Mora y Juan Gómez de Mora: Cuenca, foco renacentista*. Madrid, 1997.

Mamone, S. "El teatro de la muerte." In Bietti, *Glorias efímeras*, 35–41.

Marcos de Dios, A. "Itinerario hispánico del Chantre de Évora, Manuel Severim de Faria, en 1604." *Revista de Estudios Extremeños* 62 (1986): 139–85.

Margaça Veiga, C. A. *Herança filipina em Portugal*. Lisbon, 2005.

Marías Franco, F. *La arquitectura del Renacimiento en Toledo (1541–1631)*. 4 vols. Toledo, 1983–86.

———. *El largo siglo XVI: Los usos artísticos del Renacimiento español*. Madrid, 1989.

Marías Franco, F., with A. Bustamante. "Un tratado inédito de arquitectura de hacia 1550." *Boletín del Museo e Instituto Camón Aznar* 13 (1983): 41–57.

Marín Perellón, F. J. "Legislación sobre regalía de aposento, I: 1371–1551." *Anales del Instituto de Estudios Madrileños* 46 (2006): 51–70.

———. "La planimetría general de Madrid y la regalía de aposento." In Marín Perellón, *Planimetría general de Madrid y regalía de aposento*, 2 vols., 1:81–111. Madrid, 1988.

Markey, L. *Imagining the Americas in Medici Florence*. University Park, 2016.

Martens, P. "Pierre-Ernest de Mansfeld: L'homme de guerre." In *Un prince de la Renaissance: Pierre-Ernest de Mansfeld (1517–1604)*, edited by J. L. Mousset and K. de Jonge, 2:77–96. Luxembourg, 2007.

Martínez Bara, J. A. "Algunos aspectos del Madrid de Felipe II." *Anales del Instituto de Estudios Madrileños* 1 (1966): 67–75.

———. *Licencias de exención de aposento del Madrid*. Madrid, 1962.

Martínez García, L. "El archivo de Simancas en el antiguo régimen: Secreto, patrimonio,

justificación y legitimidad real." *Boletín de ANABAD* 49, no. 2 (1999): 77–116.

Martínez Millán, J., and S. Fernández Conti, eds. *La monarquía de Felipe II: La casa del rey*. Madrid, 2005.

Martínez Millán, J., and C. Reyero, eds. *El siglo de Carlos V y Felipe II: La construcción de los mitos en el siglo XIX*. Madrid, 2000.

Martínez Ruiz, E., ed. *Madrid, Felipe II y las ciudades de la monarquía*. Vol. 2, *Capitalidad y economía*. Madrid, 2000.

Mazzotta, G. *Cosmopoiesis: The Renaissance Experiment*. Toronto, 2001.

Menicucci, R. "'El sol de España y las mediceas estrellas': La política Toscana hacia la corona española." In Bietti, *Glorias efímeras*, 63–76.

Merluzzi, M. "Religion and State Policies in the Age of Philip II: The 1568 Junta Magna of the Indies and the New Political Guidelines for the Spanish American Colonies." In *Religion and Power in Europe: Conflict and Convergence*, edited by J. Carvalho, 183–201. Pisa, 2007.

Mileto, C., F. Vegas, and V. Cristini, eds. *Rammed Earth Conservation*. London, 2012.

Mínguez Cornelles, V. "Imágenes jeroglíficas para un imperio en fiesta." *Relaciones: Estudios de Historia y Sociedad* 30, no. 119 (2009): 81–111.

———. *Los reyes distantes: Imágenes del poder en el México virreinal*. Castellón, 1995.

———. *Los reyes solares: Iconografía astral de la monarquía hispánica*. Castellón, 2001.

Molina Campuzano, M. *Planos de Madrid de los siglos XVII y XVIII*. Madrid, 2002.

Molinié-Bertrand, A., and J. P. Duviols. *Philippe II et l'Espagne*. Paris, 1999.

Montoya Martínez, J. *El libro historiado: Significado sociopolítico en los siglos XIII–XIV*. Madrid, 2005.

Morales Folguera, J. M. *La construcción de la utopía: El proyecto de Felipe II (1556–1598) para Hispanoamérica*. Madrid, 2001.

Morales Padrón, F. *Historia de Sevilla: La ciudad del quinientos*. Seville, 1989.

Morán Turina, J. M., and F. Checa Cremades. *Las casas del rey: Casas de campo, cazaderos y jardines, siglos XVI y XVII*. Madrid, 1986.

———. *El coleccionismo en España: De la cámara de maravillas a la galería de pinturas*. Madrid, 1985.

Morrill, P. C. *The Casa del Deán: New World Imagery in a Sixteenth-Century Mexican Mural Cycle*. Austin, TX, 2014.

Mulcahy, R. "Celebrar o no celebrar: Felipe II y las representaciones de la Batalla de Lepanto." *Reales Sitios: Revista del Patrimonio Nacional* 168 (2006): 2–15.

———. "Celebrating Sainthood, Government, and Seville: The *Fiestas* for the Canonization of King Ferdinand III." *Hispanic Research Journal* 11, no. 5 (2010): 393–414.

———. *The Decoration of the Royal Basilica of El Escorial*. Cambridge, UK, 1994.

———. *Juan Fernández de Navarrete, El Mudo: Pintor de Felipe II*. Madrid, 1999.

———. "Philip II: Madrid and Elsewhere." *Burlington Magazine* 141, no. 1151 (1999): 127–29.

———. *Philip II of Spain, Patron of the Arts*. Dublin, 2004.

Mundy, B. E. *The Death of Aztec Tenochtitlan, the Life of Mexico City*. Austin, TX, 2015.

Muñiz Coello, J. "Elaboración, conservación y custodia de las fuentes documentales escritas en la antigua Roma: Los archivos (II)." *Hispania Antiqua* 22 (1998): 371–400.

Navarro Bonilla, D. *Escritura, poder y archivo: La organización documental de la diputación del reino de Aragón (siglos XV–XVIII)*. Zaragoza, 2003.

———. *La imagen del archivo: Representación y funciones en España (siglos XVI y XVII)*. Gijón, 2003.

Newcome, M. "Fresquistas genoveses en El Escorial." In *Los frescos italianos de El Escorial*, edited by M. Di Giampaolo, 5–6. Madrid, 1993.

Nieto Alcaide, V., F. Checa Cremades, and A. Morales. *Arquitectura del Renacimiento en España, 1488–1599*. Madrid, 2009.

Ortega Vidal, J. "Hacia un catálogo razonable de la arquitectura de Juan de Herrera: Un criterio topográfico." In *Juan de Herrera: Arquitecto real*, edited by C. Riaño Lozano, 47–124. Madrid, 1997.

Osorio, A. B. "The Ceremonial King: Kingly Rituals and Imperial Power in Seventeenth-Century New World Cities." In Checa Cremades and Fernández-González, *Festival Culture*, 177–94.

———. *Inventing Lima: Baroque Modernity in Peru's South Sea Metropolis*. New York, 2008.

Páez de Castro, J. *Memoria a Felipe II sobre la utilidad de juntar una buena biblioteca*. Valladolid, 2003.

Pagden, A. R. *Lords of All the World: Ideologies of Empire in Spain, Britain, and France, c. 1500–c. 1800*. New Haven, 1995.

Pallos, J. L., and D. Carrió-Invernizzi, eds. *La historia imaginada: Construcciones visuales del pasado en la edad moderna*. Madrid, 2008.

Palm, E. W. *Arquitectura y arte colonial en Santo Domingo*. 2 vols. Santo Domingo, 1974.

Paret, P. *Imagined Battles: Reflections of War in European Art*. Chapel Hill, 1997.

Parker, G. *Felipe II: La biografía definitiva*. Madrid, 2010.

———. *The Grand Strategy of Philip II*. New Haven, 1998.

———. *The Imprudent King: A New Life of Philip II*. New Haven, 2014.

Pereda, F. "Response: The Invisible? New World." *Art Bulletin* 92, nos. 1–2 (2010): 47–52.

Pereira Da Costa, J. "D. Manuel e a Torre do Tombo." *Aufsätze zur Portugiesischen Kulturgeschichte* 10 (1970): 300–301.

Pérez, J. *Los comuneros*. Madrid, 2001.

———. *La Leyenda Negra*. Gadir, 2009.

Pérez, J. J. *Pensamiento político y reforma institucional durante la Guerra de las Comunidades de Castilla (1520–1521)*. Madrid, 2007.

Pérez de Guzmán, E. "Cronica del rey don Juan el Segundo." In *Crónicas de los reyes de Castilla: Desde don Alfonso el Sabio hasta los Católicos don Fernando y doña Isabel*, edited by C. Rosell, 3 vols., 2:277–695. Madrid, 1953.

Pérez de Tudela Gabaldón, A. "Los primeros años del príncipe don Felipe (IV): 1605–1621." In *La corte de Felipe IV (1621–1665): Reconfiguración de la monarquía católica*, edited by J. Martínez Millán and M. Rodríguez Rivero, 1:21–74. Madrid, 2017.

Perry, M. E. *The Handless Maiden: Moriscos and the Politics of Religion in Early Modern Spain*. Princeton, 2005.

Pessanha, J. *A Torre do Tombo*. Lisbon, 1906.

Pírez Fernández, M. *Casa Archivo General de Simancas: La intervención, 1999–2007*. Madrid, 2008.

———. *Memoria del proyecto de rehabilitación de la casa archivo en Simancas*. Madrid, 1999.

Plaza Bores, A. *Guía del Archivo General de Simancas*. Madrid, 1992.

———. "Juan Pantoja de la Cruz y el archivo de Simancas." *Boletín del Seminario de Estudios de Arte y Arqueología* 8–9 (1935): 259–63.

Pleguezuelo, A. *Arquitectura y construcción en Sevilla, 1590–1630*. Seville, 2000.

Ponce Leiva, P. *Relaciones histórico-geográficas de la audiencia de Quito (siglos XVI–XIX)*. Vol. 1. Quito, 1992.

Poole, S. *Juan de Ovando: Governing the Spanish Empire in the Reign of Philip II*. Norman, OK, 2004.

Pope-Hennessy, J., and K. Christiansen. "Secular Painting in Fifteenth-Century Tuscany: Birth Trays, Cassone Panels, and Portraits." *Metropolitan Museum of Art Bulletin* 38, no. 1 (1980): 1–63.

Portuondo, M. M. *Secret Science: Spanish Cosmography and the New World*. Chicago, 2009.

Prast, A. "La Sala de las Batallas del Monasterio de San Lorenzo de El Escorial." *Cortijos y Rascacielos: Casas de Campo, Arquitectura, Decoración* 17 (1934): 11–16.

Prescott, W. H. *History of the Reign of Philip the Second, King of Spain*. 2 vols. Boston, 1856–58.

Puerto Castrillón, C. "Viaje al mundo de la investigación: Sobre una colección de dibujos de la Biblioteca Municipal de Jerez (catálogo)." *Revista Historia de Jerez* 9 (2003): 209–18.

Ramada Curto, D. *Cultura política no tempo dos Filipes (1580–1640)*. Lisbon, 2001.

Ramos, D. "La crisis indiana y la Junta Magna de 1568." *Jahrbuch für Geschichte Lateinamerikas* 23, no. 1 (1986): 1–62.

Rebollo Matías, A. *La plaza y mercado mayor de Valladolid, 1561–95*. Valladolid, 1989.

Reinhardt, U. "La tapisserie feinte: Un genre de décoration du maniérisme romain au XVIe siècle." *Gazette des Beaux-Arts* 84 (1974): 285–96.

Restall, M. "The Renaissance World from the East: Spanish America and the 'Real' Renaissance." In *A Companion to the Worlds of the Renaissance*, edited by G. Ruggiero, 70–87. London, 2010.

Reyes Leoz, J. L. "Evolución de la población, 1561–1857." In *Madrid: Atlas histórico de la ciudad, siglos IX–XIX*, edited by V. Pinto Crespo and S. Madrazo Madrazo, 140–45.

Richardson, J. S. "Imperium Romanum: Empire and the Language of Power." *Journal of Roman Studies* 81 (1991): 1–9.

Rio Barredo, M. J. *Madrid, urbs regia: La capital ceremonial de la monarquía católica.* Madrid, 2000.

Rivera Blanco, J. J. *Juan Bautista de Toledo y Felipe II: La implantación del clasicismo en España.* Valladolid, 1984.

Robinson, C. *Imagining the Passion in a Multi-Confessional Castile: The Virgin, Christ, Devotions, and Images in the Fourteenth and Fifteenth Centuries.* University Park, 2013.

Rodríguez-Camillon, H. "Quincha Architecture: The Development of an Antiseismic Structural System in Seventeenth-Century Lima." In *Proceedings of the First International Congress on Construction History,* edited by S. Huerta Fernández, 3:1741–52. Madrid, 2003.

Rodríguez de Diego, J. L. "Archivos del poder, archivos de la administración, archivos de la historia (s. XVI–XVII)." In *Historia de los archivos y de la archivística en España,* edited by J. J. Generelo Lanaspa, A. Moreno López, and R. Alberch i Fugueras, 29–42. Valladolid, 1998.

———. *Instrucción para el gobierno del archivo de Simancas (año 1588).* Madrid, 1998.

———. *Memoria escrita de la monarquía hispánica: Felipe II y Simancas.* Valladolid, 2018.

Rodríguez de Diego, J. L., and J. T. Rodríguez de Diego. "Un archivo no solo para el rey: Significado social del proyecto Simanquino en el siglo XVI." In *Felipe II (1527–1598): Europa y la monarquía católica,* edited by J. Martinez Millán, 4:463–76. Madrid, 1998.

Rodríguez Salgado, M. J. *The Changing Face of Empire: Charles V, Philip II, and Habsburg Authority, 1551–1559.* Cambridge, UK, 2008.

———. *Felipe II: El paladín de la Cristiandad y la paz con el Turco.* Valladolid, 2004.

Roe, J. "Iupiter hispano, España invicta y la invasión infame: Perspectivas en la representación, circulación y contestación de la identidad política en el mundo hispánico." *Atalanta* 5, no. 2 (2017): 133–79.

Ruiz, T. F. *A King Travels: Festive Traditions in Late Medieval and Early Modern Spain.* Princeton, 2012.

Ruiz de Arcaute, A., T. Anasagasti, and J. Ortega Vidal, eds. *Juan de Herrera: Arquitecto de Felipe II.* Madrid, 1997.

Ruth, J. S., trans. *Lisbon in the Renaissance, Damião de Góis: A New Translation of the Urbis Olisiponis Descriptio.* New York, 1996.

Sáenz de Miera, J. *De obra "insigne" y "heroica" a "octava maravilla del mundo": La fama de el Escorial en el siglo XVI.* Madrid, 2001.

———, ed. *El pasatiempos de Jehan Lhermite: Memorias de un gentilhombre en la corte de Felipe II y Felipe III.* Madrid, 2005.

———. "Reflejos y ecos de Erasmo y de Vives: Fray José de Sigüenza, la guerra y la pintura bélica de El Escorial." In *Erasmo en España: La Recepción del humanismo en el primer Renacimiento español,* edited by F. Checa Cremades, 112–27. Madrid, 2002.

Sánchez Cano, D. "Festeinzüge in Madrid (1560–1690)." PhD diss., Technische Universität Berlin, 2005.

———. "Festival Interventions in the Urban Space of Habsburg Madrid." In Checa Cremades and Fernández-González, *Festival Culture,* 69–86.

Sánchez Cantón, F. J. *La librería de Juan de Herrera.* Madrid, 1941.

Sánchez-Molero, J. L. G. *El aprendizaje cortesano de Felipe II: La formación de un príncipe del Renacimiento.* Madrid, 1998.

———. "Madrid y la corte itinerante de Felipe (1535–1554): Los preludios de una capitalidad." In Martínez Ruiz, *Madrid, Felipe II y las ciudades,* 2:69–82.

San Cristóbal Sebastián, A. *La casa virreinal limeña de 1570 a 1687.* 2 vols. Lima, 2003.

Schäfer, E. *El consejo real y supremo de las Indias.* Vol. 1. Madrid, 2003.

Schäffler, A. "Die 'Hohe Registratur' des Magister Lorenzen Fries." *Archiv des Historischen Vereins von Unterfranken und Aschaffenburg* 22, no. 1 (1874): 1–32.

Schäffler A., and T. Henner, eds. *Die Geschichte des Bauern-Krieges in Ostfranken von Magister Lorenz Fries.* Würzburg, 1883.

Schaub, J. F. *Portugal na monarquia hispánica (1580–1640).* Lisbon, 2001.

Schellenberg, T. R. "Archival Principles of Arrangement." *American Archivist* 24 (1961): 11–24.

Segurado, J. "Juan de Herrera em Portugal." In *As relações artísticas entre Portugal e Espanha na época dos descobrimentos*, edited by P. Dias, 99–111. Coimbra, 1987.

Seipel, W., ed. *Der Kriegszug Kaiser Karls V. gegen Tunis: Kartons und Tapisserien*. Vienna, 2000.

Shewring, M., ed. *Waterborne Pageants and Festivities in the Renaissance*. Aldershot, 2013.

Sieber, C. "The Invention of a Capital: Philip II and the First Reform of Madrid." PhD diss., Johns Hopkins University, 1986.

Sigüenza J. *Fundación del Monasterio de El Escorial*. Madrid, 1963.

———. *Historia de la Orden de San Jerónimo (1595–1605)*. 3 vols. Madrid, 1907–9.

Simons, E., and R. Godoy. *Discurso del Sr. Juan de Herrera aposentador mayor de S. M. sobre la figura cúbica*. Madrid, 1976.

Sociedad Estatal para la Conmemoración de los Centenarios de Felipe II y Carlos V, ed. *La fiesta en la Europa de Carlos V*. Seville, 2000.

———, ed. *Jardín y naturaleza en el siglo XVI: Felipe II, el rey intimo*. Aranjuez, 1998.

Solano, F. de. *Ciudades hispanoamericanas y pueblos de Indios*. Madrid, 1990.

———. *Cuestionarios para la formación de las relaciones geográficas de Indias: Siglos XVI/XIX*. Madrid, 1988.

———. *Normas y leyes de la ciudad hispanoamericana (1492–1600)*. Madrid, 1996.

Soromenho, M., ed. "*Ingegnosi ornamenti*: Arquitecturas efémeras em Lisboa no tempo dos primeiros Filipes." In Castel Branco, *Arte efémera*, 21–38.

———. *Joyeuse entrée: A vista de Lisboa do Castelo de Weilburg*. Lisbon, 2015.

Stolz, O. *Geschichte und Bestände des Staatlichen Archives zu Innsbruck*. Vienna, 1938.

Strong, R. *Art and Power: Renaissance Festivals, 1450–1650*. Berkeley, 1984.

Tabales Rodríguez, M. A. "Programa de investigaciones arqueológicas del Castillo de Jimena de la Frontera, Cádiz." *Almoraima* 33 (2006): 9–30.

Tanner, M. *The Last Descendant of Aeneas: The Hapsburgs and the Mythic Image of the Emperor*. New Haven, 1993.

Taylor, R. *Arquitectura y magia: Consideraciones sobre la idea de El Escorial*. Madrid, 2006.

Teixeira Marques de Oliveira, J. *Fontes documentais de Veneza referentes a Portugal*. Lisbon, 1997.

Terán Bonilla, J. A. "Los gremios de albañiles en España y Nueva España." *Imafronte* 12–13 (1996–97): 341–55.

Torres Megiani, A. P. *O rei ausente: Festa e cultura política nas visitas dos Filipes a Portugal, 1581 e 1619*. São Paulo, 2004.

Torres Mendoza, L. *Colección de documentos inéditos del Archivo de Indias*. Vol. 8. Madrid, 1867.

Tovar Martín, V. *Arquitectura madrileña del s. XVII: Datos para su estudio*. Madrid, 1983.

———. *Juan Gómez de Mora (1586–1648): Arquitecto y trazador del rey y maestro mayor de obras de la Villa de Madrid*. Madrid, 1986.

———. "El palacio real de Madrid en su entorno." In Checa Cremades, *Real Alcázar de Madrid*, 60–79.

———. "La plaza principal de Madrid en el reinado de Felipe II." *El Arte en las Cortes de Carlos V y Felipe II: Jornadas de Arte* 9 (1999): 259–68.

———. "Lo urbano y lo suburbano: La capital y los sitios reales." In Martínez Ruiz, *Madrid, Felipe II y las ciudades*, 2:199–212.

Tracy, J. D. *Emperor Charles V, Impresario of War: Campaign Strategy, International Finance, and Domestic Politics*. Cambridge, UK, 2002.

Urquízar-Herrera, A. *Admiration and Awe: Morisco Buildings and Identity Negotiations in Early Modern Spanish Historiography*. Oxford, 2017.

Valladares Ramírez, R. *La conquista de Lisboa: Violencia militar y comunidad política en Portugal, 1578–1583*. Madrid, 2008.

Van Kessel, E. *The Lives of Paintings: Presence, Agency, and Likeness in Venetian Art of the Sixteenth Century*. Berlin, 2017.

———. "The Making of a Hybrid Body: Corpus Christi in Lisbon, 1582." In "Visual and Spatial Hybridity in the Early Modern Iberian World," edited by L. Fernández-González and M. Trusted, special issue, *Renaissance Studies* 34, no. 4 (2019–20). https://doi.org/10.1111/rest.12590.

Ventura Villanueva, A. "Los edificios administrativos de la Córdoba romana: Problemas de localización e identificación." *Romula* 2 (2003): 183–96.

Vetter, E. M. "Der Einzug Philipps III in Lissabon 1619." *Spanische Forschungen der Görresgesellschft* 7 (1962): 187–263.

Villalpando, J. B. *El tratado de la arquitectura perfecta en la última visión del profeta Ezequiel.* Edited by J. Corral. Madrid, 1990.

Wagner U., and W. Ziegler, eds. *Lorenz Fries: Chronik der Bischöfe von Würzburg, 742–1495.* 6 vols. Würzburg, 1992–2004.

Watanabe-O'Kelly, H. "The Early Modern Festival Book: Function and Form." In *"Europa Triumphans": Court and Civic Festivals in Early Modern Europe,* edited by J. R. Mulryne, H. Watanabe-O'Kelly, and M. Shewring, 2 vols., 1:3–18. Aldershot, 2004.

Webster, S. V. *Lettered Artists and the Languages of Empire: Painters and the Profession in Early Colonial Quito.* Austin, TX, 2017.

——. *Quito, ciudad de maestros: Arquitectos, edificios y urbanismo en le largo siglo XVI.* Quito, 2012.

——. "Vantage Points: Andeans and Europeans in the Construction of Colonial Quito." *Colonial Latin American Review* 20, no. 3 (2011): 303–30.

Wilkinson-Zerner, C. *Juan de Herrera: Architect to Philip II of Spain.* New Haven, 1993.

——. "Planning a Style for the Escorial: An Architectural Treatise for Philip of Spain." *Journal of the Society of Architectural Historians* 44, no. 1 (1985): 37–47.

Wilkinson-Zerner, C., and C. P. M. Brown, eds. *Philip II and the Escorial: Technology and the Representation of Architecture.* Providence, 1990.

Williams, P. *Philip II.* New York, 2001.

Woelderink, B. "The Dutch Royal Archives: The Hague." *Court Historian* 4, no. 3 (1999): 217–28.

Zalama Rodríguez, M. A. "The Ceremonial Decoration of the Alcázar in Madrid: The Use of Tapestries and Paintings in Habsburg Festivities." In Checa Cremades and Fernández-González, *Festival Culture,* 41–67.

Zarco Cuevas, J. *Pintores italianos en San Lorenzo el Real de El Escorial (1575–1613).* Madrid, 1932.

Zozaya Montes, L. "El Archivo de la Villa de Madrid en la alta edad moderna (1556–1606)." PhD diss., Universidad Complutense de Madrid, 2008.

INDEX

Italicized page references indicate illustrations. Endnotes are noted with "n" followed by the endnote number.